Art Theory

To Julia

Yet let us ponder boldly

Robert Williams

Art Theory

An Historical Introduction

Blackwell
Publishing

BLACKWELL PUBLISHING
350 Main Street, Malden, MA 02148-5020, USA
108 Cowley Road, Oxford OX4 1JF, UK
550 Swanston Street, Carlton, Victoria 3053, Australia

First published 2004 by Blackwell Publishing Ltd
Reprinted 2004

Library of Congress Cataloging-in-Publication Data

Williams, Robert, 1955–
 Art theory : an historical introduction / Robert Williams.
 p. cm.
Includes bibliographical references and index.
 ISBN 1–4051–0706–5 (hardcover : alk. paper) — ISBN 1–4051–0707–3
(pbk. : alk. paper)
 1. Art—History. I. Title.

N5300.W647 2004
709—dc22

 2003021503

A catalogue record for this title is available from the British Library.

Set in 10/12.5pt Galliard
by Graphicraft Ltd, Hong Kong
Printed and bound in the United Kingdom
by TJ International, Padstow, Cornwall

For further information on
Blackwell Publishing, visit our website:
www.blackwellpublishing.com

contents

plates

Figures

Acknowledgments

The author and publisher gratefully acknowledge the following for permission to reproduce copyright material:

Alexander & Bonin (photo by P. Migeat), with permission of Mona Hatoum (fig. 6.10); © Alinari/Art Resource, NY (figs 1.4, 1.9, 2.3, 2.4, 2.6, 4.1); Art Institute of Chicago (figs 5.2 [© 2003 Estate of Pablo Picasso/ARS, NY], 5.16 [© 2003 Man Ray Trust/ARS, NY/ADAGP, Paris], plate 12); © Art Resource, NY (fig. 4.8); © 2003 ARS, NY/ADAGP, Paris/Succession Marcel Duchamp (fig. 5.10); © 2003 ARS,

NY/VG Bild-Kunst, Bonn (photo by F. Scruton), with permission of Hans Haacke (fig. 5.24); Arts Council of Great Britain, Hayward Gallery, London, with permission of Mary Kelly (fig. 6.6); © N. O. Battaglini/ Art Resource, NY (fig. 1.2); Bibliothèque Nationale, Paris (fig. 3.3); Bridgeman Art Library (figs 1.1, 1.3, 2.1, 2.2, 2.10, 4.6, 4.9, 4.11, 5.11 [© 2003 ARS, NY/ADAGP, Paris/Succession Marcel Duchamp], 5.12, plates 2, 16 [© 2003 Succession H. Matisse, Paris/ARS, NY], 18); Victor Burgin (fig. 6.1); Leo Castelli Gallery (figs 5.18 [© Robert Rauschenberg/licensed by VAGA, New York, NY], 5.20 [© Estate of Donald Judd/licensed by VAGA, New York, NY], 5.21 [© 2003 Robert Morris/ARS, NY]); Paula Cooper Gallery, with permission of the artist (fig. 6.4); President and Fellows of Corpus Christi College, Oxford University (fig. 1.6); Eisenman Architects (fig. 6.5); J. Paul Getty Museum/ © 2003 ARS/ADAGP, Paris (fig. 5.17); Research Library, Getty Research Institute, with permission of Allan Kaprow (fig. 5.19); © Giraudon/ Art Resource, NY (figs 3.1, 4.3, plates 10, 20); Hirshhorn Museum and Sculpture Garden, Smithsonian Institution (photo by L. Stalsworth)/ © 2003 Andy Warhol Foundation for the Visual Arts/ARS, NY (plate 24); © 2003 Jenny Holzer/ARS, NY (fig. 6.3); Huntington Library and Art Collection, San Marino, CA (fig. 4.10); © Erich Lessing/Art Resource, NY (fig. 2.7, plates 3, 5, 6, 17); Peter Lunenfeld, with permission of Stelarc (fig. 6.11); © Photothèque R. Magritte/Art Resource, NY/© 2003 C. Herscovici, Brussels/ARS, NY (fig. 5.15); © Foto Marburg/Art Resource, NY (figs 3.4, 4.4, 5.5); Menil Collection (plate 23 [© Jasper Johns and Gemini G.E.L./licensed by VAGA, New York, NY, published by Gemini G.E.L.]); Metro Pictures (figs 6.7 [with permission of the artist], 6.8 [with permission of the artist]); Museum of Fine Arts, Boston (fig. 4.7, plate 13); Digital Image © Museum of Modern Art, NY/Licensed by Scala/Art Resource, NY (figs 5.3 [© 2003 Estate of Pablo Picasso/ARS, NY], 5.13, 5.23 [© 2003 Joseph Kosuth/ ARS, NY], plates 19 [© 2003 Estate of Pablo Picasso/ARS, NY], 21 [© 2003 Pollock–Krasner Foundation/ARS, NY], 22 [© 2003 Barnett Newman Foundation/ARS, NY]); © Nimatallah/Art Resource, NY (fig. 3.2); Patrick Painter, with permission of the artist (fig. 6.9); Philadelphia Museum of Art (figs 5.4 [© ARS, NY/ADAGP, Paris], 6.2 [with permission of Barbara Kruger], plate 11); © Réunion des Musées Nationaux/ Art Resource, NY (figs 2.8, 4.5, plate 7); © Scala/Art Resource, NY (fig. 1.8, plates 1, 4, 8, 9, 14, 15); Werner Spies (fig. 5.14); UCLA Armand Hammer Museum (fig. 4.2); Musei Vaticani (fig. 2.5); VAGA (fig. 5.7 [© Estate of Vladimir Tatlin/RAO, Moscow/licensed by VAGA, New York, NY]); Whitney Museum of American Art/© 2003 Sol Lewitt/ ARS, NY (fig. 5.22).

Every effort has been made to trace all copyright holders, but if any has been inadvertently overlooked, the publisher will be pleased to make the necessary arrangement at the first opportunity.

Introduction

This book is an introduction to the history of thought about art: it attempts to provide a succinct and lucid overview of Western speculation about the visual arts from ancient times to the end of the twentieth century. It is aimed primarily at beginning students, both of studio art and art history, as well as at members of the general public who, already having some familiarity with art history and perhaps a passing acquaintance with isolated aspects of art theory, feel ready for a more comprehensive approach to the subject. An understanding of theory has obviously become increasingly important for any serious engagement with art; new editions of the texts, anthologies of excerpts, and studies of particular

theorists or aspects of theory are appearing almost every day, yet there is no synoptic guide to this complex body of thought and writing. The challenge of providing one lies not only in the sheer quantity of the material to be covered and its occasional conceptual difficulty, but also in the need – complicated by the very intensity of current interest – to give it an adequate interpretative structure.

Any book of this kind might be expected to proceed from the conviction that a theoretical or philosophical perspective is necessary to the understanding of art, but no attempt is made here to suggest that what we call theory can really be understood independently of what we call practice, and no effort is made to argue that theory precedes or influences practice in any consistent way. Rather, by approaching theoretical ideas as *documents* – as objects that open out onto practice, on the one hand, and onto intellectual and social history, on the other – it attempts to show how theory might contribute to our understanding of the history of art as a whole; that is, our understanding of the relation of artistic activity in the most comprehensive sense to the entirety of the cultural environment in which it occurs. Some discussion of works of art has been woven into the account in order to suggest how the connections between theory and practice might begin to be made; these works are intentionally well-known, "canonical" ones, the better to serve as points of reference for the student and general reader.

The purpose is thus to show that, while art history should be approached theoretically or philosophically, the study of theory should also be approached historically, that it is within a comprehensive *history of art* that the study of theory has most to offer. This point deserves emphasis because much of the current interest in theory has been generated by developments in contemporary art and thought, and there is a pervasive assumption that a theoretical approach is fundamentally opposed to an historical one, that history stands for the past, theory for the promise of the here and now. While this book certainly aims to be of use to people whose real concern is the contemporary scene – a glance at the table of contents will show that it is heavily weighted toward the modern – it also attempts to demonstrate that an historical approach can be a *critical* approach, and can be made to complement and extend the critical enterprise of contemporary theory, even that contemporary theory *requires* such an historical perspective in order to sharpen its critical edge. In insisting that the study of theory should be historical, the deeper motive is not to remove it from the domain of philosophy – from "aesthetics" – so much as to insist that any philosophical approach to art must take adequate account of history.

The justification for this insistence is the fact that art is *essentially* an historical product. The circumstances that affect the ways in which it is

made change over time and from place to place, and these circumstances also condition the ways in which it is seen, thought about, and discussed. Art is not a natural category but a cultural construct; it is thus fundamentally unstable, subject to perpetual redefinition and reconstitution: even such apparent continuities as are often found over time and across cultures mask the complex processes by which practices and ideas are selectively appropriated and adapted to current needs. This instability, which has only become more apparent in modern times, is precisely what makes theory so important, and to emphasize it is to relate theory to practice *at the most fundamental level*: the pressure of history is what makes theory necessary. History exerts all sorts of pressure on art independently of theory, of course, but the effort to conceptualize and reconceptualize art's aims is also a response to that pressure, and a deeply articulate one.

To advocate an historical approach to theory is thus really to emphasize the need for a particular kind of self-consciousness in our approach to art in general, to force ourselves to objectify the grounds of our interest in it, to expose the assumptions and desires that condition and shape our engagement with it. This kind of self-objectification and the intellectual poise that it entails are difficult to achieve and to insist upon them may at first seem perverse: in Western culture, after all, art is associated with the free expression of a unique vision or the pleasurable cultivation of individual tastes; it is an arena in which we are usually encouraged to assume the validity of our spontaneous impulses and reactions – in much the same way as when we shop. Yet our impulses and reactions are not as spontaneous as they seem and they are rarely as uniquely individual as they seem: they too are historical products; the very space that culture creates for them is framed in a manner that structures their contents. This realization can be unsettling: it implies that our interest in art is not as innocent as we suppose and, in fact, is grounded very differently from what we suppose. Even more disturbingly, it implies that the kinds of things we commonly regard as most intimate and particular to ourselves – our thoughts and feelings, even our very identities – are not entirely, not really our own, that we too are provisional, unstable categories, that we too are historical products.

Such self-consciousness is critically productive because it exposes the real urgency of our stake in art, the depth and complexity of the processes by which art affects and shapes us. Although it is often thought of as something set apart from the everyday, art draws upon all those reflexes, sentiments, and habits of mind which we use to make sense of our day-to-day lives. Its resonance and power are grounded in our need for meaning in the most fundamental and all-inclusive sense; indeed, the kinds of basic skills we use to find our way through the world themselves involve and depend on art. Art is not something we must go out of

our way to encounter but is woven, like language, into the very fabric of our experience and consciousness, and it is essential to the way in which we navigate in a complex culture. Our thoughts and feelings may not be entirely our own, but we do experience moments of coherence, achieve some semblance of identity, and manage to retain some sense of significant agency; such as they are, they are effects of art. This realization may provide the deepest possible foundation for a comprehensive art history, and it suggests the possibility of a new kind of art history. Such self-consciousness need not be inimical to artistic creativity, moreover, but is perhaps a necessary precondition for the kind of serious, informed, truly critical creativity that our times so urgently require.

There are several conspicuous ways in which the approach outlined here affects the structure and substance of the account as a whole. One is the relative lack of emphasis on the specifically visual aspects of art. The idea that the "visual arts" are fundamentally distinct from others because they are concerned primarily or essentially with optical sensations emerged into prominence in the eighteenth century and became one of the theoretical cornerstones of modernism: fidelity to the specifically visual qualities of the media was thought essential to the kind of truth such media can offer us. A longer historical view enables us to see that the interdependence of the arts is a far more pervasive theme than that of their distinctness, however, and that it plays an essential role even in modern theory. Our ability to isolate the visual elements of experience and subject them to the kind of sustained, self-conscious examination we customarily do when we look at and think about art is only conceivable in a very complex cultural environment. Specifically visual concerns are always framed by others, and the modern emphasis on the isolation of the visual presupposes a larger, deeper process of cultural integration and rationalization. This perspective yields an account of Western thought about art different from the one we usually encounter; it also offers an implicit critique of those varieties of contemporary critical and art-historical practice that stop short of questioning the visuality of the visual, and that thus fail to objectify fundamental limitations of some modernist theory.

What fills the place of the visual is an emphasis on the relation of the visual arts to other arts and other kinds of *activities*: to the various manual crafts, on the one hand, and to the more prestigious forms of intellectual endeavor, on the other, from the routine practices of everyday life to the most highly organized and self-reflexive disciplines. However much art depends upon received practices and notions of specific expertise, it also continuously draws upon and defines itself against other forms of knowledge and activity, and this process provides the essential armature of the present account: it constitutes the larger frame within which, at any historical moment, the other concerns of theory are ordered and articulated.

The implicit relation to all human practices, to human activity as a whole, is what connects art at the deepest level to the total fabric of human activity that is history. Any truly comprehensive history of art, taking account of this fact, should perhaps embrace the further implication that it is art's identity as an activity – more specifically, as a kind of labor, as *cultural work* – *not* its visual fascination or appeal, that is the real ground of its interest.

Yet another conspicuous feature of this account has to do with rationality and its relation to modernism. The idea that art is in some way fundamentally irrational, though ancient in origin, also established itself as an important feature of modern thought in the eighteenth century: dissatisfaction with the sterile, coercive, even inhuman aspects of reason encouraged a belief in the positive potential of unreason and the assumption, still widespread, that art distinguishes itself from other kinds of activities – from science, for example – in the way it mobilizes the irrational aspects of our nature. An historical perspective, on the other hand, enables us to see that earlier theory was overwhelmingly concerned with establishing the rationality of art, and that even the modern cultivation of the irrational takes place within a highly developed conceptual and institutional framework – that it is itself a function of rationalization. The irrational serves a strategic purpose: we use it to make up for what reason lacks, but thereby make it into a kind of counter-reason, a means by which reason is then enabled to fulfill its critical potential. In modern times, the rational aspects of creative activity have been increasingly absorbed by its critical function. Modern theory can thus be seen to be an extension of older theory even as it is a reaction against it. The emphasis on rationality may be disagreeable to some readers, but only by recognizing the real extent of our dependence on "reason" can we hope to carry out any serious critique of it, and exposing that dependence – even at the risk of over-emphasizing it – is one of the most important tasks a book like this can accomplish.

Any book of this kind must be extremely selective, and any emphasis in one place requires omissions in another. The most obvious omission in this case is a consequence of the exclusive emphasis on Western thought. Other great cultures, such as China, have certainly produced rich and fascinating traditions of speculation about art, but a serious consideration of what it is that makes Western thought worth studying at all, and worth trying to say something new about, does not leave much room in a book of readable length for an equally serious consideration of them: a superficial comparativism, certainly, would be contrary to the spirit of the entire enterprise. The approach taken here has been to point out the ways in which, at several important moments in the development of Western modernism, artists have turned to non-Western forms and

practices for crucial help of one kind or another. This account presents such moments as episodes in the self-critique of Western thought: it is not the best way to address non-Western ideas, but it does suggest how important non-Western art has been to the critical trajectory of modernism, and has the further advantage of reminding us that our aspiration to a new, global outlook is also the product of a long history. The overall intention is not to celebrate the Western tradition but to provide an informed basis for its critical interrogation. As Theodor Adorno, one of the most important art theorists of the twentieth century, observed, "One must have a tradition in oneself to hate it properly."

Even the account of Western theory must be extremely selective and schematic, its priorities carefully ranked, and readers who come with preconceived notions of what is important may object to some of its emphases and exclusions. The bibliographical essay at the end of the book, "Sources and Suggestions for Further Reading," is intended to supplement the text and make up in some measure for the omissions, as well as to offer some guidance through the secondary literature. Because the conceptual complexity of our engagement with the material cannot be detached from the material itself, the task of proposing a coherent *mode* of engagement is essential: the insistence on an historical approach, and one that integrates the discussion of familiar objects, should thus prove more valuable than any omissions may be damaging. Advanced readers will be more sensitive to the book's limitations, but also to its novelty and interpretative logic, and the hope is that whatever their disagreements – or even because of them – they will find something worthwhile for themselves as well.

chapter 1

Antiquity and the Middle Ages

The Shield of Achilles

Ancient Greece and Rome produced a large and varied literature about
the visual arts, but little is left of it, and the only theoretical text to survive
in its entirety is the treatise *On Architecture* by Vitruvius. Writings of the
kind we would classify as theoretical, critical, and even art-historical were
in existence by the fifth century BCE – associated with the "high classical"
phase of Greek art – and continued to be produced throughout an-
tiquity, but what we know of them comes to us in the fragmentary form
of citations in texts of other kinds: any effort to discuss *systematic* thought

about art in the ancient world has to be built around the ideas of phil-
osophers such as Plato and Aristotle, and of rhetorical theorists such as
Cicero and Quintilian, authors whose interest in visual art was fairly
tangential to their work as a whole. Before attempting to do this, how-
ever, it is useful to consider the evidence of what might be called *unsys-
tematic* thought: ancient literature also records ideas about art that reflect
broadly based, "popular" attitudes, and these can be seen as the ground
from which more sophisticated thought grew. Some of these ideas con-
tinued to be of concern down to the modern period, so that they were
assumed to constitute the perennial or universal sources of art's interest.

The importance of the visual arts in the ancient world, their nearness
to life as lived and imagined, is suggested even in myth. Creation myths
often represent God as a kind of craftsman: the God of the Old Testa-
ment "lays the foundations of the earth" like an architect and fashions
man "from the dust of the earth" like a potter or sculptor. In Greek
myth, Prometheus forms the first man and woman from clay. Such stor-
ies reflect a regard for the skills necessary to make things, to manipulate
materials, and to control natural forces. A similar regard is reflected in
the magical properties often attributed to the products of craft: Hades
possesses a helmet that can make the wearer invisible; Aphrodite's girdle
causes anyone who looks at her to fall in love with her. Perhaps the most
haunting of all stories associated with visual art is that of the sculptor
Pygmalion, who carves the image of an ideally beautiful woman, falls in
love with it, then, by praying to Aphrodite, obtains his wish of having it
come to life. The tale reflects the capacity of images to suggest living
presence, but also to inspire fantasy and to embody ideals – to supply
what is lacking in life and thus to awaken desire. It reveals a very clear
awareness that images can mobilize our deepest psychological resources.

Such myths suggest that art was understood and valued as a form of
power over nature, a power that, even if limited, might sometimes seem
to tread upon the prerogatives of the gods, and thus involve tragic
consequences. Prometheus pays dearly for giving his creation the one
gift, fire, that he believes will offer it some protection in a hostile world.
The craftsman Daedalus is not only a master of materials but has a
stratagem for almost any situation: he builds a labyrinth, devises wings
with which to fly, and creates statues that move, that come as near to
being alive as human power alone can make them – but he must watch
his son Icarus perish with the very wings he has made for him. Orpheus,
the musician, charms animals and even stones with his song; in what is
surely the most haunting story about the power of music, he almost
succeeds in bringing his lover Eurydice back from the land of the dead.
In such tales, the artist figures as a kind of hero, struggling against the
ultimately limiting conditions of human existence.

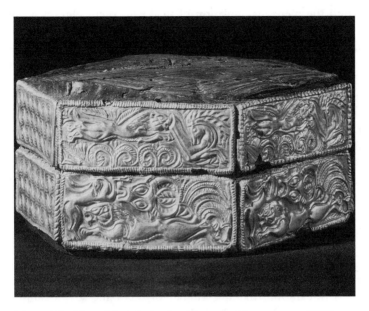

Figure 1.1 Box with embossed gold panels, Mycenaean, c.1500 BCE, National Archaeological Museum, Athens.

Ancient literature also testifies to the kind of day-to-day experience of art that seems more familiar to us. Homer's references to crafted objects indicate the significance, prestige, and fascination that painstakingly and finely made things held. His description of a simple brooch given as a present by Penelope to Odysseus may be compared with an example of the kind of goldsmith's work he might have known (figure 1.1):

> It was fashioned of gold with double clasps, and on the front it was curiously wrought: a hound held in his forepaws a dappled fawn and pinned it in his jaws as it writhed. And at this all men marvelled how, though they were of gold, the hound was pinning the fawn and strangling it, and the fawn was writhing with its feet and striving to flee.

These few words capture the elemental fascination of all illusionism, of the way in which an inanimate material can be made to seem alive, of the way in which the power of artifice momentarily replaces one reality with another. A more facetious example of the same idea is an epigram associated with the mosaic image of a laughing satyr recorded in a late-antique collection known as *The Greek Anthology*: "Why do you laugh?" the viewer asks. The image answers, "I laugh because I marvel at how, being put together out of all kinds of stones, I suddenly become a satyr."

Beyond the mere manipulation of materials, then, illusion is another source of fascination. *The Greek Anthology* preserves numerous epigrams about a famously naturalistic bronze statue of a cow by the sculptor Myron: "I am Myron's little heifer, set up on a base. Goad me, herdsman, and drive me off to the herd." As in the epigram about the mosaic satyr, the image itself speaks, a device that is used to suggest – and succeeds remarkably well in capturing – the startling effect of being fooled. A more philosophical viewer might observe that this effect undermines the distinction between the categories "nature" and "art": "Looking at this heifer of Myron's you are like to cry out: 'either Nature is lifeless, or Art is alive.'" To say that an image is alive, that it is made of flesh, that it seems to move or to be about to move, that it breathes, or that it lacks only the breath, that it speaks, or that it lacks only the capacity for speech, are all stock phrases; they testify both to the artist's skill and to the viewer's psychological engagement. Though we quickly tire of their formulaic quality, we must recognize that they say as much about the experience of art as most people needed to say.

One of the most striking examples of the value set on illusionistic deception is found in Pliny the Elder, a Roman encyclopedist of the first century CE, who provides a brief history of painting and sculpture in the context of his discussion of various minerals and how they are used by human beings for different purposes. Pliny's information is taken mostly from older secondary sources and is not very carefully integrated; much of what he says is untrustworthy in terms of factual accuracy, but it is important both for what it reveals about attitudes toward art in the ancient world and because it exerted such an influence on the imagination of later centuries. Pliny tells the story of a competition between two Greek painters, Zeuxis and Parrhasios: Zeuxis produced a picture of a cluster of grapes so true to life that when it was unveiled, birds flew down as if preparing to peck at it. He was confident of victory, but when he asked to have Parrhasios' picture unveiled, and found that what he had thought was the veil was in fact the painting, he had to admit defeat, for where he had deceived birds, Parrhasios had fooled an expert.

In addition to the power of images to persuade the viewer of physical presence and of life, there was also an intense interest in their ability to go a step further and tell stories. Homer describes at length a great golden shield, forged and embossed by Hephaestus, the god of fire himself, for the hero Achilles. Though the object is fictitious, and is certainly intended to surpass in its magnificence the work of all human goldsmiths, its description documents a profound responsiveness to the power of art, particularly to its narrative capabilities. Among the things represented on the shield are two entire cities:

In the one there were marriages and feastings, and by the light of blazing torches they were leading the brides from their bowers through the city, and loud rose the bridal song. And young men were whirling in the dance, and in their midst flutes and lyres sounded continually; and there the women stood each before her door and marvelled.

Nearby a trial is taking place, with one man arguing his case and the other disagreeing, while a group of judges listen and onlookers show their support for one side or the other. Around the second city a battle is being fought, with the kinds of incidents one would expect to see as part of such an event. Between and around the cities are landscapes, in which figures are shown engaged in characteristic activities: plowing, grain and grape harvesting, cattle and sheep herding, and dancing. In each case, the ability of the images to tell stories depends upon their capacity to suggest, not only physical forms, but movement, and not just visible things, but music and speech. These descriptions testify to a kind of projective engagement with the object that goes beyond the visual to involve all the resources of the imagination.

The description of works of art became a highly developed literary exercise, and the results are often as formulaic as the epigrams about Myron's cow. Those that give the best idea of the way in which, in the real world, cultivated people looked at works of art is the collection known simply as *Pictures* by the orator Philostratus. These little essays purport to record extemporaneous speeches made by the author in front of the paintings in his patron's collection for the edification of the patron's ten-year-old son. One of the most extensive and remarkable concerns a picture of a boar hunt. In addition to the descriptive naturalism, Philostratus admires the arrangement of episodes: the skill with which the story is told. He is especially responsive to the characterization of the hunters: "one shows in his face a touch of the palaestra, another shows grace, another urbanity, and the fourth, you will say, has just raised his head from a book." He also notes the conceptual complexity of the picture: the four hunters are led by a fifth, a boy of great beauty, with whom they are obviously all in love, so that the pursuit of the boar is paralleled by their pursuit of him. Surprised by the intensity of his absorption, Philostratus exclaims:

How I have been deceived! I was deluded by the painting into thinking that the figures were not painted but were real beings, moving and loving – at any rate I shout at them as if they could hear and I imagine that I hear some response – and you did not utter a single word to me to turn me back from my mistake, being as much overcome as I was . . .

For all its self-consciousness, his experience is not unlike that implied in Homer's descriptions of the brooch or the shield of Achilles.

The representation of the emotions and inward qualities of human figures can greatly intensify the effect of presence. The sculptors Phidias and Praxiteles were credited with having "instilled the very passions of the soul into works of stone." *The Greek Anthology* includes several epigrams about a painting of Medea murdering her children, in which the representation of intense and complex feelings was especially admired:

> When the hand of Timomachus painted baleful Medea, pulled in different directions by jealousy and the love of her children, he undertook vast labour in trying to draw her two characters, the one inclined to wrath, the other to pity. But he showed both to the full; look at the picture: in her threat dwell tears and wrath dwells in her pity.

Perhaps the most famous representation of emotion in ancient art was the *Sacrifice of Iphigenia* by Timanthes. The painting illustrated the episode from the story of the Trojan War in which the Greek leader, Agamemnon, must sacrifice his daughter in order to propitiate the gods. The other leaders of the Greek host were each shown expressing a different kind of horror and sorrow at the event, but the emotional climax was the figure of Agamemnon himself, whose face was covered by a veil as he performed the sacrifice: as his emotions were not explicitly revealed, the viewer was left to imagine them in all their unbearable intensity. The picture thus succeeded in representing what it did not represent; in acknowledging the limits of art, it transcended them.

Related to the depiction of emotional states is the ability to suggest the deeper, more permanent aspects of the personality: "character" or "soul." Apelles the painter and Lysippos the sculptor were famous for being able to capture not only the physical appearance of Alexander the Great, but also his heroic character or spirit (*ethos*). Yet not everyone seems to have believed that images could really reveal the soul, and the claim was often explained by saying that the artist represents it by depicting its visible manifestations. The form of the body and face, onto which the character of the soul was believed to be imprinted, along with the representation of emotions, might thus serve the higher purpose of revealing something beyond either physical form or transient states.

If a high value was placed on the depiction of emotions, the powerful emotional responses elicited from *viewers* were also a source of wonder. Apelles so effectively captured Alexander's stormy temperament in one portrait that, when the emperor's generals saw it, they trembled as if they were in his presence. The Roman emperor Tiberius developed such a passion for the statue of a young athlete that he had it removed from a

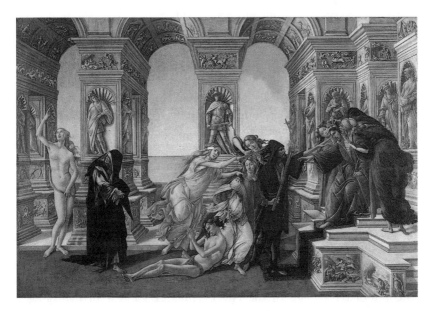

Figure 1.2 Botticelli, *Calumny of Apelles*, c.1494–5, Uffizi Gallery, Florence.

public place to his bedroom; popular outcry forced him to put it back, even though, as Pliny says, "he had completely fallen in love with it." The ability of works of art to arouse uncontrollable sexual urges is also reflected in the stories of adolescent boys attacking the famously beautiful *Aphrodite* of Praxiteles on the island of Knidos.

Closely related to the representation of emotional states and character, yet also distinct, is the capacity of images to suggest abstract ideas. Zeuxis painted a picture of Penelope, wife of Odysseus, "in which one saw morality itself." Parrhasios did a picture of two children in which one saw "the simplicity and contentment of that age"; his image of the people of Athens, which may have been, or included, a personification, a single figure representing the idea of the Athenian people, showed them to be "fickle, choleric, unjust and variable, but also placable, merciful and compassionate, boastful, proud and humble, fierce and timid – in short, everything at once."

The most famous demonstration of the power of personification was the picture of *Calumny* by Apelles. The painter had been falsely accused of a crime and exonerated, but chose to memorialize his experience by painting a picture in which he sought to express the nature of calumny – what we would call vicious gossip. The picture is lost, but a description by the essayist Lucian survived to tantalize later generations (figure 1.2). A judge with the ears of an ass sat enthroned, and to either side stood

female figures, representing Ignorance and Suspicion, to show that the judge was about to act under the influence of those qualities. Before him, Calumny, a lovely young woman but with a wicked expression on her face, dragged a young man, Innocence, by the hair. She was preceded by a haggard male figure symbolizing Envy, and was attended by two female figures, representing Artifice and Deceit. Behind them, ignored by all, was a female figure representing Truth. By combining personification with narrative, such a picture demonstrates the capacity of painting to make complex philosophical statements.

The ancients were clearly intrigued by other aspects of art than those dependent on the experience of particular objects: they included the high prices commanded by certain works and the social prestige enjoyed by some artists. Pliny never fails to mention when a picture or statue has been bought for an extraordinary sum, or, as sometimes happens, cannot be bought at all: the people of Knidos would not part with their beloved *Aphrodite*, even when a foreign king who coveted it offered to pay off their considerable public debt in return. Another king is said to have discontinued his siege of the city of Rhodes for fear of damaging a famous picture by Protogenes in the area of the city where he had to press his attack. The financial and social success enjoyed by famous artists is also an object of interest: Zeuxis could afford to have his name sewed in gold thread into his garments, and he began to give away his pictures, saying that they could not be bought for any price.

The most famous success story is that of Apelles. Alexander the Great was so fond of him that he forbade anyone else but Apelles to paint his portrait (only Lysippos was allowed to sculpt it), and he let Apelles treat him with an unusual degree of familiarity. One story tells how the emperor came to visit the painter in his studio and began to talk at great length about painting, though he knew nothing about it: Apelles advised him to change the subject, since even the studio assistants had begun to snicker behind his back. The most remarkable indication of Alexander's regard is indicated by the story of how, when he ordered Apelles to make a portrait of his favorite mistress, Campaspe, and realized that in the process of painting her Apelles had fallen in love with her himself, he gave her to him as a gift.

The truthfulness of such stories cannot be confirmed: they are not entirely implausible, yet they smack of legend. Spectacular success of the kind attributed to Apelles was surely exceptional: in general, painters and sculptors were considered manual craftsmen and did not enjoy either great wealth or social prestige. Pliny emphasizes the respect with which the arts were regarded in Greece: he says that in some places there were laws forbidding their practice to slaves, and that not only free men but aristocrats practiced them – and there is some independent evidence

to support these claims. But he also betrays what would have been the more commonplace, dismissive attitude when he says that in the case of Campaspe, Alexander acted "without regard for the feelings of his mistress," who went from being "the property of a great king" to "the property of a painter." Unique as he was, Apelles became the enduring symbol and standard of artistic success: many a later painter would be praised as "a new Apelles."

The personalities of artists were another source of fascination. The trait most often associated with them was not eccentricity, but competitiveness: it is a theme that figures even in myth. The satyr Marsyas considered himself so good at playing the pipes that he challenged Apollo, the god of music, to a contest; Marsyas lost and for his insolence was flayed alive. Arachne, skilled in weaving, challenged Pallas to a similar contest; her reward was to be changed into a spider. Among historical artists, we have already encountered the contest between Zeuxis and Parrhasios. A courteous competitiveness is illustrated by the story of a visit Apelles made to his colleague, Protogenes: finding him away from home, he drew a single, exquisitely thin line on an unused panel in the studio. Protogenes, arriving home, knew exactly who his caller had been, since only the famous Apelles could possess such skill. Protogenes nevertheless drew an even finer line, and told his housekeeper to show it to Apelles if he should call again. When Apelles returned, and managed to paint a third line, finer still, Protogenes conceded defeat. The two artists agreed that the panel should be preserved as a demonstration of skill, and it became a famous picture, winding up in the collection of the Caesars in Rome before being destroyed in a fire.

Arrogance and obsessiveness were also thought to be common in artists. Parrhasios called himself "prince of painters," and went around claiming that he had brought painting to perfection. Apollodorus, known as "the madman," was so critical of his own work that he destroyed much of it, "his intense passion for his art making him unable to be satisfied." Apelles, who was gracious toward rivals, made a point of working every day in order to keep up his skill. He challenged himself "to paint what could not be painted" – things like thunderstorms – and did not think it importunate to make portraits of people as they died.

Ancient anecdotes also testify to the fascination of the creative process. Though artistic practice was mostly laborious and formulaic, there was an awareness that following the rules does not always yield the desired result. Protogenes was once trying unsuccessfully to render the appearance of foam around a dog's mouth; exasperated, he finally threw his sponge at the panel, which hit it in such a way as to get just the effect he wanted. One of the most famous stories concerns the ever-flamboyant Zeuxis: asked to produce a picture of Helen of Troy (or Aphrodite) for

the people of Croton, he demanded first that he be allowed to see the five most beautiful girls in the town naked, so that he might choose the best parts of each to form an ideally beautiful figure. Though this story also savors of the legendary, like those of Pygmalion and of Apelles and Campaspe, it makes the more serious art-theoretical point that the artist does not simply copy what he sees but combines and distills his experiences in order to arrive at some kind of ideal conception.

Discussions of what we would call inspiration are rare in connection with the visual arts: the most striking are all associated with the figure of Zeus, now lost, made by Phidias for the temple at Olympia. An epigram in *The Greek Anthology* says that "either God came from heaven to Earth to show thee his image, Phidias, or thou didst go to see God." Some sources say that Phidias had refused to use a model, claiming that his conception of Zeus was inspired by a reading of Homer. Cicero says that Phidias "did not look at any person as a model, but there dwelt in his mind an idea of extraordinary beauty, and at this he fixed his attention constantly, guiding his art and hand to produce its likeness." The ability to imagine the ideal, to produce an image that does not so much resemble nature as surpass it – erotically motivated in the story of Pygmalion – here reveals its moral dimension, its claim upon the most exalted values. So impressive was the Olympian *Zeus* that it was often credited with having revitalized religious devotion.

Yet another feature of the attitude toward art reflected in ancient literature is an awareness of its historical development, usually expressed in terms of "progress" and "decline." Pliny's account of the arts is presented as a history, with individual artists making contributions to the improvement of technique in a way that we associate more readily with science or technology than art. The understanding of art as something that develops over time seems to have been widespread: Cicero and Quintilian, writing about the development of rhetoric, compare it to the development of painting in ways that suggest that the history of art was familiar to their readers – the kind of thing any educated person would know.

Pliny also presents a tantalizing record of what may have been the beginning of art theory. The sculptor Polykleitos, active around the middle of the fifth century BCE, "made what artists call a 'canon' or model statue, because they draw their outlines from it as from a sort of standard; and he alone of mankind is deemed by means of one work of art to have created the art itself." This notice does not give us many details, but the *Canon* was famous in antiquity: though the original bronze was lost, numerous marble copies survive (figure 1.3). Other sources tell us that Polykleitos also wrote an essay explaining the principles upon which the sculpture had been based, and this essay, like the statue, came to be

known as the *Canon*. This text was also lost, but it too seems to have been well known, and there are several significant indications of its content scattered through other ancient writings.

The *Canon* will be discussed in more detail in the third section of this chapter; for now, it is enough to attend to Pliny's remark that Polykleitos was believed to have "created the art itself" in a single work. This does not mean simply that the statue was so innovative that it set a new standard; it means that Polykleitos had produced a work in which the whole art of sculpture seemed to be contained – in the same way that Homer's shield of Achilles contains the entire art of goldsmithy. The shield is a microcosm, a world in itself; for, in addition to the cities and the landscapes with all their inhabitants, it represents the order of the cosmos: "therein he wrought the earth, therein the heavens, therein the sea, and the unwearied sun and the moon at the full, and therein all the constellations wherewith heaven is crowned." The *Canon* is simply a microcosm of a different kind.

When a picture succeeds in creating an illusion, it can be said to point beyond itself. It points in this way when it suggests physical presence; it points further when it represents a story or an emotional state or a type of character; further still when it gives form to ideals of physical beauty or moral perfection, or attempts to express complex philosophical truths. Where might such pointing end? Perhaps where the individual work of art points to art itself. Texts

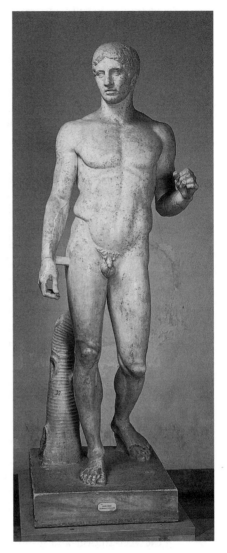

Figure 1.3 Polykleitos, *Doryphoros* (Roman marble copy after 5th-century BCE Greek bronze original), National Museum, Naples.

like Homer's and Pliny's suggest that this idea is not at all new, but was present in remote antiquity and was fundamental to ancient notions of what art is. They suggest that the desire to define art in general could contribute to the production of particular works, that those works were held to be greatest in which that aim was realized, and that art was thus

recognized as in some essential way a self-reflexive – we might say theoretical – activity.

Imitation and Knowledge

The myths, anecdotes, descriptions, and epigrams presented in the previous section all agree in the fundamental assumption that works of art are objects made by hand, distinct as a category from objects that come into being as a result of "natural" processes, even though people sometimes wondered whether birds' nests or beehives were not a kind of art. "Art" (*techne*) is a category thus defined by its opposition to "nature," yet – as the same sources clearly indicate – the relation between art and nature is not *simply* one of opposition. The idea that art *imitates* nature was a commonplace in antiquity, and its philosophical elaboration at the hands of Plato (c.428–c.348 BCE) and Aristotle (384–322 BCE), especially of the relation it implies between art and knowledge, becomes decisive for all subsequent thought about what art is.

Plato's attitude toward art is famously problematical. His most notorious and extensive treatment of it occurs in his most ambitious work, the dialogue known as *The Republic*, an attempt to describe the sociopolitical order of the ideal city-state. Early on, Plato has his spokesman, Socrates, declare that the arts of poetry and music, while beneficial in many ways, can also exert a harmful influence on society, especially on the young, and must be strictly controlled by those in authority. Poets like Homer tell stories that would lead one to believe that the gods are wicked and deceitful, for instance; such tales undermine religion and society's entire system of values: in the ideal city-state, only stories in which the gods are represented as good, heroes are always heroic, and evildoers are always punished, are to be allowed. Similarly, only those forms of music that encourage virtues useful to the citizen or soldier will be permitted. Socrates admits that the visual arts can also have a positive influence, encouraging the recognition and appreciation of qualities like harmony and grace – "there is certainly much of these qualities in painting and in all similar craftsmanship: weaving is full of them and embroidery and architecture and likewise the manufacture of household furnishings" – but the visual arts too must be controlled: artists must be forbidden to represent "the evil disposition, the licentious, the illiberal, the graceless, either in the likeness of living creatures or in buildings or in any other product of their art."

We find this advocacy of censorship reprehensible, and the ruthless elitism on which the whole system depends certainly does not make it any more appealing, but there is a forward-looking – indeed, revolutionary

– aspect to Plato's extremism. Poetry and music had played an important role in Greek education since earliest times: in attacking them, his aim is to make the case that philosophy, not poetry, should occupy the central place in the education of the ruling class. Only philosophy can provide the mental training comprehensive yet rigorous enough to prepare future leaders with the ability to discern truth and to establish and maintain a just society. As we shall see, Plato developed his position in order to meet not only the ancient challenge of poetry, but also the newer one of rhetoric.

After having outlined his utopia in more detail – as well as his case for philosophy as the best, indeed the only true, mode of knowing – Plato returns to his offensive against poetry, music, and the visual arts, and gives it both a more aggressive edge and a more explicit philosophical grounding. What is fundamentally objectionable about these arts is that they are all based on imitation (*mimesis*): they provide us with reproductions of something, yet always fail to reproduce its real essence or value. A painting, for instance, reproduces only "appearances" (*phantasma*). Poetry has the same problem: Homer represents only the "appearance" of virtue as manifest in, say, Achilles, not virtue itself. It has been suggested that Plato's disdain for *mimesis* also has to do with its importance in traditional culture, with its origins in ritual and magic, and that, even as practiced in the more evolved forms of dance, drama, and poetic recitation in Plato's day, still reminded him of the primitive, superstitious system of values he wanted to supplant.

Plato does not deny the fascination or amusement value of imitation; what he questions is its capacity to serve the pursuit of truth. At best, mimetic images distract us from what is essential by emphasizing appearances; at worst, they lead the mind in precisely the wrong direction, filling it with lies. He insists that a beautiful design based on geometric principles, no matter how pleasant to look at, is still less useful to the mind than the contemplation of the principles themselves. In another place, he makes a distinction between sculptors who copy the proper proportions of the figure they imitate, and those who then deliberately distort the proportions in order to make the statue seem more graceful from a certain angle: the visual arts are given to such cheap trickery; they customarily make concessions to the limitations of our senses, rather than appealing to our powers of rational understanding. Imitation is a realm of "play," with no potential for serious content, and, in a memorable phrase, paintings are called "dreams for those who are awake."

Plato's extremism must be seen as a product of his concern to establish once and for all the true basis of knowledge. At one point he uses the example of a horse's harness. Who really "knows" the harness? Is it the

craftsman who knows how to make it, or the painter who knows how to represent it? Clearly, the craftsman's knowledge is superior: he must have some understanding of the function it serves, of its parts and materials, and how they are to be combined; a painter need only know how the finished product looks. But superior even to the craftsman's understanding is that of the expert rider, who knows how to use the harness properly to control his horse. His understanding of the harness assumes its place within a more comprehensive kind of knowledge. Plato thus creates a hierarchical relationship between three modes of knowing, three kinds of art: that of the rider, that of the craftsman, and – at the bottom of the heap – that of the painter.

It is worth noting Plato's insistence that the craftsman – the harness-maker or potter or weaver – occupies a higher place in the hierarchy of knowledge than the painter. The object that the craftsman produces has a functional value; his expertise is specific and he makes no claim to universal knowledge. The knowledge of the imitative artist – whether he be a poet, musician, actor, painter or sculptor – is essentially false, no deeper or more comprehensive, Plato says, than that of a man who holds a mirror up to the world and turns around and around in one place, casting back reflections of everything around him.

In the satirical little dialogue *Ion*, Plato insists upon an even more emphatic separation of art from knowledge. He demonstrates that imitative artists – the example is a rhapsode, a performer of musical verse – do not really understand why they do what they do. They may be "inspired," but then it is "a god or a muse" who "speaks" through them, in which case they do not proceed by "art" in the commonly accepted sense. It is significant that Plato's discussion of inspiration refers to poetry and not the visual arts: there is no suggestion that the painter or sculptor can be inspired. Despite his contempt for poets and his high regard for useful craftsmen, Plato thus reproduces the commonplace assumption that arts involving reading and writing are of a higher kind than those that depend on manual labor.

Plato's disdain for the kind of knowledge imitative art requires must be understood in relation to his radical and profoundly influential conception of what knowledge is. For him, the true knowledge of anything is a knowledge of its ideal form (*idea*). Beds differ, but we readily recognize all as beds, and this is enough to indicate that there is some single idea or form of bed in which all physical beds somehow participate. It is this idea of the bed that, in Plato – as in all idealistic philosophy – is the *real* bed. What we would call real beds – the ones we sleep on – are all only partial and imperfect reproductions of the ideal. It is important to note that, by "idea," Plato does not mean what we generally use the word to mean: the representation of something in the mind of a

particular individual. For him, real ideas have an objective existence: they dwell in a realm apart, a realm that he describes in other of his writings in terms suggestive of later Christian conceptions of heaven. Our mental representations *may* bear some resemblance to these ideas, but not necessarily, and any resemblance they do have may stand in no closer relation to the ideas themselves than appearance does to essence.

Radical idealism of this kind seems a little silly when applied to beds, but consider the examples of "justice," or "goodness," or "beauty": such things are never wholly present in the world of our day-to-day experience, yet the fact that we find such concepts meaningful at all is profoundly significant; it seems to testify to their reality. When we are able to say about an action that we witness, for instance, that it is just or good, we testify to the fact that we have come into contact with a higher, invisible reality, that we have seen through the limited world of sense experience to something purer and more perfect. Elsewhere in his writings, Plato develops the notion that our ability to recognize abstract qualities in particular cases comes from our existence before birth, when our immortal souls lived in the heavenly realm of ideas and knew them directly, in their pure form. When we, in our earthly life, recognize justice in some particular instance of just behavior, it is our memory that has been jogged: we remember – or, to translate Plato's own term more exactly, we "unforget" – our previous, more perfect life.

Though attached to a metaphysics that most of us would not accept, there is something intuitively compelling and intensely beautiful about this account of experience. At the deepest level, perhaps, Plato's insistence on an ideal order above or behind the world accessible to sense is a way of explaining the feeling that we, as moral agents, make a crucial contribution to reality; that reality in some way depends upon our witnessing and our active intervention. One does not have to be an idealist to sense that seeing the truth of things necessarily involves seeing "through" them in some way. Plato believed that real insight of this kind is available only to philosophers, but most of us would respond by saying that artists can achieve it too, and that great art does exactly what he says only philosophy can do.

In fact, there are plenty of indications in Plato's work of a more generous attitude toward art. We have already noted his idea that well-made objects bring us into contact with harmony and grace. In some places he goes much further. At two points in *The Republic*, for instance, he likens his own philosophical method to that of an artist: in trying to define the ideal state, he says that he is like the painter who tries to depict, not any particular living person, but the most beautiful and perfect person imaginable. He thus seems to acknowledge the possibility of a kind of painting that does not imitate mere appearances, but essences

– and, what is more, that philosophy itself is a kind of painting. Elsewhere, at several points in his writings, philosophy is likened to music, and in one place, the dialogue *Phaedo*, it is described as "the best kind of music."

Perhaps Plato's condemnation of art should be understood as a challenge, a call for a higher, truly philosophical art: it certainly has functioned that way, both in antiquity and in later periods. His idealism provided a set of tools with which to describe what the most serious and exalted art might do; the importance he assigned to beauty, discussed in the next section of this chapter, also offered an enduring positive stimulus. Many ancient writers influenced by Plato did not feel the need to follow him in his assault on art – we will consider the example of Plotinus in the next section – and one source even says that Plato was trained as a sculptor: though implausible, the very existence of such a story indicates a widespread belief that Plato's attitude toward art was not as rigid as he sometimes makes it seem.

There is some evidence scattered through Plato's writings of his attitudes toward the art of his own time. His reference to optical adjustments in sculpture, also to illusionistic stage painting, indicate that he was aware of outstanding developments: these references usually occur in a strongly negative context, but they also reveal a genuine appreciation of the technical achievements involved, and it is very likely that he enjoyed art – as he enjoyed poetry – despite his philosophical misgivings. In one passage he says that he prefers old Egyptian statues to the work of his fellow Greeks because they follow a single, unchanging pattern: this remark suggests a real antipathy to contemporary trends, and perhaps even a pointed response to his older contemporary, the sculptor Lysippos, who claimed to be less concerned with the way human figures actually are than the way they appear.

Aristotle, who was Plato's student, also understood art as involving the imitation of nature, but he had an altogether more positive view of imitation, as well as a more positive view of nature – that imperfect realm of ceaseless change and deceptive appearance that Plato so mistrusted. For Aristotle, imitation is a natural instinct and a mode of knowing: it is by imitating adults that children learn. As adults, we delight in imitation for its own sake – as is proven by the fact that we enjoy pictures of things that, in themselves, we would find disgusting – but our pleasure also depends on the fact that we associate imitation with learning, and learning is always pleasant.

Aristotle's theory of knowledge is unlike Plato's. Where Plato stresses the sharp division between appearance and essence, Aristotle describes a step-by-step process that leads from our experience of the one to our understanding of the other. In the opening pages of his *Metaphysics*, he

describes how the artist, like everyone else, learns from experience: his memories of particular instances help him arrive at an understanding of causal principles. The example Aristotle uses is the "art" of medicine: anyone with some experience of life may know that, in a particular case, a particular symptom calls for a particular treatment; only the true doctor, the "man of art," understands the symptom as the manifestation of a condition – the product of a certain cause – and how, in any case, that condition should be treated. Art is a *systematic* understanding of cause and effect; it is essentially a mode of rational thought.

Elsewhere in his writings, especially in the *Nicomachean Ethics*, Aristotle establishes a hierarchical relationship among the modes of knowing and clearly defines the place of art. He identifies three modes: the theoretical or speculative (what we would call abstract thought), the practical (which has to do with action), and the productive or factive (which has to do with making something). Philosophy, properly speaking, belongs to the first, which is the highest kind; art to the last and lowest. In another place he divides the "rational soul" into two parts, the speculative or contemplative (which addresses those things that are eternal and unchanging, the objects of philosophy) and the deliberative (which addresses those things that vary, that can be other than they are or not at all). The higher, contemplative part is composed of three "faculties": science, intuition, and wisdom (which is the highest, most perfect mode of knowing); the deliberative part consists of two: prudence (which covers all forms of conduct), and art (which, again, has to do with making). Art is defined as "a state of capacity to make, involving a true course of reasoning." Though Aristotle places art in the lowest position, he firmly identifies it as a mode of knowing: where Plato had been concerned to sever art from knowledge, Aristotle insists upon connecting them.

Plato seems to have thought of imitation largely in terms of a resemblance between the finished product and an object in nature. Perhaps because Aristotle understands art primarily as a process of making, he sees imitation rather as a resemblance between two kinds of becoming. Like nature, art causes things to come into being, but where nature is a principle of coming-to-be, or movement, in the thing itself (the seed will naturally become a tree), art is a principle of movement in something other than the thing moved (a stone must be acted upon by a sculptor to become a statue). Nature and art run parallel to each other, so to speak; the artist does not so much seek to imitate the way nature *looks* – though he may do that as well – as the way it *works* in causing things to come into being. Aristotle clarifies this point in another place, his treatise *On the Parts of Animals*: "Art is an order of the work" – that is, the working process – "independent of the material."

Aristotle's most influential ideas about art are found in the *Poetics*, a brief treatise which comes down to us in incomplete form. Its subject is poetry, which is provisionally defined as the "imitation of life," by which Aristotle seems to mean primarily the imitation of living persons, of human action. The different forms of poetry have evolved out of our natural delight in imitation. In a manner characteristic of his systematic method, Aristotle classifies them according to the means, the objects, and modes of imitation. Of principal interest to him are the two "best" forms: tragedy and epic. These are better primarily because they represent better sorts of men – heroes.

Of the two, Aristotle clearly prefers tragedy, and much of the surviving text is directed toward demonstrating its superiority. Tragedy had evolved from ritual forms and was still highly ritualized in his time; in offering his famous definition of it, he accommodates tradition while attempting to discover some normative principle:

> Tragedy, then, is the representation of an action that is heroic and complete and of a certain magnitude, by means of language enriched with all kinds of ornament, each used separately in the different parts of the play: it represents men in action and does not use narrative, and through pity and fear it effects relief to these and similar emotions.

The idea of "relief" (*catharsis*) has proved to be the point of greatest psychological interest to modern readers; elsewhere Aristotle speaks of the pleasure we take in feeling such emotions when we know that we are not personally involved in the events represented on stage.

Proceeding with his rational redefinition of the form, Aristotle distills tragedy into six ingredients: plot, character depiction, thought (the expression of internal states through words and actions), diction (speech), and "song and spectacle." By far the most important is the plot: it is both the most essential and the hardest to get right. He calls it "the soul of tragedy" and likens it to the role of drawing in painting: "if a man smeared a panel with the loveliest colors at random, it would not give as much pleasure as a simple outline in black and white." Many playwrights do not recognize that a tragedy is primarily a representation of action, and only secondarily of the persons performing the action, so that they tend to put too much emphasis on character depiction; in so doing, they confuse the aims of tragedy with those of the epic poem. A tragic plot must be selective and tightly structured: like a living body, it must have a beginning, middle, and end; it must confine itself to a single sequence of events, with the episodes arranged in such a way that, if any one were changed or taken away, the effect of the whole would be seriously damaged. Aristotle's attentiveness to the effect of a well-structured plot is

revealed in his remark that we are most moved when "incidents are unexpected, yet one is a consequence of another."

All the elements of tragedy must be made to serve the plot. The characters should be as noble as possible, but it is more important that they behave in a manner appropriate to their function in the story. Character is revealed by thought, and thought in turn by speech, so that these third and fourth parts of tragedy are also determined by the demands of the whole. The legibility of this overarching structure, the effect of necessity, of inevitability, in the arrangement of every detail, is essential to the particular kind of pleasure or satisfaction that a tragedy gives us.

Because the subject matter of poetry is human action, the poet must possess a knowledge of human nature. For Aristotle, this implies not just a vivid imaginative grasp of particular character types, but an understanding of the general principles that shape and govern them; it is *systematic* in the same way as the doctor's or philosopher's. In his manipulation of well-known stories, the tragic poet in particular has the opportunity to display this kind of understanding:

> A poet's object is not to tell what actually happened, but what could or would happen either probably or inevitably . . . The difference between the historian and the poet is that one tells what happened and the other what might happen. For this reason, poetry is a more serious and more philosophical thing than history, because poetry tends to give us general truths while history gives us particular facts.

The poet is free to depart from historical truth in order to reveal a higher truth, to demonstrate the enduring principles of human conduct. These principles are the real subject matter of both art and philosophy, and there is no reason why a great tragic poet may not be considered a philosopher.

Where Plato had so stubbornly insisted on the separation between imitative art and true knowledge, Aristotle discovers the ground of their similarity. Again, it should be pointed out that Aristotle argues his case in connection with poetry, not the visual arts: while he makes numerous comparisons between poetry and painting, which later theorists of art eagerly cited as evidence of a kinship between the two, he did not pursue the analogy very far.

Beauty

Like the idea that art imitates nature, the idea that beauty is somehow fundamental to art – that beautiful natural forms, for instance, should be

the privileged objects of imitation – was highly developed in ancient times. Yet at certain points the pursuit of beauty may seem to lead away from the imitation of nature. The resolution of this potential tension, the justification for the pursuit of beauty in art, again depended on the theory of knowledge, on establishing the status of the beautiful as an object of knowledge.

Beauty played a fundamental role in Plato's philosophy. For him, the ideal form of something is also its most beautiful: the idea of the bed is the most beautiful of beds. Of course, such beauty is not to be confused with what is most pleasing to our senses: the beds that look most beautiful may correspond less to the idea than ones which, by comparison, at first seem unappealing. Yet beauty is an essential attribute of any ideal form: it is not a mere appearance or a lesser substitute for some higher integrity; it is essential to what things are when they are most real. Though in at least one place in his writings, the dialogue known as *Hippias Major*, Plato takes care to distinguish between the beautiful and the good, in others he links them and insists upon the existence of an absolute beauty, which stands with the absolutely true and the absolutely good as a supreme value, and which partakes of their nature. Our encounters with beauty consequently have an important role to play in our growth as individuals and in the search for truth, however much we must be on our guard against the distraction of mere appearances.

The way in which our experiences of the beautiful help us to achieve higher understanding is described most clearly and compellingly in the *Symposium*, perhaps the most beautiful of Plato's dialogues, a series of speeches in praise of love made at a banquet, in which each speaker tries to outdo the one before, until Socrates delivers the most extraordinary of all. Beauty is understood as that which inspires love: love is defined at one point as the desire to possess the beautiful, though the beautiful is then identified with the good. While desire is a longing for what we do not have, it is also an expression of that which is self-sufficient and eternal – as well as beautiful – in ourselves: at the lowest level, it is the desire to procreate, to reproduce oneself, thus to give oneself a kind of eternal life. Making babies is as close as animals and simple people come to realizing the eternal in themselves, but, for the finer spirit, the kindling of love is the first step in a long spiritual journey, a journey which, if properly pursued, leads toward the understanding of absolute beauty, goodness, and truth. Love, the desire for the beautiful, is thus the sustaining and guiding impulse of philosophy.

The process begins when the lover starts to see the beauty of his beloved in everything around him. He recognizes from this experience that "the beauty of one form is akin to the beauty of another" and will

realize that "the beauty in every form is one and the same." As a result, his desire for any particular instance, or individual, is tempered. Next, he will come to appreciate how the beauty of the mind is more beautiful than that of the body. This recognition leads, in turn, to an understanding of the beauty of moral principles and laws, and, beyond these, of the beauty of abstract thought, especially philosophy. The appreciation of these exalted things results in a further independence from the need for lower ones. For those who persevere in this journey, the true philosophers, the final step is the revelation of absolute beauty:

> This beauty is first of all eternal; it neither comes into being nor passes away, neither waxes nor wanes; next, it is not beautiful in part and ugly in part, nor beautiful at one time and ugly at another, nor beautiful in this relation and ugly in that, nor beautiful here and ugly there, as varying according to its beholders; nor again will this beauty appear to him like the beauty of a face or hands or anything corporeal, or like the beauty of a thought or a science, or like beauty which has its seat in something other than itself, be it a living thing or the earth or the sky or anything else whatever; he will see it as absolute, existing alone with itself, unique, eternal, and all other beautiful things as partaking of it, yet in such a manner that, while they come into being and pass away, it neither undergoes any increase or diminution nor suffers any change.

This idea of an ascent, prompted by love, from the particular to the universal, from the many to the one, from the contingent to the absolute, is perhaps Plato's most profoundly influential contribution; we will see it reappear in various forms in later thought. Again, one need not accept it as stated to find it intuitively compelling: a modern reader inclined to see it as a calculating displacement of erotic energy onto increasingly abstract objects might yet be moved by the way in which it testifies to the reality and intensity of our inner life, to the *dynamic* quality of being, and to the fundamental instability or incompleteness of individual identity. Its description of the progress from the sense experience of particulars to the understanding of the absolute is less rigid than the abrupt distinction between appearance and reality expressed elsewhere in Plato's writings, and more nearly anticipates Aristotle's account of how we come to know things.

Plato does not mention the visual arts in this connection. His principal concern is with the relation of beauty to truth, and he is not interested in exploring in detail the nature of physical beauty in any way that would, say, help an artist create a beautiful picture or statue. Yet elsewhere in his work he hints at how one might begin to move in that direction. Our ability to see the resemblances between forms, to see order in the world, depends on our ability to find similarities between objects that do not at

first seem similar. To do so implies abstracting, if only unconsciously, a third term, a mean or unit by which both might be measured. Measure involves number, and numbers are, in fact, the most common and paradigmatic kind of idea. Plato mentions that all the arts and forms of higher understanding depend upon a "science of measure"; all involve recognizing and avoiding the extremes of too much and too little, and arriving at some mean. An "art of measurement" thus underlies all the arts, including the "art" of personal conduct: "measure and proportion are everywhere identified with beauty and virtue." Plato's word for proportion is *symmetria*, which does not mean symmetry as we now use the term, but is best translated as "commensurability," the susceptibility of unlike parts to measure by a single unit, a third term.

The belief that numbers constitute the ultimate reality was already well developed by Plato's time: it is traditionally attributed to Pythagoras, a philosopher who lived about a century earlier. Pythagoras claimed to have discovered that the numerical relations governing musical harmony also governed the motion of the stars, and from this he inferred that such relations were the structural principle of the universe. Some of Plato's writings show the influence of Pythagorean doctrine; one way in which it affects his conception of the experience of the beautiful is seen in a passage in which he advises the seeker after truth, in considering the night sky, not to be distracted by the splendor of the spectacle – which is likened to a painting – from the numerical intervals that structure it. In listening to music, by the same token, one ought not to attend to the sensuous delight of the sounds so much as contemplate the numerical relations present in the harmony.

The idea that proper understanding involves determining extremes and avoiding them by choosing a middle path, the mean, was a commonplace in antiquity: Aristotle made it a systematic practice in defining happiness in his *Ethics*. The notion of measure and of a mean between extremes was also invoked in the *Poetics*, when he says that the ideal plot must form a whole – it must have a beginning, a middle, and an end – and that the whole must not be either too large or too small. He even likens this plot to a living creature, "which, to be beautiful, must be a whole made up of parts presented in a certain order and of a certain magnitude." His most comprehensive definition of beauty, however, occurs in the *Metaphysics*. Taking issue with those who argue that mathematics can teach us nothing about the good or the beautiful, he says: "The chief forms of beauty are order, symmetry and distinctness, which the mathematical sciences demonstrate in a special degree."

The idea that a work of art will be more beautiful if it is made according to numerical relationships had been demonstrated at least as early as the mid-fifth century BCE, when the sculptor Polykleitos made the

famous figure that came to be known as the *Canon*. One of the most important bits of evidence about this figure is a passage in the medical treatises of Galen. The author is commenting on the opinion of another philosopher that health in the body is the result of a harmony among all its constituent elements:

> And beauty, he feels, resides not in the harmony of the elements but in the commensurability [*symmetria*] of the parts, such as the finger to the finger, and of all the fingers to the metacarpus and the wrist, and of these to the forearm, and of the forearm to the arm, and in fact of everything to everything else, as it is written in the *Canon* of Polykleitos. For having taught us in that treatise all the commensurabilities of the body, Polykleitos supported his ideas with a demonstration, a statue of a man made in accordance to his principles, and called the statue itself, like the treatise, the *Canon*.

More testimony about the *Canon* is found in the treatise *On Architecture* by Vitruvius. The third book, on the design of temples, begins with a discussion of the importance of symmetry, which is said in turn to depend upon proportion. Symmetry must be present if the temple is to have the beauty of a well-shaped human body:

> For nature composed the human body in such a way that the face, from the chin to the top of the forehead and the lowermost roots of the hairline should be one-tenth [of the total height of the body]; the palm of the hand from the wrist to the tip of the middle finger should measure likewise; the head from the chin to the crown, one-eighth; from the top of the chest to hairline including the base of the neck, one-sixth; from the center of the chest to the crown of the head, one-fourth. Of the height of the face itself, one-third goes from the base of the chin to the lowermost part of the nostrils, another third from the base of the nostrils to a point between the eyebrows, and from that point to the hairline, the forehead also measures one-third. The [length of the] foot should be one-sixth the height, the forearm and hand, one fourth, the chest also one-fourth. The other limbs, as well, have their own commensurate proportions, which the famous ancient painters and sculptors employed to attain great and unending praise.

The "famous ancient painters and sculptors" must include Polykleitos. Vitruvius goes on to suggest another system, this one geometric, also derived from the body:

> So, too, for example, the center and midpoint of the human body is, naturally, the navel. For if a person is imagined lying back with outstretched arms and feet within a circle whose center is the navel, the fingers and toes will trace the circumference of this circle as they move about. But

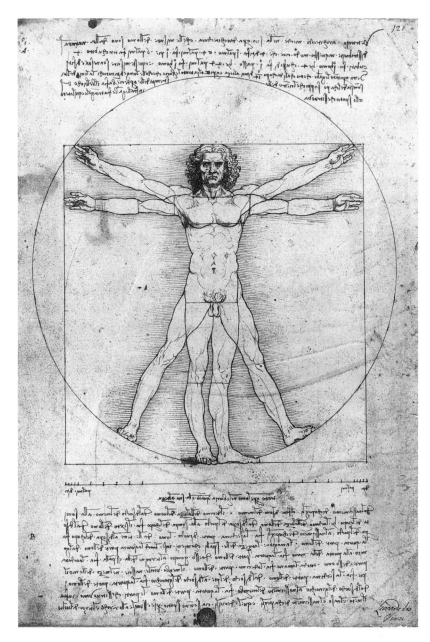

Figure 1.4 Leonardo da Vinci, "Vitruvian Man," c.1487, Accademia Gallery, Venice.

to whatever extent a circular scheme may be present in the body, a square design may also be discerned there. For if we measure from the soles of the feet to the crown of the head, and this measurement is compared with that of the outstretched hands, one discovers that this breadth equals the height, just as in areas which have been squared off by use of the set square.

It is this second alternative that was illustrated, fifteen centuries after Vitruvius, in a famous drawing by Leonardo da Vinci (figure 1.4); whether this system also derives from Polykleitos, or comes from another source, is uncertain. Vitruvius proceeds to present conflicting ideas as to whether six or ten is the more perfect number, and therefore the more appropriate basis for a proportional system, and then to suggest yet another system of subdivisions based on Greek and Roman money. All this serves to introduce his discussion of the architectural styles, later called "orders" – Doric, Ionic, and Corinthian – each of which involved its own proportional system (figure 1.5). Clearly, there were a variety of canons available in antiquity, for the human body as well as for buildings.

An important contribution to the Platonic tradition of speculation about the nature of beauty and its relation to art was made by the philosopher Plotinus, who lived in the third century CE – seven centuries after Plato – and was the leader of a school of thought that came to be known as Neoplatonism. His writings were collected and edited after his death by one of his followers, Porphyry; the result is a single large treatise, the *Enneads*. Plotinus liked to say that all he wanted to do was clarify and systematize Plato, but in fact he and his editor created something new, and some of their most striking innovations concern beauty and art.

Plotinus departs from Plato on two major points: the first, that art is imitation; the second, that beauty can be reduced to a harmonious disposition of parts – proportion or symmetry. "Since one face, constant in symmetry, is sometimes fair and sometimes not, can we doubt that beauty is something more than symmetry, that symmetry itself owes its beauty to some remoter principle?" Any definition of beauty as symmetry is simply inadequate, both because things not divisible into parts, like light, or color, or the dawn, or the night sky, are undeniably beautiful, and because things divisible into parts between which some proportional relationship exists can yet be ugly.

In constructing a cosmic system out of Plato's writings, Plotinus relies heavily on the notion of love described in the *Symposium*. We recognize beauty chiefly in the emotion it calls up in us, which Plotinus describes as a profound perturbation – in the words of one translator, a "delicious trouble." That "remoter principle" which bestows beauty on material things is "something perceived at first glance, something the soul names as if from an ancient knowledge and, recognizing, welcomes it, and

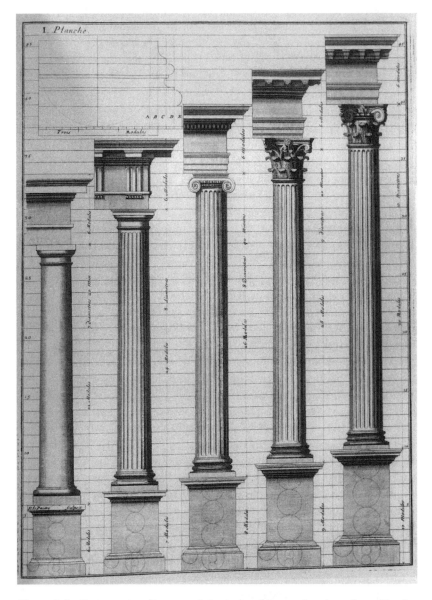

Figure 1.5 Comparative diagram of classical architectural orders, from Claude
Perrault, *Ordonnance des cinq espèces de colonnes*...(Paris, 1683).

enters into union with it." Plato's concept of spiritual ascent and purifi-
cation becomes the basis of an entire metaphysical system.

From an understanding of the diversity of human character, the lover
comes to achieve a perception of the unity of human nature: Plotinus

calls this unity the "world-soul." The sure grasp of this unity, in turn, leads to the awareness of the power of higher intuition which Plotinus calls "mind." Practice in intuition then leads to the recognition of mind as a single principle, "world-mind": this is the highest point that human thought can reach, but it is still one step beneath the ultimate reality, which Plotinus calls the One.

As our thoughts ascend, they retrace the path of our own origin. The One is the source of all being; it is not static but superabundant: its nature is to spill over, to emanate. From its own perfect unity it spills over into diversity, into a less perfect form of existence in which knowing is distinct from being, knower from thing known: this is the realm of mind. From mind, being spills over into soul, a still less perfect realm, in which diversity is governed, that is, structured, by the principles of time and space. At the bottom of this hierarchical scheme is matter. In its pure state, matter is a kind of non-being, a mode of existence untouched by emanations, uninformed by any unifying principle or form. In several places Plotinus uses the metaphors of light and darkness to illustrate the relation of the One to matter.

The individual human being is composed of matter and soul. The soul, having descended from the One, feels itself to be in exile. In experiencing beauty, it recognizes another part of that unity from which it came and is stimulated by a desire to return to it again – at first through union with the beautiful particular; finally, by virtue of proper intellectual training, in the single principle of mind. The ultimate step, direct union with the One, is beyond the power of the mind to achieve, for mind still requires a distinction between knower and known. In the final leap, so to speak, this distinction would have to dissolve: it can occur only in ecstasy, an inspired, super-rational state, by a direct emanation from above, when absolute being accepts us – if only for a moment – into itself.

What emerges from the *Enneads* is a picture of the universe as a single, vast organism, through which being literally circulates, like blood through the body, downward from the One, then back again. Beauty has an important role to play in this system. For Plotinus, any beauty, even the most physical, is an emanation of the One, and has an absolute value by virtue of its place in the cosmic hierarchy. A degree of unity on one level always serves to lead us upward toward the higher more perfect unity from which it derives. Preoccupied as he is with what lies beyond the world of everyday experience, Plotinus actually helps to redeem mere physical beauty from the suspicion with which Plato had treated it. His sensitivity to physical beauty is revealed many times in the examples he discusses – taken from the natural world as well as from music, dance, and the visual arts.

In such a system, what is of value in art cannot be described in terms of imitation. Artistic creation is rather a re-enactment – and the result, the work of art, a symbol – of natural or divine creation. Just as individual natural objects, in the degree of unity they exhibit, reveal the higher principle of being acting through them, so the artist's products are beautiful by virtue of the intention they reflect – the idea in the artist's mind. A stone that has been fashioned into a figure is more beautiful than an unworked stone because in a statue matter has been patterned, given a degree of unity which moves it toward the unity of the One. The artist imposing his idea on resistant matter is like the One spilling over into less perfect modes of being.

In one way, this conception of the creative act brings Plotinus close to Aristotle – for whom the artist works in a manner parallel to nature, emulating its processes. The difference is that, for Aristotle, the validity of the result is still to be measured in terms of its relation to some external standard. For Plotinus, all that matters is the relation of the finished product to the idea in the artist's mind; in fact, the finished product is always much less important than the idea. The result will never perfectly reflect his intentions, just as no emanation of the One is as perfect as the One itself.

The work of art is a reflection of the artist's idea, but how is one to understand and assess the value of that idea? Does it have the objective truth of a Platonic idea, or only a relative value as the product of an individual, idiosyncratic imagination? The answer, for Plotinus, is clearly the former – at least in the cases that matter. The sculptor Phidias, he says, did not create the great statue of Zeus at Olympia by copying any model in nature, but by conceiving its form in his mind. Nevertheless, this shape is the one that Zeus himself would *necessarily* have taken had he chosen to become visible. The artist attained through contemplation a point at which a direct emanation from above was granted: the statue represents the real essence of divinity making itself perceptible to human sense.

In this way, art can rival the very highest achievements of philosophy and theology. Another passage offers a revealing perspective on how the process works:

> Those ancient sages who sought to secure the presence of divine beings by the building of shrines and statues showed insight into the nature of the One; they perceived that though the soul is everywhere traceable, its presence will be secured all the more readily when an appropriate receptacle is elaborated, a place specially capable of receiving some portion or aspect of it, something reproducing or representing it, serving like a mirror to catch an image of it.

Here the image functions as a kind of talisman, an instrument for drawing down and storing divine power. Though Plotinus implies that such idols are only ever partial and imperfect expressions of the One – and thereby moves in the direction of a rational monotheism – he plainly understands the power of art in terms of primitive magic. One cannot imagine Plato approving of the way in which his disciple thus surrenders the rigorous distinction between truth and superstition.

Rhetoric

The art of public speaking – rhetoric or oratory – played an extremely important role in the ancient world: it was an essential skill for lawyers, politicians, and diplomats; military commanders too were expected to be able to rouse their troops before a battle with a stirring speech. Rhetoric was even something of a public entertainment. The leading orators developed great reputations; one imagines that the crowds that gathered to hear two well-known speakers debate a case were as intrigued by the professional rivalry as by the issues at stake. Some orators specialized in virtuoso displays of rhetorical skill, arguing one side of a question until the audience was persuaded, then arguing the other side with equal conviction.

It is not surprising, therefore, that rhetoric developed a vast theoretical and critical literature of its own: to judge from what remains, much more than concerned the visual arts, poetry, and music combined. Because the rules of rhetoric were felt to be applicable to writing – and to poetry as well as to prose – rhetorical principles governed the discussion of literature in general. It is in rhetorical theory, for instance, that one finds the most sophisticated analysis of literary devices and effects, but it is an indication of what rhetoric meant to the ancient world that one also finds much more. Cicero, the greatest of the Roman orators and an important theorist, believed that "eloquence" was a civilizing force, the fountain from which flow all the institutions and benefits of civilized life, the arts and the sciences. Quintilian, a follower of Cicero, showed how a training in rhetoric might form the basis of an ideal education. Rhetoric embraced philosophical concerns as well as poetic ones: it might be useful to think of it as a middle realm between poetry and philosophy.

Another point of importance is the immense influence of this literature in later phases of European civilization. The classics of rhetorical theory were well known during the Middle Ages; during the Renaissance they became the basis of what used to be called liberal education. Cicero, in particular, became a supreme cultural hero. He had suggested that the ideal man, if he ever were to exist, would have to be an orator; and

because he himself had written philosophical essays, on the one hand, and led an active and heroic political life, on the other, he was regarded as very nearly the perfect man, and thus the proof of his own claim. All educated Europeans, from the Renaissance down to the time of World War I, knew their Cicero: an indication of how much things have changed is that only students of Latin and cultural historians read him now.

Rhetorical theory deserves attention here because of this influence. The entire vocabulary of literary stylistics, which was soon adapted to the visual arts, derives from it. In addition, rhetorical theory preserved and elaborated in a more accessible form many philosophical ideas bearing upon literature and art: Cicero's adaptation of Plato's theory of ideas to his own definition of ideal eloquence probably introduced more readers to Plato's thought than the philosopher's own writings. On a deeper level, however, because rhetoric was an art that mediated so directly between intellectual and practical – especially political – life, it offered to later periods an appealing model of what art might do; it brought with it a particular notion of ideal personhood, one that can be said to ground identity itself in a kind of artistic performance.

Rhetorical theory was already well developed by the late fifth century BCE. A number of treatises were in circulation; none survives in anything but small fragments and excerpts in the writings of later authors, and these suggest that the approach was practical and technical. Several of the authors were Sophists, however, and we know enough about this school of thought to supplement the fragments in an illuminating way. Though their opinions varied, most Sophists believed that the kind of truth pursued by philosophy is either inaccessible to the human mind, or irrelevant, and that in its absence there is only belief: the power to persuade, to manipulate belief through the use of language, is the highest intellectual skill; the pursuit of power through eloquence replaces the pursuit of wisdom. They insisted that rhetoric should be the basis of education – that it should assume the position traditionally occupied by poetry and that Plato would try to claim for philosophy – and they were energetic campaigners for their cause. Plato seems to have been attracted to them early in his career, but soon rejected them, and many of his writings are direct attacks upon them. The formation of his own ideas seems to have owed a good deal to the negative stimulus provided by the Sophists.

The first complete surviving treatise on rhetoric was written by Aristotle. As one would expect, it is characterized by a breadth of intellectual perspective, a speculative, rather than practical or technical approach. He defines rhetoric in general as "the faculty of discerning the means of persuasion in any case," and he clearly divides it into different categories. His first concern, however, is with the relation of rhetoric to truth. The art of speaking can be easily misused, he admits, but most good things

can; it can also be a useful means of defending the truth against those who lie. He goes on to define the nature of rhetorical reasoning in relation to logic, saying that where logic makes use of the syllogism – a series of propositions which lead to an inevitable conclusion – rhetoric employs the enthymeme, a syllogism in which one of the propositions is left unstated, or in which the propositions are probable rather than demonstrably true. In marking the difference between rhetoric and philosophy so carefully, he seems to be responding both to the challenge of the Sophists, with their radical relativism, and to Plato's sweeping repudiation of them in the interests of an equally radical idealism.

Like the tragic poet, Aristotle's orator must possess a practical knowledge of human nature, which will enable him to represent the actions of men he attacks or defends, as well as fashion arguments that will appeal to the various "classes and conditions" of men. Aristotle provides an inventory of social groups – rich, poor, middle class, educated and uneducated, noblemen, professionals, artisans, and slaves – as well as drawing attention to the differences between the young, the middle aged, and the elderly. These groups tend to have certain traits that the orator must know. When he wishes to describe the actions of a young man, for instance, he should make them seem rash and impulsive (if he wishes to blame them) or bold and idealistic (if he wishes to praise them). Similarly, if he wishes to appeal to a group of young men, he should speak boldly, with energy, and suggest a tendency to get carried away by feeling; if his auditors are old men, he must come across as a person of judgment, thoughtful, and inclined to caution.

Aristotle is well aware that the successful speech is not always the most truthful speech; rhetoric, especially the narration of events in a lawsuit, is governed by the same principles of probability and necessity that he describes in the *Poetics*. It is much more important that a story seem plausible than that it actually be true: an audience or jury will be more readily persuaded by a lie which conforms to their expectations than a truth which defies them. In narrating or explaining the actions of his client or his adversary, the orator must take account of this fact, select details with care and present them in such a way that the actions conform to general preconceptions about human nature.

If the list of the "classes and conditions" of men presents a survey of human nature in breadth, so to speak, Aristotle also provides a catalogue of emotional states which surveys it in depth. He describes a range of emotions, their causes and consequences, and the ways in which people experiencing them tend to behave: the orator must have a sure grasp of these as well if his representations of human conduct are to persuade, but each class, condition, and emotional state also demands a slightly different strategy on the part of the orator, each must be described, or

addressed, in a different way. Aristotle comes close to seeming like a Sophist when he says that "every condition of life and moral habit has a language appropriate to it." Yet what is most remarkable about these catalogues is not the veracity of each individual characterization so much as the impression they give of constituting a kind of system, of providing a map, so to speak, of the human condition as a whole. This orderliness, this systematic approach, which makes this part of the *Rhetoric* into a handbook of practical psychology and sociology, works to ground the potentially infinite diversity of human nature in a comprehensive unity; it represents rhetoric reclaimed, as it were, brought under the synoptic vision of philosophy.

Perhaps the single most important principle of rhetorical theory is that of propriety or *decorum*. In the most general terms, it is the principle that governs the relation between form, content, and audience. What one has to say determines how one says it, but the circumstances in which it is said – which include one's own position, the position and attitude of those one is addressing, as well as the purpose one wishes to achieve by speaking – will also determine how one says it. All three factors need not be equally important in all cases, of course. A writer may take his audience for granted and devote himself entirely to working out a satisfactory relationship between content and form. An orator may let his choice of both content and form be shaped by his audience. If he is a diplomat, the content of whose statement is not his to change and whose audience may not want to hear it, he will probably devote his attention to clothing it in the least offensive form possible. Adherence to decorum requires a comprehensive understanding of expressive possibilities combined with an acute sensitivity to social circumstances and the intellectual flexibility – the sheer ability to think on one's feet – to be continually adjusting the one to the other.

Though decorum may thus seem to demand a rather servile willingness to accommodate oneself to external conditions, rhetorical theorists almost always treat it as a *positive* principle: they emphasize the way in which it enables them to negotiate circumstances and to generate an entire speech – to deduce every detail of its structure and style, down to the choice of individual words – from general considerations of form, content, and audience. Decorum guarantees both the internal consistency – the stylistic unity – of the speech and its appropriateness to its context; it adjusts the order of the work of art to the order of the world beyond it.

Aristotle himself has relatively little to say about style in the *Rhetoric*. He discusses a few verbal ornaments of the kind that would later be called "tropes" (*tropoi*) or "figures" (*figurae*), such as metaphor. He discusses word choice in some detail: the words of an oration must not

mimic too closely the patterns of everyday speech; they must be artful enough to set themselves apart, but they must not be so artful as to seem contrived, affected, or pompous. In general, he advocates his usual policy of the middle path between extremes. He refers readers to the *Poetics*, where some aspects of rhythm and word choice are discussed at greater length: if rhetoric touches on philosophy at one end, it touches on poetry at the other.

Later theorists went much further, dividing speeches into different parts, classifying the various types of argument, often providing lengthy inventories of ornaments illustrated with numerous examples from the works of famous writers, and offering detailed instruction in metrics and word choice. Quintilian, for example, distinguishes between tropes and figures: he classes metaphor among the former, first identifying three types, then suggesting another, four-part division susceptible of further subdivision. Other theorists advanced different systems, and even within each system there was a great deal of overlap: the same passage from a speech or poem might be described by different theorists as making use of different ornaments, and an individual writer might have a hard time distinguishing the effects of several superimposed ornaments in a single passage. Combinations of ornaments were sometimes identified as independent classes.

Despite this tendency to over-complication, rhetorical theory is an effective tool for the analysis of artful language, and some of the ancient terminology is still in use. Metaphor, for instance, which Quintilian calls *translatio* (a literal equivalent of the Greek, meaning to "carry over"), and identifies as "the most common and by far the most beautiful" of tropes, refers to the substitution of one thing for another in order to suggest a similarity between them. When we describe a man as "a fountain of ideas," or as "the shepherd of his people," we suggest a similarity that vividly inflects our representation of him. Another common figure is metonymy, which involves replacing the name of a thing with a word denoting something related to it in some way: the expression "Ceres spoiled," for instance, intensifies the image of a ruined harvest by suggesting that the goddess of the harvest herself has been violated. Yet another term is synecdoche, the substitution of a part for the whole – as in the expression "all hands on deck" – or the whole for a part; it also applies to the substitution of a more specific term for a general one, as when we say "cut-throat" for "murderer," or the more general for the specific, as when we say "creature" for "man."

Such "figurative" language – departures from ordinary or expected usage – engages our imaginations and intensifies our response to what is said. On a deeper level, however, orators seemed to have understood that the distinction between the literal and the figurative is far from fixed

– that the imagination is always at work in our response to language and in the way we make sense of things generally. Quintilian points out how even peasants use metaphors when they call a bud a "gem," or when they say that soil is "thirsty." The *visual* nature of the imagination in particular is an extremely powerful force: Quintilian says that metaphor "is designed to move the feelings, to give special distinction to things and place them vividly before the eyes." He also describes a device called *enargeia* (which he translates as "vivid representation"), by which a speaker may embellish an account with details that force the hearer to reckon with it in visual terms: "For oratory fails of its full effect, and does not assert itself as it should, if its appeal is merely to the hearing, and if the judge feels that the facts on which he has to give his decision are merely being narrated to him, and not displayed before the eyes of the mind."

Other similarities between verbal and visual artifice were observed: just as Aristotle had compared poetry and painting at several points in the *Poetics,* rhetorical theorists made use of analogies with painting in order to clarify their discussion of various techniques. Quintilian likens *sententia* – aphorisms or pithy remarks – to the highlights painters employ to enhance the three-dimensionality of their pictures: brilliantly effective when used sparingly, they can quickly become tiresome, just as too many highlights can confuse and undermine the illusion of forms in space. Rhetorical theorists also commonly referred to their various devices as "colors" – a metaphor that could suggest either decorative or deceptive qualities.

An important feature of ancient rhetorical theory – an extension, essentially, of the principle of decorum – is the idea that the various styles available to speakers fall into categories which can be arranged hierarchically. The simplest and most commonplace scheme was the distinction between "low," "middle," and "high" styles: modes of speaking appropriate to trivial, middling, and exalted subject matter, respectively. This tripartite division was too simple for some theorists. Demetrius of Phalerum described four styles – the "plain," the "elegant," the "elevated," and the "forceful" – and listed the themes, arrangements, figures, and metric rhythms appropriate to each.

The forceful style – the word Demetrius uses, *deinos,* is usually translated as "terrible," meaning "awe-inspiring" or "overwhelming" – deserves special attention because it is characterized by a deliberate bluntness or clumsiness of expression that seems to ignore all the rules of good speech. An orator may use it when he wishes to give the impression that he is in the grip of a powerful emotion or a profound idea and cannot be bothered with the usual stylistic refinements. In other words, it is an artful artlessness, a kind of speech that turns the limits of speech to advantage. In the hands of a master, even silence can be made eloquent, as when Demosthenes, attacking an opponent, said: "I could on my part . . . but

I do not desire to say anything offensive." Nothing Demosthenes could have said, Demetrius observes, would have been as effective as that ellipsis. The principle is similar to the one employed by the painter Timanthes when he veiled the face of Agamemnon in his *Sacrifice of Iphigenia.*

Another theorist, Hermogenes, believed that the different styles were ideas in the Platonic sense, essences that the orator should strive to embody as fully as he can, but which can never be perfectly realized in any single oration. He identified seven such "ideas of style," which he sub-divided into others. For the seventh, he used the same word, *deinos*, that Demetrius had used for his "forceful" style, but he defined it differently – as a mastery of the other six styles and an ability to deploy them at will: it represents an ideal or absolute eloquence, the power of which is "terrible."

In addition to comprehensive treatises, there were entire works devoted to a single style. The most famous and influential of these, traditionally attributed to a writer named Longinus, is a study of the "elevated" or "sublime" (*hypsos*) in literature. As with the "forceful" style of Demetrius, the sublime can involve a certain disregard for refinement that suggests a mind preoccupied with more important things. Examples are taken from all over ancient literature and even include the opening words of *Genesis* – grand and powerful despite their simplicity. This sensitivity to the way in which departures from the rules can sometimes be effective, this con-sciousness of the fact that systems of rules, however elaborate, must always be flexible enough to allow for such departures, is a good indica-tion of the real acuity and intellectual vitality of ancient rhetorical theory. The awareness that art depends upon rules in some essential way, and yet that any system of rules must remain open-ended, is a recurrent theme in later art theory.

An example of the influence of rhetorical principles on the discussion of poetry is the verse letter known as *The Art of Poetry* by the Roman lyricist Horace. Succinct, commonsensical, and witty, it is unlike a formal treatise: its purpose is to offer a few useful guidelines to aspiring poets – and to exemplify its own precepts. Most of the advice depends upon the principle of decorum. The poet should take particular care to make his characters behave in a natural and consistent fashion: old men should be described as behaving like old men, young men like young men; the style of their speech should also reflect their ages, fortunes, and emotional states. The poet is entitled to certain departures from nature, a freedom shared also with painters: "as is painting, so is poetry" (*ut pictura poesis*), Horace says; "painters and poets have always enjoyed the same preroga-tive to dare whatever they would," but one should never stray so far from nature that one's inventions seem improbable or impossible. An effect of naturalness – of artlessness – is the highest achievement of art.

Perhaps the most remarkable passage in the poem is one in which literary skill is shown to depend upon wisdom and character:

> Of good writing the source and fount is wisdom. Your matter the Socratic pages can set forth, and when matter is in hand words will not be loath to follow. He who has learned what he owes his country and his friends, what love is due a parent, a brother, and a guest, what is imposed on senator and judge, what is the function of a general sent to war, he surely knows how to give each character his fitting part.

Beyond the comprehensive understanding of human nature advocated by Aristotle, Horace suggests that poetry demands a kind of moral knowledge acquired in the active living of a virtuous life.

Partly because its author was a famous poet, partly because of its entertaining form, and partly because the advice it offers tallied with the best of ancient rhetorical and poetic theory, this little poem became an important influence on literary theory in the Middle Ages and early modern period. And because it draws so much from rhetoric, on the one hand, and suggests a close kinship between poetry and painting, on the other, it became the most important channel through which ancient rhetorical theory exerted its influence on later theories of the visual arts.

Word and World

Medieval thought about art takes up and creatively elaborates several of the themes introduced in ancient times. The relation of art to knowledge and its place in the hierarchy of human activities continues to be a concern for formal philosophy and theology: as in antiquity, the "mechanical," craft-based arts, such as painting and sculpture, generally occupy a lowly position in relation to the "liberal" arts; though their practical usefulness for human life is recognized, claims for their relevance to the higher reaches of speculative thought meets with resistance. Because the leading thinkers of the period were members of the Church, there is a pervasive interest in defining the value of art in religious terms. Magnificent buildings and ornaments are sometimes regarded as appropriate instruments of devotion; just as often they are seen as irrelevant and a waste of money – or worse, as sinister distractions, idols, and incitements to vice. Much medieval discussion of art revolves around the tension between the obvious usefulness of images – as a means of teaching the illiterate, or of stimulating spiritual life through an appeal to the emotions – and the equally obvious danger of their being misunderstood and misused.

Some medieval thinkers did recognize the value of images, however, even at the highest levels of thought, and they were perhaps no more

uncommon in their time than the ancient philosophers willing to admit the same thing. Some recognized that the inability to think in anything *but* images is one of the fundamental limitations of the human mind; others seem to have assumed that images may occasionally exceed the capacity of rational thought to express the loftiest and most precious truths, those insights available only to intuition touched by divine grace. One example is the Italian mystic Joachim of Flora, active toward the end of the twelfth century, who made use of "figures" (*figurae*) – diagrams – to express his complex ideas about the presence of God in history (figure 1.6). These diagrams were not simply illustrations but essential to the form of Joachim's revelations. They can be said to document the importance of figurative thought in the medieval period, even of the way in which thinking itself was believed to involve a kind of art. At the same time, their abstractness and complexity indicate why such thinking remained detached, in all but a few isolated circumstances, from the practice of the visual arts as we usually understand them.

Debate over the nature and function of images could become violent. During the eighth and ninth centuries, the Greek Church twice came under the control of iconoclasts (literally, "breakers of images") who vehemently renounced the use of images for religious purposes: the making of religious pictures was outlawed and many existing ones were destroyed. For a time it seemed that the Western Church might follow suit. The appeal of such pictures proved to be too profound, however, and their value for the faith was eventually upheld, though not before the kind of veneration owed to them was precisely defined in order to distance it from any suspicion of idolatry.

If the appeal of images is profound, however, so is mistrust of them, and iconoclastic sentiment resurfaced repeatedly, even in the West: it was usually associated with religious reform movements, though its motives are often impossible to disentangle from a general resentment of ecclesiastical wealth and power. Even Renaissance Florentines were susceptible to iconoclasm: when, for a time at the end of the fifteenth century, the city came under the influence of Girolamo Savonarola, a spellbinding preacher – an orator, thus himself a kind of artist – paintings, along with other luxury items such as expensive clothes, were destroyed as "vanities" in public bonfires. The Protestant Reformers of the next century were concerned to circumscribe the use of religious images, and in some places in Northern Europe extremists vandalized churches. At the final session of the Council of Trent in 1563, the Roman Catholic Church reaffirmed the value of images in devotional life – and also set guidelines to distinguish proper from improper ones. All this anxiety testifies to an awareness of the power of art, an awareness that only deepens as the Middle Ages give way to the early modern period.

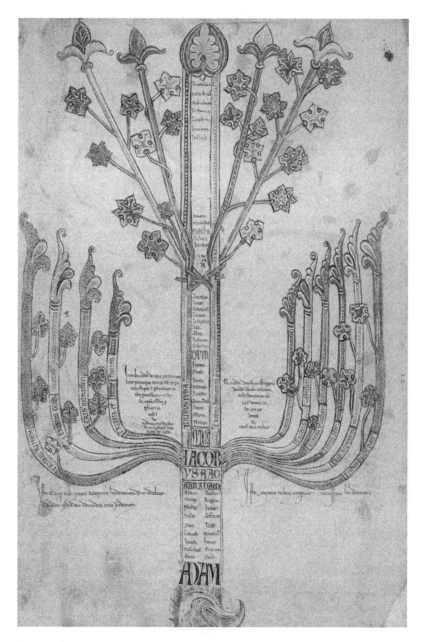

Figure 1.6 "Tree-Eagle" figure, from the *Liber Figurarum*, a manuscript of works of Joachim of Flora, c.1200, Bodleian Library, Collection of Corpus Christi College (MS 255A), Oxford University.

The sensitivity of medieval thinkers to the psychological function of images is part of a preoccupation with signs and symbols generally – with the experience of meaning in the most comprehensive sense. Their involvement with this issue, and its urgency for them, is an outgrowth of biblical exegesis, of the need to explain the single, divinely planned order – the Word – in the many words of sacred Scripture, as well as show how that order governs the world at large. The systematic methods of interpretation that they evolved, which continued to influence ideas of how meaning is produced well after they were transferred from Scripture to secular texts, and from texts to images, can perhaps be called the most original contribution of the Middle Ages to the theory of art – but only if we remember that their inventors would never have thought of them in such terms.

The best place to begin a survey of this development is with St Augustine (354–430 CE), who was both a great theologian and a famous teacher. In the broadest historical perspective, Augustine's achievement may be described as the appropriation for Christianity of the rich intellectual tradition of classical antiquity. Trained as an orator, he rose to prominence in Rome; after his conversion, he came to use his skills to defend and promote Christianity. In response to more extreme Christians, who distrusted all "pagan" learning, he urged the study of ancient philosophy and rhetoric: "we must not fear what those philosophers say, but appropriate the truths they contain from those who are, in a sense, their illegal possessors." Also, "every good and true Christian should understand that wherever he discovers truth, it is the Lord's." Such arguments were revived during the later Middle Ages and early modern period to justify the preservation and study of ancient texts: without Augustine's authority and influence, it is likely that many more would have been lost.

Augustine's *On Christian Learning* is a treatise about how one should study Scripture, or, rather, how an education might be based upon or built around the study of Scripture. He begins by distinguishing between signs and things. Signs are things, but ones that signify or symbolize other things. He says he will use the term "thing" primarily for what we would call "referents," those things to which signs refer. Of course, some things can also function as signs. A stone, for example, may be regarded as a thing, but the stone upon which the patriarch Jacob rested his head is a sign. On the other hand, some signs are such that their whole value consists in signifying: the principal example of this type is words.

Some things are to be enjoyed, he continues, some used; some are to be both enjoyed and used. Those that we enjoy make us happy, while those that we use help us to obtain the things that make us happy. Since, in the end, God is the only source of complete enjoyment, all other things – everything in the world – exists to be used. The world is a means

to God: "through what is corporeal and temporal we may comprehend the eternal and spiritual." Even man, who, because he contains an eternal part, the soul, might be the one thing in the world that we might enjoy in itself, is ultimately to be valued as an image of God.

"A sign," Augustine says, "is a thing which, apart from the impression that it presents to the senses, causes of itself some other thing to enter our thoughts." Following Plato, he distinguishes between "natural" and "conventional" signs: natural signs are those which lead us to the thought of something else by their very nature. Smoke is a natural sign of fire. Conventional signs, "those which living creatures give to one another," depend for their understanding upon associations that are learned. The most important of these is words, which depend upon a knowledge of language, but other signs of this kind are visual symbols such as flags, or aural symbols such as a trumpet call signaling attack.

Augustine's real concern is the problem posed by "ambiguous" signs, those the meaning of which is unclear, either because the recipient – the reader, say – has no idea what is meant, or because he finds it possible to infer more than one meaning. Sacred Scripture is full of such ambiguities, and since it is impossible that God should be incoherent, or ambiguous for no reason, Augustine concludes that God planted these difficulties in the text in order to humble those who are used to understanding things easily, and, by forcing us to work hard in order to understand, to impress upon us the value of the truths contained in the text. The apparent incoherence of such passages – and of the world at large, of course – is itself part of the divine plan.

The understanding of difficult signs can thus be a source of both pleasure and deeper insight. "Everything is learned more willingly through the use of figures, and we discover things with much more delight when we have had trouble searching for them." He suggests that there is a way of finally solving all the riddles because "practically nothing is dug out from those unintelligible texts which is not discovered to be said very plainly in another place."

Much of *On Christian Learning* is devoted to analyzing Scripture in terms of classical rhetorical classifications; Augustine also suggests that some of the devices of rhetoric – various tropes and figures, but also the low, middle, and high styles – should be used by Christian teachers. He also discusses symbolism, including number symbolism, at some length: for instance, the forty days that Moses and Christ both fasted is broken down into four times ten, ten into seven and three, seven into three and four – each of which numbers has specific symbolic associations that enhance the significance of the passage. Though we tend to think of this technique as a strange and distinctly medieval habit of thought, it was widely practiced in antiquity.

Augustine distinguishes between "literal" and "figurative" meaning. "It is necessary," he says, "to understand as figurative anything in Scripture which cannot in a literal sense be attributed to an upright character or a pure faith." It is ridiculous to suppose that Mary Magdalene anointed Christ's feet with fragrant oils "for the same reason that was customary among sensuous and dissolute men, whose banquets were such that we loathe them." In this case, rather, the oil is "the good reputation which each one will possess who follows in the footsteps of Christ." Augustine sometimes refers to the literal as the "historical" meaning because it simply describes an event in real time. There are also at least two distinct types of "figural" meaning. On the one hand, a passage may suggest a principle of good conduct; it may express a moral principle applicable to our own lives. On the other, it may refer to the *ideal* state of things – showing how they are in heaven, or will be at Christ's second coming – for heaven, or the end of time, is by definition a condition when the corporeal and temporal fall away to reveal only the spiritual and eternal, the true nature of things.

Later theologians elaborated upon the distinctions between the levels of meaning suggested by Augustine. The fifth-century mystic who called himself Dionysius the Areopagite wrote a treatise about heaven, *The Celestial Hierarchy*. He begins by explaining how he gathered his evidence – drawn from Scripture primarily, of course, but also other sources – and he says that he has read them all figuratively, as referring to the state of things in heaven, a mode of reading he calls "anagogical."

Dionysius has some fascinating things to say about figures and metaphors. For example, because the ultimate truth is so exalted, so far beyond the capacity of our minds to grasp, it was *necessary* for God to express himself through symbols. His glory is like a blinding light, which he has taken care to cover with "many veils." Elsewhere, obviously influenced by Platonism, Dionysius says that these symbols are such that they do not allow the mind to rest content and thus do not lull it into a false sense of understanding, but urge it on toward the higher truths of which they are merely images. In one place, he even advises the Christian, in contemplating God, or in trying to explain the nature of God to an unbeliever or neophyte, to use deliberately inappropriate metaphors, so that the listener is not tempted to take the image for the reality, and so that the mind, which cannot approach God directly, may move toward him step by step by coming to understand what he is not. If one says that Christ is like a worm, for instance, one makes a point about his humility without allowing the hearer to suppose that he or she really understands it. "Similitudes drawn from things farthest away from God form within us a truer estimate that God is above whatever we may say or think of Him." This idea radically inverts the classical rhetorical notion of decorum.

St Thomas Aquinas, active around the middle of the thirteenth century, relied on both Augustine and Dionysius in his discussion of figural language in the Scriptures. He distinguishes four levels of meaning: the literal or historical and not two, but three, figurative senses – the "moral" (sometimes called "tropological"), the anagogical, and the "allegorical." The moral sense is essentially the same as for Augustine, the anagogical essentially the same as for Dionysius. The term "allegorical" had been used in ancient rhetorical theory to refer to an extended use of metaphor or a discussion of some topic disguised as the discussion of something else. For Aquinas, it has a more specific meaning, reserved for events in the Old Testament or features of the "old" law of Judaism that anticipate events in the New Testament or aspects of the new, Christian dispensation. Aquinas agrees with Augustine that any passage of Scripture may have more than one level of meaning; indeed, any passage may have all four levels of meaning.

All this may seem to lead only into the obscure entanglements of biblical exegesis, but different levels of meaning were also felt to exist in the world at large: indeed, medieval thinkers commonly thought of the world as God's other "book," and assumed that it had been planned as carefully as the Scriptures. A thirteenth-century troubadour, Ramon Llull, developed a system for reading the world in this way – he called it his "art" – in which the attributes of God, identified by abstract nouns such as "goodness," "power," "truth," and so on, are recognized in a series of ascending levels in the hierarchy of creation, from the traditional four elements through plants, animals, and man, until they are apprehended in their pure form in God himself (figure 1.7). These words thus provide tools with which to understand how the perfection of God is manifest in the world. Apart from its general dependence on common medieval habits of thought, Llull's art drew upon techniques for the training of memory developed in ancient rhetorical theory as well as the Jewish mystical lore known as cabbala.

Another remarkable example of the application of figurative thinking, and one with the advantage of bringing us immediately to the issue of its relevance for the visual arts, are the writings of Abbot Suger of St Denis, who

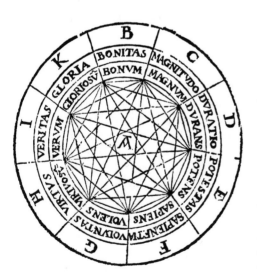

Figure 1.7 Diagram of divine attributes, from Ramon Llull, *Opera* (Strasburg, 1617).

lived in the mid-twelfth century. Suger's church was the ancient burial place of the kings of France; during his lifetime – and thanks in great part to his energy and influence – it was enlarged and redecorated: the choir (figure 1.8) is one of the first examples of Gothic style in architecture, and older histories attributed its invention to Suger himself. In any event, he left a description of the church, along with an account of its rebuilding and an inventory of the precious objects in its treasury.

Suger demonstrates profound responsiveness to the sensuous beauty of objects, especially of precious materials like gold and jewels, but he takes pains to insist upon the superior value of workmanship. The verses which he composed for the doors of the main portal direct the viewer's attention beyond the materials to the craftsmanship, and beyond craftsmanship to their symbolic significance:

> Whoever thou art, if thou seekest to extol the glory of these doors,
> Marvel not at the gold and the expense but at the craftsmanship
> of the work.
> Bright is the noble work, but, being nobly bright, the work
> should brighten the minds, so that they may travel,
> Through the true lights to the True Light where Christ is the
> True Door.

The idea of an ascent from the physical to the spiritual, from a lower to a higher beauty, reaches back to Plato and Plotinus; the idea that the literal door is to be experienced by the viewer figuratively, as a symbol of Christ, derives from Augustine and Dionysius. The light imagery, also a feature of these other writers, is especially conspicuous in Suger's discussion of the stained-glass windows.

In fact, the St Denis to whom the church is dedicated was believed to be none other than Dionysius the Areopagite. Suger had read *The Celestial Hierarchy*, and there can be no doubt that he intended the church and its riches to be seen and understood in terms of the principles explained there:

> Thus when, out of my delight in the beauty of the house of God, the loveliness of the many-colored gems has called me away from external cares, and worthy meditation has induced me to reflect – transferring that which is material to that which is immaterial – on the diversity of the sacred virtues: then it seems to me that I see myself dwelling, as it were, in some strange region of the universe which neither exists entirely in the slime of the earth nor entirely in the purity of heaven; and that, by the grace of God, I can be transported from this inferior to that higher world in an anagogical manner.

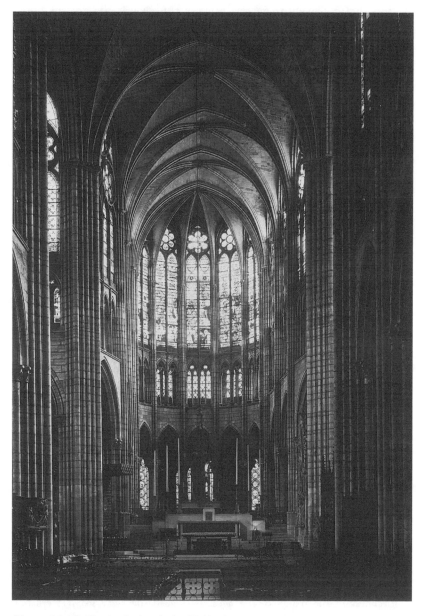

Figure 1.8 St Denis, Paris, choir, 1140–4.

This passage has tended to strike modern readers as exceedingly disingenuous. Did Suger really experience religious ecstasy as he gazed at his extraordinary horde of gold and jewels? Or is his mysticism a cover – conscious or unconscious – for simple greed? He was not an otherworldly

personality, but one of the shrewdest, most powerful men in France, and it has been suggested that his mystical posturing had a political purpose: that it was intended as a response to reformers who questioned whether the Church should accumulate and display wealth. Suger may have been trying to show that material richness is transfigured when dedicated to God, and its contemplation can have a spiritually uplifting effect.

If Suger's writings present us with the example of a sophisticated and highly placed churchman able to experience works of art anagogically, we may still want to ask whether artists themselves understood their work in such terms. It would be surprising if the complex conception of what meaning is, and of what artifice, in its highest form, can be, had no effect – did not stimulate the ambition of writers and craftsmen, or prompt them to approach their task with a new exaltation of purpose. At the same time, it would be surprising if more than a very few possessed the intellectual resources to explore its implications fully. One who did was the Florentine poet, Dante Alighieri, whose *Divine Comedy*, composed in the early years of the fourteenth century, describes a journey through hell, purgatory, and heaven. An allegory of the soul's ascent from sin to salvation, it is also an inventory of spiritual states, from abject damnation through various complex processes of purification to exquisitely nuanced degrees of blessedness. It is a microcosm as ambitious as a medieval mind was capable of conceiving: a survey of the human condition in its breadth and depth, a map of the universe that seeks to reveal its divinely ordained structure. Later commentators made the same claim for Dante's poem that ancient commentators had made about the works of Homer and Virgil: that it is a summation of all learning, a distillation of all wisdom, a synopsis of all modes of being in their ideal interrelation.

Dante intended to write his own commentary on the *Divine Comedy*, and he claimed, in a letter to one of his patrons, that he would explain how the entire poem could be read on any one of the four levels of meaning described by Aquinas – the literal, moral, allegorical, and anagogical. In other words, he would show how his work possessed the same complexity and depth as sacred Scripture – as creation itself. Though he never got around to the commentary, his boast is significant: he could have made no more emphatic assertion of the poet's creative prerogatives.

Again, significantly, it is a poet who scales the highest intellectual summit, but we do not need to look far from Dante in order to discover visual artists determined to invest their work with unprecedented significative richness. The sculptor Nicola Pisano and his son, Giovanni, were Dante's exact contemporaries, and active in the same part of Italy. They are best known for a series of pulpits which combine extraordinarily complex, dramatically charged narrative reliefs with allegorical figures that beautifully express abstract ideas, as well as compelling characterizations

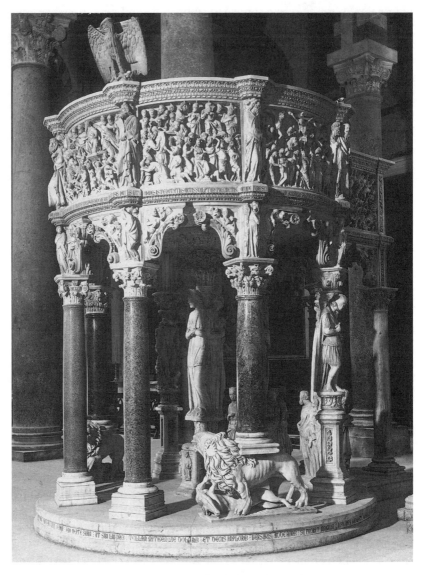

Figure 1.9 Giovanni Pisano, pulpit, Pisa Cathedral, 1302–10.

of prophets and saints. Anticipating the orientation we associate with the Renaissance, their work makes continual reference to the art of classical antiquity, as if inviting comparison and attempting to demonstrate an equal or superior degree of skill.

Toward the end of his career, Giovanni made a pulpit for the Cathedral of Pisa which he probably envisioned as his crowning masterpiece (figure 1.9). Most modern viewers do not find it as successful, on the whole,

as his earlier work, or that of his father, but the inscription – which, following ancient custom, is presented as if being spoken by the sculpture itself – is memorable for its overweening pride:

> I praise the true God, the creator of all excellent things, who has permitted a man to form figures of such purity. In the year of Our Lord, thirteen hundred and eleven, the hands of Giovanni, son of the late Nicola, by their art alone, carved this work . . . [he] is endowed above all others with the command of the pure art of sculpture, shaping splendid things in stone, wood, and gold. He would not know how to make ugly or base things even if he wished to do so. There are many sculptors, but to Giovanni alone remain the honors of praise.

Another part of the inscription directs the viewer's attention specifically to the comprehensive artistic ambition reflected in the work: "Giovanni has encircled all the rivers and parts of the world endeavoring to learn much and preparing everything with heavy labor . . ." Whether we understand the "rivers and parts of the world" as something Giovanni has sought to represent on the pulpit itself, or as alluding to his travels and studies, and thus to his comprehensive understanding of things, this inscription testifies to his desire that the work be seen as a microcosm, as an exemplification of art itself – like the shield of Achilles.

The early
Modern period

Craftsmen and Theorists

One of the most interesting documents of the transition from a medieval
to an early modern conception of art is the treatise known simply as the
Book of Art or *Craftsman's Handbook*, by Cennino Cennini, a Florentine
painter active in the decades before 1400. Essentially a "recipe book," a
compilation of practical advice regarding the materials and processes of
painting, it is one of the few surviving examples of a type of text that
must have been common in the Middle Ages. Cennino describes all the
humblest aspects of the craft: how to mix gesso, plaster, and varnish,

how to find good pigments and combine them for various effects, even how to make different kinds of brushes. At the same time, his book is animated by a new and striking kind of intellectual ambition.

Cennino begins by invoking God, the Virgin Mary, and several patron saints; he presents his own qualifications by saying that he learned his craft from the master Agnolo Gaddi, the son of Taddeo Gaddi, who had been, in turn, an apprentice of the great Giotto. He then explains the origin and nature of painting with reference to the division of labor that occurred after Adam and Eve were driven from Paradise:

> Man afterward pursued many useful occupations, differing from each other; and some were, and are, more philosophical than others; they could not all be alike, since philosophy [*theoria*] is the most worthy. Close to that [philosophy] man pursued some related to the one which calls for a basis of that [philosophy], coupled with skill of hand, and this is an occupation known as painting, which calls for imagination and skill of hand, in order to discover things not seen, hiding themselves under the shadow of natural objects, and to fix them with the hand, presenting to plain sight what does not actually exist.

Though the mode of expression is clumsy, the claims are bold. He goes on to compare painting to poetry:

> And justly it [painting] deserves to be enthroned just below philosophy, and to be crowned with poetry. The justice lies in this: that the poet, with his philosophy – though he have but one, it makes him worthy – is free to compose and bind together, or not, as he pleases, according to his inclination. In the same way, the painter is given freedom to compose a figure standing, seated, half-man, half-horse, as he pleases, according to his imagination.

Cennino's pride is not new in itself – it is of the same kind reflected in Giovanni Pisano's inscription on the Pisa Cathedral pulpit – but the reference to the kinship between painting and poetry derives from Horace's *Art of Poetry*, and sounds a bookish, slightly pretentious note. To claim that painting's relation to poetry places it "just below" philosophy in the hierarchy of knowledge, moreover, is to announce a theme that later theorists will find necessary to rework in increasingly explicit and elaborate terms.

Among the practical tips that make up most of the book, Cennino addresses issues of a more speculative kind. One of his principal concerns is the imitation of other artists. This reflects the workshop training common in his time, in which young apprentices learned by copying the drawings, then the paintings, of the master-painter who was both their

teacher and their employer. Cennino says that it is best to follow a single model, but also admits that one can learn from the work of others as well, and that, especially "if one lives in a place where there are many good masters," one should observe and copy their works too. Care must be taken to choose only the best examples, however, and not complicate things by trying to assimilate too much diversity: "for if you undertake to copy after one master today and after another one tomorrow, you will not acquire the style of either," but will only become "capricious." The sensitivity to this issue, the tension between authority and freedom, will also be more explicitly articulated in later thought.

Though one learns a great deal by imitating the work of one's teachers, the "best steersman" and – mixing metaphors – the "triumphal gateway" through which one achieves perfect mastery in painting is the continuous study of "nature." Cennino recommends that one take care to draw a little every day, and even that one carry paper in a wooden portfolio that can double as a drawing board, so that one can sketch wherever one goes. At the same time, he suggests some quaint shortcuts, like using a pile of stones set up in the studio to serve as a model for a mountain.

Ambitious as it is in its own way, Cennino's text hardly prepares us for what is usually and rightly regarded as the first work of early modern art theory, Leone Battista Alberti's *On Painting*, written in 1435. Because this little treatise is the starting-point of so much, because nearly every idea that it contains was taken up, elaborated, and codified in the course of subsequent centuries, modern readers usually find it disappointingly simplistic and bland. Yet in its time it was a radically original text, and had a polemical edge not unlike a modern artistic manifesto. At the beginning, for instance, Alberti makes the rather supercilious claim that the "difficult" subject of painting "has not, as far as I can see, been treated before by anyone else." He may not have known Cennino's book, but he certainly knew texts of the kind: his point is that no previous treatment satisfies *his* intellectual standards.

Alberti's originality can be explained largely in terms of his social position and education. Though he says that he is writing as "a painter for painters," he came to art by a very different route, and with a very different set of mental tools, than working-class craftsmen like Cennino. The illegitimate son of a wealthy Florentine banker, he attended one of the elite schools pioneering the new type of education, based on the study of ancient literature, that came to be known as "humanist." Cut off from his inheritance, he made a brilliant career as a literary man, writing on an unusually wide range of topics. No paintings securely attributable to him survive, but he was an important architect, and also wrote, later in life, an immense and learned treatise on architecture. *On Painting* was

composed in Latin, and dedicated to the Duke of Mantua; Alberti then translated it into Italian, apparently so that artists could read it. He dedicated the translation to Filippo Brunelleschi, the Florentine architect credited with having revived classical architectural style and the invention of one-point perspective.

The first part of the treatise is devoted to a careful explanation of the optical and geometric principles necessary for producing perspectival projections. The importance attached to perspective is an indication of how central it had become in the few years since it had been developed, of how profoundly it was felt to have transformed the very nature of painting. For Alberti, the efficacy of perspective proves that painting depends upon the "certain" science of mathematics, and this dependency offers him a far more rigorous and compelling argument for the intellectual dignity of the craft than was available to Cennino.

"No one will deny that things which are not visible do not concern the painter." With this remark, Alberti further distances himself from his predecessor, who had exalted precisely the artist's ability "to present to plain sight what does not actually exist." Though Alberti comes across here as very tough-minded, he insists further on in the text that the painter must also be concerned with the representation of emotion and character, and even of ideal beauty. That there is still much of Cennino's regard for what might be called the magical suggestiveness of images is evident when Alberti refers to their power "to make the absent present, as friendship is said to do."

In the subsequent sections of the treatise, Alberti supports his argument for the dignity of painting with an impressive and carefully deployed array of passages from ancient literature, a mode of argument directed as much toward educated aristocrats as toward craftsmen. He does not let his erudition overwhelm the clarity of his argument, however, for he also divides the art of painting into three parts, or sub-skills: circumscription (the drawing of outlines), composition (the arrangement of forms), and "reception of light" (modeling and coloring). This bold rationalistic stroke, this attempt to redefine the art from first principles, depends upon habits of thought acquired in the course of his humanist education: his concept of composition, in particular, is indebted to ancient grammatical and rhetorical theory, and he explicitly compares learning to paint with learning to write.

The highest challenge that the painter can face is the type of picture Alberti calls an *istoria* – literally, a "story," a composition with human figures, ideally, a narrative. If done well, such a picture demonstrates the painter's command of all the parts of his art; it reveals not only his skill at duplicating natural appearances, and his sensitivity to things like variety and harmony, but also a more comprehensive understanding of the world

– of anatomical proportion and of various personality types, the kind of knowledge Aristotle and those after him had recommended to the orator and poet. The painter reveals this knowledge primarily in his adherence to the principle of decorum: old men should be restrained in their gestures, young men vigorous; soldiers should dress and move in a manner different from philosophers or hermit saints. Because "the motions of the body reveal the motions of the soul," the successful representation of emotionally charged actions will succeed not only in expressing the inner states of the figures, but will also elicit an irresistible emotional response from the viewer. The painter's ability to orchestrate such reactions will be a further indication of his psychological insight and philosophical depth.

Alberti gives much more emphasis than Cennino to the study of nature. The painter must be willing to devote his entire life to a sustained and careful observation of all aspects of the visible world, and nature can always be counted on to provide him with guidance in any situation. Though Alberti is here using the word "nature" primarily with reference to visual appearances, he also understands it in terms taken from ancient philosophy, as the set of laws that govern the world: the natural, the true, and the decorous overlap in such a way as to make them virtually indistinguishable. In fact, nature as appearance is always imperfect: "complete beauties are never found in a single body, but are rare and dispersed in many bodies." The painter must thus do more than imitate the way things look, he must take care to improve upon what he sees around him so that his pictures may be full of especially beautiful things. Alberti recommends the example of Zeuxis, combining the best features of several models into a single figure. The aim of such idealization is not just to make the picture more pleasing to look at, but to demonstrate the artist's comprehensive, philosophical knowledge of the world. As a result of his long and diligent study of nature, the painter will arrive at an "idea of beauty" which will guide him in any improvements he makes upon appearances.

Alberti thus manages to fuse empiricism with idealism. Having emphasized the artist's prerogative to transform the world, however, he sternly warns young artists against presuming to improve upon nature without sufficient study: "This idea of beauty, which even the well-trained barely discern, flees entirely from the inexperienced." Young painters who are too fond of their own imaginings "never learn to paint well, but merely become accustomed to their own errors." Only a continual, disciplined engagement with nature can lead to perfection. The art of painting is *essentially* a critical process, a kind of intense, mutually correcting interaction between mind and world.

If Alberti begins by insisting upon the need for an understanding of optics and geometry, he ends by saying that the painter should be well

versed in all the liberal arts, and even that he should be a good man. He knows that such self-perfection is extremely difficult to attain: one can make up for some of one's own limitations by consulting other people, by frequenting the company of literary men, for instance, who can provide ideas for *istorie*: Alberti himself has been endlessly stimulated by Lucian's description of the *Calumny of Apelles*. Ideally, painting may be a means for the expression of encyclopedic learning. It is not just that all the arts and sciences contribute to painting, but that in combining and containing them, painting reveals itself to be something more profound, more elemental than they are:

> Is it not true that painting is the mistress of all the arts or their principal ornament? If I am not mistaken, the architect took from the painter architraves, capitals, bases, columns, and pediments, and all the other fine features of buildings. The stonemason, the sculptor and all the workshops and crafts of artificers are guided by the rule and art of the painter. Indeed, hardly any art, except the very meanest, can be found that does not somehow pertain to painting. So I would venture to assert that whatever beauty there is in things has been derived from painting.

Painting is a form of knowledge that subordinates and integrates other forms. Going further than Cennino, Alberti claims for painting a kind of intellectual importance that ancient and medieval thinkers had generally reserved for philosophy.

In the letter of dedication to the Italian translation of his treatise, Alberti praises Brunelleschi's architectural achievements and briefly mentions a group of other artists whose work he admires and who seem to be reviving the arts, restoring them to the high position they had enjoyed in antiquity. These artists include the sculptor Donatello and the painter Masaccio, and Alberti's text can be seen as the theoretical expression of that dramatic phase of innovation in Florentine art that began in the early decades of the fifteenth century. If one compares Masaccio's badly damaged, yet still imposing *Trinity* fresco, painted around 1425 (figure 2.1), with Giotto's *Madonna* from the church of Ognissanti in Florence (figure 2.2), painted a little more than a century before, one begins to understand how the artists of Alberti's generation could feel that they had improved on the work of their predecessors, that perspective, in particular, had given them the key to perfection in painting.

Though Giotto shows a prodigious determination to render the way forms behave in space, and is able to suggest an illusion of real space sufficient to his purposes through the drawing of the architecture of the throne, the arrangement of the figures in relation to one another, and the modeling of the individual forms in light and shade, Masaccio is able to create a deeper and more convincing illusion through the use

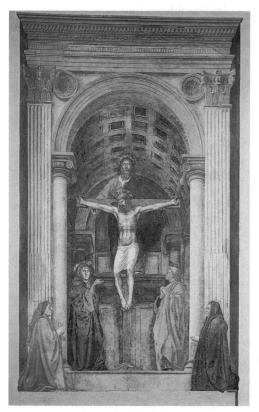

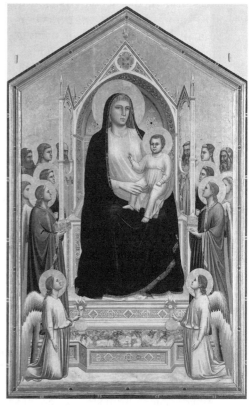

Figure 2.1 Masaccio, *Trinity*, c.1425,
S. Maria Novella, Florence.

Figure 2.2 Giotto, *Ognissanti Madonna*,
c.1310, Uffizi Gallery, Florence.

of geometrically consistent perspective. The picture is arranged around a vanishing point that is placed at the eye level of a viewer standing in the church, so that the effect of the fictive space being an extension of the real space is powerfully enhanced. At the same time, Masaccio exploits the potential of such perspective constructions for ambiguity: because the vanishing point is just below the step on which the holy figures are placed, we cannot judge their relative positions with certainty. As a result, they loom over us in a way that reminds us we are dealing with supernatural presences.

The subsequent development of fifteenth-century painting, especially in Florence, can be seen as a response to the innovations of painters like Masaccio, as well as to the challenge of Alberti's radical intellectualism. In the course of the following decades, painters assimilated perspective into their way of thinking about what painting is; they combined it with an intensified interest in all aspects of nature – human anatomy, for

instance, and landscape. The way in which this enterprise came to fulfill-
ment in the second half of the century is best represented by Leonardo
da Vinci (1452–1519), and at least partly illustrated by his *Last Supper*
(plate 1), painted in the years 1495–7. Though in ruinous condition, this
great mural can still be recognized as one of the most impressive realiza-
tions of Alberti's concept of *istoria*: the scene is dramatically conceived,
and perspective has been used both to structure space and to focus the
drama; the figures are variously and decorously characterized, and every
detail has been calculated to enhance the effect of the whole. Though
the meticulous surface and exquisitely subtle effects for which Leonardo
was also known are lost, they can be imagined with the help of other
pictures, such as the *Mona Lisa*. His painting set new standards both of
grandeur and refinement.

Throughout his career, Leonardo compiled notes for a comprehensive
treatise on painting. He never completed it, but after his death, many
of his ideas were collected and copied into manuscripts that circulated
widely. Taken together, these notes show that theory had developed just
as rapidly as practice since Alberti's time. Though the basic structure
of Alberti's enterprise is still intact, Leonardo both refines its premises
and enlarges its scope. From his now fragile and scattered sheets there
emerges a conception of art that is truly awe-inspiring in its comprehens-
iveness and exaltation of purpose, one that makes Alberti's seem almost
amateurish – almost as quaint in its own way as it had made Cennino's
seem. To Alberti's urging that the painter study nature, Leonardo responds
with the most probing and wide-ranging scientific investigations of the
fifteenth century. In answer to his predecessor's cautiously ventured claim
that painting is the "mistress of all the arts," he proudly and passionately
affirms its place among the loftiest intellectual pursuits:

> If you despise painting, which is the sole imitator of all the visible works of
> nature, you will certainly be despising a subtle invention which brings
> philosophy and subtle speculation to bear upon the nature of all forms –
> sea and land, plants and animals, grasses and flowers – which are enveloped in
> shade and light. Truly, painting is a science, the true-born child of nature.
> For painting is born of nature; to be more correct we should call it the
> grandchild of nature, since all visible things were brought forth by nature
> and these, her children, have given birth to painting. Therefore we may
> justly speak of it as the grandchild of nature and as a descendant of God.

When Leonardo uses the word "philosophy," he means the "natural phil-
osophy" of his time, an early form of our idea of natural science. When
he uses the word "science," he means something closer to what we mean
by philosophy – a systematic, self-reflexive form of inquiry. Following a

model developed in medieval theories of the liberal arts, he understands painting to be a form of philosophical activity combining inductive and deductive reasoning.

Unlike Alberti, Leonardo was trained in the traditional workshop system. His formal schooling seems to have been minimal, and his Latin was spotty: in an age when knowledge of Latin distinguished "learned" from "ignorant," Leonardo could describe himself as an *omo sanza lettere* – "a man without letters." This only makes his intellectual achievements all the more remarkable; it also explains some of the distinctive features of his art theory. He seldom alludes to classical literature, for instance, and remarks like the ones just cited reveal a certain defensiveness as well as bold self-assurance. Whereas the humanistically educated intellectuals of his day continually appealed to the authority of ancient writers, Leonardo insists that the painter is responsible only to the higher authority of nature, and that one learns more from experience than from books. This intellectual independence, this skepticism and empiricism, make him one of the heroic forerunners of the modern scientific mentality.

Many of his surviving notes concern the relation of painting to sculpture, poetry, and music. These seem to have been written in response to a debate at the court of Milan, where Leonardo worked for many years, and since their arguments are sometimes strained and pedantic, they are perhaps not always to be taken with the greatest seriousness, but they do reveal several of Leonardo's most deeply held beliefs. Painting is better than poetry because it is a system of natural rather than conventional signs: its appeal is immediate and universal; it transmits knowledge directly, more securely, and more accurately than words. Painting is better than sculpture, primarily because it can imitate a greater variety of natural effects; it can be a more comprehensive means for expressing a total understanding of nature:

> The art of painting includes in its domain all visible things, and sculpture with its limitations does not, namely, the colors of all things in their varying intensity and the transparency of the objects. The sculptor simply shows you the shapes of natural objects without further artifice. The painter can suggest to you various distances by a change in color produced by the atmosphere intervening between the object and the eye. He can depict mists through which the shapes of things can only be discerned with difficulty; rain with cloud-capped mountains and valleys showing through; clouds of dust whirling about the combatants who raised them; streams of varying transparency, and fishes at play between the surface of the water and the bottom; and polished pebbles of many colors deposited on the clean sand of the river bed surrounded by green plants seen underneath the water's surface. He will represent the stars at varying heights above us and innumerable other effects to which sculpture cannot aspire.

Leonardo worked as a sculptor and knew better, of course, than that sculpture simply "shows you the shapes" of things, but this passage, with its rapturous inventory of challenging optical effects, gives a clear sense of what was most important to him.

Indeed, Leonardo several times invokes Plato's image of the mirror deliberately to reverse the Platonic censure of imitation. "The painter's mind should be like a mirror, which transforms itself into the color of the thing that it has as its object, and is filled with as many likenesses as there are things placed before it." Leonardo seems to delight precisely in those shifting appearances that Plato most distrusted; at the same time, he knows that there is much more to painting than appearances. "The painter who copies by practice and judgment of the eye, without rules, is like a mirror which imitates within itself all the things placed before it without any understanding of them." Leonardo's challenge to Plato depends on his being able to claim that painting is a critical process, a means of arriving at truth, not just illusion, that it can do what Plato insisted only philosophy could do.

One indication of the distance that separates Leonardo from Alberti is the way in which he deals with the geometric aspects of painting. Alberti says that a painter need not concern himself with whether, in strictly geometric terms, a point has any substance; he is only concerned with what is large enough to be seen. Leonardo takes his geometry much more seriously: points and lines have no substance; they are mental constructs. Where Alberti had simply advised the painter not to make outlines too thick lest they undermine the effect of depth, Leonardo urges painters to remember that a line is a provisional conceptual tool: the real challenge of painting is to show the subtle way in which forms are defined by light and bounded by atmosphere. Beyond a sensitivity to light and atmosphere as the specific conditioning media of visual perception, this insight shows how, for Leonardo, the study of nature leads back to a critically self-reflexive, hence philosophical, awareness of its means.

Alberti had recommended that the painter study the appearance of the human body, learning enough as is necessary for representing plausibly constructed figures that seem to be made of flesh and bone beneath their clothes. Artists of the next generations gave themselves to a more deter-mined study of anatomy; some even performed dissections. Leonardo's anatomical investigations took him much further. He went beyond the kind of concern with the skeletal and muscular structure most immedi-ately relevant to painting, and studied the inner organs as well. His interest in appearances led to an interest in function; his curiosity about visible effects prompted a philosophical desire to understand causes. As a result, he came to know more about the body than any medical doctor of his time. His interests extended beyond the human body to all aspects

of the natural world: he made studies of animal anatomy, plants, geology, meteorology, light, and the motion of water.

Alberti had discussed the need for variety and adherence to the principle of decorum in the characterization of figures; his remarks depend as much upon ancient sources, such as Horace, as upon his own experience. For Leonardo, such precepts become the starting-point for an intense and wide-ranging study of facial and figural types, as well as of the movements of the body. Characteristically, his observations suggest to him the possibility of a *systematic* approach to human variety. Going further than Cennino or Alberti, he encourages artists to roam the streets, observing and sketching different faces, and he seems to have followed his own advice. Once one has reached the point where this kind of sketching has become easy, he recommends that one raise the bar, as it were, by leaving the sketchbook at home and training oneself to record what one has seen mentally, so that one may reproduce it from memory later.

Such advice, based on the assumption that the endless challenge of art must be met with endlessly more demanding self-exertions, points to another aspect of Leonardo's relation to his predecessors: the greater rigor with which he feels it necessary to structure the artist's time, his working routine. Cennino had said painters should cultivate good personal habits and avoid excesses like wanton womanizing; Alberti had urged them to develop the discipline necessary to carry their work to completion in prompt fashion and to learn to take criticism. Leonardo goes much further. The life of a painter demands a round-the-clock regimen. One should organize one's day to take best advantage of the lighting conditions: in warm weather one should draw from life; winter evenings should be used to scrutinize the drawings made in warm weather and to combine their best features in new drawings. Feast days should not be spent idly, but used for study. On breaks from work, and as one walks from place to place, one should remain observant: things as unpromising as the irregularities and stains on old walls can suggest fresh ideas. Even as one lies awake in bed at night, waiting to fall asleep, one can train the memory "to recall in fancy the outlines of forms" seen during the day.

This kind of self-discipline should not be regarded as unique to Leonardo, even if he was probably more obsessive than most of his contemporaries: it reflects a general sense of the intensified demands that the new intellectual conception of art placed on its practitioners; it suggests that this new conception of art participates in a larger rationalization of labor. A similar point may be made about Leonardo's remarkable advice that painters have their own bodies measured. Because artists always tend to make figures that resemble themselves, a good painter should know how his own body conforms to or departs from normative proportions. He can thus compensate as he paints, with the result that

his figures will be properly proportioned. Only this kind of relentless self-consciousness enables the painter to overcome his personal idiosyncracies and limitations, and allows him to give his pictures the objective validity of solid philosophical propositions.

The discipline of art also requires the painter to maintain a certain self-conscious distance in his dealings with other people. In general, he should keep to himself and take care to sustain an *inner* dialogue – to "debate with himself." He should occasionally draw in the company of other artists only so that he may arouse and channel his natural competitiveness to produce better work. Leonardo does not recommend complete withdrawal from society, but a calculated, diplomatically dissembled posture of isolation that is the necessary complement to the selfless engagement with nature advocated elsewhere: as much as being an artist involves an infinite openness to the world, it also demands a discipline and distance that are in many ways unnatural. This duality casts a poignant light on Leonardo's use of the mirror metaphor: in one of his simplest and most beautiful statements, he says that the artist should be "like a mirror which is transformed into as many colors as are placed before it, and doing this, he will seem to be a second nature." The work of the artist is nothing less than to bridge in himself the distance between the purely passive receptivity of the mirror and the infinite creative abundance of God.

Humanism

The emergence of the kind of theoretical self-consciousness exemplified by Cennino, Alberti, and Leonardo must be seen, not only as the result of specifically artistic developments, but as part of a larger, deeper cultural transformation. To use the term Renaissance to describe the process is to evoke the notion of a "rebirth" – specifically, the rebirth of the forms and values of classical antiquity. There is much merit to this time-honored idea, but it does not quite do justice to the complexity of the historical process as a whole: it does not give enough emphasis to the fact that early modern culture was nourished by other sources than antiquity, or that even the most sincere and precise imitation of antiquity always resulted in the creation of something new. We have already had an indication of this complexity in art theory: Alberti cited ancient sources at every opportunity, yet came up with a radically original book; Leonardo was his greatest heir, yet minimized his own dependence on ancient authority.

Humanism is another concept traditionally associated with the emergence of early modern culture. Sometimes it is defined narrowly, as the study of classical antiquity, sometimes broadly, as the cultivation of universal values inspired by that study. Some humanists were preoccupied

with literary technique, some with the problems of political and moral life, some with speculative philosophy, and because they held divergent views on these matters, it has proved impossible to associate humanism with a single set of beliefs or a conscious system of values. A similar difficulty exists in trying to pin down the nature of its influence on art, but that influence was profound, and worth making an effort to define.

The most obvious effect of humanism on art is the increasing interest in classical subject matter and style. We have already seen an example in Botticelli's recreation of Apelles' *Calumny*, an even more sophisticated example is his *Spring* (*Primavera*) (plate 2), painted about 1478. The picture does not narrate any particular ancient myth, but assembles a number of mythological characters in order to express the idea that love is the source of life and generative principle of the world – an idea found, for instance, in the great ancient philosophical poem *On the Nature of Things* by Lucretius. Only someone with a rich knowledge of ancient literature could have conceived such a picture, and it is likely that Botticelli collaborated with a scholarly adviser in the manner recommended by Alberti. At the same time, he enlivened the complex literary conceit by imitating the forms of ancient art: the arrangement of three dancing Graces is derived from a well-known statue group, and in bringing them to life, as it were, with color, he may have intended to persuade his viewers that painting is better than sculpture.

Spring may be thought of as a painted poem: it makes the claim that painting is like poetry, a claim already made by Cennino and elaborated by Alberti. Botticelli's picture invites the viewer to reflect upon the capacity of painting to capture the spirit of ancient poetry and also, perhaps, to surpass it in spontaneous appeal and evocative power – to *demonstrate* in practice the theoretical idea that the painter is the equal of the poet. The great Venetian painter Titian liked to refer to his mythological scenes, such as the stupendous *Bacchus and Ariadne*, painted in 1522–3 (plate 3), as *poesie*, poems. He also combines motifs from various sources in a creative fashion and signals his sophistication through all sorts of details: the fluttering drapery, for instance, though a brilliant visual effect, is a motif found in several well-known poems. Titian's formal means are obviously unlike Botticelli's: instead of lyrical linear patterns, he exploits the capacity of oil paint to create vivid effects of color and texture; he presents a feast for the eyes that brilliantly captures the intensified sensuous life celebrated in the ancient texts.

Beyond the revival of ancient subject matter and style, then, the cultural environment created by humanism supported the tendency of artists to emphasize the relation of art to poetry. At the same time, this idea – which we designate by Horace's phrase *ut pictura poesis* – always involved something beyond poetry as narrowly conceived: it pointed to a relation

between art and language generally, art and the power of discursive reason that was believed to be the distinguishing attribute of the human mind. Poetry could thus include rhetoric or history or philosophy, and the tendency to think in such fluid terms was encouraged by ancient writers, like Horace, and Aristotle before him, who sought to show how poetry, at least in its most exalted forms, might touch upon philosophy. In this way, the notion of *ut pictura poesis* leads back to the idea that art is a form of philosophical activity: it provides an alternative path to the same conclusion that Leonardo had reached with his more scientific approach.

One image that illustrates how the poetic, or "literary," and philosophical might overlap is Raphael's fresco known as the *School of Athens* (plate 4), painted in 1509–10. The picture represents philosophy itself: it decorates one wall of a room in the Vatican Palace which served as the library of Pope Julius II, and represents one of the four divisions of learning into which the books in libraries were customarily arranged. Libraries were often decorated with imaginary portraits of famous authors, but Raphael shows the great philosophers of antiquity as if assembled at one time in a single place. Borrowing and elaborating compositional principles derived from Leonardo's *Last Supper*, he is able, not only to suggest an assembly of famous men, but to imply something about their doctrines by the way he positions them, even to suggest the nature of their conversation. The picture is a kind of humanist fantasy, an image that seems to bring to life the entire intellectual legacy of the ancient world. Pointing beyond itself, as it were, in such a deep and complex way, it sets a new standard of discursiveness for visual images; it demonstrates even more clearly than the work of earlier artists the systematicity of representation. Adapting the ancient "speaking likeness" topos, one writer said of Raphael's Vatican Palace frescos that "everything in its silence seems as if it might speak."

Among the ancient authors revived by the humanists, Plato was bound to have an important and complex influence, especially on the visual arts. In the mid-fifteenth century, Cosimo de' Medici, a wealthy banker and de facto ruler of Florence, commissioned a scholar, Marsilio Ficino, to translate all of Plato's works into Latin. Ficino also studied the writings of ancient Neoplatonists such as Plotinus, as well as a variety of other ancient texts that he believed were Plato's sources. Out of this material he concocted his own form of Neoplatonism, one which, beyond synthesizing different aspects of Platonic thought, served as the foundation of what he imagined to be a new and universal philosophical system, embracing the fundamental truths contained in all systems – ancient and modern, Christian and non-Christian. Not all humanists were Neoplatonists, but this syncretistic aspect of Neoplatonism did develop something fundamental to humanism: it restored and revivified ancient

thought; it appropriated antiquity for the purpose of creating a new culture; it made of antiquity the instrument of a new, utopian rationalism. Something of this project – the recovery from antiquity of something eternally valid – can be glimpsed in Botticelli's *Spring*, even if we might want to stop short of calling it a Neoplatonic picture.

One of the obvious ways in which Neoplatonism might be expected to affect the visual arts has to do with the representation of the ideal. A work in which its influence has been detected is Donatello's bronze *David* (figure 2.3), probably produced in the 1450s or early 1460s. The first mention of the piece, from 1469, describes it in the Medici Palace, and it is assumed to have been made for the Medici, possibly for Cosimo himself – the man who had commissioned Ficino's translations of Plato. Though the subject is biblical, the figure is obviously inspired by ancient bronze statues of a kind that celebrate the beauty of the youthful male body. Its subtle eroticism is underscored by the relief on the helmet of the dead Goliath: it shows Cupid riding on a chariot – hence, a triumph of love – and suggests an undercurrent of personal meaning. The idea that the beauty of the beloved "slays" the lover was a common theme in courtly love poetry and its popular derivatives: that Donatello was encouraged to reinterpret it in classical and homoerotic terms may have had something to do with his awareness of current interest in Plato.

A much stronger argument for Neoplatonic influence can be made in the case of Michelangelo. His exclusive, single-minded, lifelong devotion to the cultivation of ideal beauty certainly owes something to the fact that he grew up in the Medici household, where he was exposed to Neoplatonic thought – as well as to Donatello's *David*. That his interest in the ideal was grounded in a self-conscious philosophical idealism is supported by some of his own statements, including his poetry; that he was understood by his contemporaries to be an idealist also emerges from their recorded comments. Yet the extent to which Neoplatonic meanings can be read into his individual works remains a matter of debate.

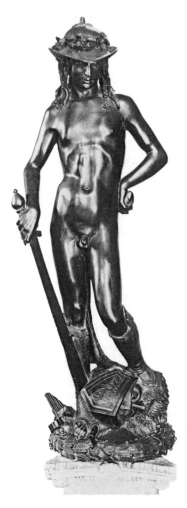

Figure 2.3 Donatello, *David*, c.1460, Bargello Museum, Florence.

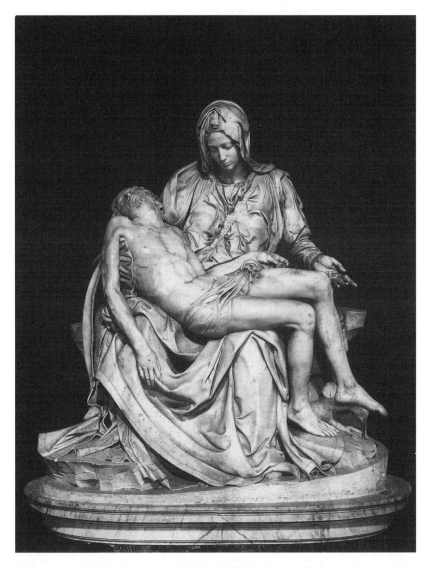

Figure 2.4 Michelangelo, *Pietà*, 1496–1501, St Peter's, Vatican City.

An illustration of this problem is the case of the Vatican *Pietà* (figure 2.4), carved between 1496 and 1501. The contract for the work survives and reveals that Michelangelo, who was only twenty-two years old, intended to produce the most beautiful statue in Rome, an astonishingly bold aim, considering all the ancient sculpture in the city. This pursuit of beauty was felt by some viewers to strain the principle of decorum: they claimed that the Virgin Mary was too young to be the mother of

the full-grown man on her lap. Michelangelo later said that he had meant her outward beauty to suggest her incorruptible inward perfection, but whether this was really his aim at the beginning is open to doubt.

More explicit evidence of Neoplatonism is found in Michelangelo's poems. Most are rather conventional courtly love lyrics, but a good many invoke themes like the idea of absolute beauty:

> Love, your beauty is not a mortal thing:
> There is no face among us that can equal
> The image in the heart, which you kindle and sustain
> With another fire and stir with other wings.

Michelangelo repeatedly confesses his vulnerability to beauty, his utter helplessness before it, and he suggests that his only possible path in life – both as an artist and as a Christian – is a deliberate, consciously cultivated susceptibility to all beauty, a path that he can only hope will ultimately liberate him from his own appetites:

> My eyes, desirous of beautiful things,
> And my soul, likewise, of its salvation,
> Have no other means to rise
> To Heaven but to gaze at all such things.

Leonardo had sought to realize the philosophical potential of painting through a comprehensive study of nature. Claims for the philosophical value of Michelangelo's art rested instead on its ability to suggest a supernatural reality. Since the ideal does not occur in nature, we cannot recognize it in the usual way we identify things by sight: our sense of recognition comes to us out of the depths of our entire emotional life, and it often erupts out of us with the violence of a sudden revelation. We should not be surprised that many of Michelangelo's contemporaries understood his art in Platonic terms, while some detected a kinship between Leonardo's approach and that of Aristotle. Nor should we be surprised that at least one writer, Benedetto Varchi, himself an Aristotelian, tried to define Michelangelo's achievement in Aristotelian terms, while Raphael gave his figure of Plato in the *School of Athens* the features of the elderly Leonardo da Vinci. In the end, the important point is not that art became either Platonic or Aristotelian, but that it was recognized to have become philosophical, to have achieved the stature of the most serious and exalted kind of intellectual activity.

One of the most important and complex documents bearing upon the relation of humanism to the visual arts is *The Lives of the Most Excellent Painters, Sculptors, and Architects*, by the artist and courtier Giorgio Vasari (1511–74). First published in 1550, then again in a revised and

enlarged edition in 1568, the *Lives* is made up of more than one hundred and fifty biographies, arranged in roughly chronological order to present an account of the development of art in Italy from the later thirteenth century to Vasari's own time. This development is made to fall into three phases, which Vasari likens to stages in the growth of an individual: the first, the "infancy" of art, stretches from the late thirteenth to the end of the fourteenth century; the second, corresponding to "youth," spans the fifteenth century; and the third, the period of art's "maturity" and perfection, begins in the late fifteenth century and extends up to the time of writing. The leading figure of the first phase is Giotto; Masaccio and Donatello help to inaugurate the second; the third begins with Leonardo and reaches its culmination in Michelangelo.

The most important feature of Vasari's book is its historical format. Though the idea of a history of art was not entirely new, the *Lives* is vastly more ambitious than the closest precedent, Pliny's chapters on the painting and sculpture of antiquity, and the very idea that art is an appropriate subject for a serious and sustained history is itself a significant achievement: such histories were usually reserved for the "heroic" exploits of generals and statesmen. Vasari was fully conscious of what he was doing: he followed the model of humanist historiography, insisting upon his right, not simply to record facts, but to express judgments and to extract lessons, to use the past as raw data from which to derive universal laws:

> Having carefully considered these things, I conclude that it is a property and natural quality of these arts that they improve themselves little by little from a humble beginning, finally attaining the height of perfection; and I am further convinced seeing that virtually the same thing occurred in other disciplines, which, because there is a certain kinship between all the liberal arts, is no small argument in favor of its truth. Something so similar must have happened in other times that if the names were exchanged between the one and the other, their accounts would be exactly the same.

Not only do the visual arts improve in a manner similar to the liberal arts, their progress in modern times exactly reproduces a pattern first seen in antiquity. The fact that art behaves according to such rules proves its fundamentally rational nature. To demonstrate art's susceptibility to historical treatment is thus to make much the same point as one would make by insisting upon its relation to poetry or philosophy.

The progress of art is not simply a matter of increasing naturalism, but also of increasing beauty, of more persuasive storytelling, and of greater success in the expression of abstract ideas. The progress of architecture is seen in its growing mastery of classical form and style. Vasari's confidence that his standards of quality are wholly objective and universal can come

as something of a shock to modern readers: his view of history depends upon the belief that Masaccio is simply better than Giotto and Leonardo better than Masaccio. Naïve as it seems to us, increasing speed and ease of production are also an important aspect of the progress of art: in the fourteenth century, Vasari observes complacently, painters had to work six years on one picture; now they can make six pictures in one year. Even more disturbing is his contempt for Gothic architecture, which he thinks simply "barbaric," and the rather condescending way in which he treats artists whom he considers provincial, such as the Venetian painter Titian.

Michelangelo's pre-eminence in Vasari's scheme rests upon the belief that he has brought the three arts of painting, sculpture, and architecture to perfection individually, but also that in doing so he has revealed their relation to one another, demonstrating their unity on the principle of design (*disegno*). Vasari describes *disegno* as the "father" of the three arts: since painting and sculpture are "daughters" of this one father, it is pointless to argue, as Leonardo had, over which is better. Design is what unites the visual arts and what distinguishes them from other arts; at the same time, it offers a way of relating them to all other rational activities. It is nothing less than a fundamental faculty of the human mind: it "proceeds from the intellect" and "derives from many things a universal judgment, like a form or idea of all things in nature." Design is what "understands the proportion that the whole has to the part and the parts to one another and to the whole"; it is what enables us to see an underlying order in the apparent randomness of things, to detect the one in the many. Vasari's wording deliberately invokes ancient philosophy – the phrase "universal judgment" comes from Aristotle, while the words "form" and "idea" recall Plato – and his aim is obviously to ground art as deeply as possible in the basic processes of thought, linking it to all activities involving thought. Design is thus both an historical *and* a theoretical principle: in revealing how the arts are rooted in the mind it shows how they are woven into the very fabric of human experience.

As art theory develops in the course of the sixteenth century, it becomes more comprehensive and systematic; it seeks to ground art in human nature in an even more integral way, and to make its connections to other disciplines even more explicit. One example is the work of Giovanni Paolo Lomazzo, a Milanese painter whose massive *Treatise on the Art of Painting* was published in 1584. Lomazzo divides painting into seven elements: proportion, motion, color, light, perspective, composition, and form, and devotes a section of the *Treatise* to each. In the sixth section, on "composition," he surveys all the principal types of picture, the various subjects that can be treated in each of them, and the variety of characters painters can include in them, along with an inventory of symbols. This encyclopedic appropriation of humanistic

learning is supported wherever possible with citations from ancient and modern literature.

A few years later, in 1590, Lomazzo published a much shorter volume, *The Idea of the Temple of Painting*, intended as an introduction to the larger book, in which he represents the art of painting in the form of a circular temple. The pavement of the temple is *disegno* – for which Lomazzo prefers the term *euritmia*, "eurhythmy" – and which he understands as the numerical relationships discerned in nature by the artist. The walls are made up of five superimposed registers, corresponding to the first five parts of painting described in the *Treatise*: proportion, motion, color, light, and perspective. The last two parts, composition and form, which he calls "practical" – as opposed to "theoretical" – constitute the dome of the temple and its lantern, respectively. Around the walls are seven "columns" or herm figures, each corresponding to one of seven great Renaissance artists: Michelangelo, Leonardo, Raphael, Titian, Andrea Mantegna, Polidoro da Caravaggio (a student of Raphael's, best known as a painter of house façades in a classicizing style), and Gaudenzio Ferrari (a Milanese painter of the late fifteenth century, hence, a local favorite). Lomazzo refers to these figures as "governors" because they represent in the purest and most potent form seven principal modes of being a painter, seven types of what might be called creative style.

The choice of the governors is no accident, but grounded in the very order of the universe. Lomazzo associates each of them with a planet: Michelangelo with Saturn, Leonardo with the Sun, Raphael with Venus, Titian with the moon, Mantegna with Mercury, Polidoro with Mars, and Gaudenzio with Jupiter. As in astrology, each governor exerts an influence over painting like the influence of his planet over human action in general. Though Lomazzo accepts the traditional idea that art imitates nature, his system of correspondences really defines art and its relation to the world as a negotiation of occult forces, a kind of astrological magic. He tries to organize the whole of culture around this relation between the order of art and the order of the world: each governor is associated with a metal appropriate to the planet, with an animal, an ancient sage, a poet, and an ancient artist: Michelangelo, for example, being "saturnine," is associated with the metal lead, his animal is the dragon, his wise man Socrates, his poet Dante, his ancient artist Parrhasios.

Though the use of such correspondences as explanatory devices is very remote to our way of thinking, Lomazzo's system actually offers an effective way of mapping the diversity of artistic temperament, of accounting for the variety of artistic excellence. And though grounded in a larger order, it offers the possibility of endless development. In one place, where he is discussing the ways in which each artist relates to his particular animal, Lomazzo says that the greatest artist would be one in whom

were united the natures of all the animals. Elsewhere he imagines an ideal painting of Adam and Eve, in which the male figure would be drawn by Michelangelo and painted by Titian, and the female figure drawn by Raphael and colored by Correggio. By combining what we would call stylistic influences, a painter may yet achieve something new: Lomazzo's arrangement is an ingenious attempt at a systematic solution to the problem of imitation, to the tension – already evident in Cennino Cennini – between individual disposition and objective correctness. It demonstrates another aspect of the systematicity of representation.

Another extremely ambitious treatise is Federico Zuccaro's *Idea of Painters, Sculptors, and Architects*, published in 1607. If Lomazzo was concerned to enumerate the elements of painting and to explain their relation to one another, Zuccaro tries to show how the whole of art, indeed, all arts, are based upon the single principle of *disegno*. Developing Vasari's concept of *disegno* as a mental activity and as the principle that unites the arts of painting, sculpture, and architecture, Zuccaro argues that *disegno* is nothing less than the fundamental principle of *all* thought. He bases his case on the authoritative theory of sense perception and cognition set forth in Aristotle's treatise *On the Soul*, according to which the mind forms "images" from sense impressions, and these images serve as the basis of all higher, more abstract, truly rational thought.

Adapting the ideas of medieval commentators on Aristotle, especially Aquinas, Zuccaro goes on to argue that *disegno* must be understood as the essential activity of the soul, the process by which the soul realizes itself, and that all our perceptions and thoughts are re-enactments and extensions into the here-and-now of the primal creative gesture of God. If Leonardo's notes had exposed a certain tension between the passive and active aspects of artistic activity, Zuccaro uses philosophy to emphasize their necessary interdependence. If Leonardo had likened the artist to a mirror, Zuccaro says that the soul has the capacity to perceive all things, to take all things into itself, and that in a certain sense it *is* all things. Design is the means by which all things enter the soul, but also by which they are ordered within the soul, by which the soul thus comes to impose its order on the world: it is the "idea of all thoughts," "the concept of all concepts, form of all forms." It is the one thought contained in all thoughts, the ground of the possibility of thought itself. It is "the image and similitude of God in us."

As if this were not enough, Zuccaro makes a point of showing that all speculative thought – philosophy and all the liberal disciplines subordinate to it – as well as all human activities derive from *disegno*. Taking up Plato's claim that the art of making horses' harnesses is subordinate to that of the rider, he claims that it is in fact design which permits the rider to recognize the form that the harness must have and to order

it from the harness-maker; in doing so, he acts "not as a rider but as a designer . . . for the art of making bridles is not of the rider, but of design. . . ." Zuccaro ends his treatise by setting up a hierarchy of knowledge, corresponding to the order of the universe, in which the visual arts occupy a higher position than everything but theology and statecraft – the highest form of speculative thought, on the one hand, and the highest form of virtuous action, on the other.

Both Lomazzo and Zuccaro were painters: that they should have felt it necessary to produce such books is an indication of how directly the concerns of theory – even such abstract theory – were felt to grow out of practice, and how important it was to insist upon the rational nature of art, to insist upon both its self-reflexivity and its systematic quality as a practice. Lomazzo says that his temple is the "figure of all figures, a painting of paintings." Zuccaro claims that it is the power of *disegno* that enables him even to describe what *disegno* is. Though these books may seem remote from the day-to-day concerns of artists, they are urgent – and in their own way heroic – responses to the challenges art had come to face.

It is to be expected that artists would push claims for the intellectual dignity of their profession as far as possible, but such claims also met with widespread acceptance in society at large. Though few literary men were willing to admit that painting was actually superior to poetry or philosophy, and some were concerned that artists should not develop too exalted a sense of their own importance, some do seem to have appreciated and perhaps envied the immediacy and communicative power of images.

More importantly, however, the consciousness of art's kinship with literature and its ability to deal with important issues in serious ways was repeatedly attested in practice. In the course of the fifteenth and sixteenth centuries, the kind of collaboration between artists and literary men recommended by Alberti became commonplace. The products of such collaboration include all kinds of images, from conventional allegorical pictures to complex didactic prints, to *imprese* or emblems – visual puzzles composed of an image and a motto, designed to express a particular idea to learned viewers – but the most spectacular are large decorative projects featuring elaborate literary subject matter. These range from fresco cycles to temporary installations set up for important festivities or state occasions. Vasari worked with the scholar Vincenzo Borghini on a number of such lavish projects for Duke Cosimo I de' Medici of Florence. Cosimo understood the value of the arts as instruments for the expression of his political ideas and the manipulation of public opinion, and this understanding speaks just as loudly as the most grandiose claims of the theorists.

The power of art was also recognized by the Roman Catholic Church, and a concern to exercise some kind of control over the production and

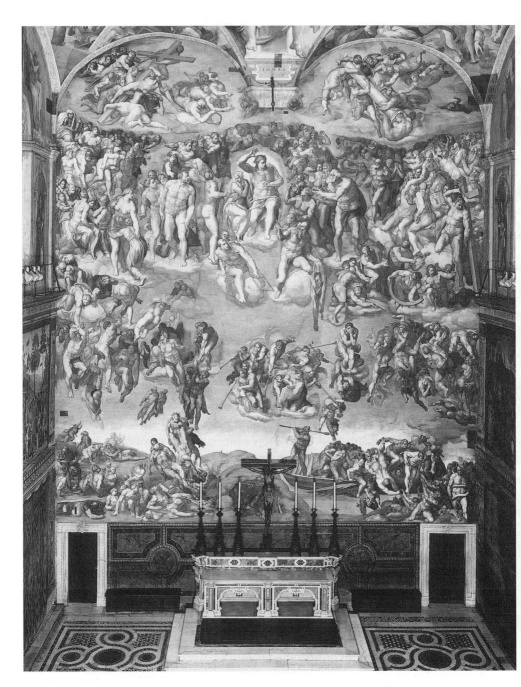

Figure 2.5 Michelangelo, *Last Judgment*, 1534–41, Vatican Museum, Vatican City.

consumption of images became especially intense in the wake of the Protestant Reformation. An exemplary incident is the controversy over Michelangelo's *Last Judgment*. This great fresco (figure 2.5), unveiled in 1541, in which Vasari had seen an unsurpassable tour de force of *disegno*, a distillation of art to its essence, was criticized by the religiously minded for being indecorous: some complained about the proliferation of nudes, which were said to give rise to lascivious thoughts inappropriate in a sacred space; others were bothered by the liberties taken with the scriptural account of Judgment Day. In general, critics felt that Michelangelo had been more concerned to show off his art than illustrate the story properly. Though it would be easy for us to dismiss these reactions as symptoms of fundamentalist retrenchment, we should recognize that they testify to higher expectations with regard to the role art should perform in society; they thus document a real-life rationalization of art not altogether unlike the one described in theory. Though the Catholic Counter-Reformation is usually seen as a reaction against humanism, it actually perpetuates a process that humanism had begun.

Beyond their involvement with specific ancient texts, the humanists were concerned with language in general, and, beyond language, with signification in its broadest and deepest sense: they recognized the importance of signs and the imaginative constructions built out of them; they understood the real and almost infinite power in the basic mental faculty of representation. Rather than a particular ideology, humanism is the discovery of the power of ideology itself and of the power of representation on which ideology depends: it was bound to support any attempt to demonstrate the systematicity of representation and the idea that art plays a fundamental role in the constitution of reality. The influence of humanism on art thus extends well beyond classicism of subject matter or style, beyond the idea of the relation of art to poetry, beyond even the relation of art to philosophy. Humanism helps to create the environment in which the visual arts are able to redefine themselves in ideal terms as a set of practices that embrace both speculative thought and moral conduct, as something implicit in and fundamental to all the operations of human nature. We might say that humanism gives art the tools with which to extend its reach into and over culture as a whole, to establish itself as the necessary and uniquely privileged activity it has remained.

The Academic System

The theoretical redefinition of art that took place in the Renaissance was consolidated by a new kind of institution, the artistic academy. Until

recently, it has been common to think of academies in negative terms – since the modernism of the nineteenth and twentieth centuries was in many ways a sustained reaction against the values they represented – but we are now in a better position to consider them more objectively. There is no denying their historical importance: they sprang up all over Europe and exerted a powerful influence over artistic life for several centuries. They were perhaps the most important means by which artists were able to win widespread recognition for themselves as professionals, as intellectuals rather than as craftsmen. Academies were also a means for the standardization and internationalization of artistic culture, spreading a system of theoretical values that remained remarkably uniform until into the nineteenth century.

For better or for worse, academies were the dominating fact of artistic life in the early modern period, and we do well to recognize how *modern* they were. If the modernist reaction against them had to do with the feeling that they had compromised their integrity by offering themselves too wholeheartedly to the service of established power, we have come to understand that some kind of relation between art and power is unavoidable, and that academies represent a stage in the continuing development of that relation.

The earliest artistic academies, which seem to date from around the beginning of the sixteenth century, were probably little more than informal clubs, made up of a few artists who gathered together, probably after regular working hours, and probably for recreational social bonding as much as for any kind of loftier pursuit. Such clubs gave artists the opportunity to establish a collective identity outside the workshop and enabled them to indulge their pretensions to be something more than artisans. In using the term "academy," they were following the example of literary men, who had adopted it for their gatherings not long before. Some of these groups seem to have included aristocratic amateurs, and the artists encouraged their participation: it had the practical advantage of fostering contact with potential patrons, and it supported the idea that art was an appropriate activity for people of high social rank – an idea that could not but have a positive effect on the status of the artists themselves. Just as essential to the function of academies as the inclusion of non-artists, however, was the *exclusion* of certain kinds of artists. Concerned to insist upon the distinction between art and mere craft, the members of academies produced and enforced a division in the artistic community between people like themselves and those they considered mere tradesmen.

The academy was thus a tool for self-advancement in a society marked by a stable and visible class hierarchy. The aristocrats, for their part, were quick to recognize the usefulness of this new type of organization, and to make the most of the willingness of artists to serve them. It is no accident

that the first formally incorporated academy of art, the Accademia del Disegno (Academy of Design), was established in Florence in 1563, during the reign of that same Duke Cosimo who had shown such acumen in the way he used Vasari and Borghini for large decorative projects. Indeed, Vasari had played a leading role in forming the Academy, and Cosimo quickly named Borghini as his official representative to the new organization. In the way it thus came under official patronage, it followed the model of the first official literary academy, the Accademia Fiorentina, which had come under Cosimo's control a few years before. The literary academy had the task of regulating standards of language and literature; it could thus be said to represent the extension of state control over the very instruments of thought and expression: the purpose and effect of the artistic academy were essentially the same. In the process of this absorption into state bureaucracy, academies went from being informal clubs to structured institutions: the Accademia del Disegno, for instance, was officially chartered and its organization regularized; it soon absorbed many of the legal responsibilities and privileges of the old guild.

Another important aspect of the early academies, and one that also became more formalized as time went by, was the education of young artists. The need for some kind of new approach to education became especially apparent in the early decades of the sixteenth century, and the urgency of the matter was enhanced by socioeconomic conditions. The rapid pace of artistic innovation in a few cities, especially Rome, seems to have upset the traditional pattern of training, based on extended apprenticeship to a single master. Many young artists in provincial centers realized that they would never learn what they needed to know from local masters and went to Rome on their own, sometimes with next to no training and no connections. This situation created a surplus of cheap labor in the city, which soon led to new patterns of employment: young artists were hired on a short-term basis – per day or project by project – rather than being formally apprenticed and systematically trained. As a result, they had to educate themselves in their free time. It became common for young artists to go around on their own, drawing ancient sculpture and the works of modern masters such as Michelangelo, Raphael, and Polidoro da Caravaggio, as well as to loiter around public baths in order to study nude bodies. This situation, which could be hard on the young men involved, led to a more aggressively and self-consciously synthetic approach to imitation; it also generated a widespread desire for the kind of institution that would provide a stable environment and a systematic training.

This crisis in education and the socioeconomic conditions of the profession help explain the extraordinary influence of Raphael, his importance to the academic system of values from the very beginning until into

the nineteenth century. Raphael had received his training in small towns in central Italy and was already the accomplished practitioner of a charming late fifteenth-century style when, at the age of twenty-one, he set himself up in Florence to study the revolutionary new works of Leonardo, Michelangelo, and other ambitious younger Florentines. Realizing that he could never match Leonardo's depth of scientific understanding or Michelangelo's mastery of expressive anatomy, Raphael developed a style that combined what he could of both, as well as maintaining something of his own native strengths. The result, Vasari says, was: "a middle style as regards both drawing and coloring; and mixing this style with certain others chosen from the best things by other masters, [he] made of many styles a single one, which was thereafter his own and which was, and will always be, infinitely admired by artists."

When, after a few years, Raphael moved on to Rome, this synthesis was deepened and enriched by sustained exposure to ancient art. He succeeded in demonstrating how, by borrowing and combining influences from different artists, one could fashion one's own identity – and not only an individual, merely personal, identity, but something more, something objectively "correct" – a style built upon the virtues of all the best styles. He did not invent the principle of stylistic synthesis, but he demonstrated how it might work at the highest creative level, as an infinitely extendable creative principle.

In Rome, Raphael became immensely popular and successful; indeed, he enjoyed the kind of success that his contemporaries could only compare to that of ancient Apelles. Though it was not uncommon for leading artists to assemble large workshops with numerous assistants and even subcontracted help, Raphael's shop set a new standard for size and efficiency of operation. As he took on more and larger projects, he devoted his own energies to design: he would often develop several different ideas for a composition, combining their best features in the definitive design. He would then turn over his ideas to be developed by his team of assistants. A division of labor was also observed in the execution, with specialists in different kinds of painting being assigned to appropriate parts. This arrangement, if not completely systematic, seemed to point in the direction of a thoroughly rationalized working method. We may find such an idea disturbingly suggestive of the modern assembly-line, but we should remember that in a pre-industrial world, the prospect of such systematicity was an exciting thing: not only did it make the productive process more efficient, the susceptibility to systematic procedure could be taken to further demonstrate the rational, hence intellectual, nature of art.

The Accademia del Disegno in Florence can be said to have picked up where Raphael left off, in the sense that its most successful productions were large collaborative enterprises. If these projects set a new standard for complexity of literary subject matter, they also set a new standard for

size and complexity of collaborative effort. The Accademia supplied the workforce and the organizational structure; it became the means through which the creative resources of Florence were put at the disposal of the Duke. The rationalization of the working process thus corresponded to the integration of artistic activity into the workings of political power. The Accademia also sought to establish a new kind of education, one that would – to follow Vasari's conception of progress – maintain the arts at the high level they had attained over the preceding generations. The aim was never to replace the workshops entirely, but to supplement the education of the most gifted young artists with instruction in drawing as well as lectures in topics like geometry, perspective, and anatomy. Still, attempts to impose this curriculum on the existing system met with resistance: the artists who were left out naturally felt slighted, and those who ran shops especially resented having their best assistants taken away to be taught by others.

Important as the collaborative mechanism developed by the Accademia del Disegno was, the work of the individual artists involved is disappointingly formulaic. In another academy set up at about the same time, however, one that remained private rather than being annexed to the state, a transformation of style was brought about that had profound consequences for the history of European art. This was the group that formed around Lodovico Carracci and his younger cousins, Annibale and Agostino, in Bologna in the early 1580s, and which called itself the Accademia degl'Incamminati (roughly, the "Academy of Men-on-the-Move"). Their primary aim was to reform artistic education: continual exercise in drawing was supplemented with lectures on perspective and anatomy, as well as theoretical discussions; seeking to channel their competitive energies productively, they also held drawing contests. The most striking result, particularly evident in the work of Annibale, is the ambitious and self-conscious effort to combine the best qualities of all the best painters – not only Raphael and Michelangelo, but Titian, Veronese, and Correggio as well. Annibale's attempt to elaborate the principle of synthetic imitation is exactly contemporary with its theoretical elaboration in cosmological terms at the hands of Lomazzo.

Annibale left Bologna for Rome in the 1590s, where – like Raphael before him, and very much inspired by Raphael's precedent – he achieved a still fuller stylistic synthesis. An example of his work is the *Choice of Hercules* (figure 2.6), an illustration of an ancient story in which the hero Hercules must choose between two women, representing the life of virtue and the life of pleasure. The style of the picture combines Raphael and Northern Italian painting with elements from ancient sculpture. Annibale uses Raphael's style as a kind of armature onto which the qualities of other styles can be added as circumstances require. He can thus be said to have reclaimed the fundamental principle of Raphael's

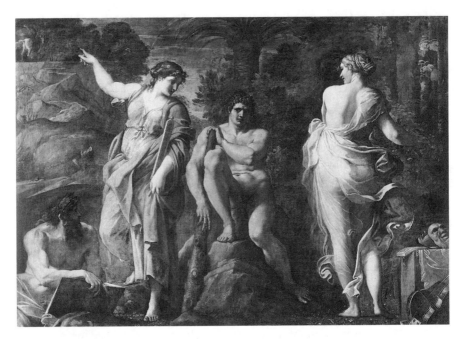

Figure 2.6 Annibale Carracci, *Choice of Hercules*, 1596–7, Capodimonte Museum, Naples.

style, as well as to have shown how it derives its authority from classical principles, how it might thus serve as the foundation of a modern classicism. It is not just the breadth of Annibale's stylistic synthesis that matters, in other words, but its depth, the way in which it makes Raphael into a structural principle, not the master of a single style so much as a universal method for organizing all possible styles.

The importance of Annibale's achievement was recognized not long afterward by the antiquarian and amateur painter Giovanni Pietro Bellori, a member of the Roman artistic academy, the Accademia di San Luca. In his *Lives of the Modern Painters, Sculptors, and Architects,* published in 1672, Bellori credits Annibale with having revived the art of painting after its "decline" in the period following Raphael's death. Annibale's work reflects the principles Bellori had explained in a lecture, "The Idea of the Painter, Sculptor, and Architect," delivered to the Academy in 1664, and which he then included as the preface to the *Lives.* The most important of these principles – that the artist, studying nature, arrives at an idea of perfect beauty, which he uses to "emend" or correct the natural forms he represents in his work – is familiar from earlier theory. What is new in Bellori is his greater insistence on the belief that ancient sculpture offers a wholly sufficient guide to the ideal.

Bellori's account of seventeenth-century painting is extremely selective and dogmatic. Annibale's contemporary, the radically original painter Michelangelo da Caravaggio, is presented as a negative example, criticized for not having idealized his forms, for being content simply to copy the model. Bellori concedes that Caravaggio was a skilled imitator of natural appearances, but "many and the best parts of painting were lacking in him, for he had neither invention nor decorum nor design nor any theory [*scienza*] of painting whatever, and if the model was taken from before his eyes his hand remained still and his mind empty." Even more astonishing is Bellori's complete neglect of the man who was undoubtedly the leading artist in Rome, the great sculptor and architect Gianlorenzo Bernini. Bellori seems to have regarded Bernini's work as insufficiently rigorous in its classicism. This kind of dogmatic posturing can be seen as an intensification of the elitism always implicit in the academic system, but before we judge Bellori too harshly, we should understand that he sought to defend what he saw as a threatened middle path between vulgar and intellectually unsatisfying extremes, that he understood the systematicity of representation and recognized the urgent need for a rigorous structuring principle within the array of stylistic possibilities. We should recall the selectivity of *modern* criticism, and how necessary to its enterprise that selectivity is.

By the later seventeenth century there were academies of art all over Europe. In the Low Countries, informal academies appeared around the middle of the sixteenth century, started by artists who had traveled to Italy and had returned as converts to Italian ways. The Dutch painter Karel Van Mander may have established such an academy in the city of Haarlem in the 1590s. Van Mander was also an ambitious theorist and expressed his ideas in *The Book of Painting*, published in 1604, a text obviously modeled on Vasari's *Lives*. Beginning with an introduction that recapitulates many of the essential principles of Italian theory in the form of a didactic poem – an emphatic way of making the point that the painter is also a poet – Van Mander moves on to a history of art divided into three sections: a survey of classical antiquity is followed by an account of Italian painting taken mostly from Vasari, which is followed, in turn, by an account of Northern European painting. The book adapts the Vasarian format and system of values to a different cultural setting, and can be taken to represent the way in which those values came to acquire an international authority. Though the kind of Dutch painting we most admire nowadays deliberately avoids classicizing idealism, we should remember that there was a vigorous tradition of academic art in Holland throughout the period.

The grandest of all academies was the Académie Royale de Peinture et de Sculpture (Royal Academy of Painting and Sculpture), established in Paris in 1648. Like the Accademia del Disegno, it was initiated by a

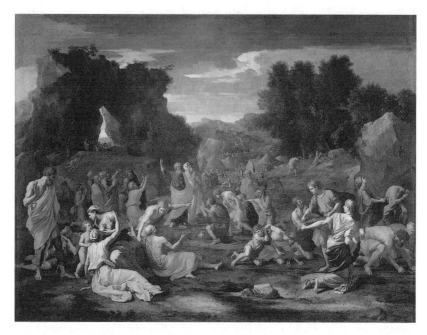

Figure 2.7 Nicolas Poussin, *The Israelites Gathering Manna*, 1639, Louvre, Paris.

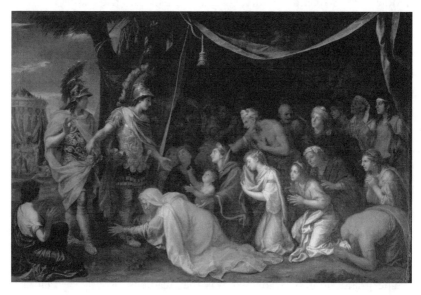

Figure 2.8 Charles LeBrun, *Alexander at the Tent of Darius*, 1660, Versailles Museum.

group of elite artists and its early history is marked by a bitter struggle to define itself in opposition to older institutional structures. Patterned after a literary academy, the Académie Française, it soon came to play a corresponding role in artistic life: as part of the wide-ranging centralization of authority under King Louis XIV, it became an instrument for the expression of his absolutist ideology. The director of the Academy, the painter, designer, and theorist Charles LeBrun (1619–90), was made director of a national center at Gobelins for the production of tapestries, furniture, utensils, and other objects to be used at the royal court. Various academicians supervised the design of these items, and gave instruction to the craftsmen who made them: the Academy could thus impose a standard of taste and quality on a range of objects that themselves served as models. This proto-industrial aspect of the operation was one of the most widely admired features of the French Academy. A school, the École Royale, was established in order to systematize the training of artists: it offered instruction in life drawing, geometry, anatomy, perspective, history, geography, and literature. The Academy also set up a branch in Rome to allow its best students the opportunity for sustained study of antiquity and Italian art.

The French Academy produced the largest volume of theoretical writing, much of it generated by regular monthly lectures and discussions. A good deal of this theory derives from earlier Italian sources: LeBrun's own lectures espouse a dogmatic classicism very similar to Bellori's. If Bellori's hero was Annibale Carracci, LeBrun's is Nicolas Poussin, a French painter who spent almost his entire career in Rome, and produced work that features a philosophical use of ancient myth and a style that outdoes even Annibale in its classicizing purity and rigor. LeBrun's first lecture to the Academy, given in 1667, was devoted to Poussin's *The Israelites Gathering Manna* (figure 2.7), painted in 1639. LeBrun points out that Poussin has combined the virtues of Raphael, Venetian painting, and ancient sculpture. He has observed decorum with great care. Each figure group is carefully conceived to express a different aspect of the story being told; each works to enrich the expressive resonance of the picture as a whole without detracting from the unity of the scene or its emotional impact. The more one looks, the more there is to see and think about; the picture can be read as one reads a poem, yet Poussin has demonstrated the greatest judgment in accommodating the textual source to the particular needs of painting. Poussin, the "philosopher painter," is also the hero of an ambitious history of art, the French Academy's equivalent of Bellori: André Félibien's *Considerations on the Lives and Works of the Most Excellent Painters, Ancient and Modern*, published in 1666–8.

An illustration of the way in which LeBrun adapted Poussin's lessons to his own work is his *Alexander at the Tent of Darius* (figure 2.8),

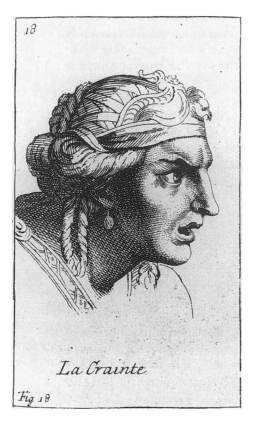

La Crainte

Fig 18

Figure 2.9 Charles LeBrun, *Fear*, engraving by Bernard Picart, from *The Conference of Monsieur Lebrun* . . . (London, 1701).

painted in 1660. Commissioned by the king, the picture offers the viewer an example of magnanimous conduct: the great conqueror visits the tent of his defeated enemy to find his wives and their servants begging for mercy; he spares their lives and honor, and grants them their freedom. LeBrun took special care, in the faces of the women, to depict a range of different emotional responses to the event, and regarded each of them as models for the representation of a particular emotion. When another of his lectures was published as *Method for Understanding the Passions*, these heads, along with others from his other works, served as illustrations (figure 2.9). LeBrun's desire to reveal the nature of individual emotions, on the one hand, and to survey the variety of possible emotions, on the other, is an expression of his ambition to be a philosopher painter. The idea that art involves a comprehensive understanding of human nature goes all the way back to Aristotle, of course, but LeBrun's formulaic approach to mapping the passions – to legislating the representation of inwardness – is a good indication of the lengths to which the process of systematization, of rationalization, might be carried.

Another aspect of this rationalization is the way in which the various types or "genres" of painting were arranged in a hierarchical order. The highest type was the *histoire* (the "history" picture; the term is a direct translation of Alberti's *istoria*) in which a serious and noble human action – like Alexander's behavior toward the family of Darius – was treated in an appropriately noble style. Portraiture, which involves the human figure but was not felt to require an understanding of the ideal, was next in descending order, followed by scenes of everyday life (often called "genre" scenes), then by landscape, and, finally, by still life. These lower genres were assumed to require only the ability to copy appearances. This hierarchy could easily be made to justify the condescending attitude toward much Dutch painting of the seventeenth century; even a painter

group of elite artists and its early history is marked by a bitter struggle to define itself in opposition to older institutional structures. Patterned after a literary academy, the Académie Française, it soon came to play a corresponding role in artistic life: as part of the wide-ranging centralization of authority under King Louis XIV, it became an instrument for the expression of his absolutist ideology. The director of the Academy, the painter, designer, and theorist Charles LeBrun (1619–90), was made director of a national center at Gobelins for the production of tapestries, furniture, utensils, and other objects to be used at the royal court. Various academicians supervised the design of these items, and gave instruction to the craftsmen who made them: the Academy could thus impose a standard of taste and quality on a range of objects that themselves served as models. This proto-industrial aspect of the operation was one of the most widely admired features of the French Academy. A school, the École Royale, was established in order to systematize the training of artists: it offered instruction in life drawing, geometry, anatomy, perspective, history, geography, and literature. The Academy also set up a branch in Rome to allow its best students the opportunity for sustained study of antiquity and Italian art.

The French Academy produced the largest volume of theoretical writing, much of it generated by regular monthly lectures and discussions. A good deal of this theory derives from earlier Italian sources: LeBrun's own lectures espouse a dogmatic classicism very similar to Bellori's. If Bellori's hero was Annibale Carracci, LeBrun's is Nicolas Poussin, a French painter who spent almost his entire career in Rome, and produced work that features a philosophical use of ancient myth and a style that outdoes even Annibale in its classicizing purity and rigor. LeBrun's first lecture to the Academy, given in 1667, was devoted to Poussin's *The Israelites Gathering Manna* (figure 2.7), painted in 1639. LeBrun points out that Poussin has combined the virtues of Raphael, Venetian painting, and ancient sculpture. He has observed decorum with great care. Each figure group is carefully conceived to express a different aspect of the story being told; each works to enrich the expressive resonance of the picture as a whole without detracting from the unity of the scene or its emotional impact. The more one looks, the more there is to see and think about; the picture can be read as one reads a poem, yet Poussin has demonstrated the greatest judgment in accommodating the textual source to the particular needs of painting. Poussin, the "philosopher painter," is also the hero of an ambitious history of art, the French Academy's equivalent of Bellori: André Félibien's *Considerations on the Lives and Works of the Most Excellent Painters, Ancient and Modern*, published in 1666–8.

An illustration of the way in which LeBrun adapted Poussin's lessons to his own work is his *Alexander at the Tent of Darius* (figure 2.8),

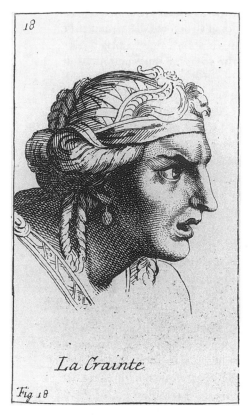

18

La Crainte

Fig 18

Figure 2.9 Charles LeBrun, *Fear*, engraving by Bernard Picart, from *The Conference of Monsieur Lebrun* ... (London, 1701).

painted in 1660. Commissioned by the king, the picture offers the viewer an example of magnanimous conduct: the great conqueror visits the tent of his defeated enemy to find his wives and their servants begging for mercy; he spares their lives and honor, and grants them their freedom. LeBrun took special care, in the faces of the women, to depict a range of different emotional responses to the event, and regarded each of them as models for the representation of a particular emotion. When another of his lectures was published as *Method for Understanding the Passions*, these heads, along with others from his other works, served as illustrations (figure 2.9). LeBrun's desire to reveal the nature of individual emotions, on the one hand, and to survey the variety of possible emotions, on the other, is an expression of his ambition to be a philosopher painter. The idea that art involves a comprehensive understanding of human nature goes all the way back to Aristotle, of course, but LeBrun's formulaic approach to mapping the passions – to legislating the representation of inwardness – is a good indication of the lengths to which the process of systematization, of rationalization, might be carried.

Another aspect of this rationalization is the way in which the various types or "genres" of painting were arranged in a hierarchical order. The highest type was the *histoire* (the "history" picture; the term is a direct translation of Alberti's *istoria*) in which a serious and noble human action – like Alexander's behavior toward the family of Darius – was treated in an appropriately noble style. Portraiture, which involves the human figure but was not felt to require an understanding of the ideal, was next in descending order, followed by scenes of everyday life (often called "genre" scenes), then by landscape, and, finally, by still life. These lower genres were assumed to require only the ability to copy appearances. This hierarchy could easily be made to justify the condescending attitude toward much Dutch painting of the seventeenth century; even a painter

of the stature of Rembrandt might be faulted for not idealizing his forms in the manner suggested by ancient sculpture. We now find this attitude ridiculous, of course, but, again, it presupposes a sense of the systematicity of representation; it reflects the belief that some modes of perceiving and representing the world are better than others, and that the best mode – no matter how rarified or difficult to master – must be maintained as a standard.

LeBrun's views did not always meet with complete agreement, and some lively disputes took place in the Academy. The most famous concerns the relative importance of design and color in painting. LeBrun and his followers argued for the primacy of design, while others, led by a literary man and amateur painter, Roger de Piles (1635–1709), insisted upon a more important role for color. LeBrun's party claimed to follow Poussin; de Piles argued for the counter-example of Peter Paul Rubens, whose freer handling and richer coloring seemed to them to combine the virtues of drawing with more interesting, powerful painterly effects. Trivial as this debate might seem, it revolved around two significantly different approaches to painting. De Piles' position, which enjoyed predominance in the years after LeBrun's death, put greater emphasis on the immediate, overall effect of a picture than on the depth of its narrative structure; in one place he even says that Rembrandt is superior to Raphael in achieving immediate effect. He thus represents something of a shift away from the literary orientation of humanistic art theory toward one which allows greater independence to optical sensation.

In England, the creation of an official academy, the Royal Academy of Art, did not occur until 1768. Earlier attempts had failed, partly because of disagreements over whether such an institution was appropriate to a society that differed in many ways from those in which academies had flourished on the Continent, and whether the kind of art that academies encouraged could or should have as important a place as it did there. By the mid-eighteenth century, however, England had become such a wealthy commercial power, so many Englishmen had traveled to France and Italy and had acquired a taste for classicizing art and architecture, that a more cosmopolitan attitude was bound to prevail. The principal theoretical text associated with the Royal Academy is the *Discourses* of its first president, Joshua Reynolds, given in the form of annual lectures between 1769 and 1790. The last great articulation of the academic system, it borrows heavily from earlier theory; at the same time, its emphases are somewhat unusual, owing both to the difference in cultural setting, and to the fact that, coming so late, it points toward some of the attitudes and values of modern thought.

Like all academic theorists before him, Reynolds insists that the young artist must study nature and the great works of the past, especially ancient

sculpture, and that his aim must not be simply to imitate natural appearances but to derive a standard, an ideal, according to which nature may be improved. Reynolds thinks of the ideal almost entirely in terms of the general – as opposed to the specific and particular – as what is *typical* of a class of objects. The ability to discern the general is the mark of the superior mind – "genius," he says, is an "art of seeing, and comprehending the whole" – but it is also the mark of the educated aristocrat, and the explanation of its importance clearly reveals the element of social posturing it involves:

> Such a student will disdain the humbler walks of painting, which, however profitable, can never assure him a permanent reputation. He will leave the meaner artist servilely to suppose that those are the best pictures, which are most likely to deceive the spectator. He will permit the lower painter, like the florist or collector of shells, to exhibit the minute discriminations, which distinguish one object of the same species from another; while he, like the philosopher, will consider nature in the abstract, and represent in every one of his figures the character of its species.

The painter should avoid contemporary costume when possible because it introduces the historically particular; he should not bother even to distinguish different kinds of cloth, and the vegetation in pictures should not be so precisely defined as to be identifiable by species. Ideas like these, which would so irritate later critics like William Blake and John Ruskin, show very clearly how the academic way of looking at the world demands a kind of studied blindness, a deliberate, effortful self-suppression.

Reynolds's remarks on the imitation of other artists' styles also draw upon older academic teaching, but he gives more pointed emphasis to the idea that originality is a product of imitation. "The more extensive therefore your acquaintance is with the works of those who have excelled, the more extensive will be your powers of invention; and what may appear still more like a paradox, the more original will be your conceptions." The key is to imitate, not specific effects, but general principles:

> It is not by laying up in the memory the particular details of any of the great works of art, that any man becomes a great artist, if he stops without making himself master of the general principles on which these works are conducted. If he even hopes to rival those whom he admires, he must consider their works as the means of teaching him the true art of seeing nature. When this is acquired, he may then be said to have appropriated their powers, or at least the foundation of their powers to himself; the rest must depend upon his own industry and application. The great business of study is to form a *mind*, adapted and adequate to all times and all occasions; to which nature is then laid open, and which may be said to possess the key of her inexhaustible riches.

Only by looking beyond particulars to the essential vital force of a style does one extract from it what one can make one's own. This process is like learning a language: the artist submits to study a system of codified signs, but in mastering them he makes them instruments of his own will. His subjectivity is objectified; he ceases to be merely a particular self, a particular mode of being, and becomes the ground of all possible modes of being. The discipline of systematic self-suppression results in a higher – if more abstract – form of self-realization. In this purified state, he can perform his work of reproducing, sustaining, and regulating the entire array of concepts and values on which culture depends.

Reynolds's extended discussion of the variety of possible styles shows how rationalized the principle of imitation had become. He distinguishes between the different historical "schools" and styles and arranges them hierarchically. The central Italian school – Roman, Florentine, and Bolognese – is the best, followed by the French academics who based themselves upon central Italian principles. The Venetian School is of a distinctly lesser stature, but is yet preferable to the Flemish and the Dutch. The styles of individual artists are discussed at length. Reynolds relieves the dogmatic quality of this survey with a sympathetic sensitivity to the dilemma that young artists face in confronting an apparently infinite variety of stylistic possibilities: "it is an art, and no easy art, to know how or what to choose." Raphael is still the best model to follow: "it is from his having taken so many models, that he became himself a model for all succeeding painters; always imitating, and always original." Yet Reynolds also cautions against the impulse to combine styles: some combinations are simply not possible, and young artists are encouraged to find a way of working congenial to their natural aptitudes rather than "dissipating" their talents "over the immense field of possible excellence." The old ideal of universal mastery – which reaches back past the Renaissance theorists to the Ciceronian notion of absolute eloquence – survives as a remote, if still necessary, point of reference: "If any man shall be master of such a transcendant, commanding, and ductile genius, as to enable him to rise to the highest, and to stoop to the lowest, flights of art, and to sweep over all of them unobstructed and secure, he is fitter to give example than to receive instruction."

One of the things that distinguishes the *Discourses* from earlier academic theory is the attention given to Michelangelo. For Vasari, Michelangelo's pre-eminence had depended on his mastery of the three arts of painting, sculpture, and architecture. Later academic theorists were concerned primarily with painting, and while they were willing to admit that Michelangelo's drawing and knowledge of anatomy were unsurpassed, they found him deficient in other ways. Reynolds does not deny that Michelangelo has limitations, but he insists that the master's strengths

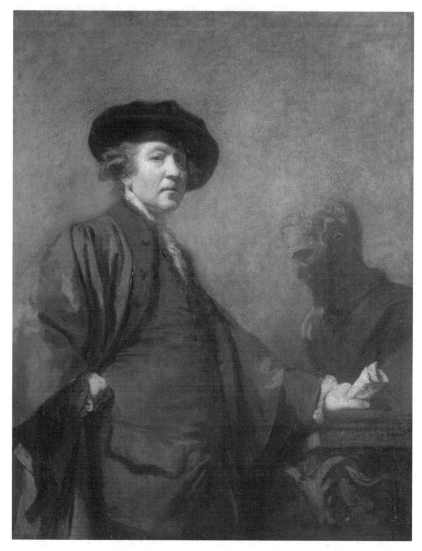

Figure 2.10 Joshua Reynolds, *Self-portrait*, c.1780, Royal Academy, London.

more than make up for them. He invokes the ancient rhetorical idea of the sublime to describe how this quality is even better than perfection:

> The sublime in Painting, as in Poetry, so overpowers, and takes such a possession of the whole mind, that no room is left for attention to minute criticism. The little elegancies of art in the presence of these great ideas thus greatly expressed, lose all their value, and are, for the instant at least, felt to be unworthy of our notice. The correct judgement, the purity of

taste, which characterise Raffaelle, the exquisite grace of Correggio and Parmegiano, all disappear before them.

Passages like these hint at a certain impatience with the formulaic, carefully calculated refinements of academic art, a longing for powerful and urgent experiences. Reynolds shares this impatience with some of his contemporaries, but it also anticipates the Romanticism of the next century. If what makes Roger de Piles seem modern to us is his emphasis on sensuous immediacy, Reynolds is no less modern for his very different orientation, with its idealism and longing for the transcendent.

Reynolds's practice as a painter is perhaps the most interesting of all commentaries on his theory. Advocating the high ideal of history painting, he nonetheless made his career as a portraitist, accommodating himself to the tastes of his place and time. One of his most intimate and articulate images is a *Self-portrait* (figure 2.10), painted around 1780. Showing himself with a bust of Michelangelo, he signals his admiration for the very greatest of artists, but his academic cap and robe, as well as the style of the picture as a whole, evoke Rembrandt, the humble painter of unadorned reality. In its own way, the picture reconciles two systems of artistic values, two modes of being, that Reynolds himself suggested were radically incompatible: for an instant, at least, he has both risen to the highest and stooped to the lowest flights of art. He adeptly exploits the systematicity of representation to dramatize the process of self-definition, suggesting how profoundly identity itself is an effect of art.

The enlightenment

The Eighteenth Century

The term "Enlightenment" is used to refer to a gradual transformation that took place in European culture in the course of the seventeenth and eighteenth centuries. Like the term "Renaissance," it is value-loaded: it signifies a process of intellectual liberation in which the natural sciences freed themselves from the erroneous beliefs of the past, developing that method of systematic experimentation that is still the standard determinant of scientific truth, while political theorists overthrew traditional values in their effort to reconceive society in *ideal* terms. Though

developed and promoted by intellectuals, these bold new ways of thinking eventually had an impact on everyday life. Scientific research contributed to the advance of technology and helped bring about the transition from an agrarian to an industrial economy: the phenomenon we call the Industrial Revolution. Utopianism helped inspire political revolutions in America and France: attempts to reconstruct the social order in ideal form, which ushered in the age of modern mass politics.

This celebratory account of the Enlightenment has to be balanced by one that recognizes the importance of other forces. The gradual transference of economic power from the aristocracy to a middle class whose prosperity was based on industry and commerce was accompanied by the emergence of a new system of values, one that emphasized the necessity of individual initiative and hard work, and that depended upon collective ideals such as reason, civility, and progress. The new ideology of personal freedom complemented the development of new and more rationalized forms of social discipline: coercive pressures might be exercised less violently, but they became more pervasive, more systematic, and all the more effective for being more subtle. One result was a complex ambivalence on the part of cultivated Europeans to the condition in which they found themselves: as much as they might value the achievements of reason, they also sensed that reason had become oppressive and that something precious was being lost; many longed for simpler modes of being, closer to nature.

Thought about art was bound to be affected by these circumstances, and in diverse ways, but the process was slow: even much late eighteenth-century art theory is conservative in tone – Reynolds is a good example – and one must look carefully for evidence of the deeper reorientation that was taking place. Some writers were concerned to approach the subject in a "scientific" manner: there is an interest, for example, in explaining the emotional effect of works of art in what we would now call psychological terms. But a scientific approach could also mean any kind of systematic approach: a rationalistic one, in which an attempt is made to deduce important things about the nature of art from first principles, or an historical one, in which generalizations about art are inferred from a study of particular cases. A wider variety of people wrote about art, and, as they did, a new array of intellectual tools was brought to bear upon it. Some of the most important ideas came from writers for whom it was not a principal interest; however, these new approaches are usually enlisted to support, rather than undermine, traditional taste and values, and the most original contributions are often presented as a return to, or clarification of, older, purer ideals. Indicative of this situation – in practice as well as in theory – is the attitude toward classical antiquity: the

engagement with ancient art remained as intense as at any time since the beginning of the Renaissance, but there was a gradual shift in the terms of that admiration – one that would ultimately yield radical results.

One writer who *did* directly challenge contemporary taste was the French philosopher, Denis Diderot, an editor and principal contributor to that great Enlightenment enterprise, the *Encyclopedia of Arts, Sciences, and Crafts* (1751–72). Diderot also wrote essays on the annual public art exhibitions sponsored by the Academy, known as *Salons*, between 1760 and 1780, which are among the earliest examples of journalistic art criticism and the first to elevate that genre to a high literary level: they are written in a lively, colloquial style – witty, analytical, erudite, and impassioned by turns – that set a standard for all future critical writing.

Diderot was fully conversant with the principles of academic art theory, and invokes them often, but he also repeatedly confesses to boredom with the formulaic quality of academic pictures:

> Almost all our paintings are characterized by a weakness of concept, a poverty of ideas that makes it impossible for them to rattle us, to evoke deep feelings. One looks, turns away, and remembers nothing of what one's seen. There's no phantom that haunts and pursues us. I dare propose to the most intrepid of our artists that they frighten us with their brushes as much as the writers of news sheets do with their simple narratives . . . What use is it for you to grind your colors, take up your brushes, and exploit all the resources of your art if you move me less than a news sheet?

This craving for powerful emotional effects went hand in hand with calls for serious subject matter, a severe style, and the highest sense of moral purpose – a full-scale reform of painting. Diderot was no prude, but he was repelled by the eroticism as well as the frothy technique of painters like François Boucher. In contrast, he championed the work of Jean-Baptiste Greuze, who had sought to treat serious subjects from modern life on the large scale and with the formal discipline of history painting (figure 3.1). Diderot also admired the still-life painter Jean-Baptiste Chardin, whose emphasis on simplicity and the close observation of visual effects offered a welcome antidote to standard academic fare. The high value Diderot placed on scenes from everyday life and still life – subordinate genres in the academic hierarchy – looks forward to the deeper and more aggressive anti-academicism of the next century.

One of the fundamental principles of academic art theory, the belief in the correspondence between painting and poetry, met with increasingly frequent expressions of dissent among eighteenth-century thinkers, Diderot included: the most sustained and decisive attack upon it is the essay entitled *Laocoon*, published in 1766 by the German playwright and

Figure 3.1 Jean-Baptiste Greuze, *The Prodigal Son Punished*, 1777, Louvre, Paris.

drama theorist Gotthold Ephraim Lessing. This text takes as its point of departure the famous Hellenistic statue group representing the priest of Troy who had warned his compatriots not to accept the Greek gift of the wooden horse, and who was then attacked by serpents, along with his two sons, and crushed to death (figure 3.2). Lessing begins by asking himself why the poet Virgil, in narrating the story, describes Laocoon as screaming and writhing desperately to escape, while the sculptors have chosen to show him behaving with a kind of reserve, not screaming, but as if sighing. Lessing's answer is that poetry and the visual arts have different areas of competence:

> If it is true that in its imitations painting uses completely different means or signs than does poetry, namely figures and colors in space rather than articulated sounds in time, and if these signs must indisputably bear a suitable relation to the thing signified, then signs existing in space can express only objects whose wholes or parts coexist, while signs that follow one another can express only objects whose wholes or parts are consecutive.

This rigorous rationalism leads to some severe conclusions. The visual arts must concern themselves primarily with beauty and only secondarily

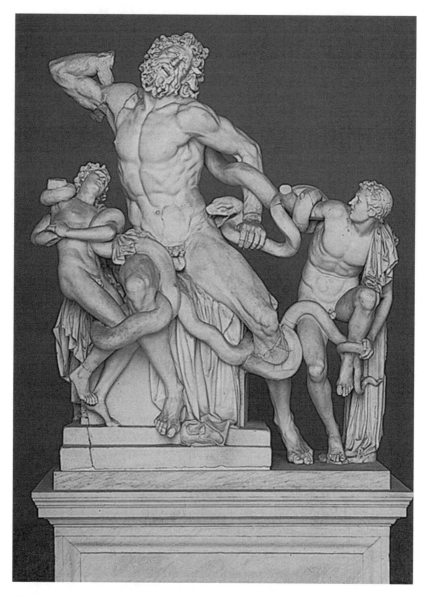

Figure 3.2 Laocoon, 1st century CE, Vatican Museum, Vatican City.

with narrative. Restating in stronger, more prescriptive terms an idea already found in academic theory, Lessing says that any attempt to tell a story requires selecting one moment in which the viewer will be able to see both what has happened before and what will follow. The sculptors of the *Laocoon* have shown their skill in choosing such a moment and in

expressing only so much anguish as does not come into conflict with the demands of beauty. In general, artists should not try to appropriate literary qualities and poets should not try to paint pictures with words. Most of Lessing's contemporaries found his reasoning persuasive, and his essay marks the crucial moment in the transition from the older insistence on the kinship of the arts to the modern tendency to define their aims and limits in terms of their particular media.

Lessing's *Laocoon* is a good example of the way in which ancient art could serve as a stimulus to innovative thought. Another is the *History of Ancient Art* (1764) by Johann Joachim Winckelmann, a German antiquarian who spent most of his career in Rome. Tired of the old collections of biographies, with their anecdotal flavor, Winckelmann sought to give his account more rigor by organizing it as a continuous narrative and a systematic investigation into the essence of art. He describes a four-phase development, corresponding to the distinctions that art historians now make between "archaic," "classic," and "hellenistic" periods (what we call the classic he divides into the "grand" and the "beautiful"), but this scheme – which differs from Vasari's in that it traces rise *and* decline rather than simple progress – ultimately serves as a tool with which to reaffirm the incomparable greatness of Greek art. For Winckelmann, the works of the classic phase are an expression of Greek culture at the moment of its most perfect realization: in them he sees an elevated serenity of expression, a "noble simplicity and quiet grandeur" that makes everything else seem clumsy, shallow, or vulgar. He attributes the superiority of Greek art to the character of the Greek people and relates it to other great achievements of Greek civilization: the establishment of a free and democratic Athens and the exalted philosophy of Socrates and Plato.

In many respects, Winckelmann's admiration for antiquity was entirely conventional; his achievement was to have found a new – historical – way of justifying it. That the effort to find such justification was felt to be necessary is an indication of the deeper process involved, a process that would lead well beyond anything Winckelmann could have foreseen. If art is a reflection of the ethnic character and spiritual values of the society that produced it, then the idea of a single, universal standard of quality becomes problematic. There is no reason why, say, a Gothic cathedral might not be as great an achievement as a Greek temple – and, in fact, a taste for the Gothic style in architecture began to develop during Winckelmann's lifetime. His historicism has to be seen as part of a larger process of objectification, one which, while it may have begun as an effort to celebrate traditional values, ultimately led to those values being relativized. The historical dimension of this process – the interest in neglected aspects of the past, such as the Middle Ages or remote, pre-classical antiquity – was complemented by an interest in the non-Western

world and the emergence of what we would call an anthropological perspective on art and culture. Other eighteenth-century thinkers, such as Giovanni Battista Vico and Johann Gottfried Herder, who were more concerned with literature and philosophy than with art, explored the critical potential of this process – its potential to reflect back upon modern Western values, to make us see ourselves differently – even more deeply than did Winckelmann.

The subtle, yet deep shift of attitude toward antiquity and the strain on traditional values that it reflects are visible in eighteenth-century art. When Jacques-Louis David's *Oath of the Horatii* (plate 5) was unveiled in 1784, it was recognized as both truly classical and radically new. Though in many ways a typical academic history painting, it is characterized by a severity that heightens the emotional tension to an almost unbearable degree. The forms of ancient art, the whole system of values built up around it, are transfigured by this new emotional urgency; what was familiar and reassuring has been made strange and threatening. It is as if David had heard Diderot's call for a more serious art, and had decided to carry the reform of painting pioneered by Greuze to a conclusion more extreme than either could have imagined.

A similar shift in orientation can be seen in architecture. Eighteenth-century architects were still dependent on classical principles, but they began to see them in a new way. In the work of Jacques-François Blondel and his students Claude-Nicholas Ledoux and Etienne-Louis Boullée, for instance, it is the underlying geometry of classical design that is emphasized; that is, the way in which ancient architecture makes use of forms validated by "reason" rather than by "custom." Once this geometry is grasped, the system of ornamentation might be regarded as dispensable. That this approach was self-consciously related to Enlightenment values is most spectacularly indicated by Boullée's design for a cenotaph to Isaac Newton (figure 3.3), published in 1784. The forms of ancient imperial mausoleums – terraces with cypress trees – are reproduced on a colossal scale; an immense dome, with holes corresponding to the positions of the stars, was to have created an effect like a modern planetarium. Visitors would have entered this vast spherical space at the bottom; surrounded by painted clouds, they would have had the sense of being far above the earth, face to face with the universe whose laws Newton had done so much to reveal. Ancient forms, reduced to their perfect geometry, are combined and enlarged in order to celebrate modern science; they are transformed by a creative intensity – analytical and visionary at the same time – comparable to the emotional intensity of David's *Oath*.

Another characteristic avenue of Enlightenment thought about art involved the exploration of the psychological bases of our responses as

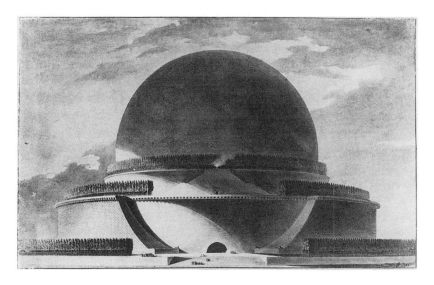

Figure 3.3 Etienne-Louis Boullée, *Cenotaph for Isaac Newton*, 1784, Bibliothèque National, Paris.

viewers. One of the most important examples is *A Philosophical Enquiry into the Origin of our Ideas of the Sublime and Beautiful*, published in 1757, then again, with additions, in 1759, by Edmund Burke, who would go on to become a politician and political theorist. Though obviously inspired by the ancient treatise attributed to Longinus, Burke extends the frame of reference well beyond rhetorical stylistics. He is concerned to distinguish sharply between the two categories of experience and to explain them in terms of our fundamental responses to pain and pleasure, instincts concerned with self-preservation, on the one hand, and sociability on the other. The sublime involves things that excite ideas of pain and danger without putting us in any real pain or danger; beauty, on the other hand, is the quality we attribute to things that prompt us to love. The sublime is associated with the qualities of vastness, power, obscurity, privation, and difficulty; beautiful things are characterized by smallness, smoothness, gradual variation, and delicacy.

Burke is very attentive to the physical basis of our emotions: he says, for instance, that the pupil of the eye contracts in extreme lighting conditions, and that even such a tiny muscular exertion is enough to evoke in us the memory of pain that we associate with the sublime. Though this kind of "scientific" explanation seems quaint to modern readers – its empiricism just as rigid as Lessing's rationalism – Burke enlivens his case with acute, sometimes disturbing, psychological insights. He observes that we experience a kind of pleasure in the misfortunes of

others, and that we feel "a sort of swelling, and triumph" when we encounter potentially painful or dangerous things without any real threat to ourselves. In explaining why beautiful things tend to be small, he says that "we submit to what we admire, but we love what submits to us." He comes close to a psychoanalytic understanding of the forces involved when he writes: "The authority of a father, so useful to our well-being, and so justly venerable upon all accounts, hinders us from having that entire love for him that we have for our mothers . . . but we generally have a great love for our grandfathers, in whom this authority is removed a degree from us, and where the weakness of age mellows it into something of feminine partiality." Though Burke's use of gender categories – like Winckelmann's invocation of Greek character – raises more questions than it answers, one cannot but admire the way he has used them to expose a fundamental ambivalence, an irreducible complexity, in our responses to the visual world.

The sublime came to be widely recognized as an independent category of experience and expression in the eighteenth century, though it is not always understood in exactly Burke's terms: it played a particularly important role in the discussion of landscape, both real and painted. Wild, rugged scenery, which impresses the viewer with an awareness of nature's destructive forces, was felt to have its own appeal, equal to or greater than the kind of domesticated nature one might encounter in, say, a formal garden: travelers sought out "sublime" vistas, especially in mountainous areas, and a taste developed for pictures that captured such experiences. But the idea of the sublime could be extended to very different kinds of things: Reynolds, as we have seen, used it to describe Michelangelo; it would soon also be identified as the distinctive quality of Gothic architecture. This range of meaning is significant, for what the sublime can really be said to have offered was a way of accounting for the fascination of the unbeautiful, for the appeal of things that break rules or elude control. That the need for such a category should have become so widespread in this particular period is perhaps an indication of how rule-bound and controlled life was felt to have become.

Formal philosophical inquiry into the nature of beauty and art go much further than Burke. The invention of "aesthetics" as an independent field within formal philosophy was the achievement of a German academic, Alexander Baumgarten, who first articulated his ideas in his thesis, *Philosophical Meditations on Some Matters Pertaining to Poems* (1735), and later returned to them in a monumental *Aesthetica*, only parts of which had been finished by the time of his death in 1762. The term comes from the Greek word *aesthesis*, meaning "feeling" in the sense of physical perception, and Baumgarten chose it to emphasize his belief that the experience of beauty in nature and art should be seen as a matter of sense

perception rather than abstract thought. Works of art – and his examples are almost all from poetry – satisfy our "lower" faculties of apprehension and cognition; they offer us varied and vivid sensations or "sensuous ideas," rather than addressing our need for logical clarity or consistency. The perfection which a poem may achieve thus cannot be reduced to any other kind of perfection, either rational or moral, and beauty is just such perfection as the senses are capable of experiencing – "the perfection of cognition by means of the senses as such." In the same way that Lessing would try to disassociate art and poetry, Baumgarten seeks to dismantle the still more fundamental link between art and reason. At the same time, his new science of aesthetics is an attempt to subject the irrational to a more acute and comprehensive form of rational analysis.

Baumgarten's ideas were taken up by a number of thinkers, the most important of whom, by far, was Immanuel Kant (1724–1804). One of the greatest figures in the history of philosophy, some would say the founder of modern thought, Kant's importance for art theory depends upon the breadth and depth of his intellectual enterprise as a whole: much of what he says about the visual arts is conventional, but these views are situated in a conceptual framework of such spectacular originality and profundity that its implications continued to nourish the thinking of forward-looking artists, critics, and theorists into the late twentieth century.

Kant characterized his project as the "critique of reason": his aim was to define the scope and limitations of reason as precisely as possible, for he believed that only such understanding enabled us to use our rational faculties properly. Since he is a famously difficult writer, much occupied with the technicalities of his argument, we do well to recall the urgency of his motives as he expressed it himself: "philosophy is not a science of representations, concepts, and ideas, or a science of all the sciences, or anything else of this sort; rather, it is a science of the human being, of its representations, thoughts, and actions." He wanted his work to show that human beings have "a thoroughly *active* existence in the world," that the individual is "the original maker of all its representations and concepts and ought to be the sole author of all its actions." The exercise of reason is thus crucially constitutive of reality; it is also essentially productive of freedom. Reason, freedom, and morality are bound together for Kant in the same powerful way that truth, beauty, and goodness are for Plato.

The foundation of Kant's system is the *Critique of Pure Reason* (1781, revised in 1787), a study of how the mind acquires knowledge of the world and itself. Kant accepts the idea that all knowledge comes to us through sense experience, but he argues that data provided by the senses are organized and shaped according to "innate" (a priori) qualities of

mind. At the most rudimentary level, we impose notions of space and time, and these generate others, such as the notion of causality, which help us to understand the world. Kant insists that spatiality and temporality are only the *forms* in which objects appear to us, not properties of the objects themselves; they are of *subjective* origin. No experience of objects in the world can be had outside these categories; we can have certain knowledge only of our mental representations, not of the things in the world they represent. Although we may assume the existence of an external world, we can only know things as they exist "for us," not as they are "in themselves." When we attribute qualities to things that are only qualities of our perceptions, we step beyond the limits of reason and risk deceiving ourselves. Kant is concerned to show that much traditional metaphysical speculation is just such delusory dogma; in a celebrated section he argues that the existence of God cannot be either proved or disproved by pure reason.

In the *Critique of Practical Reason* (1788) and related works, Kant attempts to explain how reason operates in the realm of *moral* life. Where most earlier thinkers had assumed that morals have at least some kind of ideal basis in nature, Kant argued that, because our moral instincts are often in conflict with nature, they must have a different source: morality must be a product of autonomous human reason. It is reason that makes human beings free with regard to nature – able, for instance, to risk themselves in order to save someone else, to act against the natural law of self-preservation in the interest of a higher law – and the exercise of this autonomy is the source of morality. In its essential, most perfect form, moral conduct demands that we do things not for the sake of their consequences but because of their conformity to principle. The fundamental law of moral conduct – what Kant calls the "categorical imperative" – is: "act always according to that principle by which you can, at the same time, will that it be universal law." The proper exercise of freedom is thus rather like the opposite of freedom in the usual sense: it depends upon a high and rigid sense of duty and is essentially a self-administered constraint.

The third critique, the *Critique of Judgment*, published in 1790, contains a section on *aesthetic* judgment, in which Kant performs a brilliantly acute analysis of what it means to say that something is beautiful. When we make this claim about an object, we say more than that it simply pleases us: we attribute to it some quality which we assume everyone should recognize. At the same time, it is not the object we are describing, but *our own condition*, and this condition is a pleasurable interaction – a "free play" – of our faculties of reason and sense perception, imagination, and understanding. The pleasure which beautiful things cause is "disinterested": it is not associated with the satisfaction of any compulsion

or appetite. Eating, sex, and possession are not aesthetic pleasures, but the appreciation of a well-prepared meal or of a body's form can be. An aesthetic judgment is also different from a judgment of utility or moral goodness: because we enjoy without reference to our personal advantage, we assume that our pleasure can be felt by everyone equally. Aesthetic pleasure is thus "impersonal" pleasure: though one enjoys oneself, one does so rather as an instance of some collective consciousness than as an individual.

Important for Kant, as for Baumgarten, is the idea that aesthetic judgments remain free of controlling principles or concepts. "Whether a dress, a house, or a flower is beautiful is a matter upon which one declines to allow one's judgment to be swayed by any reasons or principles." When we judge something to have a nameable function, we cease to regard it aesthetically. Though the things in nature that please us aesthetically seem to have been designed to fit our needs and desires, there is no rational basis for assuming that this is the case. Aesthetic judgments are thus characterized by a "purposiveness without purpose." We keep on looking because the object satisfies the needs of our gaze in some way we cannot fully grasp. Kant concludes with a succinct, if unlovely, formulation: "the beautiful is that which, without any concept, is cognized as the object of a necessary satisfaction."

The purpose of this relentless hair-splitting is to establish a model: Kant wants to say that aesthetic experience is a distinct and specific thing, but he knows that such an experience – one that satisfies all the criteria – rarely occurs in our day-to-day lives. Thus, besides the "pure," conceptless beauty he has described, he acknowledges an "adherent" or "dependent" beauty, which occurs when our appreciation of an object *is* affected by some judgment we make about its purpose. His principle example of pure or "free" beauties are flowers, the sight of which we commonly enjoy without reflecting more deeply; adherent beauties are objects such as buildings or furnishings, which we tend to judge with reference to their function. Indeed, most of our judgments seem to be of this second type: we expect a different kind of beauty in racehorses than in cart-horses, and human beings too, even when extremely beautiful, cannot really be objectified in a purely conceptless fashion. Our admiration of human figures *in art*, moreover, is ultimately linked to their "moral" expressiveness.

Though Kant has devoted much care to showing that aesthetic judgments are distinct from moral judgments, he is able to insist that "the beautiful is the symbol of the morally good." We acknowledge this fact even in everyday speech: "We call buildings or trees majestic and stately, or plains laughing and gay; even colors are called innocent, modest, soft, because they excite sensations containing something analogous to the consciousness of the state of mind produced by moral judgments." On a

deeper level, beauty is a symbol of the good because the freedom of the imagination it enables us to enjoy is analogous to the freedom of the will that is essential to truly moral conduct; in fact, the experience of beauty makes our freedom tangible to us in ways that our normal experience does not. Though it may seem paradoxical, the very autonomy of aesthetic experience is what links it to morality.

Kant appends a section on the sublime to his discussion of beauty. The sublime is an experience of "the absolutely great," something of overwhelming size or power. When confronted with such objects, our faculties are initially overwhelmed, but even as they "recoil upon themselves" we experience a certain pleasure: in the case of large objects, we are made to realize that our *idea* of the infinite surpasses what we see, and that the mind's powers are thus greater than nature's; in the case of overwhelming forces, such as storms or waterfalls, we recognize that our moral awareness has the capacity to resist any force:

> In the same way the irresistibility of the might of nature forces upon us the recognition of our physical helplessness as beings of nature, but at the same time reveals a faculty of estimating ourselves as independent of nature, and discovers a pre-eminence above nature that is the foundation of a self-preservation of quite another kind from that which may be assailed and brought into danger by external nature.

"Sublimity, therefore, does not reside in any of the things of nature, but only in our own mind . . ." The experience of the sublime can even offer us access to what lies beyond reason; in it, "we are capable of attaining to the idea of the sublimity of that Being which inspires deep respect in us, not by the mere display of its might in nature, but more by the faculty which is planted in us of estimating that might without fear, and of regarding our estate as exalted above it."

Because pure aesthetic judgments are conceptless, our experience of *art* cannot depend upon our awareness of the artist having striven rationally and mechanically to achieve certain effects; art of the highest kind "must not be regarded as a product of understanding and science, but of genius." Kant thus distinguishes sharply between "fine art," the product of original genius, and "mechanical art," rule-bound and imitative. Genius is not susceptible to rule, and artists cannot explain why they do what they do; yet something larger, "nature," is at work in them: art is "nature working in man," and genius the "innate mental disposition through which nature gives the rule to art." It is clear, however, that Kant sees the two types of art as interdependent: genius "can do no more than furnish rich *material* for products of fine art; its elaboration and its *form* require a talent academically trained."

For all the conceptual intricacy that supports them, these views are similar to those of Reynolds, and some of Kant's other remarks indicate a wholly conventional taste. In his discussion of adherent beauty, for instance, he argues that the human body represents the "ideal of beauty"; its most perfect form is of average size and normal proportions like that of the *Canon* of Polykleitos. As in academic art theory, the general is to be preferred to the particular. Kant believes that the visual arts occupy a lower place in the hierarchy of the arts than does poetry, but a much higher one than does music, which, he says, "plays merely with sensations." Among the visual arts he accords the first place to painting, in part because of its dependence on design, in part "because it can penetrate much further into the region of ideas."

For a long time it was customary to regard Kant as the thinker who gave definitive form to the notion of aesthetic judgment and who succeeded in explaining why aesthetic experience is something essentially distinct from other kinds of experience. Because he is concerned to describe the mechanics of thought as precisely as possible, and because his analyses are so demanding, it is easy to lose sight of the overall structure of his system, of the fact that the meaning of aesthetic experience lies in its relation to other kinds of experience, to our experience as a whole. Aesthetic experience is ultimately an expression of freedom; the rational basis and moral force of freedom are always essential parts of its content: even though it is conceptless, it occurs in a space made possible by reason. And even though genuine creativity eludes or exceeds reason, the making of art is only partly an irrational process. The aesthetic might be described as the rational reconstitution of irrationality.

At the conclusion of the *Critique of Practical Reason*, Kant comes as close as he ever does to being poetic: "There are two things which fill the mind with new and ever-increasing admiration and awe, the more often and the more steadily we reflect upon them: *the starry sky above and the moral law within*." What he means to say is that the inward order we sense in our moral consciousness is equal to the grandeur of the universe, and that *only* in the possibility of universal order do we find anything equal to ourselves. It is as exalted an assertion of human dignity and of the necessity of moral order in the world as has ever been uttered, yet it is also a chilling distillation of the human condition, a confession of something like defenselessness before the combined demands of an outer and an inner law. If this is freedom, then freedom is a frightening thing. Kant might have responded by saying that freedom is a sublime thing, and that the strength we must summon to accept its terms is the purest expression of what we are when we are at our best. That the reclamation of our autonomy and dignity should be thought to require such heroic effort is an indication of how hard it was becoming to be human.

Radical Idealism

The period of thirty years or so that began with the publication of Kant's critiques was an era of spectacular innovation in German philosophy and one of the great episodes in the history of Western thought. A culmination of the Enlightenment, it is also charged with a distinctive urgency: its leading figures came to maturity at the moment of the French Revolution, and though most of them, initially sympathetic, soon became disillusioned – and downright hostile when French armies, under Napoleon, began invading their homeland – their work breathes a revolutionary fervor of its own. If the message of Kant's thought was that the human mind constitutes the reality it perceives, then these younger thinkers sought to show how the mind might enlarge its claim upon reality, actively reshaping the world in new and more perfect form. They made creative use of Kant, extracting his radical potential, if often transgressing his delicate sense of reason's limits. Art – the visual arts, literature, drama, and music – played an important role in their work, and in their considerations of it they hit upon many of the themes that would dominate subsequent art theory. In important respects, they mapped out much of the conceptual terrain within which modern thought about art has continued to move. Perhaps their deepest, most significant achievement was to have established the essential interdependence of art and thought: at their hands, art became a kind of philosophy and philosophy a kind of art. They can thus be said to have reclaimed and restated in more systematic and philosophically more compelling terms an idea first articulated in Renaissance art theory.

One of the leading theorists of the period was the poet and playwright Friedrich Schiller, whose *Letters on the Aesthetic Education of Mankind* was written in 1793–4, as the French Revolution slipped into its bloodiest and most chaotic phase. Feeling compelled to begin by justifying his interest in the rarefied subject of beauty at a time of political upheaval, Schiller argues that social conflict has its ultimate source in deeper, spiritual divisions, and that, until these are healed, no enduring solution to political problems is possible. "If man is ever to solve the problem of politics in practice he will have to approach it through the problem of the aesthetic, because it is only through Beauty that man makes his way to Freedom." The idea that politics is the highest, most all-inclusive kind of art has its source in ancient philosophy, but Schiller restates it in a way that gives it a new, revolutionary thrust: "The most perfect of all works of art," he says, is "the construction of true political freedom."

Schiller supports his case with an analysis of human nature torn by the conflicting powers of sense and reason. On the one hand, we have a

"material drive" (*Stofftrieb*), a need for reality, for concrete, sensually stimulating experience, for variety; on the other, a "form drive" (*Formtrieb*), a need for clarity, serenity, and order. Our humanity depends upon a dynamic balance, a "reciprocal relation" between these two impulses. As long as man is driven by one or the other, he is not "really free," and is thus not "in the full sense of the word a man." But in moments when we contemplate the beautiful, these two drives cancel each other out; indeed, all the contradictory forces in our nature are reconciled:

> When we have abandoned ourselves to the enjoyment of genuine beauty, we are at such a moment masters in equal degree of our passive and our active powers, and shall turn with equal facility to seriousness or to play, to rest or to movement, to compliance or to resistance, to abstract thinking or to beholding. This lofty serenity and freedom of the spirit, combined with strength and vigor, is the mood in which a genuine work of art should leave us, and there is no surer touchstone of true aesthetic excellence. If we find ourselves after an enjoyment of this kind especially disposed toward some particular mode of feeling or action, and unfitted and unworthy for another, this serves as an infallible proof that we have experienced no purely aesthetic effect, whether owing to the object or to our mode of perception or (as is almost always the case) to both together.

At such heightened moments we achieve "the extinction of time *in time* and the reconciliation of becoming with absolute being, of variation with identity." The straightforwardly Platonic quality of this formulation reminds us of how important a point of reference classical antiquity continued to be, even for radical thought. Schiller's modern version of the duality of human nature owes something to Baumgarten's notion of a "lower" and "higher" apprehension; the evocation of "lofty serenity" echoes Winckelmann. The essential point of the passage, however, the necessary link between beauty and freedom, comes from Kant – even if the word freedom has a revolutionary ring for Schiller that it does not have for the older philosopher.

The freedom that such experiences offer us is not a negative state, simply defined by the absence of compulsion. The mutual cancellation of the two drives awakens a new impulse within us, which Schiller calls the "play drive" (*Spieltrieb*):

> Man is only serious with the agreeable, the good, the perfect; but with beauty he plays . . . Man shall only play with Beauty, and he shall play only with Beauty. For, to declare it once and for all, Man plays only when he is in the full sense of the word a man, and he is only wholly a man when he is playing.

This "play" is nothing less than *true* freedom, which, in turn, is true humanity. The term "play impulse" also derives from Kant, of course – from the "play of faculties" described in the *Critique of Judgment* – but Schiller raises the temperature here as well. To be truly human, he suggests, is to be involved in a continual effort to reclaim a completeness and authenticity that are always being threatened by social forces, that society as we know it always resists. To be human is to be, in principle, a revolutionary; art is the principle of revolution.

Other thinkers of Schiller's generation sought a similarly radical redirection of Kant's insights. Johann Gottlieb Fichte, a political activist as well as a rigorous philosopher, was dissatisfied with the distinction between "pure" (or "theoretical") and "practical" reason; he felt that it opened a paralyzing abyss between the mind and the world, and that it effaced the deeper, fundamental unity of reason itself. He insisted that thought is necessarily also an *act*, something intrinsically both "theoretical" *and* "practical." Taking Kant's concept of a "transcendental consciousness" – the capacity of the mind to assert its own unity and identity from among its perceptions and ideas – he elevated it to the fundamental principle of reality, a kind of force emanating from the subjective "I" and steadily constituting the "objective" world as an instrument of its own self-realization. For Fichte, the world is a product of the mind. His position, which came to be known as "transcendental idealism," is perhaps the boldest possible statement of the radical potential within that tradition of thought begun by Plato; it is arguably the boldest idea of which we are capable. One of his younger contemporaries, Friedrich Schlegel, said that Fichte's achievement was to have "discovered and installed the proper method in philosophy by organizing free autonomous thought as an art."

Another younger colleague of Fichte's, F. W. J. Schelling, was also unhappy with Kant's distinction between the thing "in itself" and the thing "for us," and sought a deeper principle or "ground," which would enable him to reconcile mind and nature, subject and object, freedom and necessity. Equally dissatisfied with Fichte's claims for the principle of subjective consciousness, however, he insisted that such consciousness cannot constitute an originary act; it can only be the *result* of something: to be an "I" in the first place, he reasoned, "the 'I' must be aware of something opposed to itself." Truth can only emerge in a complex interaction between subjectivity and the world of objective reality we call "nature." In fact, the opposition between mind and nature is only apparent: both are informed by a common order and ultimately in harmony with one another. Nature is "visible spirit," spirit "invisible nature." In his *System of Transcendental Idealism*, published in 1800, when he was twenty-five years old, Schelling sought to trace the "progressive history

of self-consciousness," the process that leads from unconscious nature to the transcendental consciousness that is the highest form of human reason. "In reason," Schelling says, "nature recognizes her past works; she perceives and recognizes herself as herself." Nature *needs* our minds in order to be complete; whereas, for Kant, the mind is autonomous, distinct from nature, Schelling sees it as the fulfillment and perfection of nature: "the external world lies open before us in order that we may find again in it the history of our own spirit."

Schelling comes to the conclusion that the best instrument of thought is not rational philosophy, but art. Art is "the only true and eternal organ of philosophy, which always and continuously documents what philosophy itself cannot represent externally." This idea depends upon Kant's notion of artistic genius in direct contact with nature. Schelling believes that, because art is necessarily only a partly conscious activity, it is better able to express the harmony between nature and the mind. In art, the mind opens itself to nature, while the unconscious processes of nature achieve the consciousness that only the mind can give them. It is in art that nature "consciously comprehends and completes itself," and, at the same time, that "the real becomes truly similar to and equal to its own idea." By insisting that the irrational element in human creativity plays such an important role in the revelation of truth, Schelling uses Kant's ideas about art to overcome what he sees as the limitations of Kant's system as a whole. By suggesting that thought is subject to forces which it cannot fully objectify, he bridges the gap between Kant's critique of reason and the deeper critique of rationality carried out by later thinkers such as Friedrich Nietzsche, Sigmund Freud, and Martin Heidegger.

Remote and abstract as all this may seem, its connection to actual artistic production – poetic production, at least – is surprisingly close. Schiller was a great poet and sought to make his work expressive of philosophical ideas. Fichte's concept of thought is related to notions expressed in J. W. Goethe's monumental dramatic poem, *Faust*. Schelling was a friend of the philosophical poet Friedrich Hölderlin, and he associated with a number of intellectuals, centered on the city of Jena, where he taught, who were particularly interested in art, literature, and music. The affinity between these German thinkers and the English poets William Wordsworth and S. T. Coleridge is also striking: though the best poetry of the two Englishmen seems to have been written before their exposure to post-Kantian philosophy, Coleridge's later theoretical writings, which had a powerful impact on subsequent English literary criticism, were deeply indebted to Schelling – so much so that the author has been accused of plagiarism.

The Jena group included the poet and essayist Friedrich von Hardenberg, who called himself Novalis. Like Schelling, he recognized

the philosophical value of art; for him, "the poet is but the highest degree of the thinker." Because art addresses the irrational as well as the rational side of our nature, however, it relates just as closely to religion, to myth, and to fairy tale as to philosophy; indeed, it exposes all these things as species of itself. Poetic language does not work in the same way as normal language: the poet's words are like hieroglyphs or magic spells. The poet is a philosopher, certainly, but also a priest, a wizard, a prophet, and a dreamer. These aspects cannot be separated and poetry cannot be set apart from what we are as a whole: it is "the peculiar mode of action of the human spirit." Even love is "nothing but the highest natural poetry." Novalis was capable of stating his position in terms almost as radical as Fichte's: "Poetry is the absolutely real. This is the core of my philosophy. The more poetic, the more true." Though he died before he was thirty years old, the cluster of related ideas which he was the first to articulate would reappear frequently in later theory, especially in that of the late nineteenth-century Symbolists.

Two other members of the Jena group were the brothers Friedrich and August Wilhelm Schlegel, who were not formal philosophers, or poets, but critics and historians of literature. In many ways, their work is the culmination of Enlightenment historicism: beginning as students of the classics – as a young man, Friedrich had wanted to be "the Winckelmann of Greek poetry" – they went on to develop more wide-ranging interests, studying modern, medieval, and non-Western literature; August Wilhelm ended his days as a professor specializing in Indian culture. Their aspiration to universality was complemented by their concern to develop an analytical method for this diverse material, a science or systematic "criticism" of literature, and their work would in fact become the basis of the modern academic discipline of comparative literature.

The Schlegels were interested in more than scholarship, however; they sought to promote a new kind of poetry. They used the word "romantic" to distinguish the literature of medieval and early modern Europe from that of classical antiquity, and urged the cultivation of "romantic" qualities among modern writers. They did not want to abandon antiquity entirely: they found many romantic elements in ancient poetry and believed that classical elements might be imitated in a distinctively romantic manner, but they identified the romantic as "progressive universal poetry," apt to replace traditional classicism – and thus become the poetry of the future. Whereas Schelling and Novalis had stressed the unconscious nature of artistic creation, the Schlegels insisted that a high degree of self-consciousness is essential to literature, especially to modern literature. They claimed that the greatest poetry is "transcendental poetry," "the poetry of poetry." Friedrich used the term "irony" to denote the way in which a poem might expose its own artifice: he once defined it as

"a mood that surveys everything and rises infinitely above all limitations, even above its own art, virtue, or genius," and identified it as the philosophical element in poetry. The Schlegels viewed their own activity as critics – combining literature and philosophy – as contributing to an intensified modern self-consciousness: "the true critic," they claimed, "is an author to the second power."

The most influential philosopher of the period, and the one in whom both the radically rationalistic and historicizing tendencies of Enlightenment thought come together, is G. W. F. Hegel (1770–1831). A friend of Schelling's from adolescence, when they – along with Hölderlin – had attended the same school, Hegel worked closely with him in Jena for a period, finally inheriting Fichte's chair in philosophy at the University of Berlin. He, too, sought to overcome what he saw as the limits of Kant's thought, borrowing elements of Fichte and Schelling to do so, but he also attempted to overcome what he saw as their limitations, and to provide the radical idealism they had created with a more solid and systematic foundation. In some ways, his is the last great contribution to the idealistic tradition that began with Plato, but the comprehensiveness of his philosophy – which includes the natural sciences as well as logic, law, and art – also makes it comparable to Aristotle's, and perhaps the last such integrated philosophical system. For Hegel and his followers, it was the definitive, *modern* system, the philosophy of the future. His work, like Kant's, has had immense influence over later thought, and has proved even more controversial.

Hegel offered a preliminary overview of his system in the *Phenomenology of Spirit*, published in 1807. Notoriously difficult as it is, the *Phenomenology* remains the best introduction to his thought: indeed, it must rank as one of the most original, ambitious, profound, and – in its own way – beautiful books ever written. Its subject is the principle that Hegel calls "spirit" (the German word, *Geist*, is sometimes translated as "mind") and the process by which it manifests itself in the world. Spirit is nothing less than the underlying principle of all reality: "the spiritual alone is the real," Hegel declares. It is thus closely related to the transcendental self-consciousness of Fichte; at the same time, following Schelling, the process by which it realizes itself is essential to what it is. Hegel tries to show that this process is governed by an inner necessity, that it leads in a logical – or, more specifically, "dialectical" – manner from the most primitive kind of sense experience to the most exalted, abstract, and complex modes of knowing and being. Although spirit first comes to know itself in the limited, imperfect, often painful subjectivity of the individual human mind, it gradually learns to recognize itself in everything the mind encounters, to appropriate more and more of the world to itself and thus to "objectify" itself – to become more "real." In the

final step, it comprehends the whole world as a form of its own self-knowing and thus establishes itself as reality.

The process begins on the level of our encounter with physical objects. Our sense of their being "real," of having an existence independent of our awareness of them, seems to be the most obvious, most certain form of knowledge, yet for Hegel it is actually the emptiest and most inadequate. If we try to say anything about such objects, even that they simply "are," we must employ concepts and categories of a more abstract nature. Coming to grips with the different, apparently contradictory, qualities of objects presents us with further difficulties, each of which leads to explanatory constructions that must then be rejected in favor of better ones. Though each step in the sequence is only a slight improvement, all are necessary to achieve the climactic realization that the order behind the variety of sensible qualities is a product of our own mental operations. At that moment, consciousness becomes aware of itself as the one reality underlying the phenomenal world; it becomes self-consciousness.

Much more interesting than our encounters with objects are our encounters with other self-conscious entities, and Hegel proceeds to explain the way in which self-consciousness operates at the higher, more complex level of social life. He describes the phases through which societies have moved, from raw competitiveness for survival, to the hierarchical relation between master and slave, to the system of values reflected in the Stoic and Skeptical philosophies of antiquity, finally to the "unhappy consciousness," the two-world consciousness of medieval Christianity. As in our individual encounters with objects, each of these phases gives way under its own inadequacy to the phase that succeeds it: "unhappy consciousness" finally passes over into "reason," the fundamental principle of modern society. Hegel then inventories the developmental phases of modern culture, brilliantly characterizing the various states of being that it produces, and showing how each grows out of the one before. The highest form of society that reason can achieve is one in which individuals are bound together under laws that they freely accept, but even this is only a precondition to the development of something still higher, in which the laws become less important than the ethical principles that sustain them.

In this higher awareness, reason becomes spirit. The ethical life of societies, governed by spirit, also develops in three phases. The first, in which individuals simply accept and obey the customs they see around them, is unreflective. The next, which Hegel calls the "self-estranged spirit," is more complex: in it, individuals accept some aspects of collective values but reject others, and experience various degrees of alienation as a result. Here he presents another fascinating inventory, this time

of the states of ethical consciousness that one encounters in modern culture, with all its refinements and emptinesses, and its tension between religious faith and scientific "enlightenment." This condition of self-estrangement culminates in the absolute freedom but also barbaric depravity most clearly seen in the French Revolution. Out of this disaster, however, the spirit recovers and rises, "sure of itself," to a higher level, guided by a more self-possessed form of personal morality. This step enables Hegel to expose what he sees as the limitations of the Kantian categorical imperative, and to argue instead for a principle of conduct based on an apodictic certainty of conscience – a condition that he strikingly characterizes as "moral genius."

The highest development of the spirit occurs in religion and philosophy. Religion, too, unfolds in three phases, described by Hegel as natural religion, the religion of art, and revealed or absolute religion – which he identifies with Christianity. As long as spirit clings to some notion of God as external to itself, however, it cannot achieve its final form, which is to recognize that every object of consciousness – even the most exalted – is fundamentally an externalization of consciousness itself. This realization, which is only attainable to philosophy, is not as solipsistic as it may sound, for by the time the thinking individual reaches this point, he or she has transcended his or her own subjectivity and is nothing more particular than a dynamic universalizing principle. Even this step is not quite the last: in the end, otherness itself is assimilated; the thing known is taken into knower, as it were, object into subject. The final, elemental barrier between knowing and being comes down; knowing *becomes* being, spirit becomes reality.

The self-realization of the spirit is like a vastly expanded version of Plato's ladder of ascent to the absolute, and Hegel is often reminiscent of Plotinus in the way he seeks to describe a fundamentally Platonic conception of the dynamics of being in systematic, "scientific" fashion. Some of what he says about the laws governing the natural world is simply wrong, and the dialectical pattern of development from one stage to the next is in fact more arbitrary than he lets on, but whatever the book's weaknesses as philosophy, it is a formidable work of art: it is a vast, ranked inventory of states of consciousness, a map of the human condition – a kind of modern version of Dante's *Divine Comedy*. On an even deeper level, it demonstrates the essentially transformative, creative nature of thought itself, its infinite power – and fundamental right – to dissolve and reconstitute the world.

In the *Phenomenology*, Hegel discusses art in the context of religion. At the culminating moment in the development of "natural" religion, "spirit becomes an artificer"; it requires and produces material tokens of itself. At first, the simplest geometric forms suffice, but before long they

prove insufficiently articulate, and more complex forms appear. It is in ancient Greece that the human body becomes the form ideally suited to the expression of the spirit; Hegel is thinking not only of statues, but of rituals involving living bodies. Religion also makes use of music and poetry, but these forms, which are more "abstract," come into their own later and are better able to express more complex phases of development. The visual arts are thus the most primitive forms in an evolution that finally leads beyond art altogether; art is a passing moment in the realization of the spirit, appropriate for the expression of certain states, but not, in the end, the most exalted. Where Schelling had seen art as the crowning principle in his history of consciousness, "the highest organ of philosophy," Hegel sees it as a stage on the way to philosophy, something that philosophy must assimilate and move beyond.

Hegel developed his ideas about art in courses he taught in the 1820s, reconstructed from student notes as *The Philosophy of Fine Art* (or *Aesthetics*). Here he distinguishes three types of art, "symbolic," "classic," and "romantic," each of which is associated with an historical phase in the self-realization of the spirit. Symbolic art is the art of pre-Greek antiquity, especially Egypt, and also of the non-Western world, including India and China; the art of Greece and Rome is classic; that of "modern," Christian Europe is romantic. Each of these types is defined by a different relation of the spirit to its material expression. In symbolic art, the physical form simply designates a spiritual content; the object sets itself apart from nature, either through grotesque distortion (as, in Hegel's view, in Asian art) or by offering itself as a mystery (as in Egypt). In classic art, on the other hand, the physical form *embodies* the spirit: this phase is made possible by the values of Greek religion and culture, in which the divine is understood to have the same relation to the human as the human has to the rest of nature, so that the human form becomes the perfect image of the divine. Because Christianity, in its turn, brings with it a conception of spirit that defies such embodiment, romantic art is characterized by a tension between the physical and the spiritual: though it expresses a higher stage of spiritual development, it is less successful as art. Hegel says that "romantic art must be regarded as art transcending itself, albeit within the boundary of its own province, and in the form of art itself."

Each of these types or phases best expresses itself in a particular art form. For the symbolic type, the form is architecture. Hegel characterizes the pyramids of Egypt, for instance, as "enormous crystals which secrete an inward within them . . . in such a way that we are made aware that they stand there for that very inward in its separation from the mere actuality of nature." Sculpture is the leading art of the classic phase: Greek statues succeed in making "the spirit stand in bodily form . . .

in quiet and in blessedness." Because painting is more "abstract" than sculpture – in the sense that a two-dimensional surface is made to bear the illusion of a third dimension – it is the visual art best suited to the romantic phase. But though pictures have greater mimetic and expressive range than sculpture, they also point to the limits of the visual arts as a group. It is in the even more abstract, "immaterial" forms of music and poetry that the more advanced forms of spiritual life are best expressed, yet even these give way before pure speculative philosophy. Of all the arts, poetry is the highest because it is the closest to philosophy.

Although art had an important contribution to make to the self-realization of the spirit, its time is past; what is now demanded is something else, a "science of art" (*Wissenschaft der Kunst*): "a science of art is therefore a far more urgent necessity in our own days than in times when art sufficed by itself alone to give complete satisfaction." To say that art is dead, that it can only be reclaimed by being integrated into a higher kind of intellectual practice, is to go a good deal further than the Schlegels, who said that the literary critic is *also* a kind of poet. We may want to dismiss Hegel's position as proof of the sterility of his system as a whole, but if the type of philosophy he advocates is what he sees as succeeding art, then philosophy is actually art of a new kind. Just as Plato's critique of art could be understood as a challenge to create a higher kind of art, Hegel's can be understood as a call for a new, purely conceptual art.

Just as Hegel was preparing his first lectures on aesthetics, the philosopher Arthur Schopenhauer published the first version of his system, *The World as Will and Representation* (1818; revised and enlarged in 1844). Overwhelmed at first by the tide of Hegelianism, Schopenhauer's work did not get the attention it deserved until after his death; during the second half of the century, however, it became extremely popular and had deep and widespread influence on thought about art. Schopenhauer distills the Kantian opposition of world and mind to an opposition between what he calls "will," the relentless, morally indifferent force that animates nature, and "representation," the capacity of the human mind to have ideas. Like everything in nature, we are driven by will: life is essentially a dismal cycle of desires that cannot really be satisfied and the sufferings that they cause. Our minds allow us to escape briefly from this misery, especially in aesthetic experience: in our contemplation of beauty, the force of the will is briefly suspended. Artists imitate the ideas that are the products of our desires and fantasies, but music is unique because it imitates in idealized form the motions of the will itself: "Music does not express this or that particular and definite pleasure, this or that affliction, pain, sorrow, horror, gaiety, merriment, or peace of mind, but joy, pain, sorrow, horror, gaiety, merriment, peace of mind *themselves*, to a certain extent in their abstract nature." Schopenhauer's

concept of ideas owes a good deal to Plato; his idea of release from will, though obviously dependent on Kantian disinterestedness, is also indebted to ancient Indian philosophy, which writers like the Schlegels had begun to popularize in Europe.

If, as has already been noted, there is some connection between all this abstract thought and the practice of literature, the great works of Goethe, Schiller, and Hölderlin remain somewhat resistant to translation and have never acquired the stature outside the German-speaking lands that they perhaps deserve. Although there is also some indication of philosophical ideas having an impact on the visual arts, the results are rather modest. The greatest German painter of the period was Caspar David Friedrich, whose *Wanderer above a Sea of Clouds* (figure 3.4), painted around 1818, can be taken to illustrate something like the Kantian experience of the sublime, or perhaps Schelling's sense of the mind's compatibility with nature, or perhaps even Hegel's belief in the all-comprehending principle of spirit. Friedrich's statements give us few hints. He did say that "the artist's feeling is his law," and, in a manner reminiscent of Novalis, he insisted on the value of a spiritual purity like that of children:

> The heart is the only true source of art, the language of a pure, child-like soul. Any creation not sprung from this origin can only be artifice. Every true work of art is conceived in a hallowed hour and born in a happy one, from an impulse in the artist's heart, often without his knowledge.

In the middle of the nineteenth century, the poet Charles Baudelaire would say that "genius is childhood recovered at will," and in the twentieth century, Pablo Picasso would say that he learned more from watching children draw than from any mature artist. Yet, in good Kantian fashion, Friedrich's sensitivity is combined with a scrupulously polished academic technique.

Perhaps it is only in music that the artistic achievements of this period rise to the level of its greatest philosophy. Wolfgang Amadeus Mozart and Ludwig van Beethoven were not only the intellectual equals of Kant and Hegel, they transformed music in something like the way in which Leonardo, Michelangelo, and Raphael had transformed the visual arts centuries before. It is tempting to see the music of Beethoven, in particular, as an artistic equivalent to radical romantic idealism: not only did he share his generation's dedication to revolutionary ideals, he sought to realize a new conception of what music might be, to create a music of vastly expanded scope and expressive power – a music of the future. And he succeeded: his achievement dominated the entire nineteenth century; largely because of it, music came to be widely recognized as the highest

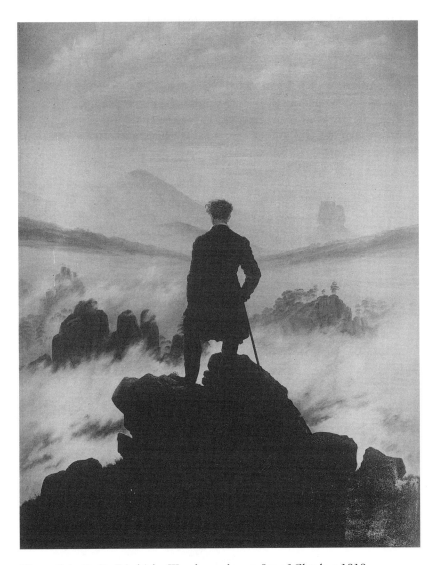

Figure 3.4 C. D. Friedrich, *Wanderer above a Sea of Clouds*, c.1818, Kunsthalle, Hamburg.

art form, higher than poetry – in the minds of some people, higher even than philosophy. This development would ultimately have an important impact on the visual arts.

Beethoven was not much of a theorist. Once, when he was young, he turned down an invitation to attend a lecture on Kantian aesthetics – one can hardly blame him, given Kant's dismissive remarks about music – but

toward the end of his life, in 1820, not long before he wrote his last piano sonata, with its *arietta* so evocative of starlight and infinite depths, he had occasion to recall the philosopher's words: "the moral law within, the starry sky above." Whether we interpret his music in Kantian terms, or refer it instead to Schiller, to Schelling, to Hegel, or to Schopenhauer, it stands as one of the most profound expressions of Enlightenment thought. That it still moves us as it does is an indication both of how much is still at stake for us in that thought – impossibly heroic as it often seems – and how essential art was to its enterprise.

chapter 4

тhe Nineteenth
century

The Crisis of the Academy

In the decades around 1800, European art began a process of rapid
and dramatic transformation, one that continued through the nineteenth
century and into the twentieth, establishing a dynamic that in some
respects, at least, still seems to be at work. From early on, this process
was recognized as "modern" – as related, that is, to the new, complex,
and rapidly changing conditions of life in the "modern world" – and,
despite all the ways that things have changed in the past two hundred
years, we still refer to it as "modernism." Opinions vary as to exactly

when it began, as well as to just what caused it and what it is – even whether it can or should be considered a single thing – and these disagreements are not unimportant, since any interpretation we may propose has implications for the way we see ourselves. We can begin by saying that modernism in art is a response to the transformation of society that resulted from the upheaval of revolution and the advent of mass politics, as well as the more gradual but still traumatic shift to an increasingly urbanized, industrial economy, dependent on technological innovation and the exploitation of inexpensive labor. These forces had such a profound effect on the conditions of life generally that they were bound to reorganize both the practice and theory of art.

Simple as this definition may seem, it is already a selective one; it structures any account we present by obliging us to highlight developments that appear to reflect those transformations most clearly. To say that modernism is a *response* to political and economic change is to be even more selective, to imply something more than if we say simply that it is the *product* of such change: it implies a degree of self-consciousness, of critical poise, and requires us to privilege works in which that self-consciousness and poise are most articulate. It leads us to the conclusion that modernism is best understood as a *critical* enterprise: critical not only in the sense that it often engages in overt social criticism, but in the deeper, philosophical sense – common after Kant – denoting the effort to think in a manner attentive to the limits of thought, and, by extension, any practice that thematizes its own means and processes. If we look at modernism in this way, then a consistent pattern begins to emerge: received assumptions about what art is are abandoned one by one in order to make new conceptions of art possible, conceptions that are felt to be somehow more appropriate or authentic, closer to the "real" nature of art. Direct social criticism may play a part in this process or may not; in many cases, radical artistic convictions are indeed linked to radical political convictions; but the argument can also be made that, since art is essentially a social product, the ways in which it critiques itself are always also indirect forms of social critique.

Artistic modernism developed most spectacularly in France, where the political and social upheaval was most profound. The overthrow of the old order left few aspects of culture untouched, and the Académie Royale, the institution through which the artistic life of the nation had been regulated since the days of Louis XIV, was dissolved by decree of the revolutionary government in July 1793. It was revived again, as the Académie des Beaux-Arts, in 1795, and continued to exist through the nineteenth and twentieth centuries. For most of the nineteenth century, in fact, the Salons sponsored by the Academy continued to grow in size – so that the institution *seemed* to be healthier than ever – but there was

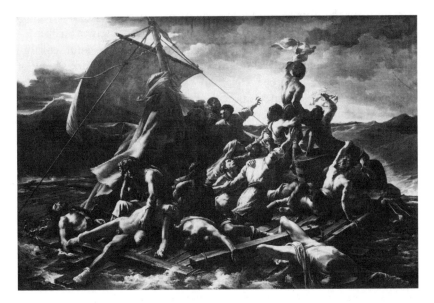

Figure 4.1 Théodore Géricault, *Raft of the Medusa*, 1818–19, Louvre, Paris.

also a growing sense that the work it produced and encouraged had become irremediably formulaic and outmoded, and that truly creative work had to be done outside it and in pointed opposition to the system of art-theoretical values it embodied. The early history of modernism is perhaps best seen as a step-by-step dismantling of that system, driven by attempts to realize new conceptions of what art is or ought to be.

This process can be illustrated in very summary fashion with a comparison of three pictures, works which, in their size and ambition, announce themselves as "masterpieces," as comprehensive representations of the art of painting, and thus as theoretical statements in themselves. The first is Théodore Géricault's *Raft of the Medusa* (figure 4.1), exhibited at the Salon of 1819. Unlike David's *Oath of the Horatii* (see plate 5) of the generation before, the subject is not an exemplary tale of ancient heroism, but a current event: the harrowing ordeal of the survivors of a shipwreck. The story, much more depraved than heroic, had horrified and scandalized the French public and had even triggered a governmental crisis. The picture created a scandal of its own: critics had a hard time dealing with a work which, by its vast size, invited consideration as a history painting, yet did not offer any of the uplifting moral lessons traditionally associated with that genre; many could only assume that it had been intended as political commentary. We recognize it today as a masterpiece of distinctly modern pessimism – the raft becomes a

metaphor for the human condition in all its bleakness – yet to many in its first audience it must have seemed like a cynical bit of sensationalism.

A few years later, in 1827, the Salon was dominated by another large and controversial picture, *The Death of Sardanapalus*, the work of one of Géricault's students, Eugène Delacroix (plate 6). Based on a poem by Lord Byron, the most internationally fashionable of the Romantics, it depicts the climactic moment when the protagonist, an ancient near-Eastern potentate whose kingdom is being overrun by his enemies, orders the destruction of all his possessions before taking his own life. The exotic setting and "barbarous" violence again depart from the classical spirit of traditional history painting; again there is a tension between the deep nihilism of the theme and the carefully orchestrated pictorial spectacle – in which we are able to see a self-conscious representation of the human condition as a brilliant, sensual, violent flourish, "full of sound and fury, signifying nothing." But where Géricault's technique had been impeccable by academic standards, Delacroix was harshly criticized for emphasizing color and texture at the expense of correct drawing, freedom of handling at the expense of discipline.

The third picture is Gustave Courbet's *Burial at Ornans* (plate 7), exhibited in the Salon of 1849–50. Another large work that invokes the tradition of academic history painting, it confounded viewers by presenting them with the kind of subject usually treated in the less serious category of "genre" – scenes of "everyday life." Courbet seemed to be suggesting that this unremarkable country funeral was worthy of the kind of attention usually reserved for heroic deeds, and this subversion of the academic hierarchy was felt to be more disturbing than anything Géricault or Delacroix had done; in the aftermath of the revolutionary uprisings of 1848, it seemed downright threatening. "The country is in danger!," some critics warned, and Courbet was identified – rightly – as a radical socialist. Though he seems not to have known Karl Marx, his picture can be said to imply a redefinition of history – not the outstanding achievements of a few great men, but the forces that shape the daily lives of the masses – similar to the one proposed in the *Communist Manifesto.*

Courbet's *Burial* defied expectations and offended viewers in other ways as well. Though a funeral is a sad occasion, and though some of the women are indeed shown crying, the overall emotional effect is diffuse: some of the figures seem to be bored, or to be thinking about something else entirely. The picture is not organized around the evocation of a powerful emotional response, as Géricault's and Delacroix's so obviously are; viewers accustomed even to Romantic painting were left in confusion as to what they should feel. Courbet's refusal to idealize the individual figures only made matters worse: critics complained that the old women were ugly, that some of the male figures were coarse and

obviously drunk, that the priest was singularly unspiritual; they wondered whether Courbet had not meant to mock his subjects. By avoiding sentimentality in his representation of country life, he made it difficult for many of his urban viewers to see any point in representing it at all.

Though there is a great deal of brilliant painting – extraordinarily effective renderings of texture, for instance, that produce a powerful sense of physical presence – certain passages, such as the large area of almost unbroken black pigment formed by the women's dresses at the right, were recognized as *deliberate* violations of academic technique. The emphasis on texture, combined with the emotional understatement, prompted many viewers to regard the picture as "materialistic." The willful clumsiness seemed like an attack on the very idea of art, on the distinction between serious, "high" art and unsophisticated "popular" imagery: the composition does, in fact, derive in part from a common, often crude type of poster known as a *souvenir mortuaire*. Today we recognize that, by drawing upon such sources and adjusting his style to suit his subject matter, Courbet was trying to create a new artistic language appropriate to unheroic themes, but most of his contemporaries could not follow the leap by which "bad" painting now offered itself as good painting.

Courbet was a man of immense self-assurance: he had intended to create controversy and he thrived on it. The time had come for this kind of provocative gesture, and he soon found admirers and defenders. The critic Champfleury (Jules Husson) was able to say that "a new art has appeared which is convincing and serious, ironic and brutal, sincere and full of poetry." The term "realism" was adopted to describe Courbet's work: he claimed not to like the label – perhaps because it was too general, too easily appropriated by others less radically committed than himself – but it had a certain value as an anti-academic rallying-cry, and he used it very effectively. When his pictures were excluded from the pavilion of French art at the Universal Exhibition in Paris in 1855, he arranged with typical bravado to have his own "Pavilion of Realism" built nearby.

It was through gestures of this kind that Courbet made his most important "theoretical" points. His few statements about the aims and methods of painting are simple and straightforward:

> I maintain . . . that painting is an essentially *concrete* art and can only exist in the representation of *real and existing* things. It is a completely physical language, the words of which consist of all visible objects; an object which is *abstract*, not visible, non-existent, is not within the realm of painting. Imagination in art consists in knowing how to find the most complete expression of an existing thing, but never in inventing or creating that thing itself.

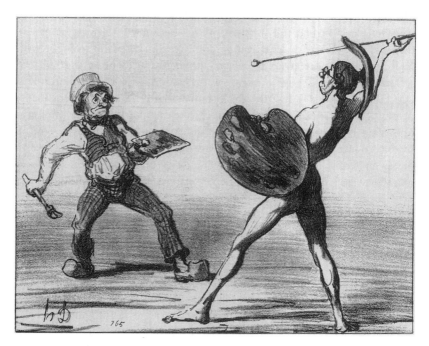

Figure 4.2 Honoré Daumier, *Duel of the Academician and the Realist*, 1855, UCLA Hammer Museum, Los Angeles.

Realism is thus a renunciation of Romanticism as well as of academic art. If the Romantics had exposed the false values of the academy, Courbet had undertaken to expose the false values of Romanticism, its dependence on the "non-existent," and his motivation was ultimately political. "By reaching the conclusion that the ideal and all that it entails should be denied, I can completely bring about the emancipation of the individual and finally achieve democracy. Realism is essentially democratic art." Courbet's critique of traditional standards had thus been carried out in the name of positive values; his admirer, the critic Théophile Thoré, described Realism as "a new, truly human art expressing a new society."

Only two generations separate David from Courbet. The distance French art had traveled in that time is illustrated in an amusing lithograph by Honoré Daumier (figure 4.2), in which an absurd old academic, striking a pose from one of David's pictures, confronts a shabby, clownish Realist. Though the image stresses the opposition between the two schools current at mid-century, it also reflects upon the historical continuity between two phases of artistic revolution.

Perhaps the most perceptive critic of this transitional period was Charles Baudelaire (1821–67), one of the greatest and most influential of

modern poets, arguably the inventor of modern poetry and the first truly
modern artistic personality. Preoccupied with the exploration of urban
experience, Baudelaire constructed out of it a new and self-consciously
modern sensibility, a new mode of being, as well as a new idea of
what art is. His verse and prose poems vividly describe the spectacle of
modern Paris: its degradation and depravity, but also its fascination and
strange, endlessly surprising beauty. At the same time, they investigate
subjective states – alienation, *ennui*, despair, drug addiction – of a kind
that figure largely in modern experience, as well as treating more trad-
itional themes, such as erotic obsession and victimization, with stunning
directness and insight. The prevailing tone of his work is dark: he was
hostile to the optimism of an emerging mass culture, with its faith in
scientific and industrial progress; he saw himself as a "*poète maudit*" – an
"accursed" or "damned" poet. When his great collection of poems, *Flowers
of Evil*, was published in 1857, it was censored and condemned by the
French Ministry of Justice as "an offence to decency and good morals."

If Baudelaire's opposition to conventional values was an important
part of his vocation as a poet, his poetic vocation was essential to his
personal identity. He sensed that the life of the imagination had become
urgently necessary for survival, that it had to be cultivated and developed
as an antidote to all the oppressive forces at work in the modern world.
We only reclaim some measure of human dignity to the extent that we
use our imaginations – to the extent that we function as artists. His
position has much in common with Schiller's, even if its generally gloomy,
disillusioned character could hardly be more unlike the utopian idealism
of the older poet. And precisely because he is otherwise so disillusioned,
there is something deeply impressive – something that can only be called
heroic – about the intensity of his poetic vocation. In an epilogue he
later wrote for the *Flowers of Evil* – perhaps in response to the censors –
he offers a proud, gritty affirmation of the moral necessity of art:

> O you, bear witness that I have done my duty
> Like a master alchemist and blessed soul:
> For from all these things I extracted the quintessence;
> You dealt me filth and I turned it into gold.

When, in another place, he says that art in its purest form is "an evocative
magic containing at once the object and the subject, the world external
to the artist and the artist himself," he reveals how deeply interdependent
art and identity have become, and how necessary, how urgent, art's role
now is.

Baudelaire was deeply interested in the visual arts and wrote extens-
ively about them. Like Diderot a century before, he reviewed the Salons,

and he too was bored by the formulaic quality of most of what he saw, but he expressed his ideas about the bankruptcy of the academic tradition in far more forceful terms. He described the Salon of 1846, which seemed to him to be dominated by a slick and shallow eclecticism, as "a vast population of mediocrities – apes of different mixed breeds, a floating race of half-castes . . ." Later he would use the word *poncif* ("pounced," that is, mass-produced) to refer to academic pictures. He complained about the sentimentality of painters like Ary Scheffer. The anecdotal pictures of Horace Vernet "have nothing whatever to do with painting"; they constitute "a brisk and frequent masturbation in paint, a kind of itching on the French skin."

Yet Baudelaire was as critical of the Realists as he was of the academicians. At the Salon of 1859 – by which time certain types of Realism had gained acceptance – he deplored the self-righteous peasants in the work of François Millet, and even set Courbet side by side with the arch-academic, J. A. D. Ingres: though "obedient to different motives," their "two opposing varieties of fanaticism lead them to the same immolation." Baudelaire regarded photography, which had been developed in the 1830s and had quickly become very popular, as a mere extension and instrument of realism, a refuge for unimaginative artists. Though he admitted its documentary value and usefulness in artistic training, he believed that photography was not an art, indeed, that it was "art's most mortal enemy."

Against the evils of hollow academicism and vulgar realism Baudelaire defended Romanticism, which he succinctly defined as "a mode of feeling" characterized by "intimacy, spirituality, color, aspiration to the infinite." His great hero was Delacroix, whom he knew, and whom he called "decidedly the most original painter of ancient or modern times." Delacroix is a powerful personality, wrestling with epic themes in new ways, but also a master of subtle moods, evoked primarily through color. He is the painter of "the invisible, the impalpable, the dream, the nerves, the *soul*." It is not surprising that such a bold talent should meet with misunderstanding and resistance; his "errors" in drawing are departures intended to permit the expression of something infinitely more important.

Delacroix has what Baudelaire calls "*naïveté*" – sincerity or fidelity to one's own temperament. In contrast to the academic eclectics, Delacroix understands that it is necessary "to accept the destiny of a talent, and not to try to bargain with genius." His character shapes his view of the world, and becomes part of the content of each of his works. Though "naïve," however, and a dreamer, Delacroix is also a "man of the world"; he possesses the "divine grace of cosmopolitanism": he is responsive to variety and to beauty in all its forms; he understands that variety is "the *sine qua non* of life," and that "the beautiful is always strange." Delacroix rejects that carefully selective method of seeing, cultivated over centuries

by academic artists, and strives instead to achieve a new and unprejudiced responsiveness to the world.

Baudelaire's position is a complex one: though he detests academicism, he still believes in the ideal in a way Courbet does not; though he dislikes Realism, he argues for the need to remain observant of the world, even to engage "the heroism of modern life." Already in 1845, before Courbet had arrived on the scene, he had complained:

> No one is cocking his ear to tomorrow's wind; and yet the heroism of
> *modern life* surrounds and presses upon us . . . There is no lack of subjects,
> nor of colors, to make epics. The painter, the true painter for whom we are
> looking, will be he who can snatch its epic quality from the life of today
> and can make us see and understand, with brush or with pencil, how great
> and poetic we are in our cravats and our patent-leather boots.

Courbet was not the artist to satisfy Baudelaire's desire: his pictures were seldom concerned with urban life, and even when they were, their approach to it was unlike the poet's. Baudelaire wrote: "The life of our city is rich in poetic and marvelous subjects. We are enveloped and steeped as though in an atmosphere of the marvelous; but we do not notice it." Courbet, who is supposed to have said "show me an angel and I'll paint you one," had no interest in the integration of imaginative experience that was so essential to Baudelaire's conception of the purpose of art in the modern world.

Baudelaire's most important essay on art is "The Painter of Modern Life," published in 1863, an extended appreciation of the graphic artist Constantin Guys. The choice might seem strange, given Baudelaire's admiration for the heroic Delacroix: Guys was self-trained and active much of his career as a journalist and illustrator; he specialized in amusing, sketchlike scenes of contemporary life (figure 4.3). More than simply to celebrate Guys, however, Baudelaire uses the essay to resolve the apparent contradictions in his views, to clarify his conception of the task of art in the modern world. He begins by addressing the very traditional concept of beauty:

> Beauty is made up of an eternal, invariable element, whose quantity it is
> excessively difficult to determine, and of a relative, circumstantial element,
> which will be, if you like, whether severally or all at once, the age, its
> fashions, its morals, its emotions. Without this second element, which
> might be described as the amusing, enticing, appetizing icing on the divine
> cake, the first element would be beyond our powers of digestion or appre-
> ciation, neither adapted nor suitable to human nature.

Guys is "the painter of the passing moment and of all the suggestions of eternity that it contains." He "makes it his business to extract from

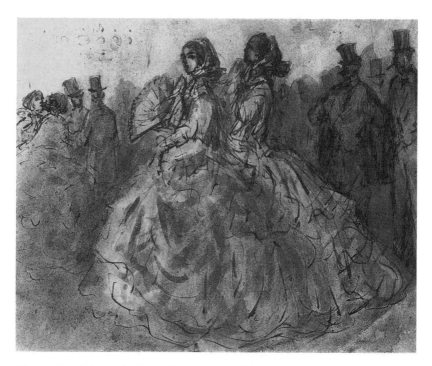

Figure 4.3 Constantin Guys, *Parisian Scene*, c.1860, Musée d'Orsay, Paris.

fashion whatever element it may contain of poetry within history, to distill the eternal from the transitory." Beauty does exist, but in order to live it must be discovered anew in the life around us; the task of modern art is specifically to reclaim beauty from modern life.

Guys is also both "naive" and a "man of the world." He has a relentless curiosity about the life around him, and an open-minded attitude toward what he sees. In this way he is fundamentally unlike a traditional kind of artist; he "does not like to be called an artist" at all, in fact, and is better described as a *flaneur*, a "loiterer," a "passionate spectator." In one passage, Baudelaire takes up and transforms the metaphor of the mirror so dear to Plato and Leonardo:

> Thus the lover of universal life enters into the crowd as though it were an immense reservoir of electrical energy. Or we might liken him to a mirror as vast as the crowd itself; or to a kaleidoscope gifted with consciousness, responding to each one of its movements and reproducing the multiplicity of life and the flickering grace of all the elements of life. He is an "I" with an inexhaustible appetite for the "non-I", which is always unstable and fugitive.

Guys has traveled widely and understands human nature comprehens-
ively: this understanding is apparent in the brilliant way he is able to
characterize different social groups, such as military men, dandies, and
women of fashion. Unconstrained by conventional morality, he extends
his interest even to prostitutes, who deserve to be represented, Baudelaire
thinks, not just because they are so numerous, but because we can see
in them "the perfect image of the savagery that lurks in the midst of
civilization."

Baudelaire also admires the artist's attentiveness to the details of dress
and cosmetics. Far from expressing any morbid condemnation of vanity,
it reveals his recognition of the fact that external adornment is "one of
the signs of the primitive nobility of the human soul": "Fashion should
thus be considered as a symptom of the taste for the ideal which floats
on the surface of all the crude, terrestrial and loathesome bric-a-brac
that the natural life accumulates in the human brain: as a sublime defor-
mation of Nature, or rather a permanent and repeated attempt at her
reformation." In the context of modern urban life, the extravagant atten-
tion to appearance characteristic of dandyism is "the last spark of heroism
amid decadence."

Though Baudelaire advocates an art of everyday life, he makes no
appeal to the authority of nature. "Nature is only a dictionary," Delacroix
had told him – an attitude that is not incompatible with traditional
academic idealism – but Baudelaire goes much further. "Nature is ugly,"
he said in an earlier essay: "I consider it useless and tedious to represent
what *exists*, because nothing that *exists* satisfies me." In "The Painter of
Modern Life," his attack on the belief that nature is "the source and type
of all possible Good and Beauty" is even more aggressive. "Nature," he
insists, "teaches us nothing":

> I admit that she *compels* man to sleep, to eat, to drink, to arm himself as
> well as he may against the inclemencies of the weather; but it is she too
> who incites man to murder his brother, to eat him, to lock him up and to
> torture him; for no sooner do we take leave of the domain of needs and
> necessities to enter that of pleasures and luxury than we see that Nature
> can counsel nothing but crime.

Though this idea is not original to Baudelaire – it is implicit in Kant's
distinction between the natural and the moral, was developed by Schiller,
and is found in very different form in the writings of the Marquis de Sade
– his statement of it has a distinctive polemical extremism: it expresses a
sense that the modern world has developed hopelessly beyond the point
where nature and the reassuring platitudes of traditional thought can

offer any guidance. Because nature is no longer the regulative principle it once was, art is all the more necessary.

Guys is an interesting figure, but not a major one, and it is often said that the artist who actually comes closest to fulfilling Baudelaire's conception of the painter of modern life is Edouard Manet. Brilliant, subtle, and rich in contradictory implications, Manet's work can be characterized as Realist, yet it is not Realist in Courbet's sense, and in contrast to Courbet's hearty activism, Manet maintained the social persona of an outwardly conforming urban sophisticate. He was something of dandy, and definitely a *flaneur*, but though he cultivated Baudelaire's friendship, the poet never wrote about him at any length.

Manet provoked a controversy in 1863 with *Luncheon on the Grass* (plate 8). Like Courbet's *Burial*, the painting deliberately confounds pictorial categories. To judge from the clothing worn by the figures, it is a modern genre scene, involving city-dwellers even though it is set in a landscape; but because the two men are dressed and the women not, the event it represents only makes sense as one of dubious propriety. Yet this arrangement – two clothed men with two unclothed women – is rather obviously derived from a famous Renaissance picture in the Louvre, *The Concert* (formerly identified as the work of Giorgione but now attributed to the young Titian). Manet seems to invoke tradition only to mock it, though he might also be seen as mocking modern academic imitators of Renaissance painting, like his own teacher Thomas Couture, whose *Romans of the Decadence* had been popularly acclaimed as a great modern masterpiece: the *Luncheon* might well be called *Parisians of the Decadence*. If audiences had been bewildered by the lack of emotional focus in Courbet's *Burial*, they were completely at a loss before this painting, in which all the elements seems to work against each other, resisting coherence at almost every level. In contrast to Courbet's blunt defiance, Manet makes use of a finely poised irony to expose all the tricks of conventional picture-making.

The deliberate awkwardness of the perspective and formulaic, prop-like quality of the landscape elements, along with the unnatural lighting, make no attempt to conceal the fact that the figures have been posed in a studio, that the natural setting is an artificial one. The painting of the figures too – especially the nude – is deliberately awkward. Titian's nudes are built up with layer upon layer of semi-transparent pigments that give a warm glow to the flesh, and are modeled in such a way as to make their bodies seem soft and inviting to the touch. Manet's nude is not only posed in an unflattering way, she is lit from the front by a harsh light, which makes her skin seem pasty and creates abrupt brown shadows. This unidealized treatment of the body seems all the more irreverent for being set against a fine still life of discarded clothes and picnic basket.

Manet's subversion of academic rules is more comprehensive and more subtle than Courbet's; his calculated effrontery is brilliantly summed up in the glances of the two figures who look out at us –as if *we* are the ones who need to explain ourselves!

Manet's first critical defender was a controversial young novelist, Emile Zola. In the aftermath of the scandal created by the exhibition of 1865 – in which Manet's *Olympia* and *Dead Christ* caused an even greater uproar than the *Luncheon* had two years before – Zola produced essays that offer an especially interesting example of a critic undertaking to champion the work of a misunderstood artist. While they are insightful, and among the most important statements of modernist values, they also oversimplify Manet and make him into a representative of Zola's own ideas.

Like Baudelaire, Zola celebrates *naïveté*: it is the evidence of the artist's temperament that gives a work its value. A work of art is "a personal mark, an individuality," "a corner of Creation seen through a temperament." "If temperaments did not exist, all paintings would simply be photographs." In a beautiful formulation that echoes Baudelaire's critique of academic eclecticism, Zola tells his readers that, in order to be an artist, "you must abandon yourself bravely to your nature and try not to lie to yourself." Yet when he says that every great artist offers us "a new and personal translation of nature," he is betraying a traditional faith in objective nature very unlike Baudelaire's.

For Zola, Manet's achievement is to have reclaimed a fundamental integrity of personal vision by shaking off his academic training. Manet wants "to see nature as it is" and to paint it "with his own vision and faculties of understanding," returning "to the exact observation of facts":

> The artist, confronted with some object or other, allows himself to be guided by his eyes, which perceive this subject in terms of broad colors which control each other. A head posed against a wall becomes only a patch of something more or less gray; and the clothing, in juxtaposition to the head, becomes, for example, a patch of color which is more or less white. Thus a great simplicity is achieved – hardly any details, a combination of accurate and delicate patches of color, which, from a few paces away, give the picture an impressive sense of relief.

The result, Zola believes, is a more honest kind of painting, one that yet has the formal integrity and refinement of the Japanese woodcuts that had become popular collector's items since the opening of trade with Japan in the late 1850s.

Zola pushes his argument for Manet's *naïveté* as far as he can. He insists that the artist should not be seen as someone trying to advance Baudelaire's agenda: "I believe that I can affirm that the painter has never committed the foolishness, practiced by so many others, of wanting to

put ideas into his paintings." This striking claim certainly suggests a still more radical departure from the academic ideal of artistic intellectuality and a confident sense of some emerging new standard, yet to represent Manet in such terms is not entirely convincing. When Zola says that the painter "tried to forget everything that he had studied in the museums," he is obviously wrong: an engagement with the traditions of high art is indispensable to a picture like *Luncheon on the Grass*. We could even say that Manet's Realism represents a critical advance over the Realism of Courbet because it is able to suggest that the real cannot simply be approached directly, but emerges only in a critical engagement with illusion. Manet proves that *naïveté* is anything but naive, that it is in fact a sophisticated critical posture, a carefully cultivated technique of opposition, a kind of counter-reason not entirely unlike the older form of reason it sets itself against.

Impressionism

Realism in French art was accompanied by the development of a kind of realism in literature, reflected in the novels of Honoré Balzac, Stendhal (Henri Beyle), and especially Gustave Flaubert, whose masterpiece, *Madame Bovary*, was published in the same year, 1857, as Baudelaire's *Flowers of Evil*, and was also condemned for indecency. Flaubert's book presented an unidealized picture of provincial society, exposing its oppressive backwardness and hypocrisy without oversimplifying the characters or situations and without overt moralizing commentary of a kind common in earlier fiction. He worked hard to achieve a rigorous objectivity, telling one of his friends that "the author, in his work, must be like God in the universe, present everywhere and visible nowhere." Many readers found the tone of the book "pitiless," and Flaubert was accused of having "dissected" his subjects with the cold impassivity of a surgeon.

Zola admired Flaubert's objectivity, and sought to carry it further in his own work; he did so by giving it a theoretical grounding in the most recent scientific thought available to him. Adapting a term much in use at the time, he called his approach "naturalism" in order to imply something more than was suggested by the term "realism." His first novel to employ these principles was composed at just the moment when he was writing his essays on Manet. When it too was criticized, he defended it by saying that his aim was a "scientific" one, a "study of temperament and of the profound modifications of the organism under the pressure of circumstances." He later came to refer to his method as "experimental," and claimed that it was preferable to all others, that it was "the modern method, the instrument of universal inquiry." He applied his theories in

a monumental series of twenty novels, written in the period 1870–93, in which he told the story of a single contemporary family: taken together, the books seek to demonstrate the effects of heredity and socioeconomic circumstance on character and behavior, and constitute an extraordinarily comprehensive and acutely critical account of French society.

The idea that literature might be practiced "scientifically" was one whose time had come. Philosophers and historians had begun to examine artistic production of all kinds, to classify and analyze it with the new tools that experimental science had provided. Zola was influenced by the eminent scholar Hippolyte Taine, who sought to explain literature as the product of what he called "race" (national, ethnic, and genetic identity), "milieu" (the structure of society), and "moment" (specific historical circumstances). The creative process itself came under various kinds of scientific scrutiny: an example – and a book that Zola knew – was the physiological psychologist Emile Deschanel's *Physiology of the Writer*, published in 1864, which discussed the peculiar, even pathological, nature of the artistic temperament. Though we may be unsympathetic in principle to the idea of approaching art scientifically – and though the science of someone like Deschanel seems quaint by contemporary standards – we should appreciate the demand for objectivity and analytic rigor as an answer to the challenge of a scientific age. The concern to integrate systematic knowledge had been a feature of much earlier art theory; in Zola, it had a political and moral dimension as well.

This dedication to the objective and scientific seems at first to be at odds with the emphasis on temperament we have seen in Zola's writings on Manet. When he says, for instance, that "in a painting I look above all for a man, not a picture," he sounds very much like Baudelaire, insisting upon the value of the artist's unique personality, but when we consider carefully, we see that his conception of this subjective element is subtly different, and influenced by Taine:

> In human creations, in works of art, I seek to find an artist, a brother, who presents nature to me under a new face, with all the power and sweetness of his personality. The work, thus seen, tells me the story of a heart and of a body, speaks to me of a civilization and of a locality.

Temperament is not just a subjective possession, but a product of the artist's circumstances, shaped by forces beyond his control; it is historically conditioned and produced. Subjectivity contains something objective – the fact, the reality of subjectivity as a limiting condition – and this is what gives it value.

This literary, scientific, and sociological background – especially this complex attitude toward subjectivity – must be taken into account when

trying to form some understanding of the theoretical issues at stake in Impressionism. On the one hand, Impressionism seems to emerge out of Realism, to deflect it away from overt political and social engagement, perhaps, but also to extend and deepen its exploration of the "real" in something like a scientific direction. In this respect, it is analogous to Naturalism. On the other hand, it seems to lead elsewhere, to involve an intensified emphasis on individual perception and temperament, and even to anticipate the radical subjectivity of Symbolism and Expressionism. Part of the problem is that Impressionism is heterogeneous: it was created by a handful of strongly individual personalities, and how one sees it as a whole depends upon which personalities one chooses to emphasize. Another problem is that none of the artists involved were much given to verbal theorizing: Claude Monet spoke for most of them when he claimed to "abhor all theory." Such statements have succeeded in diverting attention from the theoretical content of their work; they make the task of revealing the underlying theory more difficult, but no less necessary or rewarding.

Impressionism coalesced as a movement in the spring of 1874, when a group of about thirty painters and sculptors of various stylistic orientations, whose work had been frequently rejected from the Salons, banded together to exhibit on their own. Most of the controversy surrounding the show centered on a group of painters whose pictures were characterized by an unprecedented looseness and freedom of technique. One unsympathetic critic, taking particular offense at Monet's little *Impression: Sunrise*, dubbed the group "Impressionists"; the artists and their critical supporters were quick to take up the label as a *nom de guerre*, but, as the title of Monet's picture makes clear, some self-conscious involvement with "impressions" was present from the beginning. Most of the group specialized in landscapes, and acknowledged their relation to earlier landscape painting; they also recognized their debt to Realism and to Manet, though Manet did not exhibit with the group and preferred to maintain a certain distance from them. With some defections and additions, the group exhibited together just eight times, the last show taking place in 1886.

Impressionism has become so familiar to us, so much a part of our way of seeing the world, that we must really make an effort to imagine how anyone could ever have been offended by it. Standing before a picture like Monet's *Bridge at Argenteuil*, painted in 1874 (plate 9), even a viewer familiar with the history of landscape painting can believe for a moment that no one had ever "seen" nature before, or had succeeded in capturing its true appearance so well. And yet to audiences used to academic painting, or even to earlier Realist landscape painting, Monet's pictures simply looked unfinished. The emphasis on light and atmosphere

which seems to us entirely sufficient in itself, and so effective an evocation of immediate experience, struck many of them as an irresponsible evasion of more important painterly tasks like the definition of form. Some were especially irritated by the way in which, in other pictures, Monet reduced the human figure to a few patches or dots – "tongue-lickings," in the words of one critic.

Monet's own remarks tend to stress the sheer effort, the discipline, and obsessive persistence involved in painting; occasionally he seems to invoke the concept of *naïveté*. After he had become famous, he told a young American painter who had come to study with him that she should "try to forget" what the objects were that she was painting: "Merely think, here is a little square of blue, here an oblong of pink, here a streak of yellow, and paint it just as it looks to you." He then added that "he wished he had been born blind and then had suddenly recovered his sight so that he could have begun to paint in this way, without knowing what the objects were that he saw before him." At times, however, Monet's comments suggest some notion of "scientific" research: "it is by dint of observation and reflection that one makes discoveries."

Defenders of the new painting could and often did justify it by appealing to the idea of *naïveté*. Zola praised the pictures of Camille Pissarro in terms very similar to those he had used for Manet: "The artist is scrupulous, concerned only with the truth . . . he is neither a poet nor philosopher, but simply a naturalist . . ." Yet for all Zola's investment in science, he is profoundly responsive to the expressive qualities of the pictures: "In them one can hear the earth's deep voices, one can sense the powerful life of the trees."

The case for *naïveté* was also made for Monet; though perhaps because his technical skill was so extraordinary, another critical strategy seemed called for, one that gave due weight to the effect of objective truth that his pictures convey. An example is this passage by Théodore Duret:

> Claude Monet has succeeded in setting down the fleeting impressions which his predecessors had neglected or considered impossible to render with the brush. The thousand nuances which the water of the sea and rivers takes on, the play of light in the clouds, the vibrant coloring of the flowers, and the checkered reflections of foliage in the rays of a burning sun have been seized by him in all their truth. No longer painting merely the immobile and permanent aspect of the landscape, but also the fleeting appearances which the actions of the atmosphere present to him, Monet presents a singularly lively and striking sensation of the observed scene.

Other critics, such as Edmond Duranty, made more explicit connections between Impressionism and the methods of empirical science:

Proceeding by intuition, they little by little succeeded in splitting sunlight into its rays, and then re-establishing its unity in the general harmony of the iridescent color that they scatter over their canvases. With regard to visual subtleties and delicate blending of colors, the result is utterly extraordinary. Even the most learned physicist could find nothing to criticize in these painters' analysis of light.

Another critic who saw Impressionism in scientific terms was the young poet Jules Laforgue. He claimed that the Impressionist painter succeeded in "remaking for himself a natural eye, and in seeing naturally and painting simply as he sees." This Impressionist eye "can see reality in the living atmosphere of forms, decomposed, refracted, reflected by beings and things, in incessant variation"; it is, in his words, "the most advanced eye in human evolution, the one which until now has grasped and rendered the most complicated combinations of nuances known." Laforgue's view of the creative process evokes Taine and Zola: "Each man is according to his moment in time, his racial milieu and social situation, his moment of individual evolution, a kind of keyboard on which the exterior world plays in a certain way."

The Impressionists were well aware of recent scientific research on color perception. All told, the extent of their dependence on it does not seem to have been very great, but some aspects of their work reveal preconceived notions about the way color behaves as much as strict fidelity to empirical observation. The idea that complementary colors intensify each other when set side by side, for instance, had been carefully examined in Michel-Eugène Chevreul's *On the Law of the Simultaneous Contrast of Colors*, published in 1839, and his findings had been reported, along with other color lore, in Charles Blanc's *Grammar of Painting and Engraving* of 1867. Monet's extensive use of deep blue or violet in shadows, especially in his early work, may also have owed something to scientific studies. Earlier painters, such as Delacroix, had shown an intuitive grasp of these principles, and it must be said that the scientific literature hardly anticipates all the ways in which someone like Monet made use of them; still, his claim to "abhor" theory must be regarded as a bit of posturing.

Not all the early critics saw Impressionism in scientific terms; some stressed its subjective, "temperamental" quality. One of its first defenders, Emile Blémont, said of the new painters: "They do not imitate; they translate, they interpret." Jules-Antoine Castagnary, an old supporter of Courbet's, had an ambivalent response to the Impressionists: "they do not render the landscape, but the sensation produced by the landscape . . . Thus they take leave of reality and enter the realm of full idealism." In other words, Castagnary perceived a dangerous turn *away* from the real, an involvement with one's own personal responses that savored of

Romanticism. Laforgue, too, recognized a subjective element: a painter simply cannot work fast enough to achieve real immediacy; his temperament goes through rapid alterations – even if he paints a picture in a quarter of an hour. Painting involves a complex, high-speed exchange between object and subject: "Object and subject are then irretrievably in motion, inapprehensible and unapprehending." The "genius" of Impressionism lies in its "flashes of identity between subject and object."

The term "impression" had a very specific meaning in nineteenth-century theories of perception, one that goes a long way toward explaining the tensions between the objective and subjective aspects of Impressionism. In an essay of 1860, the physiological psychologist Emile Littré used "impression" to describe the point of contact between external reality and the individual percipient: it is something "primordial," "neither the subject nor the object, neither the self nor the nonself." It is thus the origin both of objective knowledge and of subjectivity; it is something that exists prior to consciousness, to the moment when subject and object are distinguished. Some of these ideas were also treated in Taine's widely read *On Intelligence*, first published in 1870. Taine does not use the word "impression," but does discuss "sensation" in similar terms: most strikingly – reminiscent of Monet's remark to his American student – he compares the way in which blind people who recover their sight at a mature age experience perceptual confusions similar to those of small children. The "impression" thus provides a means of reconceiving the relation of the individual to the world; to cultivate an art based on impressions is to pursue a primal, pristine, truly "naive" – we might say "unconscious" – reality.

A picture like *Bridge at Argenteuil* obviously sets a new standard of optical description, but there is also much more going on in it. The composition is arranged so that the background sky is reflected in the foreground water; with the near shore cut off, an effect of flatness is created like that of Japanese prints. The thick, unblended brushstrokes create a rich texture which, even as it intensifies the immediacy of the sensation, forces one to attend to the picture as a painted surface. As insistently painterly as a Manet, the overall effect is more decorative: we might say that it gestures in two directions at once – toward optical truth and toward decorative autonomy and beauty – and that these two qualities support and enhance each other.

Monet's subsequent work productively develops this very two-sidedness: he actually intensifies both his research into appearances and his decorative effects. The process comes to its climax in his *Nymphéas*, the large, scroll-like pictures of his water-lily pond (plate 10), begun around the turn of the century and continued up until his death in 1926. Some of these canvases were intended to fill entire rooms – easel pictures that yet

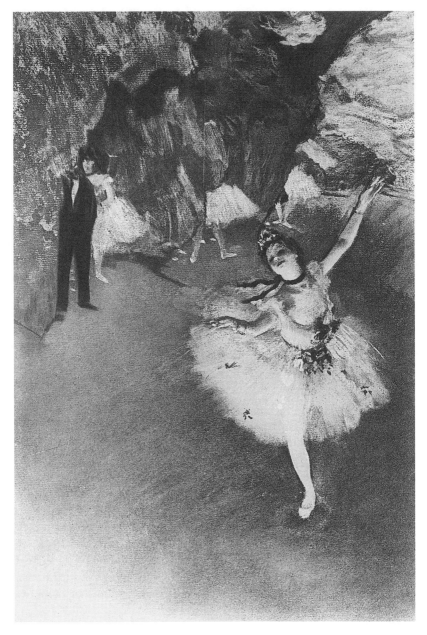

Figure 4.4 Edgar Degas, *Dancer on Stage: The Star*, c.1876, Musée d'Orsay, Paris.

manage to have something like the decorative effect of Japanese screens. On one level, they represent Monet's obsessive return to the difficult descriptive challenge of water, but they also go far beyond description: we often cannot tell exactly what we are looking at – whether it is the surface of the pond or its depths or the reflected sky – and return again and again to the realization that what we are looking at is painting itself, strokes and patches of color that seem to have a logic of their own, that suggest some personal calligraphy. We realize that nature is both an object of study and a point of departure, that the line between seeing and feeling, between the outer and the inner world, has been obscured.

Though Monet is thus sometimes said to have shifted emphasis over the course of his career – from the description of nature to the expression of internal states – the interdependence of these two ambitions was implicit in Impressionism from the beginning and present in the scientific thought most closely related to it. Taine's *On Intelligence* had also undermined the distinction between objective and subjective reality, between reality and reverie. All consciousness is "hallucinatory," Taine asserts: "true hallucinations" are simply those that seem to be verified through continuing contact with the external world. "Our external perception is an internal dream which is found to be in harmony with external things; and instead of saying that hallucination is a false external perception, it is necessary to say that external perception is a *true hallucination.*"

Monet's late work seems to provide a visual equivalent to this idea, yet he always maintained the importance of engaging nature. As a very old man, he told a visitor to his garden: "How many times I have remained for hours near the little bridge, exactly where we are now, in the full glare of the sun, sitting on my camp-stool under my sunshade, forcing myself to resume my interrupted task and to capture the freshness my palette had lost." The recovery of authentic perception and experience, of true *naïveté*, demands the most intense discipline. Laforgue's strikingly paradoxical formulation that the Impressionist is "remaking for himself a natural eye" gives a good indication of the daunting complexity – even the fundamental impossibility – of the process involved. Since the days of Alberti and Leonardo the artist's work had involved sustained engagement with nature: in Monet, one senses the pace of that work having accelerated, become more urgent, even desperate. In producing images of nature, the artist affirms his own existence; he produces himself. If Impressionism is an exploration of the conditions of subjectivity, it is also a method for producing subjectivity, and can be seen as a response to the deep anxieties exposed by the pressures of modern life.

Edgar Degas was less interested than Monet in the challenges of landscape painting; his work is dominated by urban themes, and most of them, such as his famous studies of the ballet (figure 4.4), are interiors.

For this reason, he seems closer in spirit to Manet than any of the other Impressionists, and perhaps more self-consciously guided by Baudelaire's program for the painting of modern life. His distinctive mode of composition – with figures placed off-center, often clustered in the extreme foreground and distant background, sometimes cut off by the frame – situates the viewer in the scene and creates an effect of immediacy, of "natural" vision; at the same time it is carefully calculated, elegantly poised, and subtly expressive. Forced to adopt the artist's physical position, the viewer enters into his subjective disposition as well.

Where most of the Impressionists were concerned with color and brushstroke, Degas managed to transform drawing – a skill closely identified with academic art – into an instrument of temperament; we might even say that he made drawing modern. He told his friend, the poet Paul Valéry, that "drawing is not the same as form, it is a way of seeing form." The spatial tensions that his drawing creates capture something of the poetic quality of modern life but also register the subtlest psychological tensions. Part of their resonance certainly has to do with the fact that many of them – scenes of women bathing and of brothels, as well as of ballet rehearsals – evoke the theme of voyeurism, and are charged with complicated ambivalences toward women. In his work one is especially aware of the fact that any impression has a pathological as well as lyrical dimension.

Another member of the original Impressionist group was Paul Cézanne, an example of whose early mature work is *Bridge at Maincy* (figure 4.5), painted in 1879–80. Cézanne's scene involves some of the same painterly challenges – foliage in sunlight, reflections in water – that Monet had faced in *Bridge at Argenteuil*, but where Monet concentrated on surface effects, Cézanne seeks out an underlying structural armature. The picture is built up with very similar kinds of brushstrokes, as if he wanted to reduce all elements of the scene to a single material, and there is even a reduction of coloristic complexity: shadows between the trees and in the water are the same color as the tree trunks. The strokes are set down in a manner that has the patient, accumulative quality of brickwork, and that, as a result, gives the picture a subtle, yet powerful effect of structural integrity. Instead of Monet's facile brilliance, we have a hard-won struggle between the demands of objective description and the desire to give the picture a life of its own, an independent existence and value.

This struggle continues throughout Cézanne's career, leading to bolder interpretative departures from what he sees before him. In one of his late works, *Mont Sainte-Victoire* (plate 11), painted between 1902 and his death in 1906, the process of rendering the scene has yielded powerfully simplifying controlling gestures, such as reducing the composition to a

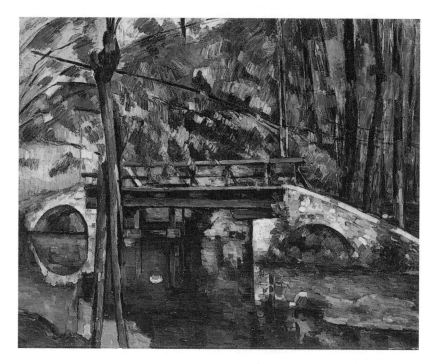

Figure 4.5 Paul Cézanne, *Bridge at Maincy*, 1879–80, Musée d'Orsay, Paris.

rectangle surmounted by a triangle. The foreground forms suggest trees, houses, and roads, but their descriptive function is minimal, subordinated to the task of contributing to the overall structure. The green patches in the sky probably derive from the overhanging branches of trees in the extreme foreground, but Cézanne makes no effort to explain them as such; their presence is justified by their function of integrating the upper and lower parts of the picture, foreground and background. The overall result has the quality both of an objective truth wrested from nature and of an exultant affirmation of something deeply personal; it is as if, after a long and dedicated search, the artist has discovered an integrity in the outside world that answers the immensity of his own inner need.

Cézanne's "theory," his remarks on art, come to us from two kinds of sources: his letters, and recollections by others of his conversation. The letters can be taken as reliable reflections of his ideas, but they are often terse and vague in ways that suggest real impatience with the task of writing about difficult things; what he chooses to say in them also seems to depend a good deal on the addressee. The recollections vary greatly in reliability, and in some cases have to be dismissed as creative elaborations.

Appealing as it is to imagine, for instance, Cézanne may never have said: "Monet is only an eye, but good God, what an eye!" The most recurrent themes in his letters are the difficulties and frustrations of trying to realize his vision, and the absolute need for continual, concentrated study of nature: the other sources are probably best judged by the degree to which they reflect those concerns.

One of the more reliable attributions is the remark made to a friend that the challenge of being a painter is in trying "to see like a man who has just been born." On the other hand, he did advise a young artist to "treat nature by the cylinder, the sphere, the cone." There is reason to doubt whether he ever said that he wanted to "do Poussin over again from nature," or that he wanted "to make Impressionism something solid and lasting like the art of the museums," but these remarks are close enough in content to things he wrote or that are reported by several sources to be accepted as expressing something like his real thoughts.

The most voluble Cézanne emerges from a very unreliable post-humous account by his friend Joachim Gasquet. The remark that "art is a harmony parallel to Nature" does correspond to other expressions of the idea that there are limits to what painting can accomplish in capturing natural light and color, and that a picture must thus be different from, and independent of, nature. The belief that the artist's study of nature demands the most intense selflessness also tallies with things Cézanne said elsewhere, even if Gasquet embellished it in an implausibly poetic way: "He must silence all the voices of prejudice within him, he must forget, be silent, become a perfect echo. Then the entire landscape will engrave itself on the sensitive plate of his being." And wonderful as it is, much as it seems to express what we think Cézanne is about – and, we should note, how very like Schelling it sounds – we must be doubtful of the remark: "The landscape reflects itself, humanizes itself, thinks itself in me."

The real voice of Cézanne can be heard in a letter written to his son a few weeks before Cézanne's death:

> Anyhow, I must tell you that as a painter I am becoming more lucid with regard to nature, but in my own mind the realization of my feelings is still very difficult. I can't manage to achieve the intensity my senses feel . . . Here on the river bank, there are so many motifs, the same subject seen from a different angle offers a subject of the most compelling interest, and so varied that I believe I could work away for months without changing position but just by leaning a little to the right and then a little to the left.

Here we have the same obsessive singlemindedness as with Monet, and the same – very traditional – humility before nature.

If Impressionism poses a difficult interpretative challenge, then an added complication is the emergence of what came to be called "Neo-Impressionism." The picture that best exemplifies this development is *Sunday Afternoon on the Isle de la Grande Jatte*, by Georges Seurat (plate 12), which created a sensation at the last Impressionist exhibition in 1886. The painstaking technique popularly dubbed "pointillism" (Seurat preferred to call it "chromo-luminarism"; his associate Paul Signac preferred "divisionism") in which small spots and patches of bright color are set side by side, is often said to make the picture even more successful at the description of brilliant outdoor light than those of earlier Impressionists, but it also dissolves form and renders details indistinct. Seurat has heightened the unreality of the overall effect by posing figures rather rigidly, at right angles to one another, and reducing them to near caricature.

Seurat was deeply interested in color theory, and seems to have studied whatever in the way of scientific research he could get his hands on: Chevreul and Blanc, but also the work of Hermann von Helmholtz, and the American physicist Ogden Rood's *Modern Chromatics*, translated into French in 1881. He died in 1891, in his early thirties, and left few hints regarding his aims, but the best evidence suggests that he wanted to give Impressionism something like a definitive, theoretically consistent, "scientific" grounding. Yet he was keenly aware of the distance between art and nature, and of the obligation of art to pursue a "harmony" independent of nature. He is supposed to have told one of his friends that in the *Grande Jatte* he had wanted to show modern Parisians "in their essential aspect" and make them look like the figures in ancient reliefs; that is, perhaps, to distill a timeless beauty from the everyday in the manner recommended by Baudelaire. This attenuated combination of intensified scientism and poetic idealism made him very popular for a time with the fashionable poets who had taken to calling themselves Symbolists.

Seurat's subsequent work was influenced by the theories of an eccentric polymath, Charles Henry, whose *Introduction to a Scientific Aesthetics* was published in 1885. Henry proposed a "psychophysical aesthetics," a systematic approach to the ways in which formal elements such as line and color affect viewers; he also sought to analyze the relationship between the effects of visual forms and musical sounds. Seurat's application of Henry's principles yields results even stranger than the *Grande Jatte*, highly stylized images of popular Parisian entertainments involving music, which suggest that the artist saw himself as "composing" in paint, trying to fashion a kind of painting that could register musical effects.

With his labored painterly method, Seurat carries the critique of *naïveté* much further than any of the other Impressionists: only an objectified,

de-personalized "temperament" – a kind of anti-temperament – can see the world this way. The conspicuous artificiality of his work seems to move away from whatever traditional faith in direct engagement with nature still clings to the aged Monet or Cézanne: it works to deconstruct any practice based on the opposed, yet mutually reinforcing categories "nature" and "artist." It recalls Baudelaire's belief that nature is obsolete and points toward the art of the twentieth century.

"Absolute Art Exists at Last"

Impressionism was a movement confined almost entirely to painting; Symbolism, on the other hand, was the name of a literary movement that was soon also used to denote a variety of developments in the other arts. Though it began in Paris, announcing itself with a manifesto in 1886, its influence was quickly felt in other centers and it soon achieved the ubiquity of an international movement as well as one affecting all forms of expression. The Symbolists themselves were partly responsible for this process: they were eager to demonstrate the deep pervasiveness of their principles in all kinds of creative work, and tended to claim any work with similarities to theirs as in some way a part of their movement – even when it was produced independently. Symbolism was not a single style, but a set of principles or a creative strategy that embraced a wide variety of styles. Our account of it will have to be very selective, and while we must acknowledge its range and extent, we must try to be even more attentive to its depth: only such an approach can suggest something of the real importance of Symbolism – of the way in which it gathered earlier developments into itself and shaped those that were to come.

Symbolism began as a reaction to Realism and especially to Zola's Naturalism. In the most general terms, it involved a redirection of literary interest away from the representation of material and social reality toward an exploration of subjective experience. One member of the original Parisian group, the poet Gustave Kahn, wrote that "The essential aim of our art is to objectify the subjective (the externalization of the Idea) instead of subjectifying the objective (nature seen through a temperament)." This aim can be seen as involving a return to idealism: some Symbolists seem to have been genuine idealists, but, for most, the "ideas" in question are not ideas in the Platonic sense: they are the products of individual human minds and need be no more than illusions; to the extent that they are shared, they have something like the cultural value of myths. Kahn believed that his form of idealism was supported by "scientific theories, inductively built up and experimentally confirmed,"

and that these theories permit one to "reject the reality of matter and only admit the existence of the world as a representation." To invoke experimental science in support of a philosophical position obviously derived from Schopenhauer may seem rather specious to us, yet it indicates the importance attached to the reconciliation of objective, rationally determinable truth with the intuitive truth of subjective experience. The same ambition may lie behind Seurat – and, in fact, Kahn invokes the authority of Charles Henry to support his views. If Symbolism is to be regarded as a strategy, then it might be described as a *modern* strategy – a technique – for reclaiming the irrational.

More essential than idealistic philosophy was the legacy of Baudelaire: all the poets of the original Parisian group thought of themselves as his followers. Before they settled on the name Symbolists, one of their number, Paul Verlaine, referred to them as "*poètes maudits*"; they had also styled themselves "decadents." The name Symbolism comes from Baudelaire's poem *Correspondences*, which is both an example of the kind of writing that the Symbolists admired and the expression of an important Symbolist idea:

> Nature is a temple, and her living pillars
> Sometimes let slip confusing words;
> Man passes through this forest of symbols,
> While all around they watch him, knowingly.
>
> Like lingering echoes from distant places,
> Reverberating together in an obscure, deep harmony,
> Vast as darkness and as day,
> Odors, colors, and sounds respond to one another.

The poet wanders through the world as through a dark forest; in the absence of any divinely ordained meaning, however, he must try to make sense of life by attending to the resonance of his own experience, to the ways in which certain things come to be charged with greater significance than others – a significance that often has nothing to do with their practical function and that seems to elude understanding. Such experiences imply a world beyond the world accessible to rational consciousness.

Though Baudelaire himself and many of the Symbolists had an interest in conventional symbols and symbol systems – and though this interest was not unmixed with a "spiritualist" interest in the possibility of combining or superimposing such systems to create a universal symbolic language – there was less faith in systematicity than fascination with the ways in which, in the course of one's own particular experience, the

unlikeliest things might acquire a significance that defies rational explanation.

The Symbolists perceived that language is not a perfect medium for the expression of ideas, but something with a life of its own: it often fails to say what we think, yet it just as often says something more than we think. Symbolist poets were fond of arranging words in such a way that the sounds created their own "music," suggesting a meaning independent of the conventional meaning. They thus disengaged language from its utilitarian, rational function, turning it on itself, as it were, and implied through their practice that the truth of things could only be revealed by such a process of deliberate subversion – a *critical* process in which language might come to grips with its own limitations, yet manage to suggest something beyond saying.

Symbolist poets took up the challenge of this situation in a variety of ways. On the one hand, there was the brilliant and reckless Arthur Rimbaud, who, writing at the age of seventeen, embraced the Baudelaireian sense of opposition and charged it with violent intensity, arguing that the poet must become a "seer" (*voyant*), a "thief of fire":

> The poet makes himself a *seer* by a long, prodigious, and rational *disordering* of *all his senses*. Every form of love, of suffering, of madness; he searches himself, he consumes all the poisons in him, and keeps only their quintessences. This is an unspeakable torture for which he needs all his faith and superhuman strength, and during which he becomes the great sufferer, the great criminal, the great accursed – and the great learned one! – among men. – For he arrives at the *unknown*!

On the other hand, there was the consummately urbane Stephane Mallarmé, writing essays on fashion and ballet as well as on art, and dedicating his poetry to exquisite subtlety, to the search, as he put it, for the one flower "absent from all bouquets," the mysterious object, unlike anything in nature, that language alone can evoke.

Music played an important role in Symbolist attempts to redefine the expressive capacity of poetic language and visual art. Earlier Romantic notions of "pure" or "absolute" music, which celebrated the medium's capacity to be both non-representational and profoundly expressive, to evade the rational, yet say something deeply "true," were revived in the Symbolist notion of "pure poetry," and painters explored the ways in which formal elements such as color might be used "musically" – independently of their descriptive function – to create a "pure" painting. An influential figure in this process, oddly enough, was Richard Wagner: though he did not advocate pure music – in fact he tried to replace traditional opera with a wholly integrated form of "music-drama," a "total artwork"

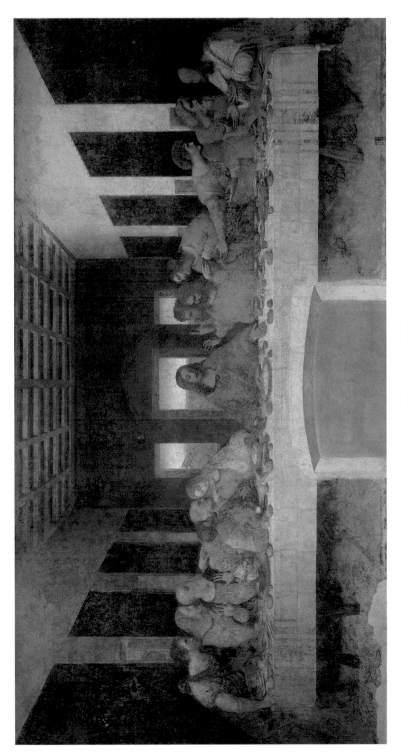

Plate 1 Leonardo da Vinci, *Last Supper*, 1495–7, Santa Maria delle Grazie, Milan.

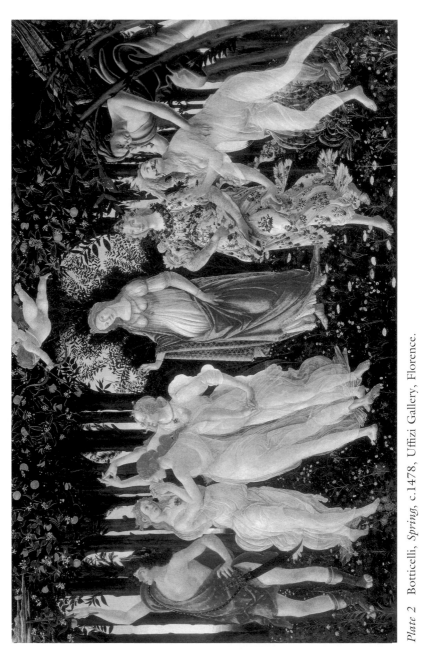

Plate 2 Botticelli, *Spring*, c.1478, Uffizi Gallery, Florence.

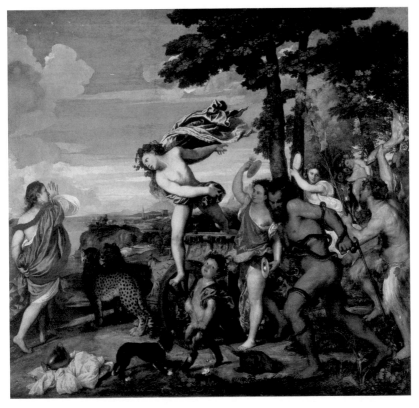

Plate 3 Titian, *Bacchus and Ariadne*, 1522–3, National Gallery, London.

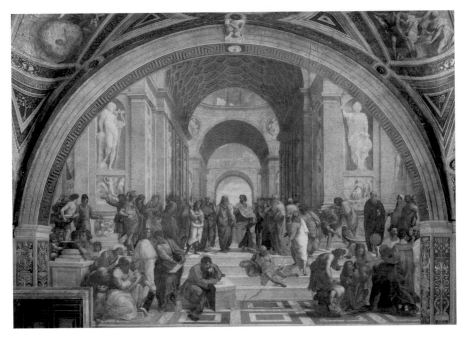

Plate 4 Raphael, *Philosophy* (the so-called *School of Athens*), 1509–10, Vatican Museum, Vatican City.

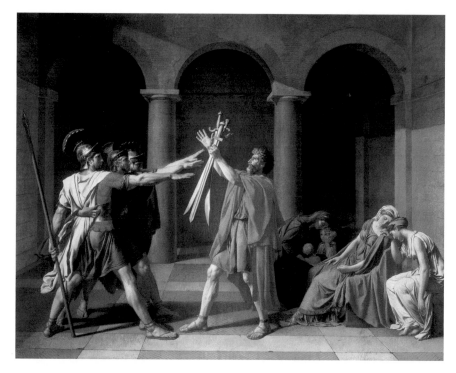

Plate 5 Jacques-Louis David, *Oath of the Horatii*, 1784, Louvre, Paris.

Plate 6 Eugène Delacroix, *The Death of Sardanapalus*, 1827, Louvre, Paris.

Plate 7 Gustave Courbet, *Burial at Ornans*, 1849–50, Musée d'Orsay, Paris.

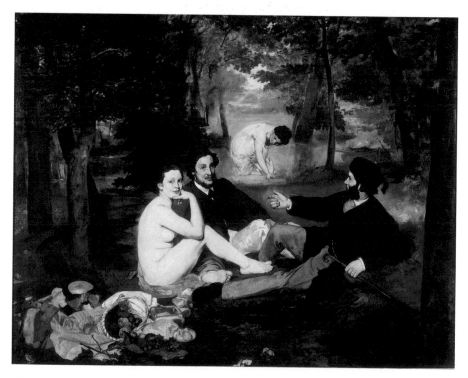

Plate 8 Edouard Manet, *Luncheon on the Grass*, 1863, Musée d'Orsay, Paris.

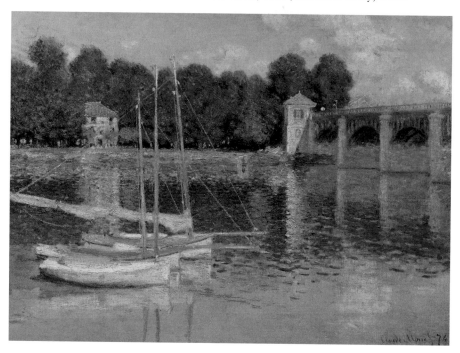

Plate 9 Claude Monet, *Bridge at Argenteuil*, 1874, Musée d'Orsay, Paris.

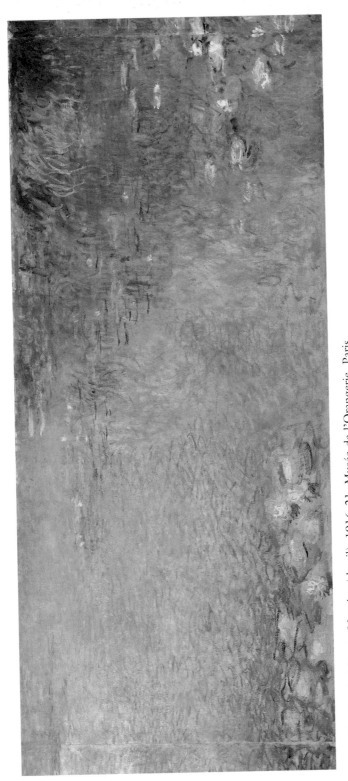

Plate 10 Claude Monet, *Morning* (detail), 1916–21, Musée de l'Orangerie, Paris.

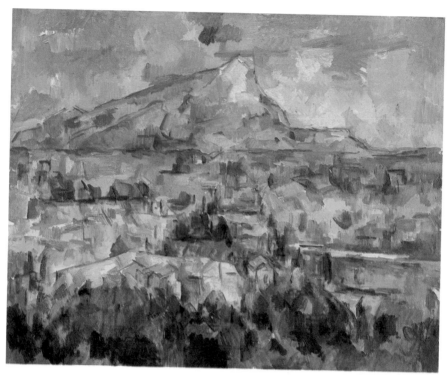

Plate 11 Paul Cézanne, *Mont Sainte-Victoire*, 1902–6, Philadelphia Museum of Art.

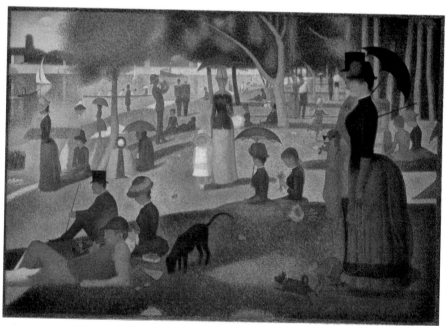

Plate 12 Georges Seurat, *Sunday Afternoon on the Isle de la Grande Jatte*, 1884–6, Art Institute of Chicago.

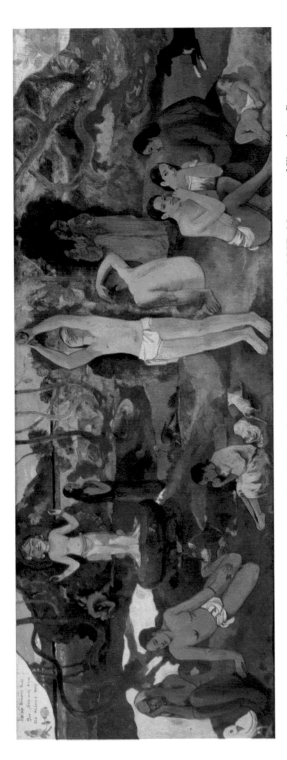

Plate 13 Paul Gauguin, *Where Do We Come From? What Are We? Where Are We Going?*, 1897, Museum of Fine Arts, Boston.

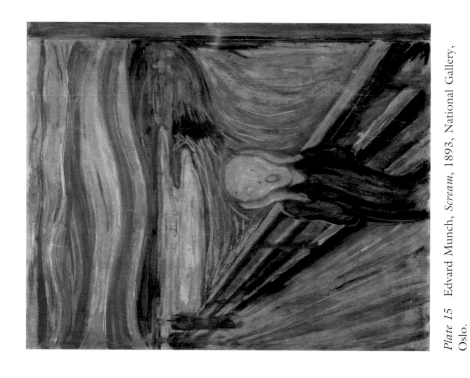

Plate 15 Edvard Munch, *Scream*, 1893, National Gallery, Oslo.

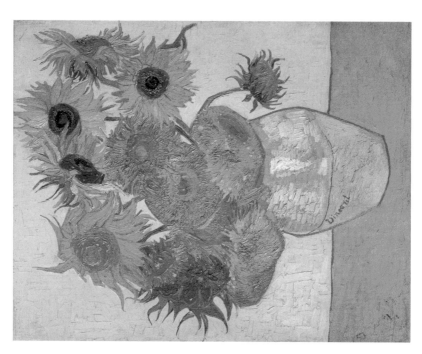

Plate 14 Vincent Van Gogh, *Sunflowers*, 1888, Neue Pinakothek, Munich.

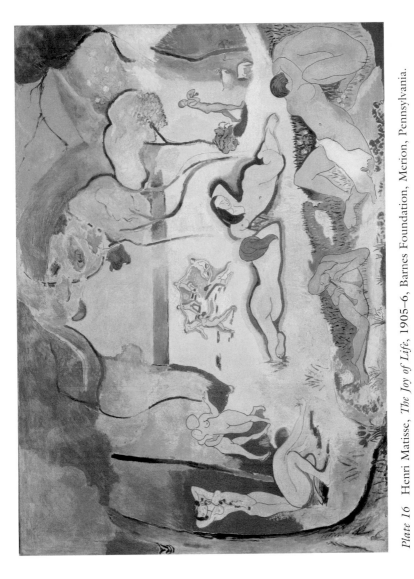

Plate 16 Henri Matisse, *The Joy of Life*, 1905–6, Barnes Foundation, Merion, Pennsylvania.

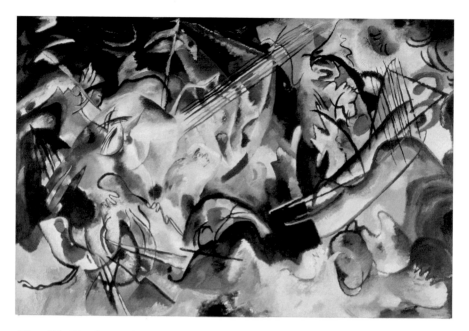

Plate 17 Wassily Kandinsky, *Composition VI*, 1913, Hermitage, St Petersburg.

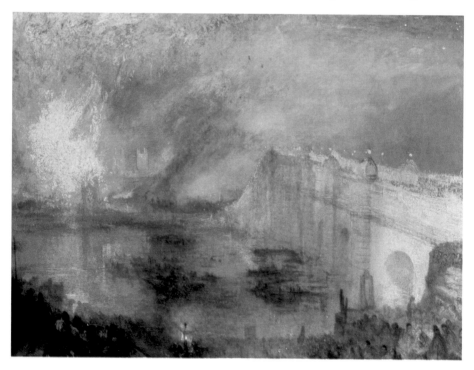

Plate 18 J. M. W. Turner, *The Burning of the Houses of Parliament*, 1835, Philadelphia Museum of Art.

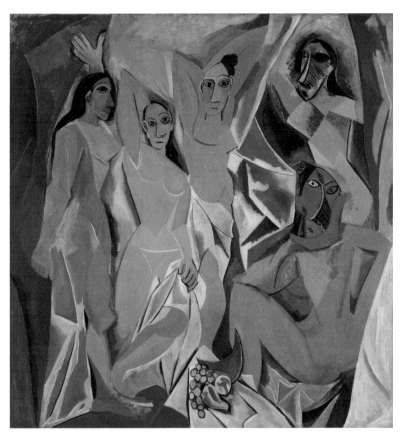

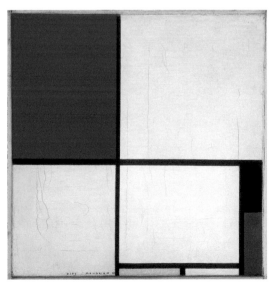

Plate 19 Pablo Picasso, *Les Demoiselles d'Avignon*, 1906–7, Museum of Modern Art, New York.

Plate 20 Piet Mondrian, *Composition with Red, Yellow, and Blue*, 1928, private collection.

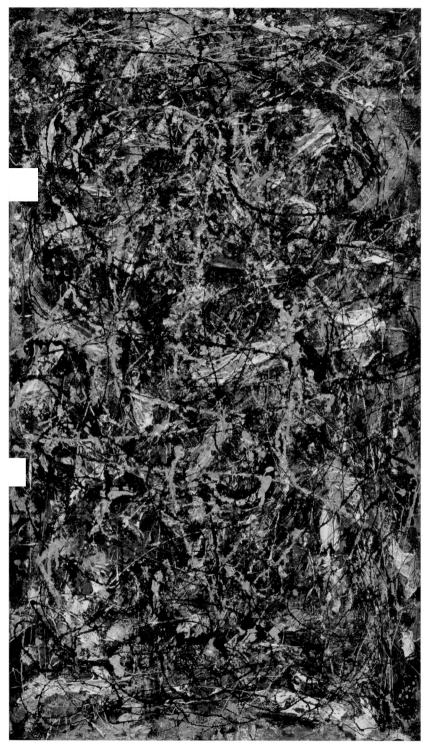

Plate 21 Jackson Pollock, *Full Fathom Five*, 1947, Museum of Modern Art, New York.

Plate 22 Barnett Newman, *Vir heroicus sublimis*, 1950–1, Museum of Modern Art, New York.

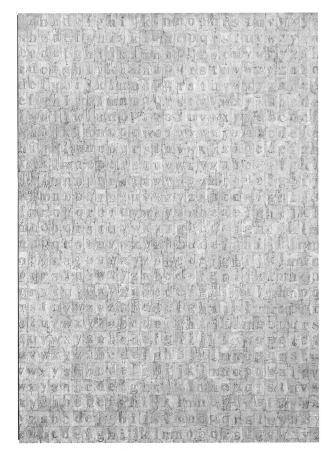

Plate 23 Jasper Johns, *Gray Alphabets*, 1956, Menil Collection, Houston.

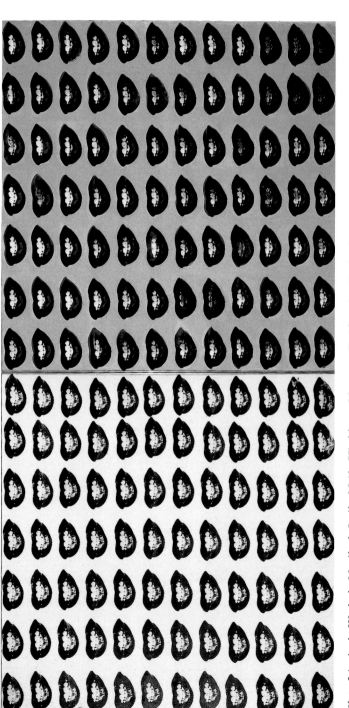

Plate 24 Andy Warhol, *Marilyn's Smile*, 1962, Hirshhorn Museum, Smithsonian Institution.

(*Gesamtkunstwerk*), combining dramatic poetry, music, dance, and the visual arts of painting, sculpture, and architecture – his work seemed to many to demonstrate the primacy and power of music in a wholly new way. More than theater in the conventional sense, Wagner envisioned music-drama as a kind of secular sacrament, and the dramatist-composer-designer as the secular equivalent of a priest. In one of his essays, he argued that art salvages the essence of religion for the modern world: "the mythical images which religion would wish to be believed as true are apprehended in art for their symbolic value, and through ideal representation of those symbols art reveals the concealed deep truth within them."

One of Wagner's most ardent admirers was the philosopher Friedrich Nietzsche, whose first book, *The Birth of Tragedy from the Spirit of Music*, published in 1872, was dedicated to the composer. Nietzsche claims that "It is only as an *aesthetic phenomenon* that existence and the world are eternally *justified*." Art is "the highest task and properly metaphysical activity of this life." He would go on to evolve a radical project of his own – an overthrow of traditional metaphysics and morality and the establishment, in their place, of a "philosophy of the future" – in which this enlarged and exalted conception of art plays an important role. His elevation of art into a principle governing the entire conduct of life looks back to the early Romantics – Novalis had said that poetry is "the peculiar mode of action of the human spirit" – and is contemporary with Mallarmé's declaration that poetry is "the only spiritual task" there is. Yet Nietzsche was also capable of saying that "we possess art lest we perish of the truth," insisting, even more forcefully than Schopenhauer, that our creative activity has value only because our need for illusion is the truth of our nature.

It is tempting to characterize Symbolism in the visual arts as a turning away from Impressionism, like the poets' turn away from Zola; in some respects it is, but in more important ways it is not. The poet Kahn compared his own free verse to Impressionist brushwork; Mallarmé identified Manet and the Impressionists together as inspirations for his own poetic practice, and we may observe that no artist comes closer to him in spirit than Degas. Some of the art most admired by the Symbolists – such as the extravagant fantasies of Gustave Moreau or the more intimate, hallucinatory images of Odilon Redon – is radically unlike Impressionism, and, among the artists who identified themselves as Symbolists, some sought inspiration in primitive folk art, while others thought of themselves as neo-traditionalists, returning to the ideals of the academy. Though Cézanne and Seurat, as well as Paul Gauguin and Vincent Van Gogh were all claimed, at one time or another, for Symbolism, none of them seems to have been entirely comfortable with the idea, and they went on referring to themselves as Impressionists.

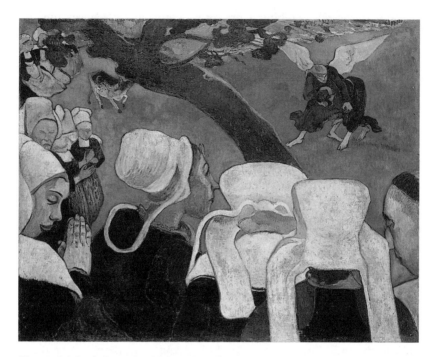

Figure 4.6 Paul Gauguin, *Vision after the Sermon: Jacob Wrestling with the Angel*, 1888, National Gallery of Scotland, Edinburgh.

Gauguin was the artist whom the Symbolists regarded as the most creative exponent of their ideas. After having begun to paint in association with the Impressionists, he left Paris to live in the artists' colony of Pont-Aven, in Brittany, where he developed a distinctive style of his own, featuring simplified drawing and flat zones of strong, often unnatural colors. In 1888 he painted his "breakthrough" picture, *Vision after the Sermon: Jacob Wrestling with the Angel* (figure 4.6). Departing from a straightforward depiction of Breton scenery and daily life, he attempts to represent two levels of reality: the local women, returning from church, and their "vision." The deliberately crude drawing and spatial construction, along with the stark simplification of the color scheme, are clearly not the product of any attempt to register "impressions," but rather of an interaction between some external stimulus and a powerfully charged subjective state; they describe a superimposition of internal reality onto external reality, of "vision" in the spiritual sense onto vision in the ordinary sense. Gauguin evidently wanted to capture the "primitive" state of mind in which belief is possible: he said he had striven for "a great simplicity, rustic and *superstitious*."

For a time, at least, Gauguin called his approach "Synthetism." On the simplest level, it seems to have involved deliberately distancing himself from immediate sense impressions. He advised a fellow artist: "Do not paint too much after nature. Art is an abstraction; derive this abstraction from nature while dreaming before it, and think more of the creation that will result than of nature." It also involved a willful selectivity from the observed scene, a "synthesis of form and color derived from the observation of the dominant element only." Some idea of what it involved in practice can be gathered from the report of a younger painter, Paul Serusier, who painted a landscape under Gauguin's direct supervision: "'How do you see this tree?'," Gauguin asked, "Is it really green? Use green then, the most beautiful green on your palette. And that shadow, rather blue? Don't be afraid to paint it as blue as possible." Far from what it had been for Monet or Cézanne, nature is simply a point of departure.

Gauguin's approach was actually a good deal more cerebral than such remarks suggest. He had absorbed much sophisticated conversation in Paris, and in Pont-Aven he worked closely with a precocious and theoretically inclined painter, Emile Bernard. In an early letter, he mentions his concern with the problem of translating thought into a medium other than language: because sense impressions reach the brain directly, it should be possible to create a visual language that would affect the mind directly. He may have been influenced by the widely publicized experiments of the clinical psychologists J. M. Charcot and Hippolyte Bernheim on hypnotized hysterics – experiments that also attracted the attention of the young Viennese psychologist Sigmund Freud – in which the efficacy of color as a means of suggestion and manipulation were noted, as well as the tendency of patients to "externalize" inner visions, to behave as though what they were imagining was actually taking place in front of them. The term "Synthetism" itself seems to derive from German philosophy, perhaps from Friedrich Lange's *History of Materialism*, a much-discussed book, originally published in 1866: for Lange, as for Kant, "synthesis" is the principle by which the mind organizes sense perception and relates it to the internal representations of abstract thought.

Gauguin even absorbed some of Wagner's ideas, and a few of his remarks seem like responses to them:

> Painting is the most beautiful of the arts; in it all sensations are condensed; a complete art which sums up all the others and completes them. Like music it acts on the soul through the intermediary of the senses, the harmonious tones corresponding to the harmonies of sounds, but in painting, a unity is obtained which is not possible in music. The sight takes in everything and at the same time simplifies at its will.

Gauguin was also wrestling with the intensity of emotional life and the problem of emotional expression in art: "Any idea may be formulated, but not so the sensations of the heart. What efforts are needed to master fear, or a moment of enthusiasm! . . . Thinking is a slave of sensation." This last remark brings him very close to Nietzsche, and it is tempting to see Gauguin as the nearest thing to a Nietzschean painter.

Though Gauguin was fully aware of having taken a step toward the formulation of a pictorial Symbolism, he seems to have regarded this step as implicit within Impressionism. In 1891, however, the critic Albert Aurier published a kind of manifesto of Symbolism in painting, and identified Gauguin as its leading figure. For Aurier, Gauguin's art is "diametrically opposed" to Impressionism, and concerned with the expression of the Idea (he describes it as "idea-ist," to distinguish it from traditional academic idealism). Gauguin and his followers represent "a return to a simple, spontaneous, and primordial art." They "read the abstract significance of every object," they "use objects as a sublime alphabet." "With this gift, symbols, that is, ideas, rise from the darkness, animate, begin to live with a life that is no longer our contingent and relative life, a dazzling life that is the essential life, the life of art, the being of being. With this gift, complete, perfect, absolute art exists at last."

Though he had begun to receive recognition as the leader of a new movement, Gauguin was unsatisfied with the circumstances of his life in France and he decided to remove himself as far as possible. He made a trip to Tahiti in 1891–3, settling permanently in the South Pacific in 1895. Weariness and disgust with European culture were not uncommon – the popular British writer Robert Louis Stevenson had made a much-publicized move to Samoa in 1888 – but Gauguin's gesture of rejection has a deliberate, "symbolic" quality: his search for a place where he might engage in deep, original, and productive dialogue with something radically different – discover the "unknown," in Rimbaud's sense – can be seen as a kind of *critical* gesture typical of modernism, one that seems to fall exactly midway between the Romantic fascination with the exotic and our own contemporary sense of living in a multicultural world. His most ambitious picture, and the one that perhaps best reflects the depth and complexity of his aims, is *Where Do We Come From? What Are We? Where Are We Going?*, which he painted in 1897 (plate 13). He intended it as a kind of testament and made an unsuccessful attempt at suicide after finishing it.

Writing to a friend a few years later, after the picture had been exhibited in Paris, he described it as the product of a "dream." He did not mean this claim to be taken literally, since the figures are borrowed quite carefully from his earlier work; he wished rather to emphasize the psychological depth from which it sprang and its irreducibility to rational

language. There are no conventional symbols which would allow one to read it as an allegory: "it is a musical poem, it needs no libretto," he said. Though there is no narrative in the usual sense either, the arrangement of figures – with the infant at the right and the old woman at the left – suggests a life cycle, one that hinges on the action of the central figure, plucking fruit from a tree. Gauguin must have witnessed such a gesture frequently; it comes from his observed experience, but it is also charged with the full weight of religious associations connected to the Judeo-Christian story of the Fall of Man. He must also have seen women stare at him, but the repetition of female figures looking out at the viewer evokes Baudelaire's image of the symbols that regard him knowingly. Yet it would be hard to say what the picture as a whole "means": Gauguin claimed that its meaning consists precisely of "that which is not expressed"; "it is not a material structure." The very title is a series of questions, and the artist himself observed that it was more like a signature than a title.

Vincent Van Gogh had worked as a businessman, a lay minister, and schoolteacher before taking up painting as a profession: his artistic career lasted only a decade, with roughly half of his more than 1,200 paintings – and almost all the ones for which he is known – dating from the last two years of his life, from the time he left Paris for Arles in southern France until his suicide, at the age of thirty-seven, in 1890. He also left nearly 800 letters, full of surprising insights into the complexity of his intellectual and emotional life. From his earliest youth he possessed a deep social consciousness, and social commitment remained essential to his artistic motivation: he began by conceiving of himself as a painter of working people – his hero was the Realist Millet, whom Baudelaire had so detested – but his identification with workers affected *how* he painted them and even his sense of what it meant to be an artist. In one of his letters he explains why he distorts his figures: "I do not want them to be academically correct: when one photographs a digger he would *certainly not be digging*." Dissatisfaction with academic drawing and a sense of the inadequacy of photography were not uncommon among his contemporaries, but Van Gogh is evidently also dissatisfied with the idea of the artist as *flaneur*, and perhaps with the general cynicism of the Parisian art world.

After moving to Arles he wrote that he hoped his new life would resemble what he imagined that of a Japanese painter's to be like, that he would be able to live "close to nature like a petty tradesman." This comment, too, reveals a remarkable independence: in its rejection of the intellectual pretentiousness widespread among artists, it cuts to the heart of a Western mythic construct just as decisively as Gauguin's move to the South Seas. Yet Van Gogh's greatest pictures achieve the transformation of the personal and particular into the symbolic and universal perhaps

more impressively than Gauguin's. Even when he is not painting peasants, as in one of his pictures of *Sunflowers* (plate 14), for instance, the viewer has the sense, not only of the intensity of the artist's emotional engagement, but something of the internal life of things being revealed, even of existence itself – an indissoluble combination of ecstasy and pain – speaking from the canvas. Just as in the case of Gauguin's *Where Do We Come From?*, it would be hard to say what the *Sunflowers* "means": it, too, is a symbol without a text. In one of his last letters, Van Gogh wrote: "My pictures are after all almost a cry of anguish, although in the rustic sunflower they may symbolize gratitude." Like Baudelaire's poet, the artist is in no position to tell us what his symbols mean.

With their expressive color and distortion of form, painters like Gauguin and Van Gogh unleashed powerful forces. An example of where these forces soon led – one that will have to stand for the many that could be cited – is provided by the Norwegian painter Edvard Munch, who spent time in Paris in the years 1889–92, at just the moment when Gauguin and Van Gogh were coming to attention. Munch's *Scream* (plate 15), painted in 1893, soon after his move to Berlin, seems to take up where they left off, as it were: the forms liquefy and the colors ignite as if by the sheer heat of emotional force projected into them. Munch has turned personal experience into an image that for many viewers still serves as a symbol of all the terror hidden just beneath the surface of modern life. This approach found particularly fruitful ground in Germany, where, after the turn of the century, artists began to call themselves "Expressionists," a term that gained wide currency and was then also applied retrospectively to Gauguin and Van Gogh. Part of the appeal of the term for its advocates was the way in which it implied a complementary relationship to Impressionism.

The development and transformation of Symbolism as an artistic strategy in the first years of the twentieth century can be illustrated with the work and theoretical writings of two painters: Henri Matisse and Wassily Kandinsky. Matisse received an academic training, but by 1901 was experimenting with color along the lines pioneered by Seurat and Gauguin. In an exhibition in 1905, his pictures, along with those of his associates, were thought so outrageous that the group was given the name *fauves*, "wild beasts." The forms in *The Joy of Life* (*La Joie de vivre*), painted in 1905–6 (plate 16), are as distorted as those of Munch, but the pressure behind the distortion has nothing to do with anguished intensity of emotion: the picture develops the coloristic freedom of Gauguin's Tahitian scenes, but adapts it to a traditional pastoral theme inspired by classical poetry. Partly in response to the fierce criticism that such pictures received, Matisse explained his intentions in an essay, "Notes of a Painter," published in 1908.

Though Matisse invites identification as an Expressionist by emphasizing the importance of "expression" to his painting, he takes care to represent himself and his approach as calm and rational. In the most well-known passage, he deliberately distances himself as far as possible from Expressionism of the obvious kind:

> What I dream of is an art of balance, of purity and serenity, devoid of troubling or depressing subject matter, an art that could be for every mental worker, for the businessman as well as for the man of letters, for example, a soothing, calming influence on the mind, something like a good armchair that provides relaxation from fatigue.

He insists that "expression" is in fact a product of careful calculation: "The whole arrangement of my picture is expressive . . . a work of art must be harmonious in its entirety; for superfluous details would, in the mind of the beholder, encroach upon the essential elements . . ." To achieve this overall harmony, this coherence of expressive structure, one must work on a single picture over time – unlike the young Monet, perhaps, but not unlike Cézanne: "Underlying this succession of moments which constitutes the superficial existence of beings and things, and which is continually modifying and transforming them, one can search for a truer, more essential character, which the artist will seize so that he may give to reality a more lasting interpretation." Matisse is especially attentive to the temporality (*durée*) of painting: the working process involves responding to all the marks previously applied to the surface, and this is not just a matter of technique but of expression. Indeed, feeling is only defined *in the process of expression*: "the thought of a painter must not be considered as separate from his pictorial means." "I am unable to distinguish between the feeling I have about life and my way of translating it." Matisse seems to be laying claim to a kind of *naïveté*, but also stressing the discipline that it involves. The object produced by this concentrated and exacting work has only the most attenuated relation to nature, but it has a life of its own.

Matisse's use of the word *durée* and his emphasis on the temporal aspect of painting point to the influence of Henri Bergson, a philosopher active in Paris from the 1880s, but whose most recent book, *Creative Evolution*, published in 1907, had become the talk of the town. In sympathy with other Symbolist attempts to devise what might be called a scientific spirituality, Bergson sought to approach reality as it is lived, rather than explaining it in either purely materialistic or purely logical terms. Reality is essentially dynamic; even what seem to be stable states or categories, our own identities included, must be understood as effects of continuity over time, and not understood, exactly – since rational

understanding tends to isolate and categorize – but grasped intuitively, "lived." Bergson's philosophy, which came to be labeled "vitalism," with its emphasis on the dynamic and the sense of infinite possibility that it offered made his work especially appealing in the first years of the new century: it seems to have helped Matisse realize the possibility of an objective, "scientific" expressionism, but it could also be made to support very different approaches to art, and would become an important stimulus to other developments such as Futurism and some forms of Cubism, as well as leaving its mark on later philosophy.

Like Matisse, Kandinsky (1866–1944) had studied law before turning to painting. He moved from Moscow to Munich, where he completed his training and became involved with a group of progressive artists and writers. He spent a year in France in 1906–7, where he was most impressed by the work of the Fauves. Returning to Germany, he pushed his own painting in the direction of greater coloristic intensity and freedom, producing landscapes in which the natural forms are barely recognizable. Sometime in 1911 he painted the first completely abstract – that is, entirely non-representational – picture, but his work seldom contains no recognizable elements at all. A serious amateur musician, he began to give his pictures titles such as "improvisation" and "composition," titles which indicate the importance of his thinking about the relation of painting to music: an example is *Composition VI*, painted in 1913 (plate 17). Late in 1911, he published *On the Spiritual in Art*, the most comprehensive statement of Symbolist principles in art theory, but one also conditioned by a particular, "spiritualist" orientation.

The essay begins by describing how the degrading materialism of the modern world, which had threatened to overwhelm and destroy the life of the spirit, has also had the effect of bringing about a spiritual awakening. The task of artists is to provide a new "language" for the spirit, a means with which it might come to know, express, and assert itself. He associates Realist painting with materialism, and the freer, abstract painting he advocates with the new spirituality, but he is less interested in attacking straw targets than in a more pointed analysis of the possibilities that now present themselves to forward-looking artists: he believes that complete freedom of expression has *already* been attained, and that it must now be the work of art to refine its instruments in the interests of a subtler, more articulate expressivity. He discusses the writers, musicians, and artists who seem to embody this new approach: among the painters are Cézanne and Matisse. An indication of Kandinsky's distinctive, highly personal interpretation of their work is his unlikely claim that Matisse "endeavors to reproduce the divine" in his pictures.

Kandinsky turns to poetry, drama, and especially music for support in developing his ideas. He believes that the various arts are in the process

of "drawing together" and are finding music, "the most non-material of the arts," to be their "best teacher." This idea derives from Wagner, but Kandinsky also reveals a remarkable admiration for the work of the still young and under-appreciated Arnold Schönberg: "His music leads us into a realm where musical experience is a matter not of the ear but of the soul alone – and from this point begins the music of the future." Modern painters, whether they realize it or not, seek to emulate the expressive power and subtlety of music in their works – as can be seen in "that modern desire for rhythm in painting, for mathematical, abstract construction, for repeated notes of color, for setting color in motion."

The deep relation of painting to music is most evident in the workings of color. Like musical sound, color "directly influences the soul." "Color is the keyboard, the eyes are the hammers, the soul is the piano with many strings. The artist is the hand which plays, touching one key or another, to cause vibrations in the soul." Much of the essay is given over to a careful analysis of the properties of individual colors, the ways in which they interact, and the ways in which colors interact with form. Though there is no specific reference to Charles Henry's psychophysical aesthetics, Kandinsky's aims are similar: to provide the foundation for a universal language of expression.

Kandinsky had pioneered non-representational painting, but he sees no need to abandon "all material objects and paint solely in abstractions": "As every word spoken rouses an inner vibration, so likewise does every object represented. To deprive oneself of this possibility is to limit one's powers of expression." The "rejection of the third dimension" was an important liberating step, but it also threatens to become limiting; at the same time, it may introduce "a very material element into painting": "If we begin at once to break the bonds which bind us to nature and devote ourselves purely to the combination of pure color and abstract form, we shall produce works which are mere decoration, which are suited to neckties and carpets." That Kandinsky sees beyond abstraction as an end in itself is an indication of how sophisticated his position is, yet his concern with nature sounds a rather traditional note, as does his belief in the "inner meaning" of pictures – an expressive essence independent of the formal devices on which it depends – so unlike Matisse's insistence that the "thought" of the painter cannot be separated from his "pictorial means."

Matisse and Kandinsky might both be described as second-generation Symbolists; the obvious differences between them reflect something of the range of possibilities within the creative strategy Symbolism had fashioned; still, they share a cooler, more methodical tone than the earlier Symbolists: Matisse stresses his rationality and Kandinsky, for all his

spiritualism, is at pains to emphasize the objective, comprehensive, scientific quality of his inquiry. This new tone says something about the intellectual climate of the new century. If Symbolism turned imaginative subjectivity into a self-conscious strategy, a technique, subsequent developments would structure it even more thoroughly.

Ruskin and the Aesthetes

The story of French modernism is so spectacular that it tends to make developments elsewhere seem dull, marginal, or epiphenomenal. There is good reason why most attempts to understand the mechanics of modernism have focused on France, but that France is also a special case – more like an exception than the rule – is clear from the fact that modernism developed so differently in other countries, such as England, only a few miles away. English art and theory offer a useful corrective to any assumptions about the nature of modernism we might tend to make on the basis of the French scene alone. The differences are certainly due in part to the fact that English society developed differently in the course of the eighteenth and nineteenth centuries: there was no political revolution, for instance, but the effects of rapid industrialization and economic expansion were perhaps especially visible there. This distinct environment results in an art theory that is different in its emphases even though it addresses many of the same issues, and because some of the pressures to which it responds most articulately are similar to those we still face – in slightly different form – it also has much to offer to our self-understanding.

Sometime around 1808, William Blake, poet, artist, visionary, and radical activist, annotated his copy of Reynolds's *Discourses* with a string of angry objections:

> I consider Reynolds's Discourses to the Royal Academy as the Simulations of a Hypocrite who smiles particularly where he means to Betray. His Praise of Raphael is like the Hysteric Smile of Revenge. His Softness & Candour, the hidden trap & the poisoned feast. He praises Michel Angelo for Qualities which Michel Angelo abhorr'd, & He blames Raphael for the only Qualities which Raphael Valued . . . I always consider'd True Art & True Artists to be particularly Insulted & Degraded by the Reputation of these Discourses, as much as they were Degraded by the Reputation of Reynolds's Paintings, & that Such Artists as Reynolds are at all times Hired by the Satans for the Depression of Art – a Pretence of Art, To Destroy Art.

Here is a repudiation of academic ideals just as fierce as Baudelaire's, even if the terms in which it is expressed are very different. Though Blake

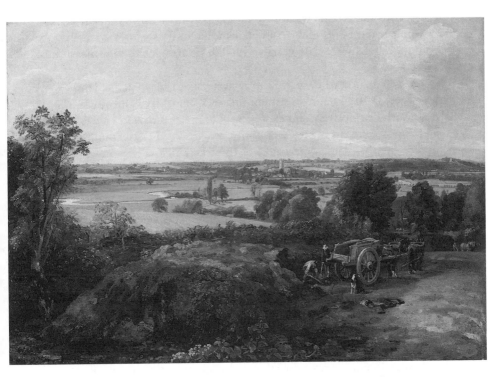

Figure 4.7 John Constable, *Dedham Vale*, 1814, Museum of Fine Arts, Boston.

repeatedly attacks the idea that calculated borrowing from the works of others is the way to achieve greatness, his frame of reference is both religious – he sees it as the work of "Satans" – and social: it is a symptom of moral corruption brought about by capitalistic greed.

A less violent dissatisfaction with academic conventions is seen in the development of landscape painting. John Constable tried to make his landscapes more descriptive of natural appearances as well as expressive of his feeling for the distinctive beauty of the English countryside; he combined an intense interest in effects of light and atmosphere with an idyllic vision of England as a free and harmonious society. He could say both that "painting is with me but another word for feeling" and that painting is a "science," to be pursued "as an inquiry into the laws of nature." He was one of the first artists to paint landscapes out of doors: an example is *Dedham Vale*, a work of 1814 (figure 4.7). As with the Impressionists in the second half of the nineteenth century, such pictures came in for surprisingly nasty criticism: viewers accustomed to the subdued colors and artificial tonal structure of academic landscape found them garish and roughly or incompletely finished. Constable did not

break with the Academy, however: his goal was to show that landscape painting could be as technically demanding and as expressive as history painting, and by the last years of his life he had achieved a measure of success.

J. M. W. Turner began his career as a painter of academic landscapes, but went on to develop an extraordinarily original style, in which color is used both descriptively and expressively to create amazing effects of light and atmosphere. In many cases, forms are dissolved to the point of being unrecognizable, and some of his pictures come close to non-objectivity. His work met with even harsher treatment than Constable's: one critic referred to his paintings as "portraits of nothing, and very like." He, too, combined an almost obsessive empirical interest in optical effects with a poetic sensibility, but his allegorical ambitions carried him much further than his colleague. *The Burning of the Houses of Parliament* (plate 18), for instance, depicts an event which Turner witnessed in 1834. The disaster is presented as a visual spectacle and great painterly care is taken to describe the reflection of the fire in the river and the first rays of the dawn striking the towers of Westminster Abbey, yet the overall effect of the picture is apocalyptic, disturbingly rich in religious and political resonances. Turner's attentiveness to the "marvelous" aspects of urban experience is not unlike Baudelaire's.

Turner found his greatest critical champion in the person of a young writer, John Ruskin (1819–1900). Barely twenty when he undertook to defend the painter's work, Ruskin at first intended to issue a journalistic essay but wound up producing a weighty tome: in order to demonstrate his case that Turner was the greatest English landscapist and, indeed, the greatest painter of modern times, he found it necessary to survey the history of art in some depth. The first volume of what he called *Modern Painters* was published in 1843, but even this was not enough, and was followed by four other volumes, the last published in 1860. By the end, the book had far outgrown its original aim and instead presented a comprehensive – if rather rambling – revision of the history of art and a theoretical foundation upon which, Ruskin believed, a modern art could be built.

Ruskin would go on to write a great deal else as well; his work was widely read and admired, and he became one of the most influential authors of his time. He is arguably the greatest writer on art that the English-speaking world has ever produced. Not all his ideas are original, and there are unresolved inconsistencies among them, but he wrote with a compelling energy and depth of moral conviction, and in a style of overwhelming magnificence. He saw art as the product of economic and political, as well as spiritual, conditions, and his writing combines art criticism with social criticism in a striking way. There is a strong religious

element in much of his work – stronger at the beginning of his career than toward the end – but his commitment to socialist principles remained strong. Indeed, his views on society were almost as influential as his ideas about art; he was regarded by many as a kind of prophet, and there is even a town in Tennessee named after him, originally founded on utopian principles inspired by his social theory.

The essential argument of *Modern Painters* is that traditional landscape painting – the "classic," academic type, but also most seventeenth-century Dutch landscape painting – is bankrupt because it is really about artifice rather than nature. Like Blake, Ruskin is infuriated by Reynolds's advice to generalize natural forms:

> It cannot, I think, be expected, that landscapes like this should have any effect on the human heart, except to harden or degrade it; to lead it from the love of what is simple, earnest, and pure, to what is as sophisticated and corrupt in arrangement, as erring and imperfect in detail. So long as such works are held up for imitation, landscape painting must be a manufacture, its productions must be toys, and its patrons must be children.

The disgust with the formulaic quality of academic painting is, of course, similar to that of French critics, but the word "manufacture" carries resonances that Ruskin will develop much more fully.

Ruskin's description of the new approach of the moderns is also comparable to those of the French; it even makes use of the word "impression" years in advance Impressionism:

> Modern landscape painters have looked at nature with totally different eyes, seeking not for what is easier to imitate, but for what is most important to tell . . . they think only of conveying the impression of nature into the mind of the spectator, and chiefly of forcing upon his feelings those delicate and refined truths of specific form, which are just what the careless eye can least detect or enjoy, because they are intended by the Deity to be the constant objects of our investigation that they may be the constant sources of our pleasure.

Ruskin's "impression" is obviously unlike that of the Impressionists, however; it is not pre-rational but based on comprehensive knowledge:

> Now there is but one grand style, in the treatment of all subjects whatsoever, and that style is based on *perfect* knowledge, and consists in the simple unencumbered rendering, of the specific characters of the given object, be it man, beast, or flower. Every change, every caricature, or abandonment of such specific character is as destructive of grandeur as it is of truth, of beauty as of propriety.

In principle, the kind of knowledge being described is not unlike that recommended by Alberti and Leonardo, but Ruskin's insistence on the "specific character" of natural forms is intended to factor out the tendency to idealizing generality that became so characteristic of academic art during and after the Renaissance. One may doubt that Ruskin has in fact succeeded in evading generalization entirely, since any determination we may make about specific character involves some kind of normative judgment. Elsewhere in his writings, he shows a preference for images that are able to reveal the specific character of, say, a *species* of plant, rather than the idiosyncracies of an individual plant.

If painting demands perfect knowledge of and regard for nature, Ruskin also finds a place for what the French call "temperament":

> And thus, though we want the thoughts and feelings of the artist as well as the truth, yet they must be thoughts and feelings arising out of the contemplation of truth. We do not want his mind to be like a badly blown glass, that distorts what we see through it, but like a glass of sweet and strange colour, that gives new tones to what we see through it; and a glass of rare strength and clearness too, to let us see more than we could see ourselves, and bring nature up to us and near to us.

This understanding of artistic subjectivity as an objectivized subjectivity is not unlike Zola's.

Ruskin's case for "modern" painting led him to a new evaluation of the art of the past. He was not the first to develop a taste for what were then known as the "primitives" – Italian painters of the early Renaissance, prior to Raphael – but he offers a more deeply reasoned basis for it. Art is better when it is not overly concerned with technical perfection: "It appears to me that a rude symbol is oftener more efficient than a refined one in touching the heart; and that as pictures rise in rank as works of art, they are regarded with less devotion and more curiosity." Giotto, for instance, though technically clumsy, is exaltedly pure and thus, in his own way, better than perfect. Conversely, the "High Renaissance," the climactic era which Vasari and all academic theorists after him regarded as having achieved perfection, is an age of decline. The Venetian painters Bellini and Titian are still great, as is Raphael himself, but Michelangelo and Tintoretto are already figures of decadence, depite their tremendous skill. Ruskin developed this view of history in his other writings and made his case so effectively that he succeeded in finally toppling the Vasarian account of the progress of art, replacing it, in the minds of readers everywhere, with a new history and a new set of artistic values. That it was radically backward-looking does not make it any less important a contribution to modernism: for Ruskin, it seems, archaism

assumes something like the significance of *naïveté*. Interestingly, he had no fondness for Dutch art of the seventeenth century: though the painters are often faithful to the particulars of nature, he finds their realism mechanical and materialistic in a manner that makes it no better than academic art.

Ruskin's compelling articulation of these new values encouraged a group of young English artists who formed the "Pre-Raphaelite Brotherhood" in 1848. Fed up with academic rules, they sought to revive the artistic qualities of an earlier painting as Ruskin had described them, and they frequently illustrated religious themes or stories from medieval history and poetry. Though they, too, may seem at first to be anti-modern reactionaries, they understood that their nostalgia for the past was a product of contemporary pressures, and we do well to recognize its distinctly modern quality. They also addressed contemporary themes, as in Holman Hunt's *Awakening Conscience*, painted 1853–4 (figure 4.8). Ruskin wrote an admiring description of the picture, arguing that its minutely descriptive realism has the effect of capturing a moment of great psychological intensity, when "trivial objects . . . thrust themselves forward with a ghastly and unendurable distinctness":

> There is not a single object in all that room – common, modern, vulgar . . . but it becomes tragical, if rightly read. That furniture so carefully painted, even to the last vein of the rosewood – is there nothing to be learnt from that terrible lustre of it, from its fatal newness; nothing there that has the old thoughts of home upon it, or that is ever to become a part of home? Those embossed books, vain and useless – they are also new – marked with no happy wearing of the beloved leaves; the torn and dying bird upon the floor; the gilded tapestry, with the fowls of the air feeding on the ripened corn; the picture above the fireplace, with its single drooping figure – the woman taken in adultery; nay, the very hem of the poor girl's dress, at which the painter has labored so closely, thread by thread, has a story in it . . .

All the details serve to deepen the expressive resonance of the scene, and Ruskin's enumeration of them becomes a sustained denunciation of modern moral emptiness. The picture's rendering of physical particulars thus succeeds in conveying an anti-materialistic message; it combines technical sophistication with *naïveté*.

The art in which this retrospective, historicist tendency was most productive, however, was architecture. An interest in Gothic style as an alternative to the classicism espoused by the academies had begun in the eighteenth century. Even then, apologists for Gothic had linked it to the sublime as an aesthetic category, distinct from the "beautiful" style of classicism; they also developed nationalistic arguments: Goethe's essay in

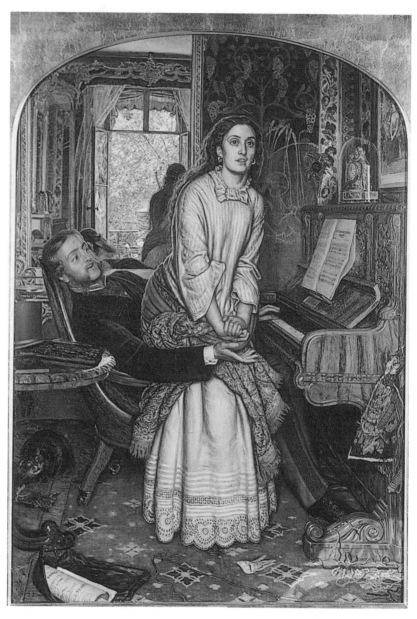

Figure 4.8 W. Holman Hunt, *Awakening Conscience*, 1853–4, Tate Gallery, London.

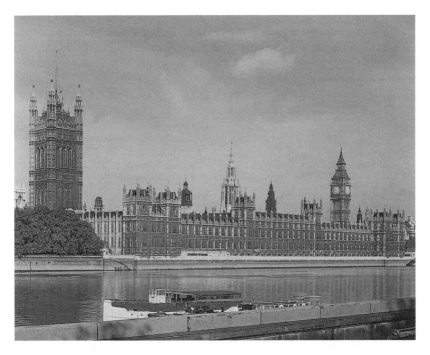

Figure 4.9 Charles Barry and A. W. N. Pugin, *Houses of Parliament*, 1839–52, London.

praise of Strasburg Cathedral, written in 1773, was entitled "On German Architecture." Whether the Germans, French, or English claimed it as their own, there was widespread belief that Gothic was the expression of a specifically Northern European, Christian culture. When after the fire of 1834, it came time to rebuild the Houses of Parliament, there was debate about whether the style of the new buildings should be classical or Gothic. A. W. N. Pugin, who campaigned energetically for the latter, was one of the team finally awarded the commission (figure 4.9).

It was Ruskin, however, who put forward the most eloquent and comprehensive case for the superiority of the Gothic style. His *Stones of Venice*, published in 1851–3, presents Venetian architecture of the late medieval period and early Renaissance as an expression of the values of the Venetian Republic at the height of its social unity, economic prosperity, and political power; it is an extended attempt to define those qualities of Gothic style that make it the perfect vehicle for such positive values. Though Ruskin avoided the usual sorts of nationalistic arguments by choosing a southern European form of Gothic, the book addresses itself to contemporary England. Venice, once a mighty maritime power with a proud tradition of democratic government, had long since descended

into decadence and was regarded by many Englishmen as a cautionary example, a warning of their own empire's possible fate. Ruskin's determination to anatomize the virtues of Venetian architecture is thus driven by a desire to restore the spiritual values that his own countrymen had once possessed but now seemed to have lost.

Ruskin's belief that it is the "strange *disquietude* of the Gothic spirit that is its greatness" fully integrates older notions of the sublime; it is also similar to Hegel's conception of the "Romantic," but it involves a more complete, more radical inversion of standards, and has something in common with the transvaluation of bad painting as good painting in the works of Courbet, Manet, and the Impressionists. The imperfection of Gothic is a positive value because it reflects a society and condition of labor in which each craftsman contributed something of his invention as well as his handiwork, and was not merely the executor of someone else's design. This system began to erode away in the Renaissance, with the division of "art" from "craft," and has been completely destroyed by modern industrialization.

Ruskin thus goes further than Hegel in linking works of art to history, in seeing them, not only as products of a particular "spirit," but of a particular socioeconomic system. He divides architectural and ornamental styles into "servile" (ancient near-Eastern), "constitutional" (Greco-Roman), and "revolutionary" (medieval Christian). Strange as it may seem to associate the Christian with the "revolutionary," the combination reflects the depth and intensity of Ruskin's belief that a return to the principles of Gothic art and the values which produced it offers the only hope for a return from the abyss of brute capitalism; it is an impressive assertion of the potentially liberating power of Christian ideals even in the modern world. Yet the willingness to dismiss the obvious injustice of feudalism also involves a disturbing blindness to the reality of medieval life.

Venetian architecture proves to Ruskin that "The demand for perfection is always a misunderstanding of the aims of art," but he drives home his point by turning from Venice to England, from the past to the "fatal newness" of the present:

> And now, reader, look round this English room of yours, about which you have been proud so often, because the work of it was so good and strong, and the ornaments of it so finished. Examine again all those accurate mouldings, and perfect polishings, and unerring adjustments of the seasoned wood and tempered steel. Many a time have you exulted over them, and thought how great England was, because her slightest work was done so thoroughly. Alas! If read rightly, these perfectnesses are signs of a slavery in our England a thousand times more bitter and more degrading

than that of the scourged African or helot Greek. Men may be beaten, chained, tormented, yoked like cattle, slaughtered like summer flies, and yet remain in one sense, and in the best sense, free. But to smother their souls within them, to blight and hew into rotting pollards the suckling branches of their human intelligence, to make the flesh and skin which, after the worm's work on it is to see God, into leathern thongs to yoke machinery with, – this it is to be slave-masters indeed; and there might be more freedom in England, though her feudal lords' lightest words were worth men's lives, and though the blood of the vexed husbandman dropped in the furrows of her fields, than there is while the animation of her multitudes is sent like fuel to feed the factory smoke, and the strength of them is given daily to be wasted into the fineness of a web or racked into the exactness of a line.

Though nostalgia for feudalism is not easy to reconcile with progressive politics, Ruskin's convictions are so powerfully expressed, they seem to surge up with such force from such a depth of moral feeling, that they carry an inflammatory charge similar to Schiller's.

More explicitly reminiscent of Schiller is Ruskin's claim that "We have much studied and much perfected, of late, the great civilized invention of the division of labor; only we give it a false name. It is not, truly speaking, the labor that is divided, but the men." It is easy to train someone to perform manual operations precisely and efficiently; if you encourage him to think for himself, however, the chances are that he will hesitate and make a mistake or two along the way, yet this form of labor is more humane, and in the end yields products of greater value. Again, the precept is underscored with a vivid example from the present:

> Glass beads are utterly unnecessary, and there is no design or thought employed in their manufacture. They are formed by first drawing out the glass into rods; these rods are chopped up into fragments of the size of beads by the human hand, and the fragments are then rounded in the furnace. The men who chop up the rods sit at their work all day, their hands vibrating with a perpetual and exquisitely timed palsy, and the beads dropping beneath their vibration like hail. Neither they, nor the men who draw out the rods, or fuse the fragments, have the smallest occasion for the use of any single human faculty; and every young lady, therefore, who buys glass beads is engaged in the slave trade, and in a much more cruel one than that which we have so long been endeavoring to put down.

Though one may not be willing to believe that economic exploitation of the kind Ruskin is describing is actually worse than the trade in African slaves, there is something audacious about the way he forces his readers to face the economic reality behind even their most seemingly innocent consumer enjoyments, reminding them, rather in the manner of a great

fulminating preacher, of the moral injustice on which their entire way of life depends.

Ruskin goes even further, however, outlining a three-part program of resistance to exploitative mass production: we should never encourage the manufacture of any object produced in a manner that does not allow the individual worker to use his own powers of invention; we should never demand perfect finish for its own sake; and we should never encourage imitation or copying, except for preserving a record of great works. In *The Political Economy of Art*, two lectures delivered in 1857, he presented a comprehensive plan for preserving and promoting art in modern capitalist society. Arguing forcefully against the wastefulness of the prevailing *laissez-faire* attitude, he urged systematic government support at all levels, from setting up schools and public works designed to find and encourage the development of artistic talent among the underclasses to regulating the prices of work by living artists so that people of modest income might afford them. In 1871 he began to publish a newspaper addressed to working men and also established an association for craftsmen on the model of medieval guilds in order to encourage training and practice according to traditional methods.

Some of Ruskin's proposals were enthusiatically received: they influenced not only the Pre-Raphaelites, but also the development of architecture and interior design. The poet, artist, and socialist activist William Morris, who was close to some of the Pre-Raphaelites, tried to apply Ruskin's ideas about craftsmanship in his own commercial ventures. In 1861 he established a design firm, which came to be known as Morris and Co., for the production of furniture, stained glass, wallpaper, and fabrics: the aim was to make works of high quality which would also be affordable to people of modest means. Much of what they made was in a medieval style, but Morris and his associates looked everywhere for inspiration, and often found it in the humblest objects: an example is the "Sussex Chair" (figure 4.10), the design of which was based on a rustic chair that one of Morris's associates supposedly discovered in a Sussex farmhouse. Such designs helped bring about a gradual shift of taste away from elaborate ornament – even the fashionable medieval ornament first produced by the firm – toward simpler and more functional styles. Morris's guiding principle was an extension of Ruskin's program for the reform of art: "Have nothing in your house that you do not know to be useful, or believe to be beautiful." He was as attentive to the process of production as to the results, avoiding assembly-lines, allowing his workmen a certain freedom of execution, and making use of machinery only where appropriate and necessary to guarantee competitive productivity. Morris's efforts themselves became the model for many others, giving rise to what is generally referred to as the Arts and Crafts movement.

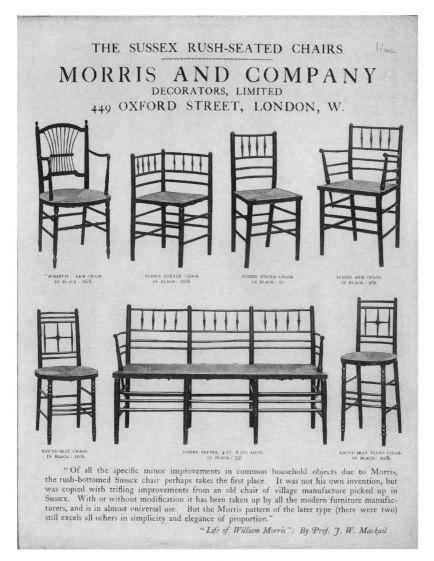

Figure 4.10 Advertisement for the "Sussex Chair," from a Morris and Co. catalogue, c.1900.

There was also a reaction against Ruskin, though it took somewhat longer to develop. A younger generation began to think that the close association of art and nature, art and morality, which was the core of Ruskin's teaching, was just as false and oppressive as Ruskin had found the values of the Royal Academy. A decisive, if comical moment occurred in 1877, when Ruskin wrote a strongly negative review of a picture,

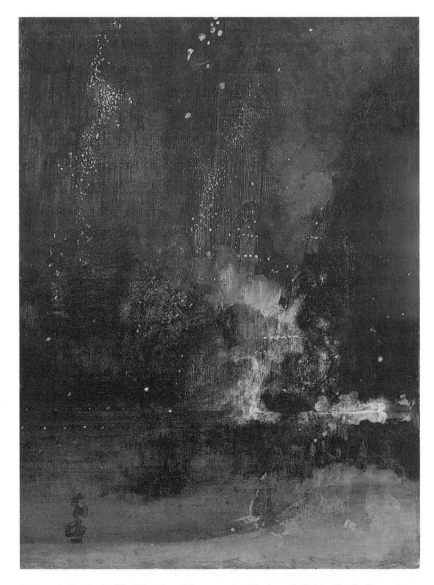

Figure 4.11 J. A. M. Whistler, *Nocturne in Black and Gold: The Falling Rocket*, 1875, Detroit Institute of Arts.

Nocturne in Black and Gold by the American expatriate painter J. A. M. Whistler (figure 4.11). The crucial sentence was: "I have seen, and heard, much of cockney impudence before now; but never expected to hear a coxcomb ask two hundred guineas for flinging a pot of paint in the public's face." Whistler sued Ruskin for libel, and won the case in principle,

but he was awarded only the minimum token settlement for damages – one farthing (one-quarter of a penny then; the equivalent, perhaps, of a dollar now).

Whistler had lived in Paris and had mixed with avant-garde painters and intellectuals, including Mallarmé. His style is much influenced by Manet and Degas, as well as by the Japanese art so popular among French artists. The style of *Nocturne* might be described as an elegantly simplified Impressionism, lyrical and suggestive in a manner similar to the poetry of Mallarmé. The use of the musical term "nocturne" for the title, like that of "composition" which he also often used, anticipates the Symbolist preoccupation with music.

Making the most of his controversy with Ruskin, Whistler appointed himself the spokesman for new values in art. In his lecture known as "Ten o'Clock," delivered in 1885, he argued that art has only a tangential relationship to nature and that its purpose has nothing whatever to do with moral improvement: "She is a goddess of dainty thought, reticent of habit, abjuring all obtrusiveness, purposing in no way to better others . . . selfishly occupied with her own perfection only – having no desire to teach – seeking and finding the beautiful in all conditions and in all times . . ." The artist's task is thus to pursue beauty rather than truth. Whistler's elaboration of this idea leads him to explain the underlying relationship between painting and music:

> Nature contains the elements, in color and form, of all pictures, as the keyboard contains the notes of all music. But the artist is born to pick and choose . . . as the musician gathers his notes and forms his chords until he brings forth from chaos some glorious harmony. To say to the painter that Nature is to be taken as she is, is to say to the player that he may sit on the piano.

Whistler's English supporters included a group of artists and writers who deliberately patterned themselves on the French "decadents" and who came to be known as "aesthetes." The most famous was the playwright and wit Oscar Wilde. Also determined to sever art from morality, Wilde declared that "there is no such thing as a moral or immoral book. Books are well written or badly written. That is all." Whistler and Wilde positioned themselves as the leading advocates of "art for art's sake," and something about their foppish posturing and glib manner of utterance makes it difficult for us to take them as seriously as their continental colleagues; still, the deeper ground of their convictions occasionally comes into view. In the lectures that Wilde delivered in America, he would often conclude by saying: "We spend our days searching for the meaning of life. Well, the meaning of life is – Art." Though directed toward a

popular audience and expressed in terms they might understand, the message is not unlike that of Nietzsche or Mallarmé.

English modernism, too, undergoes a subtle transformation in the early years of the twentieth century. The leading figure in this process was the artist, critic, and writer Roger Fry (1866–1934). Like Whistler, Fry imported French ideas into England, but he did so in an altogether less flamboyant way, and he can be said to reflect something of the new, more sober tone we have noted in the writings of Matisse and Kandinsky. He was also influenced by the theories of the German sculptor Adolf von Hildebrand, whose little book, *The Problem of Form in the Visual Arts*, had been published in 1893 and translated into English in 1907. Fry led the effort to popularize recent French painting by organizing two large exhibitions in 1910 and in 1912–13; he also set up a design firm, the Omega Workshops, in the hope of reviving the applied arts according to the principles he had derived from his study of French contemporaries. He translated Mallarmé and was an extremely popular lecturer and writer. He became an important arbiter of taste, stepping up to assume something like the position Ruskin had occupied before him, and using that position to overturn the Ruskinian system of values in the same way Ruskin had overturned the values of the old academy.

Fry's essays, collected into volumes such as *Vision and Design*, published in 1920, are characterized by an elegantly distilled formalism. All art presents us with what he calls "significant form," arrangements of elements such as line, volume, and color which affect us in articulate ways, independently of whatever they may represent. Because these values are universal, Fry feels as though he can discuss Cézanne in more or less the same terms as Giotto, African masks or Native American votive objects in the same terms as European sculpture. This approach offers a ready tool with which cultivated Westerners might approach objects of the most diverse kinds and assimilate them synoptically: it can be seen as a legacy of Enlightenment rationalism, the "anthropological" effort to find the common ground upon which all the world's artifacts might be classified, but insofar as it radically removes the objects from the cultural context in which they were made, it points up the relentlessly appropriative–imperialistic nature of that enterprise.

chapter 5

The early
Twentieth century

Beyond Nature

The pace of artistic innovation, which had begun to quicken in the nineteenth century, accelerated dramatically at the beginning of the twentieth; it also ramified in a manner that led to greater variety than ever before. A striking feature of this situation was the proliferation of movements, "isms," groups of artists organized around shared ideas, and a more intense, often contentious dialogue among those groups and their critical supporters. Modernism seems to shift into a higher gear, one that has an effect on the sociological dimension of artistic activity, but that

also involves an intensification of the specifically *theoretical* task facing artists. Theorizing in verbal and written form comes to play an increasingly important role, to be sure, but more significantly, practice becomes theory in an even more integral way than ever before. This is not to say that the most important art of the period always conforms most closely to some theoretical recipe, only that the need to define the most pressing issues and determine the best approaches becomes a more urgent and conspicuous aspect of the artist's task, essential to the process by which the most important art is made.

This acceleration and intensification, which sometimes seems like an inevitable outgrowth of the momentum established in preceding decades, is also connected to a change in the overall cultural climate specific to these years. As the new century began, there was a widespread belief that science, technology, and industry, which had already begun to affect everyday life in all sorts of ways, were about to transform it completely. There was a feeling that the human condition itself was about to be radically redefined, to break free of the limitations nature had imposed upon it. With the help of technology, it seemed, humankind was now in a position to refashion itself on its own terms.

Perhaps the most exuberant response to the new century was Futurism, a movement that began with a manifesto published in Paris by an Italian poet, F. T. Marinetti, in 1909. Marinetti called for a complete and violent rejection of the past: all traditional notions of poetry and art are obsolete; libraries and museums are cemeteries and should be destroyed. "We stand on the last promontory of the centuries! Why should we look back, when what we want is to break down the mysterious doors of the Impossible?" Modern life is dynamic; energy and movement, especially as evident in force and speed, are its characteristic forms. They must be made the basis of an entirely new system of artistic values:

> We will sing of great crowds excited by work, by pleasure, and by riot; we will sing of the multi-colored, polyphonic tides of revolution in the modern capitals; we will sing of the vibrant nightly fervor of arsenals and shipyards blazing with violent electric moons; greedy railway stations that devour smoke-plumed serpents; factories hung on clouds by the crooked lines of their smoke; bridges that stride the rivers like giant gymnasts, flashing in the sun with a glitter of knives; adventurous steamers that sniff the horizon; deep-chested locomotives whose wheels paw the tracks like the hooves of enormous steel horses bridled by tubing; and the sleek flight of planes whose propellers chatter in the wind like banners and seem to cheer like an enthusiastic crowd.

Baudelaire's commitment to capturing the beauty of modern life has here been given a specifically technological emphasis. Marinetti's ideas were

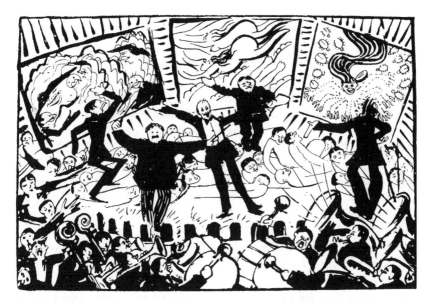

Figure 5.1 Umberto Boccioni, *A Futurist Evening*, c.1910, location unknown.

especially well received among forward-looking poets and artists in Italy, a country which had been slow to industrialize and where the challenges of sudden modernization were especially keenly felt, but his message reached other centers as well, including Russia, which he visited as early as 1910. Associations of Futurist poets and artists sprang up all over Europe, and Marinetti did his best both to give the movement direction and to win it new converts.

The Italian artists inspired by Marinetti's ideas attempted in their work to represent movement itself, sometimes creating abstract dynamic patterns with strong linear rhythms and color contrasts. A series of manifestos seeking to define Futurist painting in particular began to appear in 1910, and were followed by similar essays on sculpture, architecture, music, and cinema, but Futurism's most important contribution to art was in the field of performance. Marinetti's own work, which developed out of Symbolist free verse, involved arranging words on the page in such a way as to undermine traditional syntax with suggestive visual relationships. His aim was to "liberate" words, overthrowing the traditional poetic notion of "measure," and creating an experience of greater immediacy and intensity. Futurist performances often featured readings of poems in which several people would speak simultaneously; sometimes the performers would simply make noises imitating the sounds of machines, sometimes they would be accompanied by equally cacophonous combinations of musical instruments (figure 5.1). These performances

often met with outrage and violent responses from the audience, a result that the Futurists claimed to welcome.

Marinetti's celebration of speed and force spilled over into a celebration of violence: "We will glorify war – the world's only hygiene – militarism, patriotism, the destructive gesture of the freedom-bringers, beautiful ideas worth dying for, and scorn for women." Such sentiments remind us that the pressures of modernity have often bred violence, and that cultivating a violent disposition might be seen as an appropriate response to the challenge of the modern world. Not surprisingly, many of the Futurists welcomed the outbreak of World War I and some of those that survived it, including Marinetti himself, would later embrace Fascism. The Futurists were not the only ones who tended in this direction: in England, for example, some of the proponents of "vorticism," associated with the journal *Blast*, which included the poet Ezra Pound and artist and writer P. Wyndham Lewis, espoused similar ideas and also developed Fascist leanings.

Perhaps even more important for the subsequent direction of twentieth-century art was the movement known as Cubism. Like Impressionism, it poses a complex interpretative problem: the artists involved had differing conceptions of what it meant, the critics emphasized different things in their attempts to define it, and it has been interpreted in a variety of ways in the intervening years. The acknowledged leaders of the movement, Pablo Picasso and Georges Braque, were not given to explaining themselves, and the explanations offered by others cannot be assumed to reflect their views. As with Symbolism, Cubism quickly came to mean all sorts of things to different people, and it was developed in all sorts of directions. The variety of its implications is part of what makes it important, and we must take its dissemination into account; but we must also deal with the sources critically and be careful to structure that variety in a manner that exposes what is most innovative and most profound.

Picasso was the son of an academic painter and had achieved an impressive fluency in traditional techniques as well as more recent styles while still a boy. He moved to Paris in 1900, at the age of nineteen, and quickly made a reputation for himself with elegantly expressionistic pictures of bohemian life. Avoiding the path of the Fauves, however, he struggled to assimilate an oddly disparate variety of influences: late Cézanne, Gauguin, medieval sculpture, and African art. This phase of his career culminated in the large picture which he intended to call *The Philosophical Brothel* but later entitled *The Ladies of Avignon* (*Les Demoiselles d'Avignon*; plate 19), painted in 1906–7. Its original subject, two men entering a brothel, was Symbolist in conception, but Picasso gradually concentrated its entire expressive charge into a shocking treatment of the

female figures alone. Shattered into blade-like facets, with heads like African masks that seem to try to outdo each other in ugliness, these women remain disturbing even today. On the one hand, they might be taken as a literal illustration of Baudelaire's remark about prostitutes representing "the savagery that lurks in the midst of civilization," but, on another, one senses that Picasso has reached down to touch the deepest psychic sources of male ambivalence toward women – that combination of desire and fear that Freud, in Vienna, was beginning to suggest an explanation for at just this moment.

Picasso's work of the next few years moves away from this intense expressionism toward a more disciplined and cerebral probing of representational conventions, a deeper investigation of the way pictures work. This phase culminates in the distinctively austere and concentrated works of the years 1910–12, produced in close collaboration with Braque. An example is *Portrait of D. H. Kahnweiler* (figure 5.2), from 1910. Here the figure is also shattered, but in a manner that suggests intellectual rather than emotional intensity. Even more aggressively than a late Cézanne, the picture insists upon its independent reality: we are prevented from recognizing the figure easily; its presence is asserted and denied at the same time. We are forced to work our way over the surface in a manner that calls attention to our own processes of perception and thought.

Images of this kind created all the bewilderment that had come to be expected of modern art, but also a great deal of excitement among a now larger and more self-conscious body of artists and critics able to appreciate them. One of the first to try to explain the aims of Cubism was the Cubist painter Jean Metzinger. The new painting, Metzinger argues, is an effort to overcome "the deceptiveness of vision":

> Picasso does not deny the object, he illuminates it with his intelligence and feeling. With visual perceptions he combines tactile perceptions. He tests, understands, organizes: the picture is not to be a transposition or a diagram, in it we are to contemplate the sensible and living equivalent of an idea, a total image . . . Cézanne showed us forms living in the reality of light, Picasso brings us a material account of their real life in the mind . . .

Metzinger suggests that a Cubist picture is somehow truer to the reality of our subjective experience. The poet André Salmon, on the other hand, who was close to Picasso and Braque, said that they had "attempted the real figuration of being, and not at all the realization of the idea – most often a sentimental one – which we make of it." Picasso's own later remark, that "through art we express our conception of what nature is not," certainly indicates an awareness of the radical independence of the

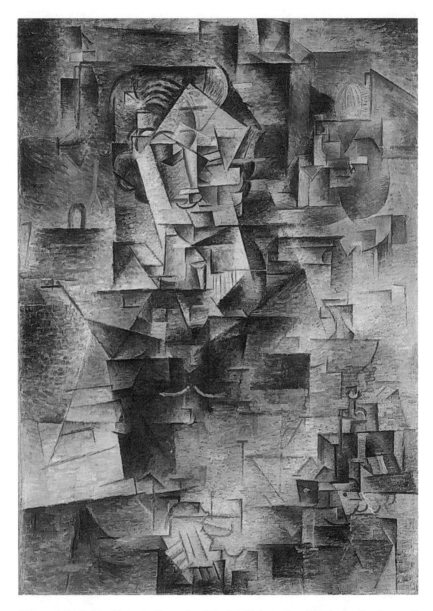

Figure 5.2 Pablo Picasso, *Portrait of D. H. Kahnweiler*, 1910, Art Institute of Chicago.

art object; Braque later said that the aim of Cubism was "not to *reconstitute* an anecdotal fact but to *constitute* a pictorial fact." "One must not imitate what one wishes to create," he insisted: "There is no certainty except in what the mind conceives."

Writing in 1912, the critic Jacques Rivière stressed the perceptual realism of Cubist painting, evoking a distinction between essence and appearance but avoiding its idealistic implications: "The true purpose of painting is to represent objects as they really are; that is to say, differently from the way we see them." Cubism gives us the "sensible *essence*" of objects, their "presence," and this is why the image it forms does not resemble their *appearance*..." Because light and shade are some of the things that prevent objects from appearing as they "really" are, Cubists alter natural lighting. The Cubist painter

> replaces a crude and unjust distribution of light and shade with a more subtle and more equal distribution: he divides up over all the surfaces the shade which used to accumulate only on some; he uses the small portion of shading allotted to each one by placing it against the nearest edge of some other lit surface, in order to mark the respective inclination and divergence of the parts of the object.

Perspective is another "accidental" aspect of perception, and is something Cubist painters have also found ways to "correct." Rivière is sensitive to the way in which Cubism emphasizes the temporality of visual experience: "Contrary to what is usually thought, sight is a successive sense; we have to combine many of its perceptions before we can know a single object well."

The poet and critic Guillaume Apollinaire stressed the conceptual nature of the new art rather than its engagement with the external world: "Cubism differs from the old schools of painting in that it is not an art of imitation, but an art of conception which tends toward creation"; it is "the art of painting original arrangements composed of elements borrowed from conceived reality rather than from the reality of vision":

> The aim of painting has remained what it always was – namely, to give pleasure to the eye – the works of the new painters require that we find in them a different kind of pleasure from the one we can just as easily find in the spectacle of nature. An entirely new art is thus being evolved, an art that will be to painting, as painting has hitherto been envisaged, what music is to literature.

Apollinaire thus sees Cubism as fulfilling the dream of a "pure art" pursued by the Symbolists.

Kahnweiler himself, an art dealer and keen observer of trends in art, wrote a perceptive book about Cubism in 1915 (*The Way to Cubism*, not published until 1920). He gives most of his attention to Picasso and Braque, and is concerned to explain how their work evolved. The crucial breakthrough occurred in the summer of 1910, when Picasso "pierced

the closed form": from that point, painting no longer needed to represent the "skin" of objects and be tied to their mere appearance. Picasso realized that "the different accommodations of the retina of the eye enable us, as it were, to 'touch' three-dimensional objects from a distance," and the mode of painting he developed "made it possible to 'represent' the forms of objects and their position in space instead of attempting to imitate them through illusionistic means." The painting consists of a "scheme of forms and small real details" which serve as "stimuli," but it is only in the process of concentrated viewing and "in the mind of the spectator" that it forms a coherent whole. Once understood, Kahnweiler claims, Cubism allows objects to be "seen" more clearly and powerfully than any illusionistic painting.

Kahnweiler relies on eighteenth-century perceptual theory to support his case. Commenting on the way in which Cubism reduces all forms to a very limited set of visual marks, he says: "Man creates no building, no product which does not have regular lines. In architecture and applied art, cubes, spheres and cylinders are the permanent basic forms. They do not exist in the natural world, nor do straight lines. But they are deeply rooted in man; they are the necessary condition for all objective perception." Simple geometric forms are "our categories of vision," they are evidence of the a priori knowledge that Kant believed precedes sense perception.

The painter Albert Gleizes collaborated with Metzinger to produce what is probably the nearest thing to a manifesto of Cubism, the essay *On Cubism*, published in 1912. Concerned to establish a genealogy for the movement, they begin with Courbet, whom they praise for his commitment to the real, even if, failing to understand that "in order to display a true relation we must be ready to sacrifice a thousand apparent truths, he accepted, without the slightest intellectual control, all that his retina presented to him." Cézanne saw through the "absurdity" of Impressionism and its preoccupation with mere appearance; he showed the way to a "profounder realism," demonstrating that painting is not "the art of imitating an object by means of lines and colors, but the art of giving our instinct a plastic consciousness."

"There is nothing real outside ourselves," Gleizes and Metzinger declare, "there is nothing real except the coincidence of sensation and an individual mental direction." Though they do not doubt the existence of objects in the outside world, they insist that "we can only have certitude with regard to the images which they make blossom in our mind." Painting does not involve visual input alone, but our "tactile and motor sensations," and indeed, "all our faculties." It is the action of our whole "personality" that is involved: "To compose, to construct, to design, reduces itself to this: to determine by our own activity the dynamism

of form." Those who say that Cubism wants to capture "essential form" are wrong: an object does not have one form, "it has as many as there are planes in the domain of meaning." Though Cubists do seek the essential, they seek it in their own subjectivity.

One of the most conspicuous features of the essay is its rather belligerent tone, its insistence on the aggressive self-assurance with which artists must wield their peculiar power. The artist "imposes his vision," his "integrated plastic consciousness" on the public. "The ultimate aim of painting is to reach the masses, not in the language of the masses, but in its own, in order to move, dominate, direct, and not in order to be understood." Being an artist is a difficult but exalted and ultimately redemptive discipline: "it is in consummating ourselves within ourselves that we will purify humanity." The Cubist, the truly modern artist, the artist of the future, "will fashion the real in the image of his mind, for there is only one truth, ours, when we impose it on everyone."

During the years 1910–12, Picasso and Braque worked so closely that they claimed they could no longer tell their work apart. This kind of collaboration offered a new model of artistic practice: it undercut the traditional notion of art as the product of a distinctive, individual sensibility – precisely the attitude Gleizes and Metzinger seem eager to reinforce – and suggested that it might be like any other kind of labor. Something of the same point is made by the brushstrokes in the *Portrait of D. H. Kahnweiler*: blunt and undifferentiated, they derive from Cézanne but have a more impersonal, mechanical quality. Braque had worked as a house-painter and interior decorator, and he was fond of employing house-painter's techniques in his paintings – such as dragging a comb through wet paint to create the effect of wood grain – wittily confounding the distinction between "high" art and "low" art, art and craft.

Related to Picasso and Braque's new attitude toward work is their new attitude toward materials. They began to make images composed in part out of pieces of paper – construction paper, newspaper, sheet music, printed images, tickets, and labels of different kinds – a practice that came to be known as *collage*. Kahnweiler was one of the first to appreciate the significance of this achievement: with it "painting uncovered a new world of beauty – this time in posters, display windows and commercial signs which play so important a role in our visual impressions." On a deeper level, however, collage could serve as an instrument with which to extend the critique of representation begun in Cubist painting. In undermining the distinction between the work of art and the world of everyday objects, it opens up the possibility of a new kind of exchange between art and life; it suggests that art is not creation from nothing, but a form of improvisation or bricolage. In so doing, it further complicates the division between artist and worker.

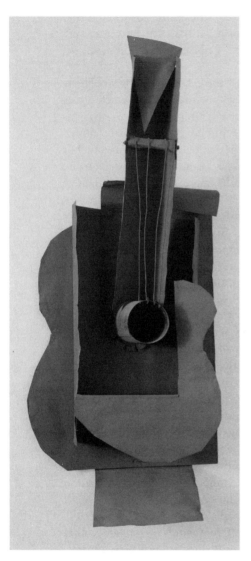

Figure 5.3 Pablo Picasso, *Guitar*, 1912, Museum of Modern Art, New York.

The implications of Cubism as especially evident in collage could be easily extended to three dimensions. Picasso's *Guitar* (figure 5.3), assembled from pieces of sheet metal and wire in 1912, plays with representational conventions in the same way as his two-dimensional works, and its manipulation of materials is perhaps even more suggestive. Though it does not resemble African sculpture in any obvious way, it is also the product of Picasso's mature reflection upon the implications of African art. Picasso was struck by the way in which, in a certain Grebo mask that he owned, for example, the hollows of the eyes are rendered as projecting cylinders, and he applies the same principle to his treatment of the sound-hole of the guitar. But there is also another principle at work, a deeper and more sophisticated one – that of the arbitrariness of visual signs in general. Kahnweiler, in a later essay, expressed this idea clearly, and his remark is perhaps the most penetrating insight by a contemporary critic into the significance of Cubism:

These painters turned away from imitation because they had discovered that the true character of painting and sculpture is that of a *script*. The products of these arts are signs, emblems, for the external world, not mirrors reflecting the external world in a more or less distorting manner. Once this was recognized, the plastic arts were freed from the slavery inherent in illusionistic styles. The masks bore testimony to the conception, in all its purity, that art aims at the creation of signs.

Whereas most of his contemporaries saw African art as the embodiment of the "primitive" or "savage," and Picasso's own use of it in his earlier work suggests a similar view, he had come to understand it differently:

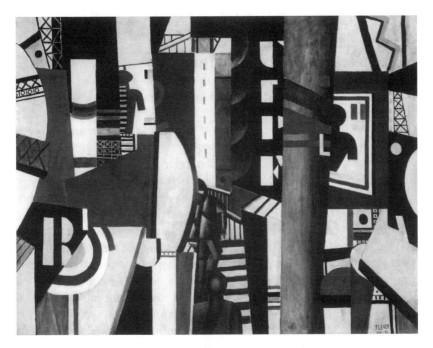

Figure 5.4 Fernand Léger, *The City*, 1919, Philadelphia Museum of Art.

in what must have seemed at the time like an outrageous remark, he told his friend Salmon that he found African art *raisonnable* ("reasonable" or "rational"). As a critique of visual representation, Cubism does something similar to what Symbolists such as Mallarmé had tried to do with language; in recognizing the arbitrariness of the sign, it resembles the linguistic theories then being advanced by C. S. Peirce and Ferdinand de Saussure – theories that would become the foundation of modern semiotics.

The importance of Cubism for later painting can be briefly suggested by considering the work of two very different artists: Fernand Léger and the Dutchman Piet Mondrian. Léger was one of the first artists to gather around Picasso and Braque; for him, the essential achievement of Cubism was to have shown that "the *realistic* value of a work of art is completely independent of any imitative character." He went on to serve in World War I, and emerged from that experience with both an increased respect for machines and a deeper commitment to social issues. He liked to describe himself as having come from "peasant stock" and wanted to create an art that would be comprehensible to working people. In a picture like *The City* (figure 5.4), painted in 1919, he adapts the formal devices of Cubism to the evocation of modern urban experience:

forbidding as it is, it is not without a certain beauty; the depersonalized, robotic figures who move through it manage to suggest both dehumanization and the kind of inner strength required to live in such an environment. Léger began to work in film in 1920, producing his own, *Mechanical Ballet*, in 1924: in his writings he emphasizes film's capacity to capture the rhythms of modern life, but also to present familiar objects in new and revealing ways.

For Mondrian, on the other hand, Cubism led to a lofty and rigorous form of abstraction (plate 20). He also thought it important to develop his ideas in writing: in one of his first essays, "The New Plasticism in Painting," published in 1917–18, he articulated the basic elements of a theoretical position he would continue to refine throughout his career. Beginning with a "spiritualist" orientation similar in many ways to Kandinsky's and informed by an exposure to Hegel, Mondrian claims that there is an objective historical development in modern culture toward greater spiritual realization. "The cultivated man of today is gradually turning away from natural things, and his life is becoming more and more abstract." "Both science and art are discovering and making us aware of the fact that *time is a process of intensification*, an evolution from the individual towards the universal, of the subjective towards the objective; towards the essence of things and of ourselves."

This process reveals itself in art as a progress toward abstraction, from an art devoted to objects to one devoted to relations between objects, and, finally, to one devoted purely to the relations themselves. The highest expression of truth is the "balanced" or "equivalent" relation: it is "the purest representation of universality, of the harmony and unity which are inherent characteristics of the mind." Mondrian's own painting expresses this balance in its dramatization of the single "primordial" relation between vertical and horizontal. His form of abstraction is thus intended to point toward the transcendence of all particular form: "Non-figurative art is created by establishing a *dynamic rhythm of determinate mutual relations* which *excludes the formation of any particular form.*" The "obstacle of form" having been overcome, the new art affirms itself as "pure plastic." This process is historically inevitable: "The culture of particular form is approaching its end. The culture of determined relations has begun." It is the culmination of all creative activity: "To destroy particular form is only to do more consistently what all art has done."

A consequence of the destruction of particular form is the breakdown of the distinction between the arts: "the new spirit must be manifested *in all the arts without exception.*"

This consequence brings us, in a future perhaps remote, towards the end of *art as a thing separated from our surrounding environment, which is*

the actual plastic reality. But this end is at the same time a new beginning. Art will not only continue but will realize itself more and more. By the unification of architecture, sculpture and painting, a new plastic reality will be created.

Mondrian was associated with a group of Dutch artists, architects, and theorists, regular contributors to the journal *Style* (*De Stijl*), who shared his views, and who sought to apply them – to apply what they understood to be the lessons of Cubism – to the built environment as a whole. Among the best examples of their efforts is the work of the furniture designer and architect Gerrit Rietveld.

In Germany, the lessons of Cubism were integrated into an independent body of thought about architecture and the role of architecture in modern society. In 1907, a group of progressive architects and designers had formed the *Deutscher Werkbund* (German Craft Alliance), with the idea of promoting a revival of architecture and the crafts along the lines suggested by Ruskin and Morris, but with an emphasis on the potential of new materials and a more positive attitude toward techniques of mass production. In 1919, one of their number, Walter Gropius, was chosen to head a new art school in Weimar, the *Bauhaus*, where he established an ambitiously systematic curriculum, intended to combine the "theoretical" orientation of the art academy with the "practical" training of the arts and crafts school. He emphasized the importance of design principles developed by painters such as the Cubists:

> Modern painting, breaking through old conventions, has released countless suggestions which are still waiting to be used by the practical world. But when, in the future, artists who sense new creative values have had practical training in the industrial world, they will themselves possess the means for realizing those values immediately. They will compel industry to serve their idea and industry will seek out and utilize their comprehensive training.

In the few years before it was closed by the Nazis in 1933, the Bauhaus became an extraordinarily productive laboratory of creative innovation. In 1926, it moved to Dessau, and into a new building designed by Gropius himself (figure 5.5). When Hannes Meyer, a Marxist, became director in 1927, he encouraged a strictly functionalist approach to architecture; his successor, Ludwig Mies van der Rohe, who took over in 1930, was more interested in classical aesthetic values. His emigration to America just before World War II helped to establish Bauhaus principles as the basis of what came to be called the "international style" in architecture. The Bauhaus also produced much of the twentieth century's most innovative industrial design: furniture, fabric design, graphic design (especially advertising), and stage design.

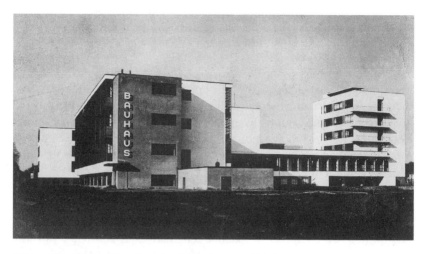

Figure 5.5 Walter Gropius, *Bauhaus*, Dessau, 1925–6.

Another architect who adapted Cubist principles was C. E. Jeanneret, known as Le Corbusier (1887–1965). Crucial to the formation of his ideas was an early period of collaboration with the Cubist painter, Amédée Ozenfant. Together they published a journal, *The New Spirit* (*L'Esprit Nouveau*), beginning in 1920, and used it to promote a theoretical position they called "purism." "The highest delectation of the human mind is the perception of order," they insist, "and the greatest human satisfaction is the feeling of collaboration or participation in that order." Le Corbusier went on to apply such principles in his buildings, and became one of the most influential architects and architectural theorists of the century, a pioneer in the design of "mass-production housing" and urban planning. His *Toward a New Architecture* (*Vers un Architecture*, published in 1923 but assembled mostly out of earlier articles) emphasizes the correspondence between the functional logic of machines and the principles of great architecture: the point is driven home by juxtaposed photographs of Greek temples and automobiles or ocean liners. Good modern design should be a rational fusion of new technology and classic ideals: it can have the socially beneficial effect of helping people adapt to the conditions of modern life – "A house is a machine for living in," he says – and neutralizing the kind of spiritual unrest that leads to revolution. *The City of Tomorrow and its Planning* (*Urbanisme*), published in 1925, is essentially a defense of his *Plan Voisin* (figure 5.6), a plan to replace the center of Paris with a modern urban complex, as radically rationalistic and implausible an idea as Boulée's *Cenotaph for Isaac Newton*. Such a plan also illustrates the limitations of rationalism:

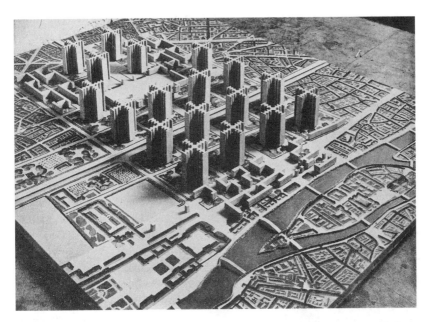

Figure 5.6 Le Corbusier, plan for the modernization of Paris (the so-called *Plan Voisin*), 1922–5.

ridiculed by conservatives as an outrage against the historical character of the city, it was criticized by progressives for being too authoritarian.

Nowhere was the sense of a new world coming into being – of its possibilities and its dangers – greater than in Russia in the years leading up to and immediately following the Revolution of 1917. In a few convulsive steps, Russia went from being one of the most backward societies in Europe to the most forward-looking of all, and artists faced the task, not simply of creating a new art for that new society, but of fashioning a new conception of what "art" might be – the art of the future. The utopian expectations would remain unfulfilled, of course, and the extraordinary burst of creativity that they nourished would soon be smothered by brutal state repression.

The work that best represents the ambition – and disappointment – of these years is Vladimir Tatlin's *Monument to the Third International* (figure 5.7), designed in 1919–20 but never built. A huge open steel frame in the form of a double spiral with a ramp ascending through it to a height of more than 1,300 feet was to have enclosed four separate buildings, each of a different shape, one atop the other, and motorized, so that each would revolve at a different speed. The two largest ones, nearest the ground, were to house the legislative and executive assemblies of the Communist International and to rotate once a year and once

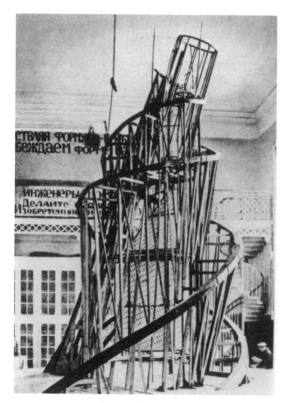

Figure 5.7 Vladimir Tatlin, *Monument to the Third International*, 1919–20, original model lost.

a month, respectively. The third, revolving once a day, was to be the "information" center, containing the offices of an international newspaper and publishing house as well as a radio station. The topmost building, a cinema, was probably intended to revolve once an hour. This astonishing design casts off all earlier architectural forms in favor of new ones determined by the potential of industrial materials and symbolic of the aspirations of the new society. That architecture should be set in motion is itself symbolic: the headquarters of worldwide revolution, it literally revolves; it is a revolutionary machine, a witness to the achievement of the impossible and the infinite potential of the future. Even more than Le Corbusier's *Plan Voisin*, it bears comparison with Boulée's *Cenotaph*.

Tatlin had worked in Paris and had derived from his study of Cubism a radical sense of the self-sufficiency of materials. After his return to Russia, he assumed a leading role in the formation of "constructivism" (which some of his comrades preferred to think of as "productivism") – a term which was meant to distinguish what its practitioners did from "art" in the old-fashioned sense. "The shaping principle of culture, production, and experience is material," he declared, and he insisted that creativity be understood as a collective achievement: "Invention is always the working out of impulses and desires of the collective and not of the individual." He and his collaborators at a state-supported agency for "research" into "material culture" produced designs for everyday objects such as worker's furniture and clothing.

The desire to reconstitute art on the model of labor and production was complemented by a desire to reconstitute it as action, an idea straightforwardly expressed by another artist, Alexander Rodchenko: "Conscious and organized life, that knows how to see and to build, is contemporary

art. The man who has organized his life, his work, and himself is a genuine artist." Just as Mondrian anticipated the breakdown of the division between the arts, and the dissolution of "particular form" altogether, Rodchenko senses the dissolution of art into "life," that is, into politics – into revolution.

The relation of art to action was also explored in Soviet theater and state spectacle, but achievements in film deserve special mention. Some early theorists of cinema, such as the Frenchman Louis Delluc, had stressed its capacity to overcome the limits of traditional representational media by including movement and thus bringing us face to face with "life itself." Others had insisted on its distinctness from theater, its autonomy as an art form, and the ways in which its technology enables us to extend and alter our perceptual faculties – to achieve a new subjective disposition toward the world. In a manifesto of 1916, Marinetti had called film "a new art, much more agile and vast than any other." The Russian leader Lenin thought similarly, saying that "for us" cinema "is the most important of the arts." Russian filmmakers of the revolutionary period can be said to have brought the two theoretical positions together, combining the medium's ability to record and reveal "life" as well as to create a new sensibility. Though even a great film like Sergei Eisenstein's *Battleship Potemkin* of 1925 may strike us as too heavily loaded with the propaganda of a discredited regime, the boldness of its vision is still impressive. Something of the joyous confidence in the combined forces of technology and revolution can be glimpsed in Dziga Vertov's *Man with a Movie Camera* of 1928, an attempt at a comprehensive demonstration of the technical and poetic possibilities of film.

Beyond Reason

World War I, the first modern technological and total war, shook European culture to its foundations. Not only were there casualties on a scale unprecedented in human history – more than eight million killed, twenty million wounded – the slaughter was made more efficient by the very technology that had seemed, not long before, to offer such hope for the improvement of mankind. There was no clear reason for the conflict, no great issue at stake, and because the industrial resources which the principal powers had accumulated over the preceding generations were so quickly and easily adapted to the needs of war production, many observers could only conclude that the war was itself an effect of capitalism – a vast destructive mechanism from which the leading industrialists on both sides stood to reap huge profits. The war brought about the Russian Revolution, it would create political and social instability throughout

Europe in its aftermath, and it would lead to an even bigger, more destructive war in only a few years. Beyond even that, however, it was widely seen as a betrayal of all enlightened values and an exposure of the utter bankruptcy and barbarism of modern society. Though the ambivalence of reason – its capacity for evil as well as good – had been sensed since the Enlightenment, the Great War, a monstrous exercise in rationalized irrationality, made reason seem like a sinister sham.

The artistic movements known as Dada and Surrealism are in large part a response to this situation. The disruption of creative life in Paris and the displacement of writers and artists to centers such as Zurich, New York, and Barcelona gave a note of urgency to artistic thinking. The feeling that the war marked an apocalyptic turning point in history, holding out at least the tenuous hope that now, finally, things must surely change, pushed artists in a more radical direction, intensifying their search for new values and methods. Like Futurism – and unlike Cubism – Dada and Surrealism were more than artistic movements; they were comprehensive strategies for living: they involved a cultivation of the irrational, though less as an end in itself than as a strategically administered antidote to the pervasive poison of corrupted reason. Although it would certainly contradict the thrust of their own rhetoric, they can be seen as highly rationalized forms of counter-reason, as systematic "critiques" of reason, and thus as attempts to reclaim and extend an Enlightenment project. Bold and incessant theorizing played an essential role in both movements, and in many ways their larger aims – those of Surrealism in particular – as revealed in theory are more impressive than the objects they produced.

Among the conscientious objectors and draft-dodgers from all countries seeking refuge in neutral Switzerland was the German poet Richard Huelsenbeck, who later wrote a vivid description of their collective state of mind:

> We were agreed that the war had been contrived by the various governments for the most autocratic, sordid, materialistic reasons . . . None of us had much appreciation for the kind of courage it takes to get shot for the idea of a nation which is at best a cartel of pelt merchants and profiteers in leather, at worst a cultural association of psychopaths who, like the Germans, marched off with a volume of Goethe in their knapsacks, to skewer Frenchmen and Russians on their bayonets.

Huelsenbeck was part of a group in Zurich that formed around another German poet, Hugo Ball, and his wife, a music-hall entertainer, Emmy Hennings. Early in 1916, Ball and Hennings had set up a nightclub which they hoped would be an oasis of international progressive culture.

They rather poignantly named it Cabaret Voltaire, in honor of the great Enlightenment thinker who had been forced to live in Switzerland to avoid censorship and imprisonment in his native France.

The cabaret served as an art gallery and experimental theater. Ball and another member of the group, Tristan Tzara, were familiar with Futurist poetry and performance, and were especially interested in the techniques of "simultaneous" poetry and "bruitism" – noise poetry. At their cabaret, performances would sometimes feature texts in three different languages read simultaneously. "We have developed the plasticity of the word to a point which can hardly be surpassed," Ball wrote in his diary. He was fond of conducting his own readings as mock religious rituals, complete with priest-like costumes: "What we are celebrating is at once a buffoonery and a requiem mass." Huelsenbeck, on the other hand, would put on blackface and bang on drums in imitation of "negro" music. These events, like the Futurist evenings before them, regularly provoked violent reactions among members of the audience. The cabaret closed after only five months but the artists found other venues for their performances.

This group soon came to refer to its activities as "dada" – a child's expression for a wooden horse, which, in French, can also mean a recurrent idea or obsession. Huelsenbeck and Tzara later claimed that they had chosen the name randomly from a dictionary. Deliberately avoiding the pretension of a word ending in "ism," the label signals an irreverent attitude toward art – even toward recent modern art – a feeling that perhaps the very idea of art needs to be kept at a certain distance. One member of the group, Jean Arp, who had been a Cubist painter before the war, had come to see "art" as the "collaborator" of mankind's "false development." He took to making his collages "according to the laws of chance" by dropping pieces of paper onto a support and gluing them where they happened to land. His method would seem to go even further than Picasso and Braque toward rejecting the prerogatives usually associated with art-making – the seemingly indispensable idea of the work of art as the product of human decision-making – but Arp actually felt that he was allowing "nature" to take a hand in the creation of his work: in a manner not at all incompatible with the principles of Enlightenment aesthetics, he saw nature as offering an alternative to the vain and sterile rationality of even the most progressive modern art. Ball, too, was something of a mystic; he did not see the new direction that he and his friends had taken as anti-art, but as art of a new kind: "Perhaps the art which we are seeking is the key to every former art: a salomonic key that will open all mysteries." Tzara expressed himself rather less grandly: "Dada remains within the framework of European weaknesses; it's still shit, but from now on we want to shit in different colors."

At the end of the war the German imperial regime collapsed and for a moment it seemed that there might be a revolution in Germany similar to the one that had just occurred in Russia. In Berlin, a group of artists with radical political views adopted "dada" as their rallying cry; for them, the rejection of traditional art went hand in hand with the rejection of a social system dominated by the interests of the mercantile middle class. One of their spokesmen was Huelsenbeck, for whom "art" in the old-fashioned sense had become merely "a large scale swindle," "a moral safety valve" for bourgeois hypocrisy. For these artists, Dada was essentially a mode of political action: Huelsenbeck went so far as to say that "Dada is German Bolshevism." With another member of the group, Raoul Hausmann, he composed a manifesto demanding "the international revolutionary union of all creative and intellectual men and women on the basis of radical Communism," and the "introduction of the simultaneist poem as a Communist state prayer."

The perpetrators of Berlin Dada looked to the new Soviet Union for guidance in artistic matters as in politics. "Art is dead – Long live the machine-art of Tatlin," was one of their slogans. Adopting the collage as their preferred medium, they turned it from a rarefied type of speculation on the nature of representation into a powerful instrument of public communication. Huelsenbeck called collage "the new medium," and said that it:

> points to the absolutely self-evident that is within reach of our hands, to the natural and naive, to action. The new medium stands in a direct relation to simultaneity and bruitism. With the new medium the picture, which as such always remains the symbol of an unattainable reality, has literally taken a decisive step forward, that is, it has taken an enormous step from the horizon across the foreground: it participates in life itself.

By making a collage from other images, that is, from photographs – a technique called photomontage – one could produce images that used the techniques of mass communication, especially advertising, against the traditional values. An example is Hannah Höch's *Cut with a Dada Kitchen Knife through the Last Era of Weimar Beer-Belly Culture* of 1919–20 (figure 5.8), in which the images of industrial machinery, capitalist bigwigs, naked women, and bits of verbal messages – including the subversive message "dada" – spill over the surface, as if the body politic could be, and actually had been, disemboweled.

Berlin Dada also made an important contribution to theater and performance art, best exemplified by the plays and theoretical pronouncements of Bertolt Brecht. Recognizing that the illusionistic devices of traditional theater served to reinforce bourgeois structures of thought

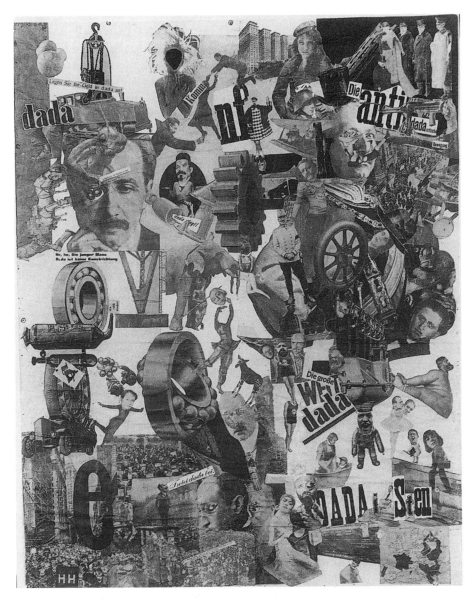

Figure 5.8 Hannah Höch, *Cut with a Dada Kitchen Knife through the Last Era of Weimar Beer-Belly Culture*, 1919–20, National Gallery, Berlin.

and behavior, Brecht developed an approach in which the audience is constantly reminded that they are in a theater, and rather than being encouraged to identify with the protagonists in order to achieve some sort of emotional catharsis, are prompted to maintain a certain detachment

and to exercise their critical faculties. He and his collaborators drew upon some of the innovations of earlier Dada performance, as well as on traditional popular theater and non-Western theater, but also made use of devices such as texts and images projected onto the sets. Deliberately artificial, this form of theater could thus be said to exist in a more realistic relation to reality, and it aimed to expose the reality of economic and political conditions more directly. It was both artistically sophist-icated and accessible to the working class whose energies Marxists were concerned to mobilize.

Elsewhere Dada did not take such an overtly political turn. By the time it arrived in Paris at the end of the war, Tzara had established himself as its leader and principal spokesman. He organized events similar to those in Zurich, and – despite his claim that "we recognize no theory" – kept up an energetic campaign of manifesto writing. "There is a great negative work of destruction to be done," he claimed: "We must sweep and clean." This work is not merely destructive, however, for it aims to "affirm the cleanliness of the individual." Though he insists that Dada is rooted in "disgust" with the "aggressive and complete madness of a world abandoned to the hands of bandits," he urges no coherent pro-gram of political action:

> Dada is not at all modern. It is more in the nature of an almost Buddhist religion of indifference. Dada covers things with an artificial gentleness, a snow of butterflies released from the head of a prestidigitator. Dada is immobility and does not comprehend the passions. You will call this a paradox, since Dada is manifested only in violent acts. Yes, the reactions of individuals contaminated by *destruction* are rather violent, but when these reactions are exhausted, annihilated by the satanic insistence of a continuous and progressive "what for?" what remains, what dominates is *indifference.* But with the same note of conviction I might maintain the contrary . . .

Francis Picabia, an artist of mixed French and Latin-American back-ground, who spent some of the war in New York and some in Barcelona before turning up in Zurich, then after the war went to Paris, provided the most caustic expression of Dada disgust with the reverence for artistic tradition: a stuffed monkey making an obscene gesture, mounted on a board, with the inscription: "Portrait of Rembrandt"/"Portrait of Cézanne"/"Portrait of Renoir"/"Still Lives" (figure 5.9).

The most complex and influential figure associated with Dada was Marcel Duchamp. Excused military service owing to a mild heart condi-tion, he spent most of the war in New York. He had begun as a Cubist, but was deeply dissatisfied with what he called "the physical aspect of painting": "I was interested in ideas – not merely in visual products. I wanted to put painting once again in the service of the mind." In 1913

Figure 5.9 Francis Picabia, *Still Lives*, 1920, original lost.

he made an object consisting simply of a bicycle wheel mounted on a stool. He soon went even further, however, taking found objects, such as a bottle rack, and claiming them as his works without modifying them at all. While in New York, in 1917, he exhibited a urinal turned on its back and entitled *Fountain* (figure 5.10), with a graffiti-like signature, "R. Mutt." As intended, the object created a furor; it was hidden from view and quickly disappeared, and Duchamp made the most of the scandal by writing a public letter of complaint: "Whether Mr Mutt with his

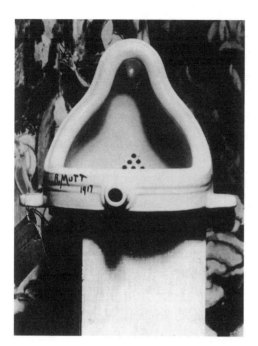

Figure 5.10 Marcel Duchamp, *Fountain*, 1917, original lost.

own hands made the fountain or not has no importance. He CHOSE it. He took an ordinary article of life, placed it so that its useful significance disappeared under the new title and point of view – created a new thought for that object."

Duchamp came to refer to these works made from found objects as "readymades"; even more than Cubist collage, they constitute a radical challenge to the very idea of art. The notion of creative work, which Picasso and Braque had begun to redefine in their technique and collaboration, is reduced to the simple act of selecting an object and designating it as art. Such objects render void all the traditional sources of aesthetic interest; they stake their claim to consideration as art simply on the label attached to them. In threatening to efface the barrier between "art" and "life" completely, they seem to empty the category "art" of all meaning, but at the same time they reveal its richness and complexity in a new way: they deflect attention from the formal qualities of the particular object to the entire constellation of conceptual, linguistic, institutional, and cultural factors that condition the way in which we deal with objects. *Fountain* is certainly an acerbic comment on that constellation of factors as it must have seemed during the war years; it surpasses even Manet's *Luncheon* in the depth and articulateness of its irreverence.

Duchamp was a man of extraordinary intellectual complexity, deeply read in Symbolist poetry, a composer, and a champion chess-player. His other work draws upon a fascinating and peculiar array of sources and involves a number of themes: as early as 1913, for instance, he had begun to experiment with works made by chance, dropping lengths of string to determine patterns that he then used as standards of measurement in his other works. His sense of the arbitrariness of measurement was matched by a sense of the arbitrariness of language. He shared the interest of Symbolist writers such as Raymond Roussel in puns – those moments when the accidental correspondence of sounds creates a meaning of its own – and was intrigued by the theories of an eccentric philologist, Jean-Pierre Brisset, who believed that similarities of sound, even

among words in different languages, necessarily indicated some deep original similarity of meaning. Duchamp developed an elaborate system of puns – a kind of personal mythology of linguistic irrationality – and put it to use in his work. His use of tailor's molds as symbols of male identity, for instance, is owed in part to the fact that "l'habit," the French word for suit, sounds like "la bitte," a mooring post – and colloquial expression for penis.

Duchamp's ironic engagement with machines also owes much to precedents in Symbolist literature and theater, especially to the plays of Alfred Jarry and Roussel, with their peculiar combination of fantasy and deadpan humor. Rather than as harbingers of a future utopia, these writers would have prompted Duchamp to regard machines as quaint, absurdly comical reflections upon the human body and its functions. The reversibility of the analogy is crucial, of course: human bodies are like machines. Duchamp was especially amused by the ways in which machines imitate sexual functions, and again, by a reversal of terms, in the mechanical nature of human sexuality. All these interests come together in the enigmatic construction known as *The Great Glass* (*The Bride Stripped Bare by her Bachelors, Even*) made between 1915 and 1923 (figure 5.11). Duchamp later provided a set of explanatory notes – an explanation which, in the tradition of Symbolism, only makes the work more mysteriously multivalent.

Some of the French poets who emerged after the war and had involved themselves in Dada soon began to grow dissatisfied with the progress of the movement. A group associated with the journal *Literature* (*Littérature*), led by André Breton (1896–1966), Philippe Soupault, and Louis Aragon, found Tzara's polemics too "negative," and felt the need for a more constructive – that is, more meaningfully critical – strategy. Breton's efforts to organize a vast congress of intellectuals in 1922 were sabotaged by Tzara and his allies, and the resulting split led to the rapid disintegration of Dada as an organized movement. In 1924, Breton and his associates broke with Dada to form their own movement, which, borrowing a term from Apollinaire, they called "surrealism." They launched a new journal, *The Surrealist Revolution* (*La Révolution Surréaliste*), which they used as a means of publicizing their poetry, criticism, and theoretical ideas.

In a manifesto published independently in the same year, the first of the Surrealist manifestos, Breton complains about the sterility of life "under the reign of logic": experience "paces back and forth in a cage from which it is more and more difficult to make it emerge." The only way to remedy this situation is to mobilize the "imagination," the non-rational resources of the mind: "If the depths of our mind contain strange forces capable of augmenting those on the surface, or of

Figure 5.11 Marcel Duchamp, *The Bride Stripped Bare by her Bachelors, Even*, 1915–23, Philadelphia Museum of Art.

waging a victorious battle against them, there is every reason to seize them – first to seize them, then, if need be, to submit them to the control of our reason." We must try to reconcile these two aspects of the mind, "dream and reality," fusing them into "a kind of absolute reality, a *surreality* . . ."

The literary tool with which a poet or writer may begin this process of reconciliation is "automatic" writing, a practice which Breton and Soupault had pioneered in 1919, and which involves an effort to relax all conscious control over what one writes. Breton calls it a "new mode of pure expression" that allows the poet to tap "the sources of poetic imagination" and trace "the actual functioning of thought." Automatism is more than a literary technique, however; it has a deeper therapeutic effect. It leads to an understanding of "the superior reality of certain forms of previously neglected associations"; it "tends to ruin once and for all all other psychic mechanisms and to substitute itself for them in solving all the principal problems of life." Surrealism is thus an instrument of personal liberation and the transformation of society as a whole: Breton foresees its ultimate effect as the substitution of "a new morality" for the prevailing one, "the source of all our trials and tribulations." In his belief that it might thus help to heal the painful breach in human nature, Breton frames the revolutionary role of art in terms not unlike Schiller's.

The practice of automatism derives from psychotherapy, and Breton associates the "imagination" with the "unconscious" as described by Freud: that realm of unacknowledged desires which the mind, beginning in early childhood, makes every effort to repress, but which returns to make its presence felt in dreams, in slips of the tongue, and in mental illness. Breton had worked in a clinic for victims of what was then called "shell shock" during the war; he studied Freud's writings and even went to visit the great doctor in Vienna in 1921. Freud's notion of the unconscious provided the Surrealists with an alternative to Dada's emphasis on chance – and enabled them to go further in exploring the complex depths of personal experience than the Symbolists. If, as we have noted, Symbolism was a "a modern strategy – a technique – for reclaiming the irrational," Surrealism can be seen as a refinement upon that technique. Even if Breton's actual understanding and application of Freudian principles was limited, the movement he helped to initiate took up the larger task – still continuing – of integrating the radical and disturbing insights of psychoanalysis into art.

Automatism is only one way of achieving the surreal. Another is to create an effect of the "marvelous" with surprising and unlikely juxtapositions. Breton was fond of illustrating this idea with a line from the poetry of the proto-Symbolist Isador Ducasse, Comte de Lautréamont: "as lovely as the chance encounter of an umbrella and a sewing machine upon an operating table." The marvelous is fundamental to literature, and Breton was concerned to point out how Surrealism is anticipated in the work, not only of the Symbolists and Romantics, but in fairy tales of all kinds and even in Dante and Shakespeare. In one of his own novels, *Nadja*, published in 1928, he explores the "marvelous" suggestiveness of

the odd juxtapositions and coincidences that occur in urban life, the peculiar poetry of circumstance, or what he called "objective chance." He was also quick to understand that Surrealism might involve a whole new way of experiencing the world of objects and our material circumstances in general. Like the engagement with psychoanalysis, this aspect of Surrealism continues to have an influence on contemporary art.

In his zeal for the movement, Breton came to exert a kind of dictatorial control over it. For all that he might be inclusive when it came to appropriating past writers, living Surrealists who strayed too far from his doctrine risked being ostracized or, as they liked to put it, "excommunicated." In defining and redefining its aims and principles, he often harshly criticized those whom he felt had betrayed the movement. His claims for the revolutionary potential of Surrealism naturally attracted the attention of Marxists, who tended to look upon it as a decadent form of self-indulgence. Breton was committed to the idea that Surrealism was a revolutionary practice, however: he joined the Communist Party, and in 1927 transformed *The Surrealist Revolution* into *Surrealism in the Service of the Revolution*. In 1929, he published a second manifesto, in which he tried to explain that subjective experiences are also the products of objective historical forces, and that the intellectual independence of artists is vital to any contribution they might make to revolution. He took particular aim at the writer Georges Bataille, whose *Story of the Eye* had recently created a sensation: Breton thought the book obscene and accused the author of "vulgar materialism." Bataille, who dismissed Breton as an idealist, created his own journal, *Documents*, which became for a while an important mouthpiece for Surrealists who had run afoul of Breton.

Bataille was, in fact, one of the most serious thinkers associated with Surrealism; his work has gathered greater acclaim with the passage of time and has exerted an important influence on postmodernism. Even more fiercely and deeply anti-rational than the other Surrealists, he set out to demolish the belief in the possibility of transcendence, the idea – especially as formulated by Hegel – that reality is finally completely assimilatable to reason, and he acknowledged Nietzsche as a precursor. He coined the term "heterology" to embrace his various strategies for thinking the unthinkable: against the traditional rationalistic preference for identity he advocated the transgression of conceptual boundaries, against the traditional preference for form he emphasized the formless; to the ideal he opposed the "base" material, to the divine, the obscene. His work explores the darkest aspects of human nature, such as the connection between eroticism and violence, even how religion is founded upon violence – a point also made in Freud's later writings – and he evolved his own theory of human drives around the notion of "expenditure" (*dépense*). He drew much of his inspiration and information from

Figure 5.12 André Masson, automatic drawing, c.1924–5, Kunsthalle, Hamburg.

contemporary anthropological research, but used the insights gained in the study of non-Western societies to expose the irrational forces at work within Western cultural institutions.

Surrealist practice in the visual arts was as diverse as in poetry. Artists like André Masson and Joan Miró began to experiment with automatic drawing in a manner obviously inspired by automatic writing (figure 5.12), but theirs was only one direction, and there was in fact a good deal of discussion about what Surrealist art should be. Some critics felt that because painting was such a laborious process, photography and film were better suited to the unpredictable workings of the unconscious.

Breton defended painting, however, suggesting that the imaginative manipulation of optical experience has a unique power to "discredit" the apparent reality of the external world. He claimed that Picasso was a Surrealist, even in work made before the movement had begun: he seems to have meant simply that Picasso's pictures achieve a vivid superimposition of subjective reality onto objective reality. Bataille, who was closely associated with Masson, also wrote about Picasso in a manner that suggests intense intellectual sympathy. Though Picasso did occasionally collaborate with Surrealist poets and exhibit with Surrealist painters, he avoided letting himself be swept up in the movement.

Breton also identified the Italian painter Giorgio DeChirico as a Surrealist *avant la lettre*. DeChirico had received an academic training; as early as 1910 he began to paint strangely affecting images involving bizarre juxtapositions of objects and hauntingly empty architectural spaces: an example is *Love Song* of 1914 (figure 5.13). The "chance encounter" between the cast of the head of an ancient Apollo and a surgical glove does not explain itself in any logical way: the cast is the kind of object that might adorn the studio of an academic painter; it might be seen as a symbol of the lofty intellectual potential of art. The glove might be a symbol of science in its threatening, invasive aspect; the image as a whole may thus be an allegory of ancient and modern, or art and science, or the poetic and the prosaic. But its resonance exceeds any such symbolic reading: it implies something deeper, something vividly felt, yet defying articulation. The green circular form in the foreground casts a shadow like a spherical object, but is articulated with lines that suggest its surface is concave: it is like an eye, and the picture as a whole seems to look back at us as much as we at it. DeChirico's own writings frequently evoke the theme of objects "staring back," of subjectivity imploding, as it were, under the pressure of the world, to become itself a kind of object. These passages shed light on the preoccupations reflected in his pictures and have been used to support psychoanalytic readings of them.

Another artist whom Breton recognized as having anticipated Surrealism was the German, Max Ernst, who had studied philosophy and psychology, including some Freud, at the University of Bonn before being called up to serve in the German army. After the war, he became involved in Dada, was impressed by the reproductions of DeChirico's pictures he saw in journals, and ultimately moved to Paris. He developed collage into a highly personal expressive language: an example is *Holy Conversation* (*Santa Conversazione*) of 1921 (figure 5.14). Ernst liked to define collage as "the alchemy of the visual image"; evoking Lautréamont, he described it as an "exploitation of the chance meeting of two distant realities on an unfamiliar plane, or, to use a shorter term, the culture of systematic displacement and its effects." Making the reference to

Figure 5.13 Giorgio DeChirico, *Love Song*, 1914, Museum of Modern Art, New York.

Symbolist methods even more explicit, he also links the "systematic confusion" he wishes his work to create to the "disordering of all the senses" advocated by Rimbaud. For Ernst, being an artist involves a kind of calculated madness, an *"intensification of the irritability of the faculties of the mind."*

The Belgian painter René Magritte was also inspired by contact with the work of DeChirico: it is said that he was moved to tears at first seeing a reproduction of *Love Song* in 1922. He became involved in a Surrealist

Figure 5.14 Max Ernst, *Holy Conversation*, 1921, original lost.

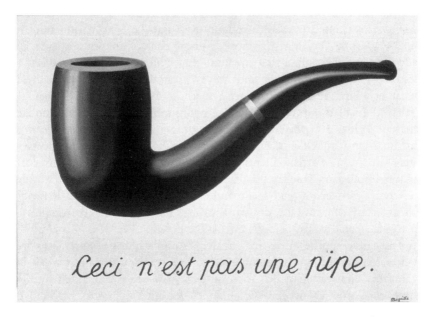

Figure 5.15 René Magritte, *The Treachery of Images*, 1929, Los Angeles County Museum of Art.

group in Belgium in 1926 and moved to Paris the next year. Among the works he painted there are a series making use of words: inspired by the automatist work of Masson and Miró, they nevertheless adopt a traditional naturalistic technique, relying for their effect on implausible juxtapositions. The most famous picture from this series is *The Treachery of Images* (figure 5.15), painted in 1929. Beneath a meticulously rendered image of a pipe are the words "This is not a pipe." On the most obvious level, the "treachery" in question involves the fact that any painted image of a pipe is simply an image, not a real pipe, but the implications are even more complex. Even a real pipe is not necessarily a pipe: in psychoanalytic terms, any object may be a fetish, a substitute for something else. Such a picture is thus a blunt statement of the fact that conventional reality, precariously supported by language, is an illusion: it invites us to contemplate the endless depths hidden beneath the surfaces of things. Much of Magritte's other work deals with the paradoxical nature of representation; it also includes some striking treatments of sexual themes.

Salvador Dalí, who arrived in Paris from Spain in 1929, was at first regarded by many Surrealists as the artist most likely to achieve the highest realization of their principles in visual form. Their expectations were based as much on the film, *Andalusian Dog* (1929), made in collaboration with Luis Buñuel, as on his paintings, with their dreamlike

combination of precise description and bizarre distortion. His picture *Lugubrious Game* attracted the attention of Bataille, who wrote about it in *Documents*. Dalí himself wrote a good deal of theory and was an advocate of photography, a medium that "offers us simultaneously a lesson of the highest rigor and the greatest freedom." He developed what he called a "paranoid-critical" method, a thought process that he believed enabled him to "systematize confusion" in a manner not unlike that of Ernst. He once declared that "the only difference between a madman and myself is that I am not mad," a remark that suggests a transformation of artistic identity similar to the transformation of the art object implied by Duchamp's readymades: one might say that the only difference between a readymade and an everyday object is that it is not an everyday object. Like the work of art, the artist's mind occupies a marginal, paradoxical, perhaps impossible position.

The case could be made that the deeper implications of Surrealism are better realized in photography, film, and the making of objects than in painting. The way in which these interests overlap is illustrated by the American artist Man Ray (Emmanuel Radnitzsky), who befriended Duchamp in New York during the war and moved to Paris in 1920. He earned his living as a photographer, producing images that sometimes make use of technical manipulation, sometimes simply capture oddly suggestive sights; he also made experimental films. A still from his 1923 film *Return to Reason*, an image of a woman's torso traversed by the shadows of a lace curtain as if by a kind of writing, was used to illustrate the first number of *The Surrealist Revolution* (figure 5.16). One of his objects, *Gift*, from 1921, a hand iron with tacks projecting from the bottom, is of obvious Duchampian inspiration, yet suggestive of specific psychological forces in a way that Duchamp's objects are not. In the early 1930s, as Hitler was coming to power, the German artist Hans Bellmer created wooden dolls made up of interlocking and interchangeable body parts, which he rearranged in various disturbing configurations and photographed (figure 5.17). His work quickly won the admiration of the French Surrealists. With their uncanny fascination as human doubles, dolls and mannequins are almost by definition Surrealist objects, and Bellmer was able to make his into articulate registers of the most conflicted erotic impulses.

Even more than such objects, however, the real achievement of Surrealism, the deeper challenge that it posed – and still poses to art – lies in its attempt to develop a comprehensive way of seeing and living, a strategy for everyday life. Surrealism conditioned the intellectual environment that produced both the existentialism of Jean-Paul Sartre, with its new approach to the problematics of human action, and the phenomenology of Maurice Merleau-Ponty, with its attentiveness to sensation

Figure 5.16 Man Ray, *Return to Reason*, 1923, Art Institute of Chicago.

and the body. As we have already seen in the case of Bataille, the concerns of the Surrealists were shared by contemporary anthropologists and sociologists: part of the enthusiasm for ethnographic research during these years had to do with the possibility of entering into other ways of thinking, other modes of being, and using them critically – as

Figure 5.17 Hans Bellmer, *Doll*, 1934, J. Paul Getty Museum, Los Angeles.

was done most influentially by Claude Lévi-Strauss – to reflect back on Western rationality. Another product of such reflected self-awareness was Henri Lefebvre's *Critique of Everyday Life*, published in 1948, which would have an influence on French radicalism of the 1960s as well as on the work of postmodernist ethnographers and sociologists.

The critic Walter Benjamin (1892–1940) deserves special mention in this context. A German Marxist who fled to Paris in 1933, Benjamin came into contact with some of the Surrealists and forward-looking anthropologists; his intellectual project had a good deal in common with theirs but had evolved independently and had a distinctive orientation of its own. Benjamin's overriding preoccupation was the nature of modernity. He was sensitive to all the ways in which modernity reveals itself in the nuances of subjective experience, but tended to analyze them historically and was well aware that his mode of analysis was itself symptomatic of the modern condition; for him, modernity is fundamentally an intensified experience of historicity. He was particularly concerned to explore the material determinants of this condition, finding them in economic forces, but also in the built environment, in social ritual, and in technology. He was fascinated by the city of Paris, and saw it as a vast material deposit of the forces that had shaped the modern world; at the time of his premature death he was planning a large and unconventional book about the city, a kind of archaeology of modern consciousness, built around the juxtaposition of a wide variety of texts and images. His writings, many of them fragmentary, were not widely known until the 1960s and 1970s;

after their translation into English they came to exert a deep influence on the development of postmodernism.

American Modern

With the rise of Fascism and the outbreak of World War II, the artistic life of Europe was again thrown into disarray. Many of its leading figures sought refuge in America, and New York in particular became something like the new capital of modern art. Although varieties of European modernism had made their way across the Atlantic prior to the war, and American artists such as the photographer Alfred Stieglitz or the architect Frank Lloyd Wright could lay claim to international stature in their own areas of specialization, it was only in the 1940s that America began to determine the direction of modernism as a whole. This process coincided with America's emergence as the world's leading military and economic power, and recent scholarship has shown just how important money, marketing, even Cold War politics, were to the rise and dissemination of American modernism, as well as how such factors tended to overshadow the interest of work being done elsewhere. The cultural specificity and peculiarity of American art are important to note: spectacular as the innovations of the twenty-five years from the end of the war to 1970 may be, much as they may seem to stand on their own, they can and should be seen as responses to the pressures of societal transformation. A new culture – perhaps a new *kind* of culture – was coming into being, one which, for better or for worse, has managed to impose itself on most of the rest of the world and to structure the reality we all now face.

The artist who best represents the initial phase of this process is Jackson Pollock. Born in Wyoming, Pollock moved at the age of seventeen to New York to study painting: his earliest works are populist scenes of American rural life, but by the early 1940s he was in contact with émigré Surrealists, undergoing psychoanalysis, and experimenting with automatism. He developed a distinctive abstract style, much indebted to Picasso's work of the late 1930s. In 1947, he began to do away with recognizable images and to drip, splatter, and pour paint onto canvases which he had spread on the floor of his studio. This technique was just novel enough to engage the interest of the general public, and Pollock became a celebrity, the first American art "star."

His characteristic paintings of this period (plate 21) are striking, first of all, in their scale: they are generally much larger than easel pictures. They are non-objective, but are not exactly "compositions" in Kandinsky's sense: the tangle of lines distributes the viewer's attention over the

surface as a whole, emphasizing its indivisibility rather than disclosing any carefully calculated set of relationships between the parts. Indeed, the combination of size and "all-over" composition engages the viewer in a much more aggressive way: looking at a Pollock is a little like doing battle with the multi-headed Hydra of ancient myth. The expressive effect depends upon the way the painting records the artist's physical movements – the act of making – and the sense of direct contact with the artist and his state of mind that thus results. Such an approach makes it very difficult to apply the usual critical criteria – to say, for instance, that this or that detail is "right" or "wrong" – and thus does away at one stroke with a whole set of habits associated with looking at works of art. The way in which Pollock has risked everything in the spontaneous, concentrated act of painting gives the pictures an impressive kind of honesty and integrity – even if very unlike the integrity of a Cézanne or a Picasso.

Pollock was not much of a theorist; indeed, his resistance to lengthy verbalizing was part of the image he and his handlers sought to convey. He was marketed as the quintessential "American" painter, but he himself seems not to have taken the image very seriously: "The idea of an isolated American painting, so popular in this country during the thirties, seems absurd to me, just as the idea of creating a purely American mathematics or physics would seem absurd." He did acknowledge the influence of Native American art, especially the sand-painting of the Navajo and other peoples of the Southwest, and he admitted that this interest owed much to the fact that the Navajo sand-painter is also a priest and healer, and produces his paintings as part of a religious ritual. Pollock's invocation of the ancient connection between art and magic, the artist and the shaman, reaches back, via Surrealism, to Symbolism and Romanticism.

The critic Harold Rosenberg described Pollock and others as "action painters": "At a certain moment the canvas began to appear to one American painter after another as an arena in which to act – rather than as a space in which to reproduce, redesign, analyze or 'express' an object, actual or imagined. What was to go on the canvas was not an image but an event." Because such works are "of the same metaphysical substance as the artist's existence," they break down "every distinction between art and life." The critic who "goes on judging" them by the same old standards is missing the point. Rosenberg's language subtly connects the new painting to European existentialism, with its redefinition of ethical integrity and its emphasis on action and the necessity of risk, a philosophy that was beginning to become popular among American intellectuals and that would inform the values of the "beat" generation just beginning to emerge.

Not all the innovative painting depended so obviously on "action," however, and Rosenberg's term has proved less durable than the more neutral designation "Abstract Expressionism." At just the moment that Pollock began to drip his paint, Barnett Newman began to make pictures dominated by a single uniform color, broken only by a few slender vertical lines (plate 22). Instead of Pollock's restless, aggressive energy, these pictures have a solemn concentration suggestive of deep inward revelation, an effect that is greatly enhanced by their suggestive titles. Yet they are not compositions in the traditional sense, either: Newman thought of them as "relationless" compositions – compositions that do not depend on the calculated effect of complex internal relationships, and that thus suggest the idea of compositionlessness. At about the same time, Mark Rothko developed his characteristic type of picture, in which atmospheric zones of color seem to hover in uneasy relation to one another.

In his theoretical pronouncements, Newman revived the idea of the "sublime" and tried to give it a distinctly American cast. European modernism, preoccupied with formal refinement, had reached a dead-end and left artists with a serious problem, but "here in America, some of us, free from the weight of European culture, are finding the answer, by completely denying that art has any concern with the problem of beauty . . . We are reasserting man's natural desire for the exalted, for a concern with our relationship to the absolute emotions." Rothko, equally interested in recovering "the transcendental," gave more emphasis to the oppressive nature of modern life generally: "The familiar identity of things has to be pulverized in order to destroy the finite associations with which our society increasingly enshrouds every aspect of our environment." The artist and critic Robert Motherwell also stressed the political motivations behind the new work, but his understanding of European modernism – especially of Symbolist poetry, Dada, and Surrealism – made him resistant to seeing American developments in nationalistic terms.

The dominant critic of this period was Clement Greenberg (1909–94). In the essay "Toward a Newer Laocoon," published in 1940 – the title of which, invoking Lessing's treatise, clearly signals its prescriptive intention – he argued for what he called "purism," supporting his case with an account of the historical development of artistic modernism. Since the nineteenth century, he insists, the visual arts have liberated themselves from the domination, first of literature, then of music, to establish their autonomy:

> Guiding themselves, whether consciously or unconsciously, by a notion of purity derived from the example of music, the avant-garde arts have in the last fifty years achieved a purity and a radical delimitation of their fields of activity for which there is no previous example in the history of culture.

The arts lie safe now, each within its "legitimate" boundaries, and free trade has been replaced by autarchy. Purity in art consists in the acceptance, willing acceptance, of the limitations of the medium of the specific art.

Modernism in art is a gradual process of confronting those limitations, and of doing away with everything that stands in the way of their recognition:

> The history of avant-garde painting is that of a progressive surrender to the resistance of its medium; which resistance consists chiefly in the flat picture plane's denial of efforts to "hole through" it for realistic perspectival space. In making this surrender, painting not only got rid of imitation – and with it, "literature" – but also of realistic imitation's corollary confusion between painting and sculpture.

The essential development of modern painting is toward increasing *flatness*: "the picture plane itself grows shallower and shallower, flattening out and pressing together the fictive planes of depth until they meet as one upon the real and material plane which is the actual surface of the canvas . . ." Greenberg traces this process from Manet and Cézanne to Matisse and the Cubists, but he later argued that European modernism was in decline, and, as Abstract Expressionism began to take shape at the end of the decade, he came to see it as an innovative continuation of the tendency toward flatness – as well as a confirmation of his historical thesis.

In a much later essay, "Modernist Painting," published in 1961, Greenberg made explicit an assumption that had directed his thinking all along: that the process by which the arts isolate the essential qualities of their media is a "self-critical" process, one that connects them to the fundamental current of modern philosophy.

> Western civilization is not the first to turn around and question its own foundations, but it is the civilization that has gone furthest in doing so. I identify Modernism with the intensification, almost the exacerbation, of this self-critical tendency that began with the philosopher Kant. Because he was the first to criticize the means itself of criticism, I conceive of Kant as the first real Modernist.

Just as Kant "used logic to establish the limits of logic," so now: "Each art had to determine, through the operations peculiar to itself, the effects peculiar and exclusive to itself. By doing this each art would, to be sure, narrow its area of competence, but at the same time it would make its possession of this area all the more secure." Greenberg's effort to bring his individual responses to works of art into line with a comprehensive

interpretation of the history of modern art and thought is a formidable critical achievement. His insistence that modernism involves a kind of ruthless integrity is reminiscent of Zola. Though his position gradually began to seem more and more stifling, and though we now tend to dismiss it as dogmatic and misguided, its rigor should be seen as a response to the challenge of the time: to provide an intellectual tool with which to distinguish the truly original from the merely derivative, the serious from the trivial.

By the mid-1950s, Abstract Expressionism began to be overshadowed by new developments, not all of which fit Greenberg's ideas about what modern art ought to be. Most spectacularly, Robert Rauschenberg had begun to produce work that integrated a wide range of found objects, and that deliberately blurred the distinction between painting and sculpture. An example is *Bed*, a work of 1955, an actual bed, smeared with paint and hung on the wall (figure 5.18). His friend, Jasper Johns, produced paintings that featured recognizable objects – most famously, the American flag – but also standardized forms like stenciled letters and numbers (plate 23). He also cast sculptures of the most commonplace objects, such as beer cans and flashlights. These artists shifted attention from the lofty, self-involved preoccupations of the Abstract Expressionists to the banality of the everyday, especially to the products of consumer culture. In making the Abstract Expressionists, with their emphasis on the exalted spiritual mission of the artist and talk of the sublime, seem old-fashioned and pompous, they struck many viewers as wickedly cynical, even nihilistic. Rauschenberg, in particular, was given to provocative gestures: as early as 1951–2, he had made paintings that were entirely white or entirely black – pushing, so it seemed, the premises of Abstract Expressionism to logical absurdity. In 1953 he had taken a drawing by the Abstract Expressionist Willem DeKooning and erased it, exhibiting the finished product as his own work. Observers were quick to make the connection with Dada, and the work of Rauschenberg and Johns came to be described as "Neo-Dada."

Efforts to reconfigure the relation of art to life went even further. Allan Kaprow gave up painting in 1956 to create installations, which he preferred to call "environments." In 1958, he published an essay, "The Legacy of Jackson Pollock," in which he argued, not that Pollock had achieved a new kind of painting, but that he had "*destroyed painting*":

Pollock, as I see him, left us at the point where we must become preoccupied with and even dazzled by the space and objects of our everyday life, either our bodies, clothes, rooms, or, if need be, the vastness of Forty-Second Street. Not satisfied with the *suggestion* through paint of our other senses, we shall utilize the specific substances of sight, sound, movements,

Figure 5.18 Robert Rauschenberg, *Bed*, 1955, Leo
Castelli Gallery, New York.

Figure 5.19 Allan Kaprow performing in his *Six Happenings in Eighteen Parts*, 1959.

people, odors, touch. Objects of every sort are materials for the new art: paint, chairs, food, electric and neon lights, smoke, water, old socks, a dog, movies, a thousand other things which will be discovered by the present generation of artists.

In contrast to Greenberg's insistence on the medium-specific, Kaprow claims that "the young artist of today need no longer say 'I am a painter' or 'I am a poet' or 'a dancer'. He is simply an 'artist'."

Kaprow had also begun to study music with the composer John Cage, and, in 1959, he added live performance to his exhibitions, producing a type of event he called a "happening" (figure 5.19). Rauschenberg, who had been involved with experimental theater and dance since the early 1950s, when he worked as a set designer in collaboration with Cage and the choreographer Merce Cunningham, also staged happenings. Another

participant in these events was Claes Oldenburg, who went on to create installations in the form of shops, in which artificial goods – his own brightly painted plaster sculptures of food – were offered for sale. Like Kaprow, Oldenburg wanted to integrate everyday objects into art, but he was also interested in the critical examination of the social and economic processes surrounding it: "I am for an art that takes its form from the lines of life itself, and twists and extends and accumulates and spits and drips and is heavy and coarse and blunt and sweet and stupid as life itself." The trend that he helped to initiate would come to be called Pop Art.

Not all the developments of the 1950s were so unfavorable to Greenberg's thesis. Ad Reinhardt produced large pictures in which two or more slightly different tones of the same color – increasingly, the color was black – were set off in simple geometric divisions. He saw his work as bringing the historical development of modern painting to completion and revealing by a process of negation the fundamental nature of art:

> The one object of fifty years of abstract art is to present art-as-art and as nothing else, to make it the one thing it is only, separating and defining it more and more, making it purer and emptier, more absolute and more exclusive – non-objective, non-representational, non-figurative, non-imagist, non-expressionist, non-subjective. The only and one way to say what abstract art or art-as-art is, is to say what it is not.

In 1959, a much younger painter, Frank Stella, created a sensation by exhibiting large black pictures articulated only by simple, uniform patterns of lines. His work had all the edgy negativity of Rauschenberg but also adhered to the Greenbergian principle of flatness: it seemed to make negation into a compelling gesture of integrity. Other painters, such as Morris Louis and Helen Frankenthaler, also produced work which seemed to confirm Greenberg's reading of modernism, and which he obligingly supported under the label "Post-Painterly Abstraction" to distinguish it from Abstract Expressionism.

Early in the 1960s, Donald Judd gave up painting to work in three dimensions, producing objects of a kind that seemed to defy classification (figure 5.20), and which soon came to be described as "minimal" art. He began to receive critical acclaim in 1964 and the next year published an essay, "Specific Objects," in which he argues for the superiority of what he calls "three-dimensional work" that is "neither painting nor sculpture" and that thus avoids their limitations:

> Three dimensions are real space. That gets rid of the problem of illusionism and of literal space, space in and around marks and colors – which is riddance of one of the salient and most objectionable relics of European

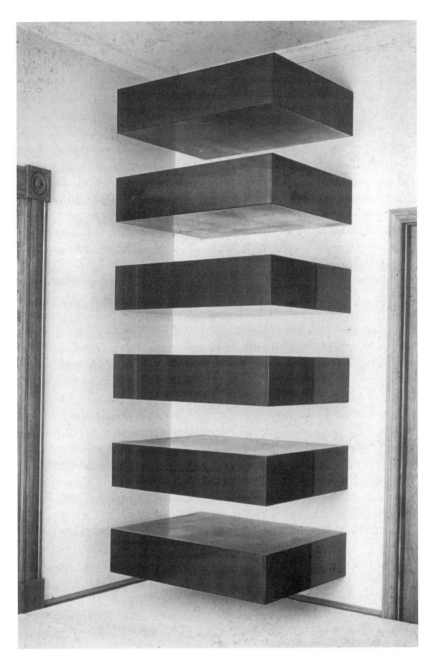

Figure 5.20 Donald Judd, untitled, 1966, Leo Castelli Gallery, New York.

art. The several limits of painting are no longer present. A work can be as powerful as it can be thought to be. Actual space is intrinsically more powerful and specific than paint on a flat surface.

Judd advocates an extreme formal simplicity, a doing away with complex internal relationships, which he associates with the illusionism of traditional painting, in the interest of greater unity and force of impact: "It isn't necessary for a work to have a lot of things to look at, to compare, to analyze one by one, to contemplate. The thing as a whole, its quality as a whole, is what is interesting. The main things are alone and are more intense, clear, and powerful." He mentions Duchamp and Johns as important models. Among painters he particularly admires Stella, both for the unity of effect and because "the order" of his pictures "is not rationalistic and underlying but is simply order, like that of continuity, one thing after another." Judd saw himself as presenting a case against Greenbergian formalism, but his position may also be seen as a logical extension of it, an application to work in three dimensions of the same demand for objectivity Greenberg had made of painting.

Robert Morris, who had worked as a set and prop designer in experimental theater, also began, in the early 1960s, to make formally minimal "objects" or "structures" (figure 5.21). His series of essays entitled "Notes on Sculpture," published in 1966–7, reveals a thoughtful engagement with earlier European modernism, especially with Tatlin and Duchamp, as well as with Americans such as Rauschenberg and Johns. He also adapts fashionable perceptual theory – "gestalt" psychology and the phenomenology of Merleau-Ponty – to help explain the perceptual mechanisms at work in our experience of art. Like Judd, he advocates simple shapes that are instantly perceived as unitary: "The sensuous object, resplendent with compressed internal relations, has had to be rejected." Care must be taken to avoid both figurative and architectonic reference, and the size of the work must be adjusted to human scale so that it is neither simply an "object" nor a "monument." What the work loses in traditional formal interest is made up in other ways:

> The better new work takes relationships out of the work and makes them a function of space, light, and the viewer's field of vision. The object is but one of the terms in the newer aesthetic . . . One is more aware than before that [the viewer] himself is establishing relationships as he apprehends the object from various positions and under various conditions of light and spatial context. Every internal relationship, whether it be set up by a structural division, a rich surface, or what have you, reduces the public external quality of the object and tends to eliminate the viewer to the degree that these details pull him into an intimate relation with the work and out of the space in which the object exists.

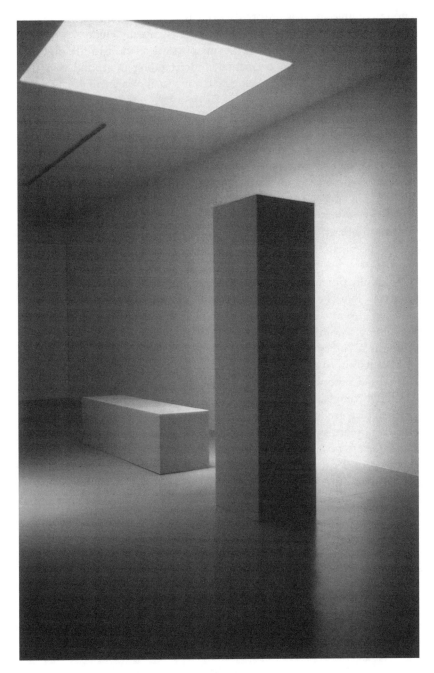

Figure 5.21 Robert Morris, *Two Columns*, 1961, Leo Castelli Gallery, New York.

Though simple in form, Morris's work is complex in effect: his objects produce the kind of responses in viewers that usually elude articulation, responses associated as much with our physical relation to the object as to our visual perception or mental understanding of it, and that thus work against our ability to segregate our visual and mental experience from our experience as a whole.

A young disciple of Greenberg's, Michael Fried, replied to Judd and Morris in the essay "Art and Objecthood," published in 1967. Fried accuses Minimal Art of "literalism," an insistence on the pure objecthood of objects; in contrast, the modern art he considers genuine works to "defeat or suspend its own objecthood." Literalism involves the experience of "an object *in a situation*"; it "amounts to nothing other than a plea for a new genre of theater," and theater, Fried insists, is the "negation of art." Theater is "what lies *between* the arts"; it is the "common denominator that binds a large and seemingly disparate variety of activities to one another, and that distinguishes those activities from the radically different enterprises" of genuinely modernist art forms. He identifies Rauschenberg and Cage with the "illusion that the barriers between the arts are crumbling . . . and that the arts themselves are at last sliding towards some kind of final, implosive, and hugely desirable synthesis." The concept of theater allows Fried to link the rarefied forms of Minimalism to the kind of Pop Art engagement with everyday objects that would otherwise seem to be their opposite.

Fried's complaint is thus with the whole of what might be called the Duchampian tradition in twentieth-century art: for him, Minimalism is anti-art, a regressive step into the chaos of confused categories where no standards are possible. Before we dismiss his essay entirely, however, we should consider that he significantly inflects and refines upon Greenberg's position, insisting that modernism cannot be simply a matter of reduction to the objective conditions of the medium – as Greenberg's writings often make it seem – but that the effort to "defeat or suspend" objecthood produces a special effect which he calls "presentness" or "instantaneousness." It is "as though if only one were infinitely more acute, a single infinitely brief instant would be long enough to see everything, to experience the work in all its depth and fullness, to be forever convinced by it." One might ask whether "conviction" of this kind is not also a "theatrical" effect, but for Fried it is something much more exalted, and the essay ends with the claim "Presentness is grace." He reclaims the notion of art, not in Greenberg's terms, as critique, but rather as a kind of revelation.

From objects of such radical formal simplicity, objects that seem to imply their own negation, it is but a small step to an art that does away with objects altogether: objecthood, too, is something that might be

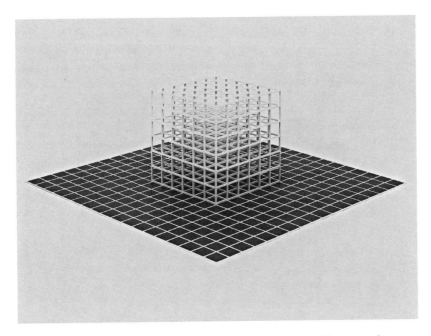

Figure 5.22 Sol Lewitt, *Modular Cube (6)*, 1968, Whitney Museum of American Art, New York.

done away with – and that might be rationalized either in terms of the pursuit of an ever-greater modernist purity or an attempt to get beyond the limitations of Greenbergianism. In the mid-1960s, this step was taken by a number of artists working in a variety of forms; their work was soon embraced under the term "conceptual art." One of the first spokesmen for the new trend was Sol Lewitt, whose constructions, such as *Modular Cube* of 1968 (figure 5.22), obviously derive from Minimal Art but give less emphasis to the material self-sufficiency of the object – or even to the object in its setting – than to the way in which an object suggests or presupposes a series or system. In his statements, beginning in 1967, he claimed that "the idea or concept is the most important part of the work." Such art is "not theoretical or illustrative of theories; it is intuitive"; conceptual artists are "mystics rather than rationalists." At the same time, however, Lewitt emphasizes the impersonal nature of the productive process: "When an artist uses a conceptual form of art, it means that all of the planning and decisions are made beforehand and the execution is a perfunctory affair. The idea becomes a machine that makes art." His emphasis on impersonality and systematicity can be seen as an attempt to explore the possibility of a subjectless or creatorless creativity.

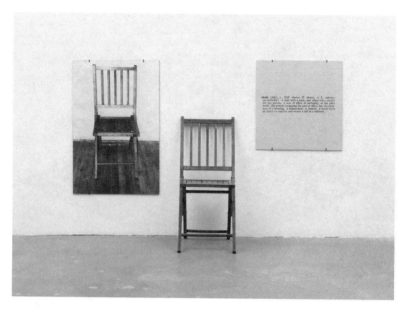

Figure 5.23 Joseph Kosuth, *One and Three Chairs*, 1965, Museum of Modern Art, New York.

Joseph Kosuth came to critical attention in the mid-1960s with works such as *One and Three Chairs*, an installation in which an actual chair was displayed beside a photograph of the chair and the text of a dictionary definition of the word "chair" (figure 5.23). Kosuth's interest in alternative descriptive systems, and especially in engaging language, was rooted in his study of analytic philosophy, primarily the work of Ludwig Wittgenstein, his follower A. J. Ayer, and the literary critic I. A. Richards. Following Richards's claim that "all thinking is radically metaphoric," Kosuth begins his most important theoretical statement, the essay "Art after Philosophy," published in 1969, by saying that the twentieth century marks "the end of philosophy and the beginning of art." "Works of art are analytic propositions . . . That is, if viewed within their context – as art – they provide no information what-so-ever about any matter of fact." A work of art is therefore a "tautology" in which the artist asserts that his "particular work of art *is* art" and at the same time "a *definition* of art." "Art's only claim is for art. Art is the definition of art."

Kosuth's position obviously owes a good deal to Reinhardt, yet it also counters the insistence of Greenberg and Fried on a medium-specific conception of art: "Being an artist now means to question the nature of art. If one is questioning the nature of painting, one cannot be questioning

the nature of art . . . Painting is a *kind* of art. If you make paintings you are already accepting (not questioning) the nature of art." He credits Duchamp's readymades with having initiated the serious interrogation of art's function: they are the beginning of modern art as well as the beginning of "conceptual" art. "All art (after Duchamp) is conceptual (in nature) because art only exists conceptually." Such rigor limits the ability of art to engage anything outside itself, and Kosuth does not fail to draw the logical conclusion of his premises: "art's unique character is the capacity to remain aloof from philosophical judgements." The price of his escape from Greenbergian formalism would seem to be an even more rigid reductivism.

Another of the early Conceptualists was Lawrence Weiner, whose *Statements*, of 1968, are simple descriptions of possible "works": "One sheet of plywood secured to the floor or wall"; or "One hole in the ground approximately one foot by one foot by one foot. One gallon water base white paint poured into this hole." Though he sometimes actually "makes" works according to these specifications, he emphasizes that they need not be made. He disassociates the art from the object without claiming that art consists solely of ideas; he thus explores the critical relation between the notional and the physical. He reduces the creative process to extreme simplicity, empties it of all special content, yet preserves a distinctive intellectual poise that can be quite poetic – reminiscent in some ways of Mallarmé. His refusal fully to occupy the position of the artist, or, rather, to define it by a kind of negation, resembles the way in which Minimalist objects both are and are not themselves.

Conceptual Art thus need not do away entirely with the object; it may simply seek to establish a new kind of relation between object and idea, physicality and meaning. Understood in this way, it has enormous range and allows art to address all sorts of issues. Dan Graham's *Homes for America*, of 1966–7, for instance, takes the form of a magazine article in which images of standardized suburban housing types are juxtaposed with descriptions and data. Its intentionally bland presentation – somewhere between a contractor's brochure and a sociology thesis – manages to comment on the everyday environment in a manner that takes up some of the concerns of Pop Art. Bruce Nauman, combining performance and object production, began in 1965–6 to treat his own body as a subject in his work. Robert Smithson created a series of installations and interventions in the landscape designed to counter the commodification of art in galleries and to mobilize nature in the critique of contemporary culture as a whole. Hans Haacke turned his attention to the economic and sociological substructure of the art world in works that test the boundary between art and direct political commentary. His *Shapolsky et al. Manhattan Real Estate Holdings: A Real-Time Social System as*

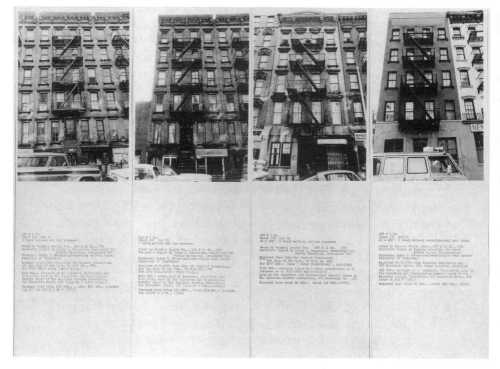

Figure 5.24 Hans Haacke, *Shapolsky et al. Manhattan Real Estate Holdings, A Real Time Social System as of May 1, 1971*, detail 1971, collection of the artist.

of May 1, 1971 (figure 5.24), an installation consisting of maps, photographs, and textual data, documents the holdings of a Manhattan slumlord: it was felt to be so dangerous an exposé that the Guggenheim Museum canceled the planned exhibition. Conceptual Art also flourished in Europe: among the proponents with the most highly developed theoretical positions – each very unlike the other – were the Art and Language group in Britain, the Frenchman Daniel Buren, and the German Joseph Beuys.

Understood in this broader sense, Conceptual Art is less a movement than a fundamental reorientation of artistic strategy, an opening up of new possibilities similar to what Cubism had achieved with collage at the beginning of the century. The implications were not easy to see or to articulate all at once. Writing at the end of the 1960s, the critic Leo Steinberg singled out Rauschenberg's new approach to the picture plane as a decisive moment of transition. The Abstract Expressionists, he said, "were still nature painters"; Rauschenberg's pictures, on the other hand, "no longer simulate vertical fields, but opaque flatbed horizontals"; they

"insist on a radically new orientation, in which the painted surface is no longer the analogue of a visual experience but of operational processes." They redefine artistic modernism: "The 'integrity of the picture plane' – once the accomplishment of good design – was to become that which is given. The picture's 'flatness' was to be no more of a problem than the flatness of a disordered desk or an unswept floor." But Rauschenberg's innovation – as evident for Steinberg in *Bed*, with its reversal of horizontal and vertical, as in the two-dimensional works – also documents a deeper cultural transformation: "I tend to regard the tilt of the picture plane from vertical to horizontal as expressive of the most radical shift of the subject matter of art, the shift from nature to culture." If the first years of the century had been marked by an awareness of the way in which technology was distancing us from nature, Steinberg's essay documents a sense, now familiar to us all, of standing at the threshold of a still more unnatural world.

chapter 6

postmodernism

The Critique of Culture

The 1960s were the climax to a period of explosive artistic innovation, but they also saw the beginnings of a deeper reorientation of thought about art, one that continued into the 1970s and 1980s and that came to identify itself as "postmodernism." The label implies a belief that this new development is more than just another in the long line of modernist "isms"; it suggests that a radical break has taken place and that modernism itself has been in some way superseded. Proponents of postmodernism saw themselves as overturning several of the fundamental principles of

modernism without returning to a pre-modernist system of values, as developing a new set of creative strategies for a radically new historical situation. With the passage of time, however, postmodernism has come to seem less like a break than an extension and intensification of modernism – a kind of super- or hyper-modernism – and its most significant achievements can still be referred to the notion of a *critical* enterprise, even if it also questions the possibility of critique. The origins of postmodernist theory are firmly embedded in modernism, and some understanding of these sources is essential to a real appreciation of what it is; to consider it historically is also to have a better chance of discerning what any post-postmodernism might be like.

If one of the most conspicuous developments in the art of the 1950s and 1960s was the rejection of Greenbergian formalism and an effort – inspired, ultimately, by Duchamp – to engage those psychological, linguistic, institutional, economic, political, and, broadly speaking, cultural conditions that structure our approach to art, then one of the real achievements of postmodernist theory was to provide a more sophisticated conceptual vocabulary for the analysis of those conditions and their effects. This vocabulary came from a number of sources, but by far the most important was the radical critique of society that developed out of Marxism. Because Marx himself believed that human existence is determined by economic forces, and by a struggle among classes of society for control of material resources and the means of production, he had little to say about art. He and his collaborator, Friedrich Engels, were not insensitive to the way in which subjective perception and thought condition action, and hence, reality, and they thus prepared the way for a thoroughgoing critique of ideology, but they tended to see culture as a "superstructure," a set of illusions supported on a "base" of economic realities. Many later thinkers committed to Marx's political ideals found this model inadequate. An ambitious attempt to create an alternative – a kind of Marxist phenomenology of mind – was György Lukács's *History and Class Consciousness*, published in 1923.

The most influential type of cultural criticism to emerge from Marxism was developed at the Institute for Social Research in Frankfurt, established also in 1923. Dispersed within a few years by the rise of Fascism, many of the leading members of what came to be called the "Frankfurt School" sought refuge in America. Though they were prolific, they continued to write much of their work in German; as a result, it did not become widely known in the English-speaking world until the late 1960s, when it began to be translated. One exception to this pattern was Herbert Marcuse, who taught at Berkeley and published in English: his work, which drew upon both Marxism and psychoanalysis, had a direct influence on student activism in the United States. Only in the course of the 1970s does

Frankfurt School thought begin to have a transformative effect on art theory and criticism.

The best place to begin in assessing its influence is the essay "The Culture Industry: Enlightenment as Mass Deception," which forms a substantial part of the book *Dialectic of Enlightenment,* jointly authored by Max Horkheimer and Theodor Adorno (1903–69). Written in America – mostly in California – during the war, the book was published in a small edition in German in 1947; reissued in 1969, it was only translated into English in 1972. The essay is a profound and powerful critique of what we naively tend to call "popular culture": under contemporary monopoly capitalism – as under Fascism – "culture" is not truly "popular" at all, but a carefully rationalized form of mass manipulation. The authors draw attention to the specific set of financial interests that govern this system – "the dependence of the most powerful broadcasting company on the electrical industry, or of the motion picture industry on the banks" – but their real concern is with the way it works *as a system.* The culture industry and the "affirmative culture" it produces are a tool with which capitalism reinforces and reproduces itself, artificially stimulating consumer appetite through advertising, instilling an ethic of productivity and submissive conformity, and relentlessly undermining the capacity of individuals to imagine anything different, anything better.

Just as the apparent variety of products masks the reality of monopoly, so the apparent variety of cultural expression masks the monolithic sameness of the system that produces and mediates it: "Under monopoly all mass culture is identical." "Not only are the hit songs, stars, and soap operas cyclically recurrent and rigidly invariable types, but the specific content of the entertainment itself is derived from them and only appears to change." "Films, radio and magazines make up a system which is uniform as a whole and in every part." The differentiations among products – those of A and B films, for example – are carefully calculated to the expectations and desires of various consumer groups: "something is provided for all so that none may escape." Advertising plays an increasingly important role, not only in guaranteeing demand and in creating a sense of community around the values of consumerism, but in slowly eroding the artistic standards – and with them, the basic coherence – of what the culture industry produces: "The assembly-line character of the culture industry, the synthetic, planned method of turning out its products . . . is very suited to advertising: the important individual points, by becoming detachable, interchangeable, and even technically alienated from any connected meaning, lend themselves to ends external to the work." Since advertising is expensive, it reinforces the exclusive dynamic of monopoly; it thus carries its own special form of legitimation, one that helps to reinforce the system as a whole: "everything that does not bear its stamp" is "suspect."

Far beyond the degraded quality of the "rubbish" it turns out, the sinister influence of the culture industry lies in the way it subliminally habituates its victims to the status quo:

> Amusement under late capitalism is the prolongation of work. It is sought after as an escape from the mechanized work process, and to recruit strength in order to be able to cope with it again. But at the same time mechanization has such power over a man's leisure and happiness, and so profoundly determines the manufacture of amusement goods, that his experiences are inevitably afterimages of the work process itself. The ostensible content is merely a faded foreground; what sinks in is the automatic succession of standardized operations. What happens at work, in the factory, or in the office can only be escaped from by approximation to it in one's leisure time.

The way in which appetites are constantly aroused only to be left unsatisfied accustoms people to lower expectations and thus to lower returns:

> The culture industry perpetually cheats its consumers of what it perpetually promises. The promissory note which, with its plots and staging, it draws on pleasure is endlessly prolonged; the promise, which is actually all the spectacle consists of, is illusory; all it actually confirms is that the real point will never be reached, that the diner must be satisfied with the menu. In front of the appetite stimulated by all those brilliant names and images there is finally set no more than a commendation of the depressing everyday world it sought to escape.

In this way, pleasure "promotes the resignation which it ought to help to forget."

At an even deeper level, however, the very ability to perceive and comprehend reality is systematically eroded. "The whole world is made to pass through the filter of the culture industry." With the advance of mechanical reproduction, it is easier today "for the illusion to prevail that the outside world is the straightforward continuation of that presented on the screen." As a result, "real life is becoming indistinguishable from the movies." Even when nature is represented, it is "denatured"; it appears as the sign of something else: "Pictures showing green trees, a blue sky, and moving clouds make these aspects of nature into so many cryptograms for factory chimneys and service stations." The idea of the tragic, a deeply significant point of reference in human experience, also survives only as an empty semblance of itself: the representation of tragic circumstances in movies, for instance, "comforts all with the thought that a tough, genuine human fate is still possible," when in fact it is not. Even language, the fundamental instrument of thought and of critical

analysis, is emptied and incapacitated: "words are debased as substantial vehicles of meaning and become signs devoid of quality"; they are used only because they "trigger off conditioned reflexes"; they are thus "trademarks which are finally all the more firmly linked to the things they denote, the less their linguistic sense is grasped."

The combined effect of these developments is to undermine the foundations of individual identity. Horkheimer and Adorno understand individuality to be an historical construct, and, in its modern form, a construct of earlier – eighteenth-century – bourgeois society; their attitude toward it is highly ambivalent, yet they perceive its "liquidation" in the contemporary world to signal something far worse. The token individualism of affirmative culture – the value placed on "personal" expression, for instance – simply masks the fact that now "any person signifies only those attributes by which he can replace everybody else; he is interchangeable, a copy." "Personality scarcely signifies anything more than shining white teeth and freedom from body odor and emotions." The pervasive taste for bland, "synthetically produced physiognomies" shows that "people of today have already forgotten that there was ever a notion of what human life was." Thus, even in the idealized stereotypes it sets before us, the culture industry exposes the tendency to dehumanization that advanced capitalism shares with Fascism.

Against mass culture, Horkheimer and Adorno hold out an ideal of serious or "high" art, an ideal that is in some respects very traditional: they invoke Kant when they observe that, though art once involved "purposiveness without purpose," it has now been replaced by "purposelessness for purposes." Though they recognize that this ideal is also a product of older bourgeois culture, they believe that it preserves the possibility of a freedom and critical function for art which are more urgently necessary now than at any time in the past. "Pure" works of art have the ability to "deny the commodity society by the very fact that they obey their own law," though they are also "just wares all the same." A serious artist addresses the fundamental tensions of his time even when, preoccupied with problems of technique, he does so unconsciously. Though a real work of art may not directly address any political issue – though it may actually be an instrument of the prevailing ideology – it is always a form of political commentary, an implicit critique. As Adorno wrote in another place: "Art, and so-called classical art no less than its more anarchical expressions, always was, and is, a force of protest of the human against the pressure of domineering institutions, religious and otherwise, no less than a reflection of their objective substance."

Horkheimer and Adorno thus manage to reclaim a traditional conception of high art *while redefining the function of art as critical.* At the same time they reclaim the value of the individual artist: however obsolete

bourgeois individuality might seem to be, the artist as individual has a crucial function to perform: "only individuals are still capable of representing consciously and negatively the concerns of collectivity." The stress on the "negative" is important, for in the modern world art must first of all not pretend to be anything other than art; it must also deny itself many of the charms associated with it in the past: it must make itself difficult, refusing any false harmony which might distract the audience from the fact that real social harmony has yet to be achieved. As Adorno said in another place: "A successful work . . . is not one which resolves objective contradictions in a spurious harmony, but one which expresses the idea of harmony negatively by embodying the contradictions, pure and uncompromised, in its innermost structure." While the prescriptive rigor of this position is often likened to Clement Greenberg's, Adorno's conception of what constitutes significant innovation in art is much richer and his view of its critical function far more complex.

Adorno had been trained as a musician and had studied composition: he had particularly strong views about what constituted serious music. He compares the two great musical modernists, Stravinsky and Schönberg, finding that Stravinsky's anti-expressionist "objectivity" is regressive, a superimposition of reified forms suggestive of authoritarian politics, while Schönberg's expressionism – which led to the rejection of traditional tonality altogether – makes use of dissonance in a truly critical manner. Schönberg's music is difficult in the right way, it "requires the listener to compose," demanding "not just contemplation but praxis." Adorno had a particular antipathy for jazz. Unwilling to recognize whatever critical value it may originally have had as the voice of an oppressed African American community, he could see it only as a corruption of serious music, one that lent itself all too easily to commercial degradation. Its liberating effects are illusory; it "does not transcend alienation, but strengthens it."

Not all thinkers associated with the Frankfurt School were as contemptuous of mass culture as Adorno. Walter Benjamin, who had been to Russia and was familiar with the way in which advanced artists were making use of new media to express a new system of values, saw the "popular" media of photography and film as having a transformative, wholly positive effect. In the essay "The Work of Art in the Age of Mechanical Reproduction," written in 1936, he extols the new potential of photography and film in terms very similar to other early twentieth-century theorists, but he also argues that they bring about a more profound and comprehensive redefinition of art, an overturning of traditional aesthetic values, by undermining the "aura" of the unique object. Mechanical reproduction "emancipates" the object from an archaic dependence on ritual:

To an ever-greater degree the work of art reproduced becomes the work of art designed for reproducibility. From a photographic negative, for example, one can make any number of prints; to ask for the "authentic" print makes no sense. But the instant the criterion of authenticity ceases to be applicable to artistic production, the total function of art is reversed. Instead of being based on ritual, it begins to be based on another practice – politics.

Mechanical reproduction forces us to abandon some of our old expectations about art, but it makes possible new forms of art, beauty, and being. Benjamin's recognition of its potential, and of the role of "popular" or "low" arts in exploring it, has been an important source of theoretical justification for postmodernists anxious to overturn the hierarchical relationship which even Adorno's writing serves to support.

Another important contribution to the Marxist critique of culture was made by Louis Althusser, a Frenchman working independently of the Frankfurt School and writing in the 1950s and 1960s. He, too, saw that modern capitalism needed to resort to overt repression less and less, that the underclasses are now kept in place by "ideology," a system of beliefs and values, administered through apparently beneficial institutions or "apparatuses" such as schools, churches, the family, sports, various types of literature, and the mass media. For Althusser, however, ideology is also something much deeper than any specific set of values: it is the medium through which society makes it possible for us to perceive the world at all. Its real work is to make conventions based on the arbitrary distribution of power into apparently "natural" laws, and in so doing it obscures its own operation, making its effects invisible. Our very identities as individuals – or "subjects," as Althusser, drawing upon psycho-analysis, prefers to call them – are ideological constructs: "There are no subjects except by and for their subjection." The fact that we are dependent for our identities on the very system that oppresses us exposes the terrible ignorance beneath our customary notions of autonomous individuality and the daunting task confronting any truly critical practice. Like Horkheimer and Adorno, Althusser emphasizes the ways in which modern capitalism affects the most basic conditions of thought and makes it increasingly difficult to imagine or articulate any alternatives.

Still another contribution to the critique of culture, one that had a direct effect on French radicalism in the 1960s and then on postmod-ernism, was made by the group that called itself the Situationist Interna-tional. Inspired in part by Surrealism, and seeking to renew its political edge, the Situationists created a comprehensive strategy of resistance to the sterility and alienation of modern life. The leading theorist of the group, Guy Debord, argued that capitalism had created a "society of the

spectacle" in which "everything that was directly lived has moved away into a representation," in which "the image has become the final form of commodity reification" and in which, as a result, illusions produced for the masses play an increasingly necessary role in the maintenance of order. Disenchanted with organized Marxism, the Situationists turned their attention from large-scale revolution to local, anarchical acts of creative subversion. Drawing upon Lefebvre's earlier *Critique of Everyday Life*, they believed that their efforts to enact revolutionary principles in their daily conduct broke down the old division between life and art. They claimed that art should not be thought of as a separate activity, but as an all-inclusive practice or mode of being. The particular forms of activity that they developed included the *dérive*, an improvised experience of urban space; another strategy was *détournement*, the subversive appropriation and transformation of pre-existent objects or disruption of events.

Other thinkers associated with the radical movements of the 1960s pushed the critique of culture still further. Perhaps the most influential was Michel Foucault (1926–84), whose historical studies of institutions such as the asylum and the prison amounted to a profound and compelling indictment of modern society and the supposedly "civilized" or "enlightened" values it claims to uphold. By considering the institutions and social practices that emerged along with modern rationalism, Foucault shows that the real meaning of the Enlightenment has more to do with repression and control than with liberation. Though the exercise of power may have become less overtly violent, it has become all the more effective. The progress of medical science that has had such beneficial effects has also brought with it sinister regimes of normalization; even psychoanalysis, the science of mental liberation, is just another means of control, a symptom of the very malady it proposes to cure. Foucault had a truly original understanding of the way power works: for him, it is not concentrated in a few persons or institutions – though it seems to be – but is dispersed through society; its circulation is controlled by our individual habits of thought and behavior as much as by any external force. As a result, he could offer a new, "micropolitical" model of revolutionary change: if power depends upon us – is located, in fact, in us – then we can and must begin by discarding those mental habits which make us "complicitous" in our own subjection.

Foucault's conception of power owed something to the work of the philosopher Gilles Deleuze (1925–94), who had found in Nietzsche what he believed to be a revolutionary alternative to Marxism. Together with Felix Guattari, Deleuze would write *Anti-Oedipus: Capitalism and Schizophrenia*, published in 1972, a book which, with its sequel, *A Thousand Plateaus*, published in 1980, offers nothing less than a

comprehensive strategy for overcoming all the internal constraints that society forces upon us, a blueprint for revolution from within. The object of this revolution is only incidentally the overthrow of capitalism: in fact, the patterns of exchange generated by capitalism provide essential models for the liberated circulation of genuinely vital energy. In a reversal of the therapeutic strategy of psychoanalysis, moreover, Deleuze and Guattari urge us to reverse the process by which we learn to force our desires into socially acceptable channels: we must try to bring about a deliberate disorganization of selfhood at the deepest possible level, one that would then enable us to reorganize ourselves in myriad new ways, cultivate a "nomadic" mode of existence that answers to the radically dynamic quality of being. A kind of extended commentary on the slogan that had inspired many of the participants in the uprisings of 1968 – "Take your desires for reality" – *Anti-Oedipus* can be said to mark the theoretical high point of 1960s' radicalism.

Of all the French thinkers who came to maturity in the 1960s, the one who had the most direct influence on postmodernist art and art theory was Jean Baudrillard. Like others of his generation, he was disenchanted with Marxism; he felt that Marx's analysis of political economy was inadequate to deal with the transformation of society that was taking place in the contemporary world. Like the Situationists, he saw that images or signs have become commodities in their own right, and that the system emerging around them is "a structure of control and of power much more subtle and more totalitarian than that of exploitation." All the usual ideological apparatuses play their roles in this process, but the electronic media have raised it to a whole new level of intensity. Reality has been replaced by a "hyperreality" in which signs have no relation at all to the things they represent. The real is rapidly becoming "extinct"; it is being "killed off" by its representation and reproduction. "The very definition of the real has become: *that of which it is possible to give an equivalent reproduction.*"

The disappearance of the real, before which we all stand helplessly, has led to a "panic-stricken" attempt to compensate by "simulation," to produce objects and experiences – "simulachra" – which attempt to be more real than reality: "When the real is no longer what it used to be, nostalgia assumes its full meaning. There is a proliferation of myths of origin and signs of reality; of second-hand truth, objectivity and authenticity." His most memorable example of this process is the decision of the Philippine government – acting on the recommendation of anthropologists – to allow a remote jungle people, the Tasaday, to live undisturbed and thus retain their traditional way of life. For Baudrillard, this gesture has not preserved the Tasaday at all, but "reinvented" them; they are now "Savages who are indebted to ethnology for still being Savages":

The museum, instead of being circumscribed in a geometrical location, is now everywhere, like a dimension of life itself. Thus ethnology, now freed from its object, will no longer be circumscribed as an objective science but is applied to all living things and becomes invisible, like an omnipresent fourth dimension, that of the simulachrum. *We are all Tasaday.*

With hyperreality comes the end of meaningful politics, the end of the possibility of politics. Criticism is futile because the media inevitably neutralize dissent even when they represent it.

The new condition of culture diagnosed by writers such as these also began to be addressed directly in art, especially in Pop Art, the movement which, in America, developed out of the work of Rauschenberg, Johns, Kaprow, and Oldenburg. The figure who best represents Pop Art, and whose creative strategies point forward most directly to postmodernism, is Andy Warhol. Already a successful commercial artist, Warhol began to attract attention in the early 1960s with paintings imitating advertisements and comic books, then with repetitive images of mass-produced objects, such as Coca-Cola bottles and Campbell's Soup cans, as well as of celebrities such as Marilyn Monroe. His silkscreen painting of Marilyn's smile (plate 24) could almost be taken as an illustration of Horkheimer and Adorno's remark that "personality scarcely signifies anything more than shining white teeth." Such works both represent commodities and do so in a manner that alludes to mass production: they can be said to reflect the culture of monopoly capitalism and its transformation of reality; they can also be said to reflect the pervasiveness of spectacle. They can even be said to reflect the condition of hyperreality: Baudrillard mentions Warhol's work in such a way as to suggest that it had an influence on the development of his own ideas.

Warhol himself was completely unaware of any of the thinkers we have discussed here until much later in his career, however, and he always disavowed any critical intention. He genuinely admired mass culture, carefully cultivated his celebrity, and had no problem at all with modern capitalism:

> Business art is the step that comes after Art. I started as a commercial artist, and I want to finish as a business artist. After I did the thing called "art" or whatever it's called, I went into business art. I wanted to be an Art Businessman or a Business Artist. Being good in business is the most fascinating kind of art . . . Making money is art and working is art and good business is the best art.

One cannot imagine Adorno having anything but contempt for someone who says such things, but Warhol's admirers, those who wish to

credit him with an important contribution to modernism, have generally fallen back on some version of Adorno's idea that the serious artist always offers an implicit critique of society, registering the cultural contradictions of his or her time, even if unconsciously. In this perspective, Warhol's refusal to adopt a critical position is itself a critical gesture; his indifference to politics becomes the sign of a crisis in the very nature of politics, one that Horkheimer and Adorno had foretold and that Baudrillard would later make explicit.

Just as the subject matter and technique of Warhol's work undermine the distinction between "high" and "low" art, the persona he took such care to fashion undermined certain traditional notions of artistic personality which still clung to the modern artist. His primary target seems to have been the "macho" image of figures such as Pollock – as well, perhaps, as the commonly accepted norms of male behavior in American culture generally, the burdensome quality of which, as a gay man, he felt especially keenly – but also the whole idea of the artist as someone with some kind of special spiritual gift. "If you want to know all about Andy Warhol, just look at the surface: of my paintings and films and me, and there I am. There's nothing behind it." He thus takes his place in a line leading from Baudelaire's *flaneur* through Duchamp, but even Duchamp worked an aura of immense intellectual superiority; Warhol's aura was of a significantly different kind, one that made no secret of its emptiness. "I want to be a machine"; "I think everybody should be a machine." "The more you look at the same exact thing, the more the meaning goes away, and the better and emptier you feel." "I always thought I'd like my tombstone to be blank. No epitaph and no name. Well, actually, I'd like it to say 'figment'." Such admissions of inner bankruptcy, which manage to be funny as well as sad, and which even bespeak a certain kind of integrity, express a loss of faith in the meaning of personhood – as well as in the belief that artists are in any position to help us retrieve it.

Some of the Conceptual artists who emerged in the years just after the rise of Pop Art dealt with social, political, and cultural themes in a more direct and pointedly critical way. Hans Haacke continued into the 1970s, 1980s and 1990s to expose the relation between art, museums, and money, hammering away at the conceptual barriers between art and politics. The English conceptual artist Victor Burgin programmatically applied Marxist and post-Marxist cultural criticism in his work. In the mid-1970s, he began to combine photographs with written statements: in some cases, as in *What Does Possession Mean to You?*, a poster displayed in the streets of Newcastle upon Tyne (figure 6.1), deliberately turning the techniques of advertising against the system of values it usually supports. In his theoretical writings, he insisted that abstract art had been co-opted by capitalism and was thus no longer of any use as a critical

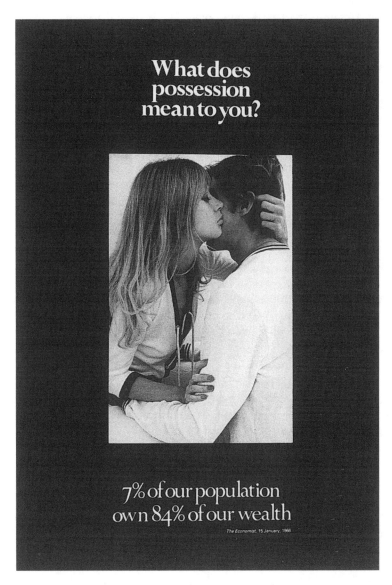

Figure 6.1 Victor Burgin, *What Does Possession Mean to You?*, 1976, collection of the artist.

tool: "Inescapably, the *work* of visual art is work in and on *representation*." Advocating a politically engaged art but mindful of the lessons of theorists such as Althusser, he pointed out the need for a new strategy, one that had less to do with the "representation of politics" and more with the "politics of representation."

An American, Barbara Kruger, who, like Warhol, had begun as a commercial artist, adopted a strategy similar to Burgin's. In the late 1970s and early 1980s she began to achieve notoriety with works that combined a photographic image, usually appropriated from another source, with verbal messages that address the viewer in a direct, even aggressive manner, and thus constitute a powerful kind of counter-ideological advertising (figure 6.2). Much of her work has also taken the form of posters and billboards. Indebted to her reading of Benjamin and Foucault, among others, she addresses issues of social control in general, but concentrates much of her attention on the politics of gender. She has written a good deal of cultural criticism, especially about the effects of the media, and at its best her writing has a splendid vehemence reminiscent of Horkheimer and Adorno:

> Indulging in relentless direct address, constantly exhorting and always on the make, television seems awash in a wildly compensatory frenzy, trying to make up for the lagging social relations of its audience. Its fascination, its riveting murder of response, reassures its viewers that social reciprocity is a boring archaism which went the way of last season's sit-com and yesterday's made-for-TV news crisis.

Kruger's engagement with mass culture can be said to take up where Warhol left off, to build upon his achievement with new theoretical tools, but the way in which she makes her work a vehicle for strong and unambiguous political convictions can also be seen as a critique of his political indifference.

The Phenomenology of Signs

After the radical critique of culture derived from Marxism, the second major source for the conceptual vocabulary of postmodernist art theory is earlier twentieth-century thought about the nature of language. Of course, the relation between art and language has been one of the recurrent motifs in the Western tradition of speculation about art since ancient times: though Enlightenment thinkers such as Lessing insisted on the fundamental *distinctness* of the visual and verbal arts, and much modernist art theory – culminating in Greenberg – followed suit, the separation has proved increasingly difficult to enforce. Futurism, Dada, and Surrealism – driven by the preoccupations they shared with Symbolism – "returned" to language, and Conceptualism made use of it in a variety of ways. As we have seen, Joseph Kosuth drew upon the analytic tradition of "plain language" philosophy established by Wittgenstein, but in the course

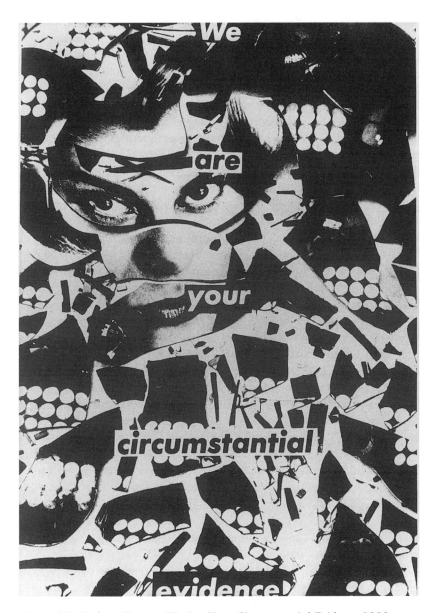

Figure 6.2 Barbara Kruger, *We Are Your Circumstantial Evidence*, 1983, Philadelphia Museum of Art.

of the 1970s the influence of French thought, with its very different intellectual orientation, began to dominate, and it is this tradition that has been the more influential on art theory. Part of its appeal has been the way in which it relates the analysis of language to the analysis of

culture as a whole – thus extending the politically motivated critique of culture discussed in the preceding section – as well as to anthropology, philosophy, and psychoanalysis.

This tradition begins with the work of Swiss linguist Ferdinand de Saussure. In lectures given in the period 1906–11 (published posthumously in 1915), Saussure proposed a new approach to signification. Language must be understood as a system of relations, "a system of inter-dependent terms in which the value of each term results solely from the simultaneous presence of the others." The meaning of a word does not derive from any natural or necessary connection to something "in the world," but from the relation of its component parts to the total set of phonetic possibilities the language contains. The word "cat" does not mean what it does because of any essential connection between it and the animal we recognize, but because it is distinguishable from words such as "bat" or "car." Not only is the relation of the linguistic sign to the world outside language entirely *arbitrary*, meaning does not even inhere in any essential way to the signs themselves: it is a function of the *difference* between them.

On the basis of this model, Saussure analyzes the workings of language in detail, introducing a number of concepts upon which later theorists will build. A sign actually consists of a relation between two components: the *signifier*, the physical sound or written letters, and the *signified*, the concept evoked in the mind of the hearer or reader (the signified is not to be confused with the object in the "real" world, which Saussure calls the *referent*). The traditional distinction between the "semantic" and "syntactic" dimensions of language, that is, between the relation of words to objects in the world, and the relation of words to each other, is redefined as a distinction between an "associative" dimension – governing the relations of words used to words *not* used, to the overall system – and a "syntagmatic" dimension, governing the relation of words in a temporal sequence. Saussure also distinguishes between what he called *langue*, language as a system, and *parole*, language as actualized in specific utterances.

Because individual words do not have meaning apart from the system of language as a whole, the concepts we associate with them are also products of language: "concepts are above all linguistic objects; they do not exist intrinsically, nor positively, but only negatively"; "their most precise characteristic is in being what others are not." Saussure understands the radical implications of this idea very clearly: language cannot be some kind of ideal mirror reflecting a world outside itself, but is a limited, highly idiosyncratic instrument that actively structures what it seems merely to describe. And because language is the privileged instrument of rational thought, the recognition of its limitations

challenges the belief that our knowledge is somehow grounded in the world. As has already been pointed out in connection with Cubism, Saussure's views resemble contemporaneous insights about the nature of pictorial representation.

Saussure also realizes that his new understanding of language implies the possibility of a whole new "science," one that studies "the life of signs within society," and within which the study of spoken or written language would form only a part: he proposes to call this new discipline "semiology," and insists that it would have to occupy a crucial position among the human sciences. At about the same time, and completely independently, the American philosopher Charles S. Peirce coined the term "semeiotics" for what he called the "quasi-necessary, or formal doctrine of signs," which he believed to be fundamental to logic, the very basis of knowledge. Though Peirce's system is extremely complicated, he distinguished three modes of relation between signs and objects in a manner often adopted by later writers on art: the *icon*, something which functions as a sign because of some resemblance or "fitness" to its object (his example is a painting in which we are able to recognize the object depicted); the *index*, which functions as a sign because of some material or causal relation to its object (to use an example also used by St Augustine, smoke is an index of fire); and the *symbol*, something which functions as a sign because of some "conventional" connection between it and its object (almost all linguistic signs). Any sign can fall into more than one of these categories.

A new approach to language similar to Saussure's emerged in the work of Russian poets and literary theorists in the years surrounding the revolution of 1917. Inspired, on the one hand, by the Symbolists' effort to free language of its conventional forms, but also aiming for a less subjective and sentimental – a more modern – kind of poetry, they devoted themselves to discovering the "laws" of poetry, isolating those formal and linguistic properties specific to it. In a remark that indicates both their indebtedness to and their distance from Rimbaud, Viktor Shklovsky claimed that poetry involves a conscious "deformation" of ordinary language; he argued that its essential function is to "make-strange," that is, to subvert the usual relation between sound and meaning and thus force us to recognize the "materiality" of language. Roman Jakobson, the leading theorist of the group, made the same point in Saussurean terms when he said that "the function of poetry is to point out that the sign is not identical to its referent." In a definition that reminds us of the revolutionary context in which these investigations took place, he declared that poetry is "organized violence committed on ordinary speech."

To the French anthropologist Claude Lévi-Strauss, Saussure's structural approach to language suggested a new approach to the study of culture

as a whole. Language could be seen as offering a key to the understanding of all those aspects of a culture – kinship systems, myths, ritual, art, even cuisine – that function as "signifying systems," a key to the hidden logic, the "unconscious attitudes" of an entire society. Lévi-Strauss recognized that myths, for instance, do not just reflect, but actively structure people's ways of thinking: they work – as "ideology" would work for Althusser – to reconstitute the relation between nature and culture. In a manner that might be said to elaborate upon Picasso's recognition of the "rational" nature of African art, Lévi-Strauss stresses the "logical" quality of myths, their effectiveness as tools with which people neutralize the fundamental conflicts they face. In the long tradition – beginning in the Enlightenment itself – of dissatisfaction with rationality, Lévi-Strauss notes the double-edged effect on culture of the invention of writing, the way in which, while conferring "vast benefits" on humanity, it also deprives us of "something fundamental," creating a distance between persons, a loss of "concrete relations between individuals." Prisoners of this sadly abstracted state, we yet make use of things like art to compensate for what we have lost; despite the edifice of rationalistic theory that has accumulated around it, art has an urgent mediating function in our lives; it is a kind of rationalized mythic language.

The potential of semiology as an instrument for the analysis of modern Western culture was most incisively, elegantly, and influentially demonstrated by the literary scholar and critic Roland Barthes (1915–80). Starting in the 1950s, Barthes wrote about strategies and codes deployed in mass-culture phenomena such as advertisements, films, and other forms of entertainment, as well as fashion and fashion literature. Pointedly invoking Lévi-Strauss's studies of "primitive" cultures, Barthes sought to expose the "mythic" content of these phenomena: the rhetoric of detergent advertisements evokes notions of purgation and ritual purification; a photograph of a black soldier on the cover of a popular French magazine reinforces all sorts of unreflexive assumptions about nation, empire, and race. Barthes proposes a semiological model for the analysis of myth, one in which the sign produced by the signifier and signified at the level of simple "denotation" then becomes itself the signifier of another, "second-order" signified at the level of "connotation" – of mythic or ideological content. Language thus serves to ground or "naturalize" ideology; in advertising, image and language work together: the "naturalism" of the image helps to ground the message of the text. Barthes makes the political implications of his insights abundantly clear: combining linguistics with leftist politics, he turns semiology into a powerful instrument for the critique of ideology – of those conceptual structures that so preoccupied Althusser at exactly the same time.

Barthes also applied the tools of semiological analysis to some of the canonical texts of French literature, and in the course of his career his view of literary artifice underwent a significant shift. Whereas in his early work he emphasized the ways in which traditional writing obscures its ideological content, constructing an apparently objective mode of description, and tending to make the reader into a passive consumer, his later work represents the task of writing as a negotiation of codes, often on many different levels, that exist outside the text, in the world at large. Instead of the higher codes being built in a solid manner upon the lower ones – connotation upon denotation – Barthes emphasizes the fact that denotation is an *effect* of connotation. Denotation is not the "first meaning," but only "pretends" to be; "it is ultimately no more than the *last* of the connotations . . . the superior myth by which the text pretends to return to the nature of language." Reality is an effect of ideology.

In an essay which became an important touchstone for postmodernism, "The Death of the Author," written in 1968, Barthes argued that the traditional notion of the author as someone who controls meaning, who imposes an end to the meanings his work creates, is simply inadequate to explain the kinds of significative processes that writing actually involves; the notion of the author as someone who gives meaning to the reader–consumer is hopelessly limited, authoritarian, and needs to be replaced with a different model: "We know now that a text is not a line of words releasing a single "theological" meaning (the "message" of the Author-God) but a multi-dimensional space in which a variety of writings, none of them original, blend and clash." Barthes advocates a kind of writing that "liberates what might be called an anti-theological activity," and that thus also liberates the reader: such writing, which opens itself to the proliferation of meaning – modernist writing of a kind that supports Mallarmé's belief that in poetry it is language itself, not the author, which "speaks" – provides us with a powerful, disruptive pleasure which Barthes likens to orgasm by naming *jouissance*. The death of the author brings with it the "birth of the reader." The notion of the death of the author was also articulated in slightly different terms the next year by Foucault, who spoke of the "author-function" as a controlling device designed to limit the chaotic significative patterns of the text and channel them in a socially useful direction. "The author is the principle of thrift in the proliferation of meaning . . . the ideological figure by which one marks the manner in which we fear the proliferation of meaning."

The transition in Barthes's work from the concern with establishing "structural" models to an emphasis on the open-endedness of significa-tion is indicative of a larger shift in the course of the 1960s from "structur-alism" to "post-structuralism." The figure in whom this shift can be said to reach its climax is the philosopher Jacques Derrida (b. 1930), who

burst onto the intellectual scene in 1967 with three books, and whose ideas had an immediate effect – on older contemporaries such as Barthes and Foucault as well as on younger thinkers. Derrida claimed that, while Saussure had exposed a fundamental truth about the way language works, he had also oversimplified the situation: by setting up a tidy one-to-one relationship between signifiers and signifieds, he tended to give language a stability – even a transparency in its relation to the world – that it does not in fact possess. Derrida insists that the signifieds on which meaning depends turn out to be nothing more than signifiers themselves. Meaning relies not only on difference, but on deferral down an endless chain of signifiers; it is a kind of illusion produced by an infinite "circulation" or "play" of signifiers. "The original or transcendental signified is never absolutely present outside a system of differences. The absence of the transcendental signified extends the domain and play of signification infinitely." The process of signification is radically "decentered"; it is animated by a kind of centrifugal energy that we must constantly suppress in order to go on pretending that our statements have real meaning.

This same effort to suppress also manifests itself in the world of ideas and values. According to Derrida, Saussure's model is conditioned by a traditional preference for speech over writing, a preference motivated by the desire to make meaning depend on some kind of authentic "presence" within or behind the words themselves. This desire lies at the very heart of Western philosophy: it explains the emphasis on the superiority of intention to result, essence to appearance, soul to body. Derrida wants to overturn this hierarchy: for him, it is writing rather than speech that exposes the real nature of language as an endless play of signifiers. By the logic of deferral, what comes "after" contributes in an essential way to what comes "before." He can thus be said to apply the tools of linguistic analysis to the subversion of Western metaphysical thought – and to writers dependent on it, such as Lévi-Strauss – begun by Nietzsche and Heidegger. If Western thought is "phonocentric" in the way it privileges speech to writing, it is also "logocentric" in its dependence on some notion of a "transcendental signified," whether it be the "idea" or "essence" of Greek philosophy, the "Word" of Christian theology, the "Spirit" of Hegel, or any of the other options on offer.

Derrida's particular method of analysis and argumentation, called "deconstruction," seeks to expose the ways in which philosophical texts build upon insupportable distinctions. Such distinctions usually involve some purposeful oversimplification or exclusion, a "cut" or act of conceptual violence, and Derrida delights in showing how they collapse, how the terms they employ depend in some essential way upon their very opposites, and how the arguments that follow from them are often structured by an anxious sense of their own instability. An example is his

analysis of Kant's distinction, in the *Critique of Judgment*, between the picture and its frame, the "inside" and "outside" of the work, an opposition which, when questioned, undermines the whole idea of aesthetics as an independent realm of inquiry. Although this technique can be used to undermine almost anything, and though one sometimes gets the impression that Derrida is a nihilist whose aim is simply to demonstrate the futility of speculative thought, he actually uses deconstruction strategically to yield important insights into the limits of language: he is guided by the assumption that only the most scrupulous attentiveness to those limits gives us any chance of glimpsing what, if anything, may lie beyond them. His emphasis on the materiality of language and its processes is part of the tradition of critical counter-language that began with Symbolism, and he himself advocates a "Nietzschean *affirmation*": "the joyous affirmation of the play of the world and of the innocence of becoming, the affirmation of a world of signs without fault, without truth, and without origin which is offered to an active interpretation. *This affirmation then determines the noncenter otherwise than as loss of the center.*"

Derrida's thought might thus be characterized as critical rather than negative; it demonstrates both the necessity and liberating potential of critique. It recognizes that signification is a complex, usually duplicitous, but necessary practice – a singularly *artful* one – and that artifice and meaning-making are linked in the most fundamental way imaginable: it is, in other words, an argument for the importance of art to human existence.

The preoccupation with language – the "linguistic turn" – in French thought that gathered force during the 1960s was evident in all aspects of intellectual life, and post-structuralism in particular exposed the deep-seated anxiety over the limitations of language. In *Discourse, Figure*, published in 1971, the philosopher Jean-François Lyotard complains of the traditional Western preference for language to visual imagery, a preference linked to the value placed on discursive reason over sense perception. Borrowing from Freud as well as from Derrida, he argues that "figural" modes of expression, especially visual images, bring us closer to the transgressive – truly liberating – force of our desire, and he advocates a kind of reasoning that manages to open itself to the extra-rational truth of the image. In a highly influential essay, *The Postmodern Condition*, published in 1979, he claims that scientific knowledge – the most privileged form of discursive reason – must be understood as a kind of narrative, governed by protocols of its own, to be sure, but no different in principle from the mythic and poetic narratives that serve as the basis of "knowledge" in older and non-Western cultures. He urges a refusal of the totalizing "master-narratives" that Western rationality has

fashioned to support itself. Even more than Derrida, he can be said to adopt a position similar to that of the ancient Sophists.

Another philosopher associated with post-structuralism is Gilles Deleuze, whose *Difference and Repetition*, published in 1968, preceded the collaboration with Felix Guattari already mentioned. He, too, was interested in overturning Western metaphysics, and he complements Derrida's critique of logocentrism with a critique of our fundamental faculty of representation. The emphasis that representation puts upon the principles of identity, resemblance, opposition, and analogy works to suppress the real role of repetition and difference in the subjective constitution of reality. For Deleuze, difference is the basic condition of being, and repetition is an effect of its "productive power." Simulation, especially in art, is an expression of the difference within identity. "Art does not imitate, above all because it repeats." Modern art has liberated the simulachrum from its negative connotation as some kind of fallen version of an original, and in so doing it has realized something fundamental about both art and modernity: "modernity is defined by the power of the simulachrum." Deleuze can be said to excavate the conceptual depths beneath Benjamin's insight about mechanical reproduction; his positive attitude – of a piece with the less rigidly hostile attitude toward capitalism expressed in *Anti-Oedipus* – contrasts sharply with Baudrillard's horror at the pervasiveness of simulachra and the nauseating disorientation they cause.

The ways in which this tradition of thought either finds an unconscious echo in, or is actively taken up by, the art we call postmodernist are varied and complex. Some of the work produced in America before the influx of French theory in the 1970s can be said to anticipate some of its concerns. Jasper Johns, the Minimalist Donald Judd, and the Conceptualist Sol Lewitt, for instance, each reveal an interest in repetition that can be understood in Deleuzian terms. Deleuze himself – like Baudrillard – acknowledged the influence of Warhol on his thinking: he claimed that Warhol's replication of mass-produced objects emphasizes the reality of simulation. Barthes sounds very much like Deleuze when, referring to Warhol in particular, he emphasizes the "radical" quality of Pop Art: "it is no longer the fact which is transformed into an image . . . it is the image which becomes a fact. Pop art thus features a philosophical quality of things, which we may call *facticity*. . . . stripped of any justification . . . they signify that they signify nothing." Reproduction "is the very being of Modernity."

By the late 1970s and early 1980s, however, the linguistic turn in French thought had begun to be assimilated outside France and to transform the way in which art was thought about and discussed. An important contribution to this process was made by the journal *October*,

founded in New York in 1976 by a group of critics under the intellectual leadership of Rosalind Krauss. In the essay "The Originality of the Avant-garde," published in 1981, Krauss offers an example of the new approach. Discussing pictures that make use of a grid format, a device that seems to testify to "the originary status of pictorial surface," to occupy the "indisputable zero ground" beyond which there is "no model, or referent, or text," she observes that in fact "the grid *follows* the canvas surface, doubles it . . . veils it through a repetition." "The very ground that the grid is thought to reveal is already riven from within by a process of repetition and representation; it is always already divided and multiple." This fact undermines the notion of originality so central to modernism; it demonstrates that "'originality' is a working assumption that itself emerges from a ground of repetition and recurrence." The copy is the "*underlying condition of the original.*" Making use of Deleuze's ideas about repetition, Krauss also "deconstructs" the opposition between repetition and originality in a manner emulative of Derrida.

The grids Krauss discusses do not engage language directly; they expose what seems to elude or lie beneath language. Other work made use of words in a manner that reveals the direct influence of the "linguistic turn": both Victor Burgin and Barbara Kruger, for example, were indebted to Barthes's analyses of advertising. Jenny Holzer established her reputation with work that consists almost entirely of verbal messages – sometimes printed and publicly posted, sometimes displayed on electronic signboards. Her *Truisms*, which originally appeared as posters in the late 1970s but were later adapted to all sorts of media (figure 6.3), consist of brief statements, such as "abuse of power comes as no surprise," "money creates taste," and "morals are for little people," which follow one another in a manner that has no logical connection and can hardly be understood as issuing from a single person. Holzer herself has referred to them as "one-liners written from multiple points of view." Her work involves the viewer in a kind of dialogue while undermining the notion of real communication and the relation between speech and identity. Subtle where Kruger is hard-hitting, she is yet capable of addressing more disturbing themes, such as violence against women.

In the late 1970s and early 1980s Sherrie Levine created a sensation with photographs of carefully chosen pictures by famous photographers exhibited as her own work. In an act of appropriation at once more nuanced and more daring than any Situationist *détournement*, she offered a critique of the idea of originality and a claim for the "death of the artist" analogous to the "death of the author" announced by Barthes. Making reference to Benjamin as well as Deleuze, Krauss emphasizes the way in which such images "act out the discourse of reproductions without originals"; they point out the vulnerability of any claims for

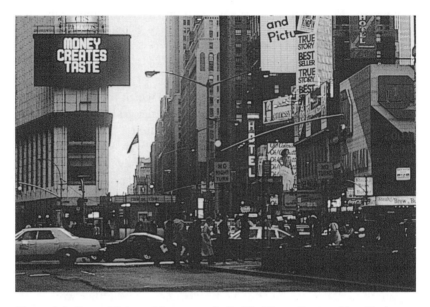

Figure 6.3 Jenny Holzer, *Messages to the Public*, Times Square, New York, 1982.

originality in photography, especially when, as in the case of one of Edward Weston's pictures of his son (figure 6.4), obvious reference is being made to the whole tradition of the nude: "Levine's act of theft, which takes place, so to speak, in front of the surface of Weston's print, opens the print from behind to the series of models from which it, in turn, has stolen, of which it is itself the reproduction." Other critics have emphasized the feminist element in Levine's work, the way in which she also deconstructs the masculinist posturing in much of the modernist rhetoric of originality. Her challenge to the idea of creative property is as Duchampian a gesture as postmodernism has yet produced, and her emptying-out of artistic subjectivity could be said to go even further than Warhol's.

The linguistic turn even found its way into architectural theory. An architectural postmodernism began to develop in the 1960s as a pointed reaction against the austere rationalism of the International Style: its most articulate early spokesman, Robert Venturi, called for "an architecture that promotes richness and ambiguity over unity and clarity, contradiction and redundancy over harmony and simplicity." Among the leading theorists of the movement is the architect Peter Eisenman, who has striven to incorporate "deconstructionist" principles into his work, and even invited Derrida to collaborate with him on an important project. He seeks to create effects of "decentering" that produce a certain tension or unease

in the viewer, as well as what he calls "betweenness" – formal indeterminacies that avoid stable resolution. He speaks of evoking "absence," of setting up a play of "absence" and "presence" that echoes Derrida's insights into the workings of language. At the deepest and most comprehensive level, he has attempted to address the apparent paradox of a deconstructive architecture. His design for a beach house in Spain (figure 6.5) overturns all sorts of assumptions about what a house should be, relentlessly undermining effects of stability and permanence; it deconstructs fundamental oppositions such as inside/outside, even up/down. Such buildings are difficult and costly to build owing to their irregularities, and they have been faulted for their insensitivity to practical requirements, but the exploration of theoretical possibilities has always had an especially

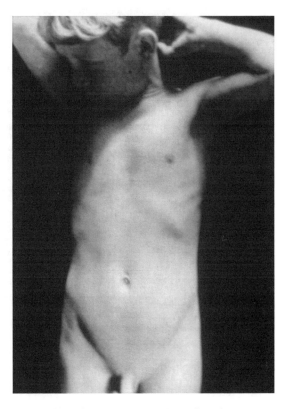

Figure 6.4 Sherrie Levine, *After Edward Weston, #1*, 1980, Paula Cooper Gallery, New York.

important role in architecture, and in at least some of his work Eisenman has managed to meet the functional specifications exceptionally well.

If thought about language had an influence on critics of culture such as Althusser, on anthropologists such as Lévi-Strauss, and on philosophers such as Derrida, Lyotard, and Deleuze, it also had an influence on psychoanalysis, the most important example of which is the work of Jacques Lacan (1901–81). Already in the 1930s and 1940s, Lacan had proposed significant revisions to the Freudian model of child development, and these, together with his later work, would affect many aspects of postmodernist thought, especially thought about art. Freud had described the decisive phase of subject formation as the Oedipus complex, the process by which the child comes to grips with its perception of sexual difference: the understanding that its claim to physical intimacy with the mother must be surrendered to the father prepares the way for the child's assumption of its mature sexual identity, and starts it down a path of socialization that leads away from self-gratification toward self-discipline

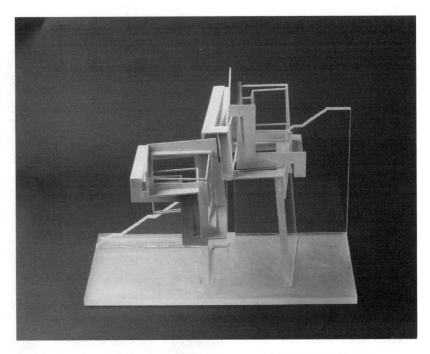

Figure 6.5 Peter Eisenman, *Guardiola House Model*, 1988, Eisenman Architects, New York.

– from the "pleasure principle" to the "reality principle" – but this accommodation also involves the enforcement of a terrible split between the conscious and unconscious, between those parts of ourselves we can express and those we must repress. Lacan emphasized that this phase coincides with the child's acquisition of language: the recognition of sexual difference is linked to the recognition of difference as it operates in language and governs the entire system of values – the "symbolic order" – that language supports. The entry into language is thus charged with the pain of division and loss; it is an exile into a realm of signs that are never what they seem to be, that are split in the same way we are, and that can only ever offer fleeting and insubstantial relief from our pain. Reversing the emphasis of Freud's terms, Lacan insists that access to the "real" is not what the child gains, but precisely what it loses when it enters into the symbolic order.

The Oedipal crisis overlays but does not entirely efface earlier stages of development. Another crucial episode is the "mirror stage," which occurs – sometime between the ages of six and eighteen months – when the child learns to recognize its reflection in a mirror. At this moment, it receives a unified visual image of itself, one that is gratifying and that instills

an ideal sense of self in its imagination, but one that is also false in that it is merely an image. The significance of this experience will grow as the child passes through the Oedipus complex: the illusory pleasure experienced before the image will often be made to compensate for the inadequacies and frustrations of the symbolic order. Our tendency to identify with others and our susceptibility to all forms of idealization are conditioned by this moment of self-perception. But if vision carries positive associations, it can also have a more threatening aspect. As we look out at the world, the world "looks" into us: it objectifies us in an impersonal – indeed, inhuman – realm of visibility which Lacan calls the "gaze." "I see only from one point, but in my existence I am looked at from all sides." Our experience of looking is always also one of protecting ourselves from this powerful objectivizing force, of parrying or mediating it, and Lacan claims that the visual arts assist us in doing so. A picture is a mirror of ourselves as much as a window onto the world; it acts as a "screen" on which we project our fears and desires, but with which we are also able to objectify in turn, and to manipulate, to "play" with them. Much of the profound and complex appeal of pictures lies in their "taming, civilizing, fascinating" effect on "the eye made desperate by the gaze."

Lacan's work came to be of particular interest to feminists, in part because its emphasis on the role of the "symbolic" in the formation of gender identity seemed to offer a key to the deep ideological basis of women's subjugation: the symbolic order could be said to be structured in such a way as to deny women the very possibility of any adequate self-representation and thus any hope of fulfillment. The psychoanalyst and writer Julia Kristeva used Lacan to help construct a distinction between the "symbolic" and the "semiotic," between language and those forms of pre-linguistic signification such as rhythm, tone, and color. Our participation in the semiotic begins at the moment of conception and is associated with the earliest experiences of the mother's body: rhythms begin to mean things to us even while we are in the womb. Kristeva believes that all the efforts of modernist poets to fashion a counter-language are in fact attempts to use the semiotic against the symbolic and thus to open reason to what it ordinarily represses. Other feminist theorists drew upon the idea that because little girls pass through the Oedipal crisis differently from little boys, never identifying as completely with the father and thus never entering as fully into the symbolic order, women remain closer to the "real," and are better situated to create a counter-language, a new kind of writing expressive of a new and more truly liberated mode of being. The effort to realize this "feminine writing" is not unlike earlier Surrealist efforts to mobilize the unconscious.

Lacan's work began to appear in English translation in the late 1960s and early 1970s. The conceptual artist Mary Kelly, an American living

in England, a feminist and leftist activist, was one of the first to make artistic use of his ideas: her *Post-partum Document*, carried out over a period of six years, from 1973 to 1979, is an extensive record of her relation to her infant son (figure 6.6). Among other things, it documents the connection between his language acquisition, his awareness of gender, and his shifting attitudes toward his mother and father. One of its most striking features is the absence of photographs: though it makes use of clothing, plaster imprints of hands, first scribbles, and gifts – such as twigs and insects – given by the boy to his mother, the refusal to employ the most common modern form of visual representation denies us a certain obvious path into the material and forces us to take another. Revealing her grasp of Althusser and Barthes as well as of Lacan, Kelly explained that she wished to avoid the naturalizing effect that images of woman-as-mother might have, the myths they would tend to reinforce of "woman as object of the look" and especially of "femininity as a pre-given identity" – as something constituted outside a specific discursive regime and existing independently of it.

Lacan's ideas found an especially fertile reception among film theorists. Feminist filmmaker and critic Laura Mulvey announced her intention to use psychoanalytic theory "as a political weapon" in an influential essay, "Visual Pleasure and Narrative Cinema," published in 1975. By examining the ways in which Hollywood movies make use of women, Mulvey tried to show how they expose "the unconscious of patriarchal society." Such movies tend to concentrate sequences in which important dramatic action takes place around male characters, while the female figures become occasions for narrative digression and objects of visual delectation. The kind of attention we direct to female figures on screen draws upon the pleasurable associations of the mirror stage, but because it is *women* who are thus detached from the action and objectified, the subliminal effect is to identify the act of looking as male: the "objectivizing" power of the gaze is given over to men, who thus become the "subjects" of vision, while women are "subjected" by patriarchy as the "objects" of vision. Gratifying as this arrangement may be for men, however, the pleasure of looking at the image of a beautiful woman is always also tinged with a certain fear – deriving from castration anxiety, one effect of the recognition of sexual difference associated with the Oedipus complex – and Mulvey sees this fact as offering a strategic path for feminist filmmaking. Mulvey's essay has come in for much subsequent revision and elaboration, an indication of how important it was, and how rapidly the theorization of such issues has developed.

If Kelly avoids direct visual representation, other feminists engage it in a critical manner. Kruger's *We Are Your Circumstantial Evidence*, for instance, also touches on the themes discussed by Mulvey: the words

Figure 6.6 Mary Kelly, *Post-partum Document* (detail "Documentation IV, Prewriting Alphabet"), 1978, Arts Council of Great Britain, Hayward Gallery, London.

indicate that women are necessary to the formation of male identity, even if only as something to be rejected; the fragmented photo, from which the woman's eyes yet manage to return our look, suggests at the same time that images of women – especially when they presume to look back, to embody the "gaze" – are fraught with castration anxiety. The artist

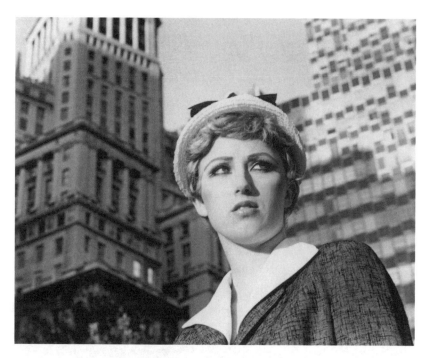

Figure 6.7 Cindy Sherman, *Film Still, #21*, 1978.

Cindy Sherman achieved spectacular success at the end of the 1970s and
beginning of the 1980s with a series called *Film Stills*, photographs of
herself dressed and posed in settings that evoke scenes from popular
movies of the 1950s and 1960s (figure 6.7). Such images address obvi-
ous issues of female stereotyping in mass culture, but also explore the
deeper ways in which femininity is constructed in and by representation,
the particular conditions under which, in the symbolic order, femininity
exists at all. Lacan suggested that patriarchy can only constitute woman
as a "symptom." By drawing attention to the role of visual representation
in that process, as well as to the way in which that process is fundamental
to the constitution of patriarchy itself, Sherman's work suggests that
"woman" must be the primary site for any critique of representation and
its determining conditions.

Future Present

The postmodernist moment in art, the late 1970s and early 1980s,
already seems long gone, yet it is still with us; we are still sorting out and

working through its achievements and implications. Its theoretical sources, too, continue to be sifted critically. Bold and exhilarating as it is, much of the radical thought of the 1960s and 1970s has come in for criticism even among thinkers sympathetic to its aims. Foucault, who modified his own positions several times, has been attacked from a number of angles, accused of being both too negative about rationalism and too naively positive about the circuitry of power and the potential of micropolitics to recode it. The same criticism has been leveled at Deleuze and Guattari. On the other hand, Baudrillard's denial of the very possibility of politics has been rejected by many as a dead-end. Lyotard's reduction of science to rhetoric has also drawn heavy fire and now finds few defenders. A quick and simple verdict on these thinkers is unlikely, and they may turn out to be both right and wrong in ways we can scarcely imagine. In the meantime, the consideration of the dilemmas they present has been inflected by new factors: the end of the Cold War in 1989 has made the "new world order" of global capitalism a reality, and in the past few years attention has shifted more and more to the possibilities and effects of technology.

Victor Burgin's suggestion that the category "art" should be reconstituted as "the politics of representation" proved prophetic. The "culture wars" of the 1980s and 1990s showed how important representation had become: in America, there were bitter public controversies over the work of artists such as Richard Serra, Robert Mapplethorpe, and Andres Serrano, as well as over pop-music lyrics, movies, free speech in the media, and political campaign advertising. The role of the media in controlling representation became the focus of public scrutiny. Museums, too, were subjected to criticism for the conceptualization of exhibitions – particularly when they dealt with artifacts from Native American or non-Western cultures – and in some cases were called upon to repatriate objects, an indication of just how widely the real political power of symbols was recognized. Schools witnessed heated debates over the integration of non-canonical literature into the curriculum. All around the world, the urgency of staking one's claims in the realm of representation was demonstrated again and again, as radio and television stations became the primary targets of any popular uprising or *coup d'état*. The emergence of something like an international system of representation seemed to imply the emergence of something like a global conscience; as a result, the control of information and communication technology became an object of intense concern.

One aspect of the culture wars was the rapid assimilation of postmodernist theory by academics in the fields of the humanities and social sciences, and the turmoil this caused in redefining both the aims and methods of the individual fields and their relations to each other. The

general sense of the importance of representation and of the socially conditioned nature of representation led to the rapid expansion of interdisciplinary – even "postdisciplinary" – modes of inquiry that looked across culture as a whole. "Cultural studies," a field that had developed earlier, largely in England, devoted mostly to the study of contemporary working-class culture as a site of creative resistance to the ideological agenda of high culture, and which had itself been transformed under the influence of postmodernist theory, offered a useful conceptual model for the kind of integrative, yet critically motivated approach that now seemed necessary. One of the most productive – and productively controversial – areas for this kind of work has been the cultural critique of science and technology. Even the rather staid discipline of art history was affected by the sudden influx of new methodological paradigms, and in an effort to get away from what was felt to be the oppressive dominance of high art, attempts were made to redefine its proper object of study as "visual culture."

Sustained by developments such as these, the most visible theme in the art of the past twenty years has been "identity politics," the investigation of the ways in which individual and collective identity are mediated by representation. Perhaps the most powerful motive force behind this trend, as well as the source of its principal conceptual tools, has been feminism, which can be said to have established a model in the way it seized upon, combined, and creatively elaborated some of the most radical aspects of political, literary, and psychoanalytic theory. The philosopher Judith Butler, for instance, drew upon the work of Foucault, Derrida, and Lacan to argue that feminism must not presume "the universality and unity" of its subject, that is, must not assume that "woman" is any one thing:

> If one "is" a woman, that surely is not all one is; the term fails to be exhaustive, not because a pre-gendered "person" transcends the specific paraphernalia of its gender, but because gender is not always constituted coherently or consistently in different historical contexts, and because gender intersects with racial, class, ethnic, sexual, and regional modalities of discursively constituted identities. As a result, it becomes impossible to separate out "gender" from the political and cultural intersections in which it is invariably produced and maintained.

Butler advocates a "performative" definition of sexual identity, one that stresses practices rather than essences. Gender is not "a stable identity or locus of agency from which various acts follow," but is something "tenuously constituted in time, instituted in an exterior space through a *stylized repetition of acts*":

That gender reality is created through sustained social performances means that the very notions of an essential sex and a true or abiding masculinity or femininity are also constituted as part of the strategy that conceals gender's performative character and the performative possibilities for proliferating gender configurations outside the restricting frames of masculinist domination and compulsory heterosexuality.

Feminism is thus made to open out onto a profound and comprehensive form of liberatory practice: "The deconstruction of identity is not the deconstruction of politics; rather, it establishes as political the very terms through which identity is articulated." Butler's interest in "proliferating gender configurations" has obvious implications for the theorization of gay identity, queer theory. Her concern with issues of representation has also prompted her to engage in the debate over the limits of free speech.

The conceptual models developed in the theorization of gender identity have also been adapted to the theorization of racial and ethnic identity. African American historian and critic Cornel West has written of the need for black activists to dispense with "the innocent notion of an essential Black subject," and to overcome the "assimilationist" and "homogenizing" strategies – strategies that ultimately deny the value of difference – it has tended to encourage:

Black cultural workers must constitute and sustain discursive and institutional networks that deconstruct earlier modern Black strategies for identity formation, demystify power relations that incorporate class, patriarchal, and homophobic biases, and construct more multivalent and multidimensional responses that articulate the complexity and diversity of Black practices in the modern and postmodern world.

Racial identity, too, thus opens out onto a more comprehensive mode of political engagement: "The aim is to dare to recast, redefine, and revise the very notions of 'modernity', 'mainstream', 'margins', 'difference', 'otherness'."

The global implications of identity politics have also been energetically theorized. One of the leading figures in this field is Indian British scholar Homi Bhabha, who also makes use of post-structuralist conceptual models, and, again, invokes the example of feminism to insist upon the importance of difference as a cultural value:

The postcolonial perspective forces us to rethink the profound limitations of a consensual and collusive "liberal" sense of cultural community. It insists that cultural and political identity are constructed through a process of alterity. Questions of race and cultural difference overlay issues of sexuality

and gender and overdetermine the social alliances of class and democratic socialism. The time for "assimilating" minorities to holistic and organic notions of cultural value has dramatically passed. The very language of cultural community needs to be rethought from a postcolonial perspective, in a move similar to the profound shift in the language of sexuality, the self and cultural community, effected by feminists in the 1970s and the gay community in the 1980s.

The urgency as well as the practical implications of such theorizing have become more apparent as individual nation-states and the international community as a whole contend with the problems and possibilities of multiculturalism and globalization.

Of all the artists engaged with themes of identity, ethnicity, and gender during the 1980s and 1990s, the one who received perhaps the widest critical acclaim was the Vietnamese American writer and filmmaker Trinh Min-ha. One of her early works, *Reassemblage*, filmed in 1982, is a kind of counter-documentary about village life in Senegal that addresses issues pertinent to the cultural identity of "underdeveloped" peoples everywhere. Subtle departures from all sorts of filmic conventions – slight shifts in camera angle and sequential leaps, deliberately ambiguous and multivalent sequences, carefully calculated disjunctions between image and sound track – work to unsettle notions of identity and reverse the relation of observer and observed. Taking issue with the entire strategy of objectification typical of Western anthropology, Trinh announces her intention not "to speak about" but to "speak nearby." In such works, representation emerges as something negotiated rather than unilaterally imposed. Their critique of ethnography – made even more explicit in Trinh's statements and theoretical writings – has been a significant influence on attempts by Western academics to theorize a postmodern ethnography.

Although a pervasive concern, identity politics is not the only issue around which substantial bodies of contemporary art and critical or theoretical writing have emerged. Within the tradition of "institutional critique," developed by artists such as Hans Haacke, much of the most articulate work deals with the institution of the museum and the terms within which art is collected, displayed, and consumed. Partly in response to the tremendous inflation of the art market during the 1980s, photographer Louise Lawler began to take pictures of works of art in their settings – whether museums or private collections – that emphasized the economic and ideological investments they "represent" (figure 6.8). Many artists have created works that consist of collections of objects and that are thus exhibitions themselves. In 1992, the African American Fred Wilson placed a set of slave's manacles into a display case full of

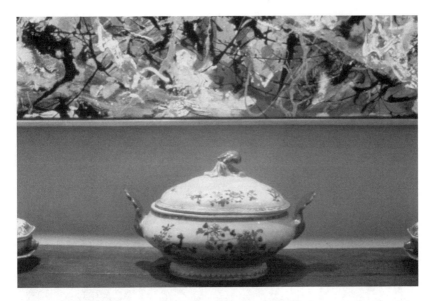

Figure 6.8 Louise Lawler, *Pollock and Soup Tureen*, 1984.

eighteenth-century American silverware, bluntly but powerfully exposing both the economic reality underlying the production of luxury objects in the past and the way in which we still tend to suppress that reality in our encounters with "art" today.

Other work engages issues of identity but in a less overtly political, more personal way. Los Angeles-based artist Mike Kelley came to attention in the late 1980s with displays, including sock dolls, that he had either made himself or collected. His choice of these homely craft objects, traditionally made and given as gifts, was a response to the emphasis on mass-produced consumer goods in some of the art then fashionable; and where such work had raised the issue of commodity fetishism in a manner directly indebted to theorists like Baudrillard, Kelley's dolls evoke the psychopathological dimensions of fetishism. An assemblage such as *Innards* (figure 6.9), simple as it is, manages to suggest both childhood trauma and the force of its repression. Freud and Lacan had evolved theories of the way in which our libidinal energies attach themselves to objects, and the exploration of what might be called the psychological resonance of objects was an important part of Surrealism. Kelley has indicated his particular sympathy with Bataille, whose interest in all the most unappealing aspects of human physicality was an effort to address what even most Surrealism tried to ignore. Although a great deal of contemporary art makes use of readymade objects, commenting upon the pervasiveness of objects in our lives and the way in which we use

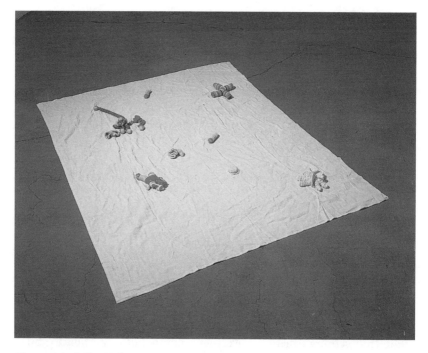

Figure 6.9 Mike Kelley, *Innards*, 1990.

them to define ourselves, Kelley's work has a raw, emotional quality, and is unusually powerful and complex.

The body – closely, if always problematically related to identity – has also been an important theme in recent art. Much of this work carries on the feminist concern with representation, much is inspired by Foucault's emphasis on the body as a site of coercive "discipline" or "inscription," and much draws upon the concepts of "base materialism" and abjection developed by writers like Bataille and by psychoanalytic theorists. Mona Hatoum, a Palestinian active primarily in England, achieved notoriety in the early 1990s with works – such as a carpet made out of simulated human intestines – that subjects the body to something like the wicked wit of Dada and Surrealism. Her installation *Corps étranger* (*Foreign Body*) (figure 6.10) consists of a video projected onto the floor of a narrow cylindrical enclosure: made with an endoscopic camera passed over the surfaces and through the various orifices of the artist's body, including the entire length of the digestive track, the video presents the body in a disoriented, close-up, and fragmented manner, one that even undoes the distinction between inside and outside. With its obvious refusal of idealization and its emphasis on materiality, on the

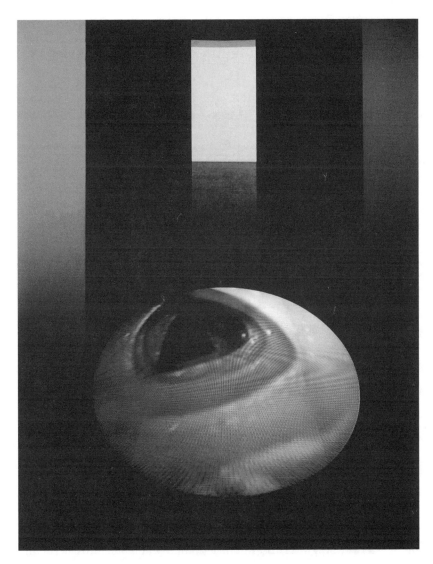

Figure 6.10 Mona Hatoum, *Corps étranger*, 1994, Musée d'art moderne, Centre Georges Pompidou

body as a *mise-en-abyme* where all sorts of things might go wrong, the overall effect is both frightening and fascinating. Projected onto the floor, the video strikingly evokes Lacan's image of the drain, which he uses to describe the way in which the constitutive incompleteness of human subjectivity is associated from infancy with the openings of the body.

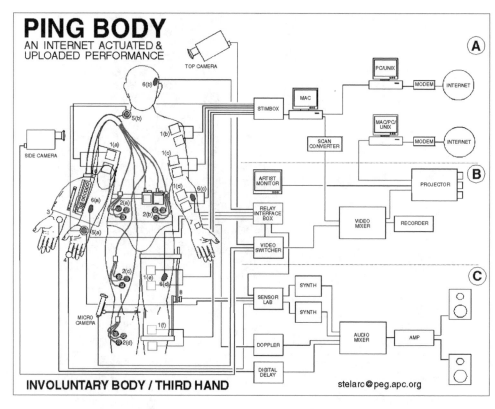

Figure 6.11 Stelarc, *Ping Body* (diagram), 1996.

The Australian performance artist who calls himself Stelarc has been one of the first to explore the ways in which the body is articulated by digital technology. In *Ping Body: An Internet Actuated and Uploaded Performance*, produced in 1996, electrodes attached all over the body administer small shocks in patterns dictated by the "ping protocol" that monitors data flow over the Internet (figure 6.11). The artist jerks and contorts involuntarily as his neuromuscular system is taken over by the global information and communication network. Not surprisingly, these performances leave him so drained that he must sometimes be carried from the stage. Such work presents us with a frightening glimpse of technology as an instrument of control and abjection, but also as offering new, darkly fascinating possibilities for the experience of ecstatic release and communion with some suprapersonal source of power and knowledge.

Contemporary artistic treatment of the body can thus be said to express an anxiety about subjectivity, about the instability of identity and

the very category "human," indicative of the "posthuman" age at which we have supposedly arrived. This anxiety has other, even more serious, consequences for art: since the Renaissance, and especially in modernism, art has been closely linked to subjectivity; it has served as the means by which subjectivity – the "personal," the "human" – has resisted coercion and articulated its claims upon the world, by which we testify to the meaning of what we see, feel, and think. Postmodernism has cast into doubt the very possibility of a coherent subjectivity, and while it recognizes that doubt as painful, it also urges the recognition of a liberatory potential and calls for an attitude of acceptance, even of affirmation.

Critics respond by saying that attempts to recast this crisis of identity in positive terms are dangerously naive: the fact is that subjectivity is also being aggressively undermined by the highly rationalized operations of the culture industry. Though capitalism helped to constitute "individuality," and still keeps it alive as a kind of empty remnant, it also pressures us to define ourselves as producers and consumers, breaks us down into our appetites, then represents the satisfaction of these appetites as some kind of meaningful self-realization. Our bodies have become machines for perpetuating the cycle of production and consumption; our minds are simply machines for motivating our bodies. Desire – which, since Plato, has been regarded as the very heart of our inwardness, the place where, being most inhabited by what we most lacked, and where being least ourselves, we were most ourselves – has been colonized by advertising, reduced to an instrument for stimulating personal productivity. In such a situation, one could argue, our misgivings about the rhetoric of decentering are no longer merely reactionary, and to buy into the abandonment of selfhood – of some notion of self-possessed subjectivity – looks more and more like surrender to coercion. It should be possible to fashion some critically poised and empowered sense of identity – "agency" would perhaps be a better word – that avoids old-fashioned, mythic investments.

If subjectivity is challenged by the theoretical awareness of its own tenuousness, on the one hand, and by "market dynamics," on the other, it is also challenged by technology. There is no question that developments in computer technology have opened new worlds of possibility to art as to much else. In some ways, they seem to support the tendencies of postmodernist theory: the development of hypertext, for instance, seemed to many to materialize Barthes's conception of a new kind of literature – "a multidimensional space in which a variety of writings, none of them original, blend and clash." Virtual reality promises unlimited possibilities for the creation of sensory illusions. Although the applications of this technology are only in their infant stages, it is possible to imagine the creation of vastly complex illusions that might absorb the mind, involve

it in interactive exchange, and do so in a manner that is genuinely pleasurable, illuminating, moving – and perhaps even other things it has not yet occurred to us to expect. Will the liberatory, artistic potential of this technology be realized, or will it simply become a degraded form of entertainment and instrument of the culture industry?

Perhaps the deeper question regarding computer technology is how artificial intelligence will redefine what it means to be human, and how that redefinition will then begin to affect the work that art is expected to do. Here again, there are both utopian and dystopian scenarios. In "A Manifesto for Cyborgs," published in 1985, feminist theorist Donna Haraway suggests that the notion of a "cyborg," a combination of human and machine, might offer a positive model for imagining an alternative subjectivity. Feminism needs to replace the myth of "organic wholeness," she believes, and cyborgs provide a composite identity, "a kind of disassembled and reassembled, postmodern collective and personal self." We should not fear, but embrace technology: "For us, in imagination and in other practice, machines can be prosthetic devices, intimate components, friendly selves." Science fiction can guide us in this process; what we call science fiction is really the theorization of new modes of being. Haraway's enthusiasm leads to some rather questionable assertions: "The boundary between science fiction and social reality is an optical illusion"; "There is no fundamental, ontological separation in our formal knowledge of machine and organism, of technical and organic." A more skeptical view has recently been articulated by Peter Lunenfeld, who points out how complicated, how critical, our engagement with technology has to be, how it must be neither "Luddite" nor indiscriminately positive. He stresses the need to balance our interest in imagining what "might be" with "rigorous investigations of what 'was' and what 'is'," and recommends "a hyperaesthetic that encourages a hybrid temporality, a real-time approach that cycles through the past, present, and future to think with and through the technocultures."

Genetic research has also begun to undermine traditional conceptions of what it means to be human. Here, too, one has one's choice between optimistic and pessimistic predictions, and here, too, it is hard to sift fact from either fantasy or corporate propaganda. If the creation of machines, especially of thinking machines, might be considered an art, then genetic engineering might also be seen as an art, even the type of all art: it puts its practitioners in the position of Daedalus, or Prometheus, or the God of the Old Testament. We have already begun to think about the implications of cloning and the use of human bodies as raw material for genetic research, and we can easily envision human beings produced not sexually, but by systematic combinations of diverse – yet carefully selected – genetic material. We can even envision a combination of such material,

perhaps in further combination with a machine, that would make the very idea of a definite identity, of subjectivity as limitation, obsolete. Our anxiety about these prospects may have less to do with the technology itself that with its political instrumentalization.

Whether our outlook for the future of humanness is utopian or apocalyptic, trying to anticipate the future has become increasingly urgent: as Lunenfeld, echoing Walter Benjamin, observes, we are now expected to think in a new and impossible tense, a "future/present." Yet we should find some reassurance in recalling that the fundamental instability or groundlessness of identity is not a new problem. Plato recognized the fundamentally dynamic quality of our inner life, of the way in which we come to be ourselves only through the process we call love; Hegel too saw being as a process, as a protracted, conflicted engagement with the other, a vision of selfhood that indicates just what a difficult but also necessary acquisition it is. Nietzsche said that man was "a bridge, not a goal," "an overcoming and a going under," and Adorno suggested that the individual – problematic bourgeois construct that it is – was still a necessary "instrument of transition." Creative activity of the most serious kind has always involved living with this instability and reckoning with it – indeed, with actively cultivating, as well as suffering it. If art and subjectivity are as intimately linked as their historical trajectory suggests, might the current situation simply have exposed their essential interrelation? Mindful of the way Burgin superimposed art and politics, might we not adapt Judith Butler to our purposes and suggest that the deconstruction of identity is not the deconstruction of *art*, but establishes as *artistic* the very terms through which identity is articulated? To insist that subjectivity or agency makes no sense as anything but an effect of art is perhaps to begin to give the consideration of both art and humanness the sophistication they deserve.

There can be little justification, after Conceptualism, for thinking of art as a particular kind of object, or for trying to define it in terms of specific media. Although it may involve the production of objects, and such objects may – and often do – address the specific conditions of visuality or objecthood and our experience of them, such categories do not provide the basis for an adequate account of what art is: any particular art is practiced in relation to a whole array of arts and is reflexively reconstituted by them. At the same time, however, not everything is possible, even now. Not all representation is art: one imagines that the special effects we take for granted in Hollywood movies would have dazzled Leonardo da Vinci – at least for awhile – but they fall far short of the expectations that the word "art" arouses in us. On the other hand, if a thought or an action alone might constitute a work of art, then there is no reason why an athlete, a venture capitalist, a genetics engineer, a

homeless wanderer, or even a terrorist might not be an artist, yet we would only apply the term to them in an attenuated or metaphorical sense. The possibilities *are* limited, but by something else, something less obvious, some content or function – some *work* – that the object, idea, or activity performs.

Although art is concerned with exploring the realm of the imaginable – all possible imaginings or representations – there is obviously more to it than that as well. Some imaginings are better than others: the realm of the imaginable is structured – even in its fluidity – and any serious attempt to explore its possibilities must also take that structure into account. Art would seem to refer the imaginable to some other principle, whether that be simply the practicable, or, more exaltedly, the true. It refers the imaginable to the do-able, but also the do-able to some notion of what *should* or *must* be done, to some condition or set of conditions that might be characterized as philosophical, political, or moral. To relate or superimpose these seemingly independent discursive systems, to force into confrontation and resolve – or not – the tensions between them, is to perform a function at once integrative and critical. Art exposes the fact that a critical outlook toward the world depends upon an integrated position of some kind – that is, a basic ability to recognize and engage the relation of different codes, different systems of value – even if it may also insist that a fully, ideally integrated position is impossible. Art thus draws upon non-art, but the way in which it does might itself be seen as art; what seems to lie outside art – political or moral convictions, for instance – may in fact be essential to it.

In the complex patterns of human action and interaction that make up history, meaning becomes attached to things but then, after a time, also falls away from them; individual and collective energies are invested in signs but then are also divested and displaced elsewhere. This process is far from arbitrary, yet because it undermines the very meanings it creates, it often seems indifferent to anything but its own relentless dynamic, a dynamic which only seems to have become more rapid and relentless in modern times. Art participates in this process, but also tries to correct it: in the past it has been a means of making signs with obvious social functions, usually in the service of power; more recently, it has exercised its own power to critique such signs, to revise them or substitute others for them, and thus to insist upon alternative values. In the way it has undermined even the products of earlier art, it too appears relentless and indifferent to anything but the illimitable play of signifiers: with modernism, it seems, art has discovered the power of its own negativity. The dynamic of history and the dynamic of art are thus similar but not the same; nor are they completely independent of each other: history does

not happen without meaning-making, and meaning-making does not occur independently of history.

We should remember, however, that even when art served the values of prevailing ideology it tended to do so by idealizing them; even at its most conservative, it subtly revised and improved, and, in so doing, critiqued, measuring the distance between the real and the ideal and exposing it to anyone who cared to notice. To suggest the ideal – to sustain the capacity to imagine the ideal – was part of the cultural work art performed. By the same token, in modern times, the function of art is still the production of socially significant signs, even if the critical content, the sheer negativity of that process, is far more evident than before: no longer a question of suggesting ideals, it may instead involve refusing communicative strategies that could in any way support odious ideological investments. The specifically critical emphasis of modern art has thus only made explicit something that was implicit all along. There has always been an awareness that to represent the world is to negate and reconstitute it. Any one sign points beyond itself to all possible signs, any one picture to all possible pictures. Art has always reminded us that all signs are merely signs, that they are arbitrary and provisional; it has always spoken both to our need for signs and to our deep sense of their ultimate insufficiency, to our need for a more self-conscious – liberated – relation to them. Art has always involved the work – both critical and integrative – of deploying its own form of negativity against the negativity of history.

The development of art in our own time would thus seem to involve both an expanding range of possibilities and the definition of a critical negativity as the center around which and in relation to which those possibilities array themselves. Even in this reconstituted form, art continues to do some of the same kinds of work it has done in the past. The more complex our culture becomes – and the more attenuated the form of subjectivity required to deal with it – the more we need art and the more complex and attenuated that art probably needs to be. The more complex art becomes, in turn, the more we need theory. We might say that postmodernism has heightened our awareness of the *essentially* theoretical nature of art, exposing the fact that theory is fundamental to the cultural work art performs; we might even say that it has enabled us to define art as the way in which we theorize ourselves. Art's answer to the crisis of subjectivity may be simply that the crisis has always existed, that subjectivity has always been provisional, heterological, decentered, that making it function at all has always demanded a kind of work, and that the name of that work is – precisely – art. If art furnishes the basis of the possibility of identity, then in the increasingly dis-integrated modes

of existence that are now perhaps all that are available to us, its role is only the more important. To recognize that art is thus essential to whatever it is we are or can be is not only to define its task in the most urgent, and, at the same time, most all-inclusive way, but also to have found the place from which we can begin to write its history.

sources and suggestions for further reading

Introduction

A survey of the history of Western art theory – one which, however, breaks off in the early twentieth century – is offered in three volumes by M. Barasch, *Theories of Art from Plato to Winckelmann* (New York: New York University Press, 1985) and *Modern Theories of Art* (2 vols, New York: New York University Press, 1990; reissued together, New York: Routledge, 2000). A brief and entertaining, if rather limited, introduction is C. Freeland, *But is it Art? An Introduction to Art Theory* (Oxford: Oxford University Press, 2001); more substantial is L. Shiner, *The Invention of Art: A Cultural History* (Chicago: University of Chicago Press, 2001). An overview of architectural theory is H-W. Kruft, *A History of Architectural*

Theory: From Vitruvius to the Present, trans. R. Taylor et al. (New York: Princeton Architectural Press, 1994). An overview of film theory is R. Stam, *Film Theory: An Introduction* (Malden, MA: Blackwell, 2000), which can be used along with *Film Theory: An Anthology*, ed. T. Miller and R. Stam (Malden, MA: Blackwell, 2000). There are many histories of aesthetics, as well as anthologies of philosophical writings on the nature of art and beauty; an older anthology that does not confine itself to philosophy, but uses various kinds of texts to shed light on the social and conceptual factors affecting the production and consumption of art is *A Documentary History of Art*, ed. E. G. Holt (3 vols, Garden City, NY: Doubleday, 1957). A much-expanded version of the same idea, the series "Sources and Documents in the History of Art," was published by Prentice-Hall under the general editorship of H. W. Janson: individual volumes are cited below where appropriate. An excellent new set of anthologies, "Art in Theory," published by Blackwell under the editorship of C. Harrison and P. Wood, covers the modern period; its volumes are also cited in the relevant sections below. Useful, up-to-date sources for some important thinkers and issues are *A Companion to Aesthetics*, ed. D. E. Cooper (Malden, MA: Blackwell, 1992) and *Encyclopedia of Aesthetics*, ed. M. Kelly (4 vols, New York: Oxford University Press, 1998). Even more relevant and recent is *A Companion to Art Theory*, ed. P. Smith and C. Wilde (Malden, MA: Blackwell, 2002).

Chapter 1 Antiquity and the Middle Ages

On recurrent themes in ancient anecdotes about the arts: E. Kris and O. Kurz, *Legend, Myth and Magic in the Image of the Artist* (New Haven, CT: Yale University Press, 1979; orig. edn 1934); on the longevity of one such theme: K. Gross, *The Dream of the Moving Statue* (Ithaca, NY: Cornell University Press, 1992). An introduction to the conceptual vocabulary of ancient writing on art is J. J. Pollitt, *The Ancient View of Greek Art* (New Haven, CT: Yale University Press, 1974). Homer's description of the brooch is found in the *Odyssey* (XIX, lines 226–30); the shield of Achilles is described in the *Iliad* (XVIII, lines 468ff). A usefully annotated edition of Pliny is *The Elder Pliny's Chapters on the History of Art*, trans. K. Jex-Blake, ed. E. Sellers (Chicago: Argonaut, 1966; orig. edn of trans. 1896). Other important sources are: *The Greek Anthology*, trans. W. R. Paton (5 vols, Cambridge, MA: Harvard University Press, 1953, orig. edn of trans. 1916–18; esp. books IX and XVI. The passages cited here are: IX, 713, 793, and XVI, 81, 136, 239, 247); Philostratus, *Imagines*, trans. A. Fairbanks (Cambridge, MA: Harvard University Press, 1979; orig. edn of trans. 1931; the description of the hunting scene is I, 28). Lucian's description of the *Calumny* of Apelles is found in *Lucian*, trans. A. M. Harmon (8 vols, Cambridge, MA: Harvard University Press, 1979, orig. edn of trans. 1913, vol. 1, pp. 368–93). On descriptions of works of art: *Art and Text in Ancient Greek Culture*, ed. S. Goldhill and R. Osborne (New York: Cambridge University Press, 1995); M. Krieger, *Ekphrasis: The Illusion of the Natural Sign* (Baltimore, MD: The Johns Hopkins University Press, 1992); and J. Heffernan, *Museum of Words: The*

Poetics of Ekphrasis from Homer to Ashberry (Chicago: University of Chicago Press, 1993).

Translations of the works of Plato are available in many forms; passages of *The Republic* quoted here are from the translation by P. Shorey (2 vols, Cambridge, MA: Harvard University Press, 1982; orig. edn of trans. 1930). A recent introduction to his thought as a whole is *The Cambridge Companion to Plato*, ed. R. Kraut (New York: Cambridge University Press, 1992); a recent study of his thought on art in particular is C. Janaway, *Images of Excellence: Plato's Critique of the Arts* (Oxford: Oxford University Press, 1995). On Plato's understanding of contemporary art, see E. Keuls, *Plato and Greek Painting* (Leiden: Brill, 1978). Aristotle's works are also available in many forms; an introduction to his thought is *The Cambridge Companion to Aristotle*, ed. J. Barnes (New York: Cambridge University Press, 1995). The Loeb Classical Library edition of the *Poetics*, translated by W. H. Fyfe (Cambridge, MA: Harvard University Press, 1982; orig. edn of trans. 1927) has the advantage of including two other important texts in the same volume: Demetrius of Phalerum, *On Style*, and Pseudo-Longinus, *On the Sublime*; R. Janko's translation (*Poetics I . . .* , Indianapolis, IN: Hackett, 1987) includes a hypothetical reconstruction of the missing parts, as well as other Aristotelian fragments on ancient poetry. See also S. Halliwell, *Aristotle's Poetics* (London: Duckworth, 1986), and *Essays on Aristotle's Poetics*, ed. A. O. Rorty (Princeton, NJ: Princeton University Press, 1992). An introduction to ancient literary theory and criticism in general is *Classical Criticism*, vol. 1 of *The Cambridge History of Literary Criticism*, ed. G. A. Kennedy (New York: Cambridge University Press, 1989).

On the *Canon* of Polykleitos: A. Stewart, "The Canon of Polykleitos: A Question of Evidence," *Journal of Hellenic Studies*, 98 (1978), pp. 122–31; *Polykleitos, The Doryphoros, and Tradition*, ed. W. Moon (Madison, WI: University of Wisconsin Press, 1995). The passage from Galen is quoted in Pollitt, *The Ancient View of Greek Art* (cited above), pp. 14–15. A recent edition of Vitruvius, usefully annotated and illustrated, is *Ten Books on Architecture*, ed. and trans. I. Rowland and T. N. Howe (New York: Cambridge University Press, 1999; the passages quoted here, III, 1, are found on p. 47). For Plotinus, see *The Enneads*, trans. S. McKenna (New York: Pantheon, 1961; principal quotation here from p. 270); *The Cambridge Companion to Plotinus*, ed. L. P. Gerson (New York: Cambridge University Press, 1996).

An overview of the history of rhetoric is T. M. Conley, *Rhetoric in the European Tradition* (Chicago: University of Chicago Press, 1990); on ancient rhetoric, see G. A. Kennedy, *A New History of Classical Rhetoric* (Princeton, NJ: Princeton University Press, 1994), and for more detailed treatment, the same author's *The Art of Persuasion in Greece* (Princeton, NJ: Princeton University Press, 1963), and *The Art of Rhetoric in the Roman World* (Princeton, NJ: Princeton University Press, 1972). For Aristotle's *Rhetoric*, see Kennedy's translation (New York: Oxford University Press, 1991), as well as E. Garver, *Aristotle's Rhetoric: An Art of Character* (Chicago: University of Chicago Press, 1994). The most important of Cicero's theoretical texts are: *De Oratore*, trans. E. Sutton and H. Rackham (2 vols, Cambridge, MA: Harvard University Press, 1976; orig. edn of trans. 1942), *Brutus* and *Orator*, trans. G. L. Hendrickson

and H. M. Hubbell (Cambridge, MA: Harvard University Press, 1971; orig. edn of trans. 1939). See also Hermogenes, *On Types of Style*, trans. C. Wooten (Chapel Hill, NC: University of North Carolina Press, 1987), Quintilian, *Institutio oratoria*, trans. H. E. Butler (4 vols, Cambridge, MA: Harvard University Press, 1980; orig. edn of trans. 1920), and *Horace: Satires, Epistles, and Ars Poetica*, trans. H. R. Fairclough (Cambridge, MA: Harvard University Press, 1961; orig. edn 1926; principal quotation here lines 306–18). See also C. O. Brink, *Horace on Poetry* (3 vols, New York: Cambridge University Press, 1963–71; the principal quotation here lines 306–16).

On medieval thought about art in general: U. Eco, *Art and Beauty in the Middle Ages*, trans. H. Bredin (New Haven, CT: Yale University Press, 1986) and *The Aesthetics of Thomas Aquinas*, trans. H. Bredin (Cambridge, MA: Harvard University Press, 1988; orig. edn 1956). Some interesting texts are also presented in *Early Medieval Art: Sources and Documents*, ed. C. Davis-Weyer (Englewood Cliffs, NJ: Prentice-Hall, 1971 and subsequent reprints). On icons: J. Pelikan, *Imago Dei: The Byzantine Apologia for Icons* (Princeton, NJ: Princeton University Press, 1990); M. Barasch, *Icon: Studies in the History of an Idea* (New York: New York University Press, 1992); and especially H. Belting, *Likeness and Presence: A History of the Image before the Era of Art*, trans. E. Jephcott (Chicago: University of Chicago Press, 1994). On later iconoclasm and the persistence of irrational attitudes toward images: D. Freedberg, *Iconoclasm and Painting in the Revolt of the Netherlands* (New York: Garland, 1988) and *The Power of Images* (Chicago: University of Chicago Press, 1989).

On conceptual "arts": F. Yates, *The Art of Memory* (Chicago: University of Chicago Press, 1966); M. Carruthers, *The Craft of Thought: Meditation, Rhetoric, and the Making of Images, 400–1200* (New York: Cambridge University Press, 1998). On Llull: M. D. Johnston, *The Evangelical Rhetoric of Ramon Llull: Lay Learning and Piety in the Christian West around 1300* (New York: Oxford University Press, 1996). On symbolism in early medieval religious art: G. Ladner, *God, the Cosmos, and Humankind: The World of Early Christian Symbolism* (Berkeley, CA: University of California Press, 1995). On theories of sign and symbol: Augustine, *On Christian Doctrine*, trans. D. W. Robertson (Indianapolis, IN: Bobbs-Merrill, 1958); *Pseudo-Dionysius: The Complete Works*, ed. C. Luibheid and P. Rorem (New York: Paulist, 1987); St Thomas Aquinas, *Summa Theologiae*, ed. T. Mcdermott (London: Blackfriars, 1964, vol. 1; I, quest. 1, articles 9–10); M. Colish, *The Mirror of Language: A Study of the Medieval Theory of Knowledge* (Lincoln: University Nebraska, 1989); E. Vance, *Mervelous Signals: Poetics and Sign Theory in the Middle Ages* (Lincoln: University of Nebraska Press, 1986). On Dante: P. Boyde, *Dante, Philomythes and Philosopher: Man in the Cosmos* (New York: Cambridge University Press, 1981); G. Mazzotta, *Dante's Vision and the Circle of Knowledge* (Princeton, NJ: Princeton University Press, 1993). On Abbot Suger: E. Panofsky, *Abbot Suger on the Abbey Church of St Denis and its Art Treasures* (Princeton, NJ: Princeton University Press, 1979; orig. edn 1948; the principal quotations here are from pp. 46–8, 62–5); P. Kidson, "Panofsky, Suger, and St Denis," *Journal of the Warburg and Courtauld Institutes*, 51 (1987), pp. 1–17. A medieval treatise on artistic technique is Theophilus Presbyter, *The Various Arts*, ed. and trans. C. R. Dodwell (London: T. Nelson, 1961). The

inscription on Giovanni Pisano's Pisa pulpit is transcribed in J. Pope-Hennessy, *Italian Gothic Sculpture* (London: Phaidon, 1996, pp. 235–6).

Chapter 2 The Early Modern Period

Cennino Cennini, *Il Libro dell'arte*, trans. D. V. Thompson (New Haven, CT: Yale University Press, 1933 and subsequent reprints; principal quotations here from pp. 1–2). L. B. Alberti, *On Painting and On Sculpture*, ed. and trans. C. Grayson (London: Phaidon, 1972; principal quotation here from pp. 60–2) and *The Art of Building in Ten Books*, trans. J. Rykwert et al. (Cambridge, MA: MIT Press, 1988); A. Grafton, *Leon Battista Alberti: Master Builder of the Italian Renaissance* (New York: Hill and Wang, 2000). A good selection of Leonardo's writings is *Leonardo on Painting*, trans. M. Kemp and M. Walker (New Haven, CT: Yale University Press, 1989; principal quotations here from pp. 13, 41–2); a rich scholarly study of Leonardo's theory is C. Farago, *Leonardo da Vinci's "Paragone": A Critical Interpretation with a New Edition of the Text in the Codex Urbinas* (Leiden: Brill, 1992). See also the essays on Leonardo in E. H. Gombrich, *The Heritage of Apelles: Studies in the Art of the Renaissance* (Ithaca, NY: Cornell University Press, 1976). On perspective: M. Kemp, *The Science of Art: Optical Themes in Western Art from Brunelleschi to Seurat* (New Haven, CT: Yale University Press, 1990); H. Damisch, *The Origin of Perspective*, trans. J. Goodman (Cambridge, MA: MIT Press, 1994); and J. Elkins, *The Poetics of Perspective* (Ithaca, NY: Cornell University Press, 1994).

On the intellectual-historical background: E. Cassirer, *The Individual and the Cosmos in Renaissance Philosophy*, trans. M. Domandi (New York: Barnes and Noble, 1963; orig. edn 1927); B. Copenhaver and C. Schmitt, *Renaissance Philosophy* (New York: Oxford University Press, 1992); *The Cambridge Companion to Renaissance Humanism*, ed. J. Kraye (New York: Cambridge University Press, 1996). On the position of the artist in society: F. Ames-Lewis, *The Intellectual Life of the Early Renaissance Artist* (New Haven, CT: Yale University Press, 2000); E. Barker et al., *The Changing Status of the Artist* (New Haven, CT: Yale University Press, 1999). Two outstanding studies which testify, each in different ways, to the depth and intensity of intellectual concerns in Italian Renaissance art are: J. Shearman, *Only Connect . . . : Art and the Spectator in the Italian Renaissance* (Princeton, NJ: Princeton University Press, 1992), and C. Dempsey, *The Portrayal of Love: Botticelli's "Primavera" and Humanist Culture at the Time of Lorenzo the Magnificent* (Princeton, NJ: Princeton University Press, 1992). See also *The Poetry of Michelangelo*, trans. and ed. J. Saslow (New Haven, CT: Yale University Press, 1991; quotations here from pp. 133, 239). For a study of the leading German artist and theorist of the Renaissance, see E. Panofsky, *The Life and Art of Albrecht Dürer* (Princeton, NJ: Princeton University Press, 1955; orig. edn 1943).

Vasari's *Lives* is available in numerous translations; the most complete is *The Lives of the Most Eminent Painters, Sculptors, and Architects*, trans. G. de Vere (3 vols, New York: Abrams, 1979; orig. edn of trans. 1912–15; quotations here

from pp. 299, 911), but even it omits Vasari's theoretical introduction, translated as *Vasari on Technique*, trans. L. Maclehouse (New York: Dover, 1960; orig. edn of trans. 1907). Another important text is presented in M. Roskill, *Dolce's "Aretino" and Renaissance Art Theory* (New York: New York University Press, 1968), and yet another in G. B. Armenini, *On the True Precepts of the Art of Painting*, trans. B. J. Olszewski (New York: B. Franklin, 1977), but Lomazzo and Zuccaro have never been fully translated: the most recent Italian editions are: G. P. Lomazzo, *Scritti sull'arte*, ed. R. P. Ciardi (2 vols, Florence: Marchi and Bertolli, 1973–4), and F. Zuccaro, *Scritti d'arte di Federico Zuccaro*, ed. D. Heikamp (Florence: Olschki, 1961). Other interesting texts are presented in *Italian Art, 1400–1500: Sources and Documents*, ed. C. Gilbert (Englewood Cliffs, NJ: Prentice-Hall, 1980) and *Italian Art, 1500–1600: Sources and Documents*, ed. R. Klein and H. Zerner (Englewood Cliffs, NJ: Prentice-Hall, 1966).

Important studies of Renaissance art theory include: E. Panofsky, *Idea: A Concept in Art Theory*, trans. J. S. Peake (New York: Harper and Row, 1968; orig. edn 1924); A. Blunt, *Artistic Theory in Italy, 1450–1600* (Oxford: Clarendon Press, 1963; orig. edn 1940); R. Lee, *Ut Pictura Poesis: The Humanistic Theory of Painting* (New York: Norton, 1967; orig. edn 1940); R. Klein, *Form and Meaning: Essays in the Renaissance and Modern Art*, trans. M. Jay and L. Wieseltier (New York: Viking, 1979); E. H. Gombrich, *"Icones Symbolicae*: Philosophies of Symbolism and their Bearing on Art," *Symbolic Images: Studies in the Art of the Renaissance* (London: Phaidon, 1972); M. Baxandall, *Giotto and the Orators: Humanist Observers of Painting in Italy and the Discovery of Pictorial Composition* (Oxford: Clarendon Press, 1971); D. Summers, *Michelangelo and the Language of Art* (Princeton, NJ: Princeton University Press, 1981) and *The Judgment of Sense: Renaissance Naturalism and the Rise of Aesthetics* (New York: Cambridge University Press, 1987); R. Williams, *Art, Theory, and Culture in Sixteenth-century Italy: From Techne to Metatechne* (New York: Cambridge University Press, 1997); and P. Sohm, *Style in the Art Theory of Early Modern Italy* (New York: Cambridge University Press, 2001).

Studies which emphasize the seventeenth century are: E. Cropper, *The Ideal of Painting: Pietro Testa's Düsseldorf Notebook* (Princeton, NJ: Princeton University Press, 1984); P. Sohm, *Pittoresco: Marco Boschini, his Critics, and their Critiques of Painterly Brushwork in Seventeenth- and Eighteenth-century Italy* (New York: Cambridge University Press, 1991); and T. Puttfarken, *The Discovery of Pictorial Composition: Theories of Visual Order in Painting, 1400–1800* (New Haven, CT: Yale University Press, 2000).

On architecture: R. Wittkower, *Architectural Principles in the Age of Humanism* (New York: Norton, 1971; orig. edn 1949); C. Smith, *Architecture in the Culture of Early Humanism: Ethics, Aesthetics, and Eloquence, 1400–1470* (New York: Oxford University Press, 1992); A. Payne, *The Architectural Treatise in the Italian Renaissance: Architectural Invention, Ornament, and Literary Culture* (New York: Cambridge University Press, 1999).

On academies in general, see: N. Pevsner, *Academies of Art Past and Present* (Cambridge: Cambridge University, 1940); C. Goldstein, *Teaching Art: Academies and Schools from Vasari to Albers* (New York: Cambridge University Press, 1996). On the Florentine Academy: K. Barzmann, *The Accademia del Disegno and the Florentine State: The Discipline of "Disegno"* (New York: Cambridge University

Press, 2000). On the Carracci academy and its influence: C. Dempsey, *Annibale Carracci and the Beginnings of Baroque Style* (Glückstadt: Augustin, 1977). Only isolated sections of Bellori's *Lives* have appeared in English translation: a usefully annotated Italian edition is *Le Vite de' pittori, scultori e architetti moderni*, ed. E. Borea (Turin: Einaudi, 1976). Excerpts of a variety of texts, offering an indication of the richness of the literature of this period, are presented in *Italy and Spain, 1600–1750: Sources and Documents*, ed. R. Enggass and J. Brown (Englewood Cliffs, NJ: Prentice-Hall, 1979).

Van Mander's biographies of the Northern European artists have been translated into English as *The Lives of the Illustrious Netherlandish and German Painters*, trans. and ed. H. Miedema (6 vols, Dornspijk: Davaco, 1994–9), but the remarkable didactic poem that precedes them has not, though it is available in an excellent modern scholarly edition in Dutch: *Den Grondt der Edel Vry Schilderkonst*, ed. H. Miedema (Utrecht: Dekker and Gumbert, 1973). A study of another seventeenth-century Dutch theorist is C. Brusati, *Artifice and Illusion: The Art and Writing of Samuel van Hoogstraten* (Chicago: University of Chicago Press, 1995). The leading German theorist of the seventeenth century was the academician Joachim von Sandrart, whose *Academia Todesca . . . oder Teutsche Akademie* (Nürnberg, 1675–9) has also not been translated into English, but is available in a modern German edition, *Academie der Bau-, Bild-, und Mahlerey-Künste von 1675*, ed. A. R. Peltzer (Munich: Hirth, 1925; reprinted Westmead: Gregg, 1971). A recent sampling of Spanish texts is *Artists' Techniques in Golden Age Spain: Six Treatises in Translation*, trans. Z. Veliz (New York: Cambridge University Press, 1986).

An introduction to French academic theory is P. Duro, *The Academy and the Limits of Painting in Seventeenth-century France* (New York: Cambridge University Press, 1997). On the social pressures underlying the circumstances of one of its debates: S. McTighe, "Abraham Bosse and the Language of Artisans: Genre and Perspective in the Académie Royale de Peinture et de Sculpture, 1648–1670," *Oxford Art Journal*, 21 (1998), pp. 1–26. On the continuity of academic values into the nineteenth century: *The French Academy: Classicism and its Antagonists*, ed. J. Hargrove (Newark, DE: University of Delaware Press, 1990). LeBrun's lecture on the passions is explicated in J. Montagu, *The Expression of the Passions: The Origin and Influence of Charles LeBrun's "Conférence sur l'expression generale et particuliere"* (New Haven, CT: Yale University Press, 1994). See also J. Lichtenstein, *The Eloquence of Color: Rhetoric and Painting in the French Classical Age*, trans. E. McVarish (Berkeley, CA: University of California Press, 1993).

Félibien's collection of lectures, *Conférences* (Paris, 1669) were translated into English in the eighteenth century (Anon., *Seven Conferences Held in the King of France's Cabinet of Paintings*, London, 1740), but this translation was never reprinted and is therefore rare. Another important text, Roland Fréart de Chambray, *Idée de la perfection de la peinture* (Mans, 1662) was translated by John Evelyn as *An Idea of the Perfection of Painting* (London, 1668) and is also rare. Charles DuFresnoy's didactic poem, *De Arte graphica* (Paris, 1667) was translated into English by John Dryden (*The Art of Painting*, London, 1695), was reprinted many times and is available in facsimile. R. de Piles, *Cours de peinture* (Paris, 1708) was translated as *The Principles of Painting* (London, 1743). Excerpts of all these texts, along with others of related interest, are found in *Art in*

Theory, 1648–1815, ed. C. Harrison, P. Wood, and J. Gaiger (Oxford: Blackwell, 2000). An excellent study devoted to one leading theorist is T. Puttfarken, *Roger de Piles' Theory of Art* (New Haven, CT: Yale University Press, 1985).

An important stimulus to the formation of the British Royal Academy were the writings of Jonathan Richardson: *An Essay on the Theory of Painting* (London, 1715) and *The Connoisseur: An Essay on the Whole Art of Criticism as it Relates to Painting* (London, 1719) are available in a recent facsimile edition (Menston: Scholar Press, 1971). On Richardson, see C. Gibson-Wood, *Jonathan Richardson: Art Theorist of the English Enlightenment* (New Haven, CT: Yale University Press, 2000). Reynolds's *Discourses* are available in a usefully annotated edition by P. Rogers (London: Penguin, 1992; the principal quotations here are from pp. 112, 138, 261, 330). An important study that situates late eighteenth-century British art theory in a sociopolitical context, and shows how it significantly inflects elements of earlier thought, is J. Barrell, *The Political Theory of Painting from Reynolds to Hazlitt: "The Body of the Public"* (New Haven, CT: Yale University Press, 1986).

Chapter 3 The Enlightenment

Attempts to describe the Enlightenment transformation of thought about art vary in approach and emphasis: P. O. Kristeller, "The Modern System of the Arts," *Renaissance Thought II: Papers on Humanism and the Arts* (New York: Harper and Row, 1963, pp. 163–227) is pure intellectual history, while L. Lipking, *The Ordering of the Arts in Eighteenth-century England* (Princeton, NJ: Princeton University Press, 1970) gives greater attention to social context. T. Eagleton, *The Ideology of the Aesthetic* (Oxford: Blackwell, 1990) presents the very idea of the aesthetic, as it emerges in the eighteenth century and develops in the course of the nineteenth and twentieth centuries, as a symptom of modern sociopolitical conditions. For a range of more recent approaches, see *Eighteenth-century Aesthetics and the Reconstitution of Art*, ed. P. Mattick (New York: Cambridge University Press, 1993).

For French art theory: *Diderot on Art*, trans. J. Goodman (2 vols, New Haven, CT: Yale University Press, 1995; quotation here from vol. 1, p. 227); F. Coleman, *Aesthetic Thought of the French Enlightenment* (Pittsburgh, PA: University of Pittsburgh Press, 1971); M. Fried, *Absorption and Theatricality: Painting and Beholder in the Age of Diderot* (Berkeley, CA: University of California Press, 1980); M. Hobson, *The Object of Art: The Theory of Illusion in Eighteenth-century France* (New York: Cambridge University Press, 1982); R. Wrigley, *The Origins of French Art Criticism: From the Ancien Régime to the Restoration* (New York: Oxford University Press, 1993). T. Crow, *Painters and Public Life in Eighteenth-century Paris* (New Haven, CT: Yale University Press, 1985) is not specifically concerned with theory, but does feature sensitive historical readings of critical texts. Very different in orientation, though equally subtle in its use of texts, is M. Baxandall, *Shadows and Enlightenment* (New Haven, CT: Yale University Press, 1995). On architecture: A. Vidler, *The Writing of the Walls: Architectural Theory in the Late Enlightenment* (Princeton, NJ: Princeton University Press, 1987).

See G. E. Lessing, *Laocoon: An Essay on the Limits of Painting and Poetry*, trans. F. A. McCormick (Indianapolis, IN: Bobbs-Merrill, 1962; quotation here from p. 78). Winckelmann's *History of Ancient Art* has been translated in its entirety (2 vols, New York: Ungar, 1969); selections, along with excerpts from his other writings, can be found in *Winckelmann: Writings on Art*, ed. D. Irwin (London: Phaidon, 1972). See also A. Potts, *Flesh and the Ideal: Winckelmann and the Origins of Art History* (New Haven, CT: Yale University Press, 1994) and W. Davis, "Winckelmann Divided," *Replications: Archaeology, Art History, Psychoanalysis* (University Park: Penn State, 1996, pp. 257–65). On eighteenth-century historicism in general: I. Berlin, *Vico and Herder: Two Studies in the History of Ideas* (London: Hogarth, 1976); more recently, J. H. Zammito, *Kant, Herder, and the Birth of Anthropology* (Chicago: University of Chicago Press, 2002).

For British art theory: E. Burke, *A Philosophical Enquiry into the Origin of our Ideas of the Sublime and Beautiful*, ed. J. T. Boulton (New York: Columbia University Press, 1968); S. Monk, *The Sublime: A Study of Critical Theories in Eighteenth-century England* (New York: MLA, 1935); W. J. Hipple, *The Beautiful, the Sublime, and the Picturesque in Eighteenth-century British Aesthetic Theory* (Carbondale, IL: Southern Illinois University Press, 1957); *The Sublime: A Reader in British Eighteenth-century Aesthetic Theory*, ed. A. Ashfield and P. de Bolla (New York: Cambridge University Press, 1996); F. Ferguson, *Solitude and the Sublime: Romanticism and the Aesthetics of Individuation* (New York: Routledge, 1992).

Baumgarten's *Aesthetica* (1750–8; repr. Hildesheim: Olms, 1961) has never been translated into English; a modern selection of excerpts in German, along with other writings, is *Texte zur Grundlegung der Aesthetik*, ed. H. Schweitzer (Hamburg: F. Meiner, 1983). For his *Reflections on Poetry*, see the translation by K. Aschenbrenner and W. B. Holther (Berkeley, CA: University of California Press, 1954).

An old but excellent introduction to Kant is E. Cassirer, *Kant's Life and Thought*, trans. J. Haden (New Haven, CT: Yale University Press, 1981; orig. edn 1918); see also *The Cambridge Companion to Kant*, ed. P. Guyer (New York: Cambridge University Press, 1992); and P. Keller, *Kant and the Demands of Self-consciousness* (New York: Cambridge University Press, 1998). The statement of philosophical aims quoted here is found in his *The Conflict of the Faculties*, trans. M. J. Gregor (Lincoln, NE: University of Nebraska Press, 1979), pp. 127–9. The standard translation of the *Critique of Judgment* is by J. C. Meredith (Oxford: Oxford University Press, 1928 and subsequent reprints; the principal quotation here, on the sublime, from p. 111); there is also a new translation, *Critique of the Power of Judgment*, ed. P. Guyer, trans. P. Guyer and E. Matthews (New York: Cambridge University Press, 2000). Studies of his aesthetic thought include: H. Caygill, *The Art of Judgement* (Oxford: Blackwell, 1989); P. Crowther, *The Kantian Sublime: From Morality to Art* (New York: Oxford University Press, 1989); and J-F. Lyotard, *Lessons on the Analytic of the Sublime*, trans. E. Rottenberg (Stanford: Stanford University Press, 1994). On his subsequent influence: M. Podro, *The Manifold in Perception: Theories of Art from Kant to Hildebrand* (Oxford: Clarendon Press, 1972); A. Bowie, *The Aesthetics and Subjectivity: From Kant to Nietzsche* (New York: University of Manchester Press, 1990); J. M. Bernstein, *The Fate of Art: Aesthetic Alienation from Kant to Derrida and Adorno*

(Cambridge: Polity Press, 1992); J-M. Schaeffer, *Art of the Modern Age: Philosophy of Art from Kant to Heidegger*, trans. S. Rendall (Princeton, NJ: Princeton University Press, 2000); and M. Cheetham, *Kant, Art, and Art History: Moments of Discipline* (New York: Cambridge University Press, 2001).

A useful anthology of excerpts from important German texts is *The Origins of Modern Critical Thought: German Aesthetic and Literary Criticism from Lessing to Hegel*, ed. D. Simpson (Cambridge: Cambridge University Press, 1989). Since the post-Kantians are difficult to approach directly through their own work, one does well to avail oneself of recent studies such as T. Pinkard, *German Philosophy, 1760–1860: The Legacy of Idealism* (New York: Cambridge University Press, 2002); *The Age of German Idealism*, ed. R. Solomon and K. Higgins, vol. 6 of the *Routledge History of Philosophy* (New York: Routledge, 1996); *The Cambridge Companion to German Idealism*, ed. A. Ameriks (New York: Cambridge University Press, 2000); and *The Reception of Kant's Critical Philosophy: Fichte, Schelling, and Hegel*, ed. S. Sedgwick (New York: Cambridge University Press, 2000). On the relation between philosophy and literature, see P. Lacoue-Labarthe and J-L. Nancy, *The Literary Absolute: The Theory of Literature in German Romanticism*, trans. P. Bernard and C. Lester (Albany, NY: State University of New York Press, 1988); and especially E. Behler, *German Romantic Literary Theory* (Cambridge: Cambridge University Press, 1993). An older but still useful introduction to the Jena School is R. Wellek, *The Romantic Age: A History of Modern Literary Criticism: 1750–1950*, vol. 2 (New Haven, CT: Yale University Press, 1968; orig. edn 1955); see also *Romanticism*, ed. M. Brown, vol. 5 of *The Cambridge History of Literary Criticism* (New York: Cambridge University Press, 2000).

For Schiller, see F. Schiller, *On the Aesthetic Education of Man in a Series of Letters*, trans. E. Wilkinson and L. Willoughby (Oxford: Clarendon Press, 1967; principal quotations here from pp. 94–5, 104–7); *Naive and Sentimental Poetry and On the Sublime*, trans. J. A. Elias (New York: Ungar, 1966; orig. edn 1795–6); R. D. Miller, *Schiller and the Ideal of Freedom* (Oxford: Clarendon Press, 1970); N. Martin, *Nietzsche and Schiller: Untimely Aesthetics* (Oxford: Clarendon Press, 1996). For Schelling, see F. W. J. Schelling, *System of Transcendental Idealism*, trans. P. Heath (Charlottesville: University of Virginia Press, 1978); *The Philosophy of Art*, trans. D. W. Stott (Minneapolis, MN: University of Minnesota Press, 1989). The case for the forward-looking, proto-postmodern quality of Schelling's thought is made in lively fashion by S. Žižek, *The Abyss of Freedom* (Ann Arbor: University of Michigan Press, 1997).

An old but excellent introduction to Hegel is J. N. Findlay, *Hegel: A Re-examination* (London: Allen and Unwin, 1958), which is especially useful when read side by side with Hegel's major works; a more recent introduction to the *Phenomenology of Spirit* is T. Pinkard, *Hegel's Phenomenology: The Sociality of Reason* (New York: Cambridge University Press, 1994). English readers have their choice of translations: *The Phenomenology of Mind*, trans. J. B. Baillie (New York: Harper and Row, 1967; orig. edn of trans. 1910) and *The Phenomenology of Spirit*, trans. A. V. Miller (Oxford: Oxford University Press, 1977); in the case of the lectures on art, the older *Philosophy of Fine Art*, trans. F. P. B. Osmaston (New York: Hacker, 1975; orig. edn of trans. 1920) and the newer *Aesthetics:*

Lectures on Fine Art, trans. T. M. Knox (2 vols, Oxford: Clarendon Press, 1975). An introduction to his thought on art is W. Desmond, *Art and the Absolute: A Study of Hegel's Aesthetics* (Albany, NY: State University of New York Press, 1986); see also *Hegel and Aesthetics*, ed. W. Maker (Albany, NY: State University of New York Press, 2000). For his influence on twentieth-century thought, see V. Descombes, *Modern French Philosophy*, trans. L. Scott-Fox and J. M. Harding (Cambridge: Cambridge University Press, 1980); and especially J. Butler, *Subjects of Desire: Hegelian Reflections in Twentieth-century France* (New York: Columbia University Press, 1987).

A. Schopenhauer, *The World as Will and Representation*, trans. E. Payne (2 vols, New York: Dover, 1969); *Parerga and Paralipomena*, trans. E. Payne (2 vols, Oxford: Clarendon Press, 1974); *The Cambridge Companion to Schopenhauer*, ed. C. Janaway (New York: Cambridge University Press, 1999). Friedrich's *Bekenntnisse*, ed. K. Eberlein (Leipzig: Klinkhardt and Bierman, 1924) has never been translated into English; a selection is found in *Neoclassicism and Romanticism, 1750–1850: Sources and Documents*, ed. L. Eitner (2 vols, Englewood Cliffs, NJ: Prentice-Hall, 1970, vol. 2, pp. 53–6). On Friedrich, see also J. L. Koerner, *Caspar David Friedrich and the Subject of Landscape* (New Haven, CT: Yale University Press, 1990). On music: *Music and Aesthetics in the Eighteenth and Early Nineteenth Centuries*, ed. P. Le Huray and J. Day (Cambridge: Cambridge University Press, 1981); C. Dahlhaus, *The Idea of Absolute Music*, trans. R. Lustig (Chicago: University of Chicago Press, 1989); *German Essays on Music*, ed. J. Hermand and M. Gilbert (New York: Continuum, 1994); *Music Theory in the Age of Romanticism*, ed. I. Bent (New York: Cambridge University Press, 1996); and T. W. Adorno, *Beethoven: The Philosophy of Music*, ed. R. Teidemann, trans. E. Jephcott (Stanford: Stanford University Press, 1998).

Chapter 4 The Nineteenth Century

The definition of artistic modernism presented here, along with the account of nineteenth-century art that follows, reflect a shift of orientation in art-historical scholarship over the past generation – itself a response to the redefinition of modernism in general that occurred with postmodernism – largely guided by the work of T. J. Clark: *The Image of the People: Gustave Courbet and the 1848 Revolution* (Greenwich, CT: New York Graphic Society, 1973); *The Absolute Bourgeois: Artists and Politics in France, 1848–51* (Greenwich, CT: New York Graphic Society, 1973); *The Painting of Modern Life: Paris in the Art of Manet and his Followers* (Princeton, NJ: Princeton University Press, 1986); and *Farewell to an Idea: Episodes from a History of Modernism* (New Haven, CT: Yale University Press, 1999). Clark's influence is evident in much of the scholarship on modern art produced in the 1980s and 1990s. See, for instance, *Modern Art and Modernism: A Critical Anthology*, ed. F. Frascina and C. Harrison (New York: Harper and Row, 1982); and *Art in Modern Culture: An Anthology of Critical Texts*, ed. F. Frascina and J. Harris (New York: Harper Collins, 1992). See also J. Drucker, *Theorizing Modernism: Visual Arts and the Critical Tradition* (New York: Columbia University Press, 1994).

The best anthology of nineteenth-century theory and criticism is *Art in Theory, 1815–1900*, ed. C. Harrison, P. Wood, and J. Gaiger (Oxford: Blackwell, 1998); others include *Ninteenth Century Theories of Art*, ed. J. Taylor (Berkeley, CA: University of California Press, 1987); *Neoclassicism and Romanticism, 1750–1850: Sources and Documents*, ed. L. Eitner (2 vols, Englewood Cliffs, NJ: Prentice-Hall, 1970); *Realism and Tradition in Art, 1848–1900: Sources and Documents*, ed. L. Nochlin (Englewood Cliffs, NJ: Prentice-Hall, 1966); *Impressionism and Post-Impressionism, 1874–1904: Sources and Documents*, ed. L. Nochlin (Englewood Cliffs, NJ: Prentice-Hall, 1966); *The Impressionists: A Retrospective*, ed. M. Kapos (New York: Macmillan, 1992); *The Post-Impressionists: A Retrospective*, ed. M. Kapos (New York: Macmillan, 1993). Two studies which shed light on the institutional context are A. Boime, *The Academy and French Painting in the Nineteenth Century* (New Haven, CT: Yale University Press, 1986); and *Art Criticism and its Institutions in Nineteenth-century France*, ed. M. Orwicz (New York: Manchester University Press, 1994).

The principal passage from Courbet here is found in *Realism and Tradition in Art, 1848–1900* (cited above), p. 35. For Baudelaire, see *Baudelaire: The Complete Verse*, ed. and trans. F. Scarfe (London: Anvil, 1986; passage here is from p. 250). Baudelaire's writings on art are available in English as *The Painter of Modern Life and Other Essays*, trans. J. Mayne (London: Phaidon, 1964; principal quotations here are from pp. 3, 9, 32–3) and *Art in Paris, 1845–1862*, trans. J. Mayne (London: Phaidon, 1965; quotation here, on painters failing to respond to the heroism of modern life, from pp. 31–2). An essential study of Baudelaire is W. Benjamin, *Charles Baudelaire: Lyric Poet in the Era of High Capitalism*, trans. H. Zohn (New York: Verso, 1973). Interesting in its own right is *The Journal of Eugène Delacroix*, trans. W. Pach (New York: Grove, 1961). A valuable contrast to Clark's book on Manet, cited above, is M. Fried, *Manet's Modernism, or, the Face of Painting in the 1860s* (Chicago: University of Chicago Press, 1996). The most complete translation of Zola's essay on Manet is found in *Portrait of Manet by Himself and his Contemporaries*, ed. P. Courthion and P. Cailler, trans. M. Ross (London: Cassell, 1960; principal quotation here from p. 122); his other writings on art are available in English only in excerpts; a French edition is *Salons*, ed. F. Hemmings and R. Niess (Geneva: Droz, 1959).

The account of Impressionism presented here is deeply dependent on the remarkable book by R. Shiff, *Cézanne and the End of Impressionism* (Chicago: University of Chicago Press, 1984). See also E. Deschanel, *Physiologie des ecrivains et des artistes* (Paris: Hachette, 1864); H. Taine, *On Intelligence*, trans. T. D. Haye (2 vols, New York: Holt and Williams, 1889). Monet's remarks are found in *Impressionism and Post-Impressionism, 1874–1904* (cited above), pp. 35, 44; the quotation from Duret is from pp. 29–30. Zola's remarks on Pissarro are found in *The Impressionists: A Retrospective* (cited above), pp. 59–61; the quotation from Duranty, p. 98. *Paul Cézanne: Letters*, ed. J. Rewald, trans. S. Hacker (New York: Hacker, 1984; quotation here from p. 322). See also M. E. Chevreul, *The Principles of Harmony and Contrasts of Colors*, ed. F. Birren (New York: Reinhold, 1967); O. Rood, *Modern Chromatics*, ed. F. Birren (New York: Van Nostrand Reinhold, 1973); C. Blanc, *Grammaire des arts du dessin* (Paris: Laurens, 1903). On Impressionist color theory: G. Roque, "Chevreul and Impressionism:

A Reappraisal," *Art Bulletin*, 78 (1996), pp. 26–39; F. Ratliff, *Paul Signac and Color in Neo-Impressionism* (New York: Rockefeller University Press, 1992); and P. Smith, *Seurat and the Avant-garde* (New Haven, CT: Yale University Press, 1997). For an introduction to the work of Henry, see J. A. Argüelles, *Charles Henry and the Formation of a Psychophysical Aesthetic* (Chicago: University of Chicago Press, 1972).

Two fascinating studies that offer a larger cultural-historical perspective on the preoccupation with visuality in late nineteenth- and early twentieth-century art are: J. Crary, *Techniques of the Observer: On Vision and Modernity in the Late Nineteenth Century* (Cambridge, MA: MIT Press, 1990); and *Suspensions of Perception: Attention, Spectacle, and Modern Culture* (Cambridge, MA: MIT Press, 1999). See also M. Jay, *Downcast Eyes: The Denigration of Vision in Twentieth-century French Thought* (Berkeley, CA: University of California Press, 1993); and *Sites of Vision: The Discursive Construction of Sight in the History of Philosophy*, ed. D. M. Levin (Cambridge, MA: MIT Press, 1997).

An old but excellent introduction to Symbolism is A. G. Lehmann, *The Symbolist Aesthetic in France, 1885–1895* (Oxford: Blackwell, 1968; orig. edn 1950). See also M. Raymond, *From Baudelaire to Surrealism* (London: Methuen, 1970; orig. edn 1933); and R. Shattuck, *The Banquet Years: The Origins of the Avant-garde in France, 1885 to World War I* (New York: Vintage, 1968). An influential study that reveals the importance of Symbolism for twentieth-century thought about language is J. Kristeva, *Revolution in Poetic Language*, trans. M. Waller (New York, 1984; orig. edn 1974). Kahn's remarks on Symbolism are found in *The Post-Impressionists: A Retrospective* (cited above), pp. 151–3. Baudelaire's "Correspondences" is found in *Baudelaire: The Complete Verse* (cited above), p. 61; the passage from Rimbaud is found in *Rimbaud: Complete Works, Selected Letters*, trans. and ed. W. Fowlie (Chicago: University of Chicago Press, 1966, pp. 306–7).

On Mallarmé in particular: R. Lloyd, *Mallarmé: The Poet and his Circle* (Ithaca, NY: Cornell University Press, 1999); *Mallarmé in the Twentieth Century*, ed. R. G. Cohn (Madison: Associated University Press, 1998); and *Meetings with Mallarmé in Contemporary French Culture*, ed. M. Temple (Exeter: University of Exeter Press, 1998). Two studies which explore the poet's relation to the visual arts are J. Kearns, *Symbolist Landscapes: The Place of Painting in the Poetry and Criticism of Mallarmé and his Circle* (London: Modern Humanities Research Association, 1989); and P. Florence, *Mallarmé, Manet, and Redon: Visual and Aural Signs and the Generation of Meaning* (New York: Cambridge University Press, 1986).

For Wagner's ideas, see *Richard Wagner's Prose Works*, trans. W. A. Ellis (8 vols, New York: Broude, 1966; orig. edn of trans. 1892), esp. vol. 1, containing the essays "Art and Revolution" and "The Art-Work of the Future" (orig. edns 1849), and vol. 6, containing the essay "Religion and Art" (orig. edn 1880).

F. Nietzsche, *The Birth of Tragedy*, ed. and trans. D. Smith (New York: Oxford University Press, 2000). On Nietzsche and art: M. Heidegger, *Nietzsche: The Will to Power as Art*, trans. D. F. Krell (San Francisco: Harper and Row, 1979; orig. edn 1961); A. Nehamas, *Nietzsche: Life as Literature* (Cambridge, MA:

Harvard University Press, 1985); J. Young, *Nietzsche's Philosophy of Art* (New York: Cambridge University Press, 1992); *Nietzsche: Philosophy and the Arts*, ed. S. Kemal et al. (New York: Cambridge University Press, 1997); *Nietzsche and "An Architecture of our Minds,"* ed. A. Kostka and I. Wolfarth (Los Angeles: Getty Research Institute, 1999).

Symbolist Art Theories: A Critical Anthology, ed. H. Dorra (Berkeley, CA: University of California Press, 1994); H. Rookmaaker, *Synthetist Art Theories: Genesis and Nature of the Ideas on Art of Gauguin and his Circle* (Amsterdam: Swets and Zeitlinger, 1959). A sampling of Gauguin's letters and notes is available in English in *Gauguin by Himself*, ed. B. Thompson (Boston: Little, Brown, 1993; principal quotation here from p. 33); see also his *Intimate Journals*, trans. V. W. Brooks (New York: Crown, 1936); and *Noa-Noa*, trans. S. Whiteside (London: Thames and Hudson, 1996; orig. edn 1897). An abridged translation of Aurier's essay is found in *The Post-Impressionists: A Retrospective* (cited above), pp. 175–80. The idea that Gauguin may have been influenced by Charcot and Bernheim is suggested by D. Silverman, *Art Nouveau in Fin-de-siècle France: Politics, Psychology, and Style* (Berkeley, CA: University of California Press, 1989). See also the same author's *Van Gogh and Gauguin: The Search for the Sacred* (New York: Farrar, Straus, and Giroux, 2000). *The Letters of Vincent van Gogh*, ed. J. van Gogh-Bonger, trans. C. de Dood (3 vols, Boston: Little, Brown, 2000; orig. edn of trans. 1958); W. Kandinsky, *The Complete Writings on Art*, ed. K. Lindsay and P. Vergo (Boston: G. K. Hall, 1982); *Matisse on Art*, ed. J. Flam (Berkeley, CA: University of California Press, 1995; principal quotation here, p. 42).

H. Bergson, *Creative Evolution*, trans. A. Mitchell (New York: Modern Library, 1944; orig. edn of trans. 1911); see also *Time and Free Will*, trans. F. L. Pogson (London: Allen and Unwin, 1912; orig. edn 1889); and *Matter and Memory*, trans. N. M. Paul and W. S. Palmer (New York: Zone, 1988; orig. edn 1896). For Bergson's place in modern philosophy: G. Gutting, *French Philosophy in the Twentieth Century* (Cambridge: Cambridge University Press, 2001). For the cultural context and reception of his thought: *The Crisis in Modernism: Bergson and the Vitalist Controversy*, ed. F. Burwick and P. Douglas (New York: Cambridge University Press, 1992); M. Antliff, *Inventing Bergson: Cultural Politics and the Parisian Avant-garde* (Princeton, NJ: Princeton University Press, 1993). An influential, if highly personal interpretation that reveals his importance for postmodernism is G. Deleuze, *Bergsonism*, trans. H. Tomlinson (New York: Zone, 1988). A contemporary of Bergson's, Benedetto Croce, developed a theory of art that was similar in its emphasis on intuition, though also distinctive and of independent interest and influence: see his *Aesthetic as a Science of Expression and General Linguistic*, trans. D. Ainslie (Boston: Godine, 1983; orig. edn of trans. 1909).

A sampling of Blake's notes on Reynolds is found in *Neoclassicism and Romanticism, 1750–1850* (cited above), vol. 1, pp. 120–5. See also M. Eaves, *William Blake's Theory of Art* (Princeton, NJ: Princeton University Press, 1982); *John Constable's Discourses*, ed. R. B. Beckett (Ipswich: Suffolk Records Society, 1970). An introduction to Ruskin is W. Kemp, *The Desire of My Eyes: The Life*

and Work of John Ruskin, trans. J. van Heurck (New York: Farrar, Straus and Giroux, 1990). Ruskin's collected works fill 39 volumes: *The Works of John Ruskin*, ed. E. T. Cook and A. Wedderburn (London: George Allen, 1903–12; principal quotations here are from vol. 3, pp. 25, 44, 137, 168; vol. 10, pp. 193, 197). There is an abridged version of *Modern Painters*, ed. D. Barrie (New York: Knopf, 1987); two collections of excerpts from his writings are *The Lamp of Beauty: Writings on Art*, ed. J. Evans (London: Phaidon, 1959; the quotation here on Holman Hunt's *Awakening Conscience* is found on pp. 67–9) and *The Art Criticism of John Ruskin*, ed. R. Herbert (Garden City, NY: Anchor, 1964). The lectures *On the Political Economy of Art* were later republished as *A Joy Forever* and are now found in vol. 16 of Ruskin's *Works* (cited above).

The case for the modernity of the Pre-Raphaelites is forcefully made by E. Prettejohn, *Art of the Pre-Raphaelites* (Princeton, NJ: Princeton University Press, 2000). On the Gothic revival: C. L. Eastlake, *A History of the Gothic Revival . . .* (London: Longmans, 1872; repr. New York, 1970); K. Clark, *The Gothic Revival: An Essay in the History of Taste* (New York: Harper and Row, 1974; orig. edn 1928); and, more recently, C. Brooks, *The Gothic Revival* (London: Phaidon, 1999). On Pugin: *Pugin: A Gothic Passion*, ed. P. Atterbury and C. Wainwright (New Haven, CT: Yale University Press, 1994). German architectural theory of the nineteenth century offers an interesting perspective on British historicism: *In What Style Should We Build? The German Debate on Architectural Style*, ed. W. Herrmann (Los Angeles: Getty Center, 1992).

The writings of William Morris fill 24 volumes: *Collected Works*, ed. M. Morris (24 vols, London: Longmans, 1910–15). Editions of selections include *William Morris on Art and Design*, ed. C. Poulson (Sheffield: Sheffield Academic Press, 1997); and *Political Writings of William Morris*, ed. A. L. Morton (New York: International, 1973). For Wilde's criticism, see *The Artist as Critic: Critical Writings of Oscar Wilde*, ed. R. Ellman (New York: Random House, 1969). See also: *Whistler on Art: Selected Letters and Writings, 1849–1903*, ed. N. Thorp (Manchester: Fyfield, 1994; quotations here are from pp. 80, 84). Fry's most important book is *Vision and Design* (New York, 1998; orig. edn 1920); see also *A Roger Fry Reader*, ed. C. Reed (Chicago: University of Chicago Press, 1996); and V. Woolf, *Roger Fry: A Biography* (London: Hogarth, 1940). The little book by Fry's disciple, C. Bell, *Art* (London: Chatto and Windus, 1914 and subsequent reprints) remains a classic statement of aesthetic formalism.

Chapter 5 The Early Twentieth Century

The outstanding anthology of twentieth-century art theory is *Art in Theory, 1900–1990*, ed. C. Harrison and P. Wood (Oxford: Blackwell, 1992), recently enlarged and reissued as *Art in Theory, 1900–2000* (Oxford: Blackwell, 2002); also useful are: *Modern Artists on Art: Ten Unabridged Essays*, ed. R. Herbert (Englewood Cliffs, NJ: Prentice-Hall, 1965); *Theories of Modern Art: A Source Book by Artists and Critics*, ed. H. Chipp (Berkeley, CA: University of California Press, 1968); *Theories and Documents of Contemporary Art: A Sourcebook of*

282 Sources and Suggestions for Further Reading

Artists' Writings, ed. K. Stiles and P. Selz (Berkeley, CA: University of California Press, 1996); and *Manifesto: A Century of Isms*, ed. M. A. Caws (Lincoln, NE: University of Nebraska Press, 2001). *Futurist Manifestos*, ed. U. Appolonio, trans. R. Brain et al. (New York: Viking, 1973; principal quotation here from p. 22); M. Martin, *Futurist Art and Theory* (Oxford: Clarendon Press, 1968); M. Perloff, *The Futurist Moment: Avant-garde, Avant-guerre, and the Language of Rupture* (Chicago: University of Chicago Press, 1986); G. Berghaus, *Italian Futurist Theater, 1909–1944* (New York: Oxford University Press, 1998). An introduction to the history of performance art is R. Goldberg, *Performance Art from Futurism to the Present* (London: Thames and Hudson, 2001); an anthology of writing about performance is *The Twentieth-century Performance Reader*, ed. M. Huxley and N. Witts (New York: Routledge, 1996).

A recent introduction to Cubism that sets it in social and intellectual-historical context is M. Antliff and P. Leighten, *Cubism and Culture* (London: Thames and Hudson, 2001); a recent anthology of writings about a major work is *Picasso's "Les Demoiselles d'Avignon,"* ed. C. Green (New York: Cambridge University Press, 2001). The account of Cubism presented here is greatly indebted to Y-A. Bois, "Kahnweiler's Lesson," *Painting as Model* (Cambridge, MA: MIT Press, 1990, pp. 65–97; quotation from Kahnweiler on "script," p. 74). Metzinger's remarks on Picasso and Rivière's on Cubism are found in *Art in Theory, 1900–1990* (cited above), pp. 184, 197. *Apollinaire on Art: Essays and Reviews, 1902–1918*, ed. L. Breunig, trans. S. Sulieman (New York: Viking, 1972; principal quotation here is from p. 197); D. H. Kahnweiler, *The Rise of Cubism*, trans. H. Aronson (New York: Wittenborn, Schultz, 1949; principal quotation here from pp. 13–14). A complete translation of Gleizes and Metzinger's essay on Cubism is found in *Modern Artists on Art* (cited above).

F. Léger, *The Functions of Painting*, ed. E. Fry, trans. A. Anderson (New York: Viking, 1973); *The New Art – The New Life: The Collected Writings of Piet Mondrian*, ed. and trans. H. Holtzman and M. James (Boston: G. K. Hall, 1986; principal quotation here from pp. 299–300). A translation of Le Corbusier and Ozenfant's essay on Purism is found in *Modern Artists on Art* (cited above). Le Corbusier, *Toward a New Architecture*, trans. F. Etchells (New York: Dover, 1987; orig. edn of trans. 1927); *The City of Tomorrow and its Planning*, trans. F. Etchells (London: Rodker, 1929). The passage from Gropius is found in *Art in Theory, 1900–1990* (cited above), p. 343. See also W. Gropius, *The New Architecture and the Bauhaus*, trans. P. M. Shand (London: Faber and Faber, 1935); and *The Scope of Total Architecture* (New York: Harper, 1955). For an overview of early twentieth-century architectural and design theory, see R. Banham, *Theory and Design in the First Machine Age* (New York: Praeger, 1967). An anthology of early film theory is: *French Film Theory and Criticism*, ed. R. Abel (2. vols, Princeton, NJ: Princeton University Press, 1988).

On Russian modernism: *Art into Life: Russian Constructivism, 1914–1932* (exhibition catalogue, Seattle: University of Washington Press, 1990); *The Great Utopia: The Russian and Soviet Avant-garde, 1915–1932* (exhibition catalogue, New York: Guggenheim Museum, 1992); S. Kahn-Magomedov, *Rodchenko: The Complete Work* (Cambridge, MA: MIT Press, 1987). For theoretical and

critical writings: *The Tradition of Constructivism*, ed. S. Bann (New York: Viking, 1974); *Russian Art of the Avant-garde: Theory and Criticism*, ed. J. E. Bowlt (New York: Thames and Hudson, 1988); and *K. S. Malevich: Essays on Art*, ed. T. Andersen, trans. X. Glowacki-Prus and A. McMillin (4 vols, Copenhagen: Borgen, 1968–78). An anthology of early Russian writings on film is *The Film Factory: Russian and Soviet Cinema in Documents, 1896–1939*, ed. R. Taylor and I. Christie, trans. R. Taylor (London: Routledge, 1988).

Dada Painters and Poets: An Anthology, ed. R. Motherwell (New York: Wittenborn, Schultz, 1951; the principal quotations here from Huelsenbeck are found on pp. 23, 37; from Tzara, p. 247); J. D. Erickson, *Dada: Performance, Poetry, and Art* (Boston: Twayne, 1984); A. Melzer, *Dada and Surrealist Performance* (Baltimore, MD: The Johns Hopkins University Press, 1994). See also M. Foucault, *Death and the Labyrinth: The World of Raymond Roussel*, trans. C. Ruas (Garden City, NY: Doubleday, 1986); *Brecht on Theater*, trans. D. Willett (New York: Hill and Wang, 1964); W. Benjamin, *Understanding Brecht*, trans. A. Bostock (London: New Left, 1973); J. Fuegi, *Brecht and Company: Sex, Politics, and the Making of Modern Drama* (New York: Grove, 1994).

For Duchamp's statements, see *Salt Seller: The Writings of Marcel Duchamp*, trans. M. Sanouillet and E. Peterson (New York: Oxford University Press, 1973) and *Dialogues with Marcel Duchamp*, ed. P. Cabanne, trans. R. Padgett (New York: Viking, 1971). An interesting attempt to set him in cultural-historical context is J. Siegel, *The Private Worlds of Marcel Duchamp: Desire, Liberation, and the Self in Modern Culture* (Berkeley, CA: University of California Press, 1995). An introduction to the *Great Glass* is J. Golding, *Marcel Duchamp: The Bride Stripped Bare by her Bachelors, Even* (London: Allen Lane, 1973); Duchamp's explanatory notes are gathered in *Marcel Duchamp: The Bride Stripped Bare by her Bachelors, Even: A Typographic Version by Richard Hamilton of Marcel Duchamp's Green Box*, trans. G. H. Hamilton (London: Percy Lund, Humphries, 1960); and interpreted by C. Adcock, *Marcel Duchamp's Notes from the Large Glass: An N-Dimensional Analysis* (Ann Arbor: University of Michigan Press, 1983). See also L. D. Henderson, *Duchamp in Context: Science and Technology in the Large Glass and Other Works* (Princeton, NJ: Princeton University Press, 1998). On theoretical aspects and implications of Duchamp's works: A. Jones, *Postmodernism and the En-gendering of Marcel Duchamp* (New York: Cambridge University Press, 1994); D. Judovitz, *Unpacking Duchamp: Art in Transit* (Berkeley, CA: University of California Press, 1995); T. de Duve, *Kant after Duchamp* (Cambridge, MA: MIT Press, 1996); and D. Joselit, *Infinite Regress: Marcel Duchamp, 1910–41* (Cambridge, MA: MIT Press, 1998).

A. Breton, *Manifestos of Surrealism*, trans. R. Seaver and H. Lane (Ann Arbor: University of Michigan Press, 1969); *Nadja*, trans. R. Howard (New York: Grove, 1960; orig. edn 1928); *Mad Love [L'Amour fou]*, trans. M. Caws (Lincoln, NE: University of Nebraska Press, 1986; orig. edn 1937); *The Poetry of Dada and Surrealism*, ed. and trans. M. Caws (Princeton, NJ: Princeton University Press, 1970). Important studies of Surrealism include: R. Krauss et al., *Amour Fou: Photography and Surrealism* (New York: Abbeville, 1985); R. Krauss, *The Optical Unconscious* (Cambridge, MA: MIT Press, 1993); H. Foster, *Compulsive Beauty* (Cambridge, MA: MIT Press, 1993); and G. Durozoi, *History of the Surrealist*

Movement, trans. A. Anderson (Chicago: University of Chicago Press, 2002). Of special interest is M. Foucault, *This is Not a Pipe*, trans. J. Harkness (Berkeley, CA: University of California Press, 1983; orig. edn 1973).

DeChirico's principal writings are *Hebdomeros: A Novel*, trans. M. Crosland (New York: PAJ, 1988; orig. edn 1929) and *The Memoirs of Giorgio de Chirico*, trans. M. Crosland (London: Owen, 1971). M. Ernst, *Beyond Painting and Other Writings by the Artist and his Friends*, ed. R. Motherwell (New York: Wittenborn, Schultz, 1948). *Collected Writings of Salvador Dalí*, ed. and trans. H. Finkelstein (New York: Cambridge University Press, 1998).

Bataille's work can be approached through a number of anthologies: *Visions of Excess: Selected Writings, 1927–39*, ed. and trans. A. Stoekl et al. (Minneapolis, MN: University of Minnesota Press, 1986); *The Absence of Myth: Writings on Surrealism*, ed. and trans. M. Richardson (London: Verso, 1994); and *The Bataille Reader*, ed. F. Bolting and S. Wilson (Oxford: Oxford University Press, 1997); see also his *Story of the Eye*, trans. J. Neugroschel (New York: Urizen Books, 1977) and *The Tears of Eros*, trans. P. Connor (San Francisco: City Lights, 1990; orig. edn 1961). An excellent overview of his work is D. Hollier, *Against Architecture: The Writings of Georges Bataille*, trans. B. Wing (Cambridge, MA: MIT Press, 1989). An indication of his importance for contemporary thought about art is Y-A. Bois and R. Krauss, *Formless: A User's Guide* (New York: Zone, 1997).

On the relation of Surrealism to anthropology and sociology: J. Clifford, "On Ethnographic Surrealism," *The Predicament of Culture: Twentieth Century Ethography, Literature, and Art* (Cambridge, MA: Harvard University Press, 1988), pp. 117–51; and *The College of Sociology (1937–39)*, ed. D. Hollier, trans. B. Wing (Minneapolis, MN: University of Minnesota Press, 1988). Lefebvre's *Critique of Everyday Life* is available in a translation by J. Moore (London: Verso, 1991).

M. Merleau-Ponty: *Phenomenology of Perception*, trans. C. Smith (New York: Routledge, 1962; orig. edn 1945); *Essential Writings of Merleau-Ponty*, ed. A. Fisher (New York: Harcourt, 1969); S. Priest, *Merleau-Ponty* (New York: Routledge, 1998). See also D. Moran, *Introduction to Phenomenology* (New York: Routledge, 2000).

The older anthologies of Benjamin's writings, *Illuminations: Essays and Reflections*, trans. H. Zohn (New York: Schocken, 1969) and *Reflections: Essays, Aphorisms, Autobiographical Writings*, ed. P. Demetz, trans. E. Jephcott (New York: Schocken, 1978) are in the process of being supplanted by *Walter Benjamin: Selected Writings*, ed. M. Jennings (3 vols, Cambridge, MA: Harvard University Press, 1996–). See also *The Arcades Project*, ed. R. Teidemann, trans. H. Eiland and K. McLaughlin (Cambridge, MA: Harvard University Press, 1999). Important studies include: T. Eagleton, *Walter Benjamin, or, Towards a Revolutionary Criticism* (London: Verso, 1981); R. Wolin, *Walter Benjamin: An Aesthetic of Redemption* (New York: Columbia University Press, 1982); S. Buck-Morss, *The Dialectics of Seeing: Walter Benjamin and the Arcades Project* (Cambridge, MA: MIT Press, 1991); and M. Cohen, *Profane Illumination: Walter Benjamin and the Paris of Surrealist Revolution* (Berkeley, CA: University of California Press, 1993).

The emergence of a new interpretation of American modernism, following upon T. J. Clark's reinterpretation of French modernism, is reflected in books such as *Pollock and After: The Critical Debate*, ed. F. Frascina (New York: Harper

and Row, 1985) and M. Leja, *Reframing Abstract Expressionism: Subjectivity and Painting in the 1940s* (New Haven, CT: Yale University Press, 1993). C. Greenberg, *Collected Essays and Criticism*, ed. J. O'Brian (4 vols, Chicago: University of Chicago Press, 1986–93; principal quotations here are from vol. 1, pp. 32, 34, and vol. 4, pp. 85, 86); Rosenberg's essay "The American Action Painters" is found in his *The Tradition of the New* (New York: Grove, 1961). B. Newman, *Selected Writings and Interviews*, ed. J. P. O'Neill (New York: Knopf, 1990); *The Collected Writings of Robert Motherwell*, ed. S. Terenzio (New York: Oxford University Press, 1992); *Art-as-Art: The Selected Writings of Ad Reinhardt*, ed. B. Rose (New York: Viking, 1975; quotation here from p. 53); J. Cage, *Silence: Lectures and Writings* (Middletown: Wesleyan University Press, 1961); A. Kaprow, *Essays on the Blurring of Art and Life*, ed. J. Kelley (Berkeley, CA: University of California Press, 1993; quotation here from pp. 7–9); Steinberg's essay, "Other Criteria," is found in his *Other Criteria: Confrontations with Twentieth-century Art* (New York: Oxford University Press, 1972).

A recent introduction to Minimalism is J. Meyer, *Minimalism: Art and Polemics in the '60s* (New Haven, CT: Yale University Press, 2001). *Minimal Art: A Critical Anthology*, ed. G. Battcock (New York: Dutton, 1968); D. Judd, *Complete Writings, 1959–1975* (Halifax: Nova Scotia College of Art and Design, 1975; principal quotation here from p. 184); and *Complete Writings, 1975–1987* (Eindhoven: Abbemuseum, 1987); *Continuous Project Altered Daily: The Writings of Robert Morris* (Cambridge, MA: MIT Press, 1993; quotation here from p. 15); M. Fried, *Art and Objecthood: Essays and Reviews* (Chicago: University of Chicago Press, 1998). On Fried's use of Merleau-Ponty, see S. Melville, "Phenomenology and the Limits of Hermeneutics," *The Subjects of Art History*, ed. M. Cheetham et al. (New York: Cambridge University Press, 1998), pp. 143–54.

Idea Art: A Critical Anthology, ed. G. Battcock (New York: Dutton, 1973); *Conceptual Art: A Critical Anthology*, ed. A. Alberro and B. Stimson (Cambridge, MA: MIT Press, 1999); C. Harrison, *Essays on Art and Language* (Oxford: Blackwell, 1991); S. Lewitt, *Critical Texts*, ed. A. Zevi (Rome: AEIUO, 1994); J. Kosuth, *Art after Philosophy and After: Collected Writings, 1966–1990*, ed. G. Guercio (Cambridge, MA: MIT Press, 1991); L. Weiner, *Statements* (New York: Kellner Foundation, 1968); *Lawrence Weiner*, ed. A. Alberro et al. (London: Phaidon, 1998); D. Graham, *Rock my Religion: Writings and Art Projects, 1965–1990*, ed. B. Wallis (Cambridge, MA: MIT Press, 1993). For the writings of an influential figure not discussed here, see *Robert Smithson: The Collected Writings*, ed. J. Flam (Berkeley, CA: University of California Press, 1996).

Chapter 6 Postmodernism

There are a great many attempts to define postmodernism and the condition of postmodernity; there is even an *Encyclopedia of Postmodernism*, ed. V. Taylor and C. Winquist (London: Routledge, 2001). A descriptive overview of its manifestations in various kinds of cultural activity, including theory, is S. Connor, *Postmodernist Culture: An Introduction to Theories of the Contemporary* (Malden, MA: Blackwell, 1997). A more intensive and critical summary of the major

theorists is S. Best and D. Kellner, *Postmodern Theory: Critical Interrogations* (New York: Guilford, 1991). F. Jameson, *Postmodernism, or the Cultural Logic of Late Capitalism* (Durham, NC: Duke University Press, 1991) sets postmodernism in a broad economic and cultural-historical context. J. Habermas, *The Philosophical Discourse of Modernity*, trans. F. Lawrence (Cambridge, MA: MIT Press, 1987) is a critical examination of the philosophical tendencies that led to postmodernism and an attempt to distinguish its legitimate from its illegitimate forms.

On the Frankfurt School: M. Jay, *The Dialectical Imagination: A History of the Frankfurt School and the Institute of Social Research 1923–1950* (Boston: Little, Brown, 1973). An excellent sampling of their work is *The Essential Frankfurt School Reader*, ed. A. Arato and E. Gebhardt (Oxford: Blackwell, 1978). One of Marcuse's most influential texts is *One-dimensional Man: Studies in the Ideology of Advanced Industrial Society* (Boston: Beacon, 1964). On the relation of Frankfurt School thought to postmodernism: A. Huyssen, *After the Great Divide: Modernism, Mass Culture, Postmodernism* (Bloomington, IN: University of Indiana Press, 1987); *The Problems of Modernism: Adorno and Benjamin*, ed. A. Benjamin (New York: Routledge, 1989); and F. Jameson, *Late Modernism: Adorno, or the Persistence of the Dialectic* (New York: Verso, 1990).

M. Horkheimer and T. W. Adorno, *Dialectic of Enlightenment*, trans. J. Cumming (New York: Continuum, 1972; principal quotations here from pp. 137, 139, 163). The culture industry essay has been reprinted separately, with other related works, in *Adorno: The Culture Industry: Selected Essays on Mass Culture*, ed. J. M. Bernstein (New York: Routledge, 2001). A good discussion of Adorno's evolving ideas about the culture industry is D. Cook, *The Culture Industry Revisited: Theodor W. Adorno on Mass Culture* (London: Rowman and Littlefield, 1996); for his ideas on modern music, see *Philosophy of Modern Music*, trans. A. Mitchell and W. Blomster (New York: Seabury, 1973; orig. edn 1958) and *Essays on Music*, ed. R. Leppert, trans. S. Gillespie et al. (Berkeley, CA: University of California Press, 2002). A good introduction to his thought as a whole is M. Jay, *Adorno* (Cambridge, MA: Harvard University Press, 1984); a range of current attitudes is reflected in *Adorno: A Critical Reader*, ed. N. Gibson and A. Rubin (Malden, MA: Blackwell, 2002). His late *Aesthetic Theory*, trans. R. Hullot-Kentor (Minneapolis, MN: University of Minnesota Press, 1997) has proved to be an important, if problematic, work: see *The Semblance of Subjectivity: Essays in Adorno's Aesthetic Theory*, ed. T. Huhn and L. Zuidervaart (Cambridge, MA: MIT Press, 1997); and C. Menke-Eggers, *The Sovereignty of Art: Aesthetic Negativity in Adorno and Derrida*, trans. N. Solomon (Cambridge, MA: MIT Press, 1998). The passage from Benjamin's essay "The Work of Art in the Age of Mechanical Reproduction" is found in his *Illuminations* (cited above), p. 224.

L. Althusser, "Ideology and Ideological State Apparatuses," *Lenin and Philosophy and Other Essays*, trans. B. Brewster (London: NLB, 1971). An historical survey of the concept of ideology is T. Eagleton, *Ideology: An Introduction* (London: Verso, 1991). An important early twentieth-century theorist not discussed here is the Italian Antonio Gramsci, whose concept of hegemony, designed to explain the ways in which the domination of the underclass is achieved with their consent, anticipates some of the concerns of later theorists such as

Althusser and was particularly influential in the development of postmodernism in Britain. See *Selections from the Prison Notebooks of Antonio Gramsci*, ed. and trans. Q. Hoare and G. Smith (New York: International, 1971) and, as an example of its continued importance for leftist thought, E. Laclau and C. Mouffe, *Hegemony and Socialist Strategy: Toward a Radical Democratic Politics* (London: Verso, 1985).

On the Situationists: *On the Passage of a Few People Through a Rather Brief Moment in Time*, ed. E. Sussman (Cambridge, MA: MIT Press, 1989); *Situationist International Anthology*, ed. and trans K. Knabb (Berkeley, CA: Public Secrets, 1981); G. Debord, *The Society of the Spectacle*, trans. D. Nicholson-Smith (New York: Zone, 1994; orig. edn 1967); R. Vaneigem, *The Revolution of Everyday Life*, trans. D. Nicholson-Smith (Seattle: Left Bank, 1994; orig. edn 1967); and *Guy Debord and the Situationist International*, ed. T. McDonough (Cambridge, MA: MIT Press, 2002). An example of their continued influence is the work of Michel de Certeau: *The Practice of Everyday Life*, trans. S. Rendall (Berkeley, CA: University of California Press, 1984; orig. edn 1980); *Heterologies: Discourse on the Other*, trans. B. Massumi (Minneapolis, MN: University of Minnesota Press, 1986); see also I. Buchanan, *Michel de Certeau: Cultural Theorist* (London: Sage, 2000).

The best point of entry into Foucault's work is *Discipline and Punish: The Birth of the Prison*, trans. A. Sheridan (New York: Random House, 1995). There is a one-volume selection of his writings and interviews, *The Foucault Reader*, ed. P. Rabinow (New York: Pantheon, 1984); a three-volume selection is *The Essential Works of Michel Foucault, 1954–1984*, ed. P. Rabinow (New York: New Press, 1997). For an overview of his work: *The Cambridge Companion to Foucault*, ed. G. Gutting (New York: Cambridge University Press, 1994). His late work has been the focus of particular interest since his death. The major project of his last years was *The History of Sexuality*, trans. R. Hurley (3 vols, New York: Random House, 1978–86); other collections and studies focused on the late work include: *Politics, Philosophy, Culture: Interviews and Other Writings, 1977–84*, ed. and trans. A. Sheridan et al. (New York: Routledge, 1988); *Technologies of the Self: A Seminar with Michel Foucault*, ed. L. Martin et al. (Amherst, MA: University of Massachusetts Press, 1988); *Aesthetics, Method, and Epistemology*, ed. J. Faubion, trans. R. Hurley et al. (New York: New Press, 1998); *The Later Foucault: Politics and Philosophy*, ed. J. Moss (London: Sage, 1998); G. Deleuze, *Foucault*, trans. S. Hand (Minneapolis, MN: University of Minnesota Press, 1988); T. Miller, *The Well-tempered Self: Citizenship, Culture, and the Postmodern Subject* (Baltimore, MD: The Johns Hopkins University Press, 1993); and J. Ransom, *Foucault's Discipline: The Politics of Subjectivity* (Durham, NC: Duke University Press, 1997).

G. Deleuze, *Nietzsche and Philosophy*, trans. H. Tomlinson (New York: Columbia University Press, 1983; orig. edn 1962); see also *Pure Immanence*, ed. J. Rajchman, trans. A. Boyman (New York: Zone, 2001). G. Deleuze and F. Guattari, *Anti-Oedipus: Capitalism and Schizophrenia*, ed. R. Hurley et al. (Minneapolis, MN: University of Minnesota Press, 1983); *A Thousand Plateaus: Capitalism and Schizophrenia*, trans. B. Massumi (Minneapolis, MN: University of Minnesota Press, 1987). A more recent collaboration between them, one that provides

another point of entry into their thought, is *What is Philosophy?*, trans. H. Tomlinson and G. Burchell (New York: Columbia University Press, 1994; orig. edn 1991). See also B. Massumi, *A User's Guide to Capitalism and Schizophrenia: Deviations from Deleuze and Guattari* (Cambridge, MA: MIT Press, 1992) and P. Goodchild, *Deleuze and Guattari: An Introduction to the Politics of Desire* (London: Sage, 1996). For applications to the analysis of contemporary media: *Micropolitics of Media Culture: Reading the Rhizomes of Deleuze and Guattari*, ed. P. Pisters (Amsterdam: University of Amsterdam Press, 2001).

J. Baudrillard, *The Mirror of Production*, trans. M. Poster (St Louis: Telos, 1975; orig. edn 1973); *Simulations*, trans. Paul Foss et al. (New York: Semiotext(e), 1983; principal quotation here from pp. 15–16); and *America*, trans. C. Turner (New York; Routledge, 1989; orig. edn 1986). D. Kellner, *Jean Baudrillard: From Marxism to Postmodernism and Beyond* (Stanford: Stanford University Press, 1989); *Baudrillard: A Critical Reader*, ed. D. Kellner (Oxford: Blackwell, 1994); M. Gane, *Jean Baudrillard: In Radical Uncertainty* (London: Pluto, 2000).

Some of the insights of Debord, Baudrillard, and others into the ways in which the media were changing the world had been anticipated – albeit from a very different philosophical position – by the Canadian Marshall McLuhan, whose *Understanding Media: The Extensions of Man* (London: Routledge, 1994; orig. edn 1964) and other works were very popular among English-speaking intellectuals in the years before French thought became widely available: his ideas were known to Andy Warhol and had an influence on Barbara Kruger.

For an introduction to Pop Art, see *Pop Art: A Critical History*, ed. S. Madoff (Berkeley, CA: University of California Press, 1997). A. Warhol and P. Hackett, *The Philosophy of Andy Warhol from A to B and Back Again* (New York: Harcourt, 1975; principal quotation here from p. 92); *POPism: The Warhol '60s* (New York: Harcourt, 1980); B. Buchloh, "Andy Warhol's One-dimensional Art," *Andy Warhol: A Retrospective*, ed. K. McShine et al. (exhibition catalogue, New York: Museum of Modern Art, 1989); D. James, "The Unsecret Life: A Warhol Advertisement," *Power Misses: Essays Across (Un)Popular Culture* (London: Verso, 1996). V. Burgin, *The End of Art Theory* (Atlantic Highlands, NJ: Humanities Press, 1986); B. Kruger, *Remote Control: Power, Culture, and the World of Appearances* (Cambridge, MA: MIT Press, 1993; quotation here from p. 99).

The emergence of the most incisive form of postmodernist art criticism is associated with the group surrounding Rosalind Krauss and the journal *October*. Their major texts, in some cases collections of previously published essays, include: R. Krauss, *The Originality of the Avant-garde and Other Modernist Myths* (Cambridge, MA: MIT Press, 1985); *The Anti-Aesthetic: Essays on Postmodern Culture*, ed. H. Foster (Port Townsend: Bay, 1983); and *Recodings: Art, Spectacle, Cultural Politics* (Port Townsend: Bay, 1985); C. Owens, *Beyond Recognition: Representation, Power, and Culture* (Berkeley, CA: University of California Press, 1992); D. Crimp, *On the Museum's Ruins* (Cambridge, MA: MIT Press, 1994); and B. Buchloh, *Neo-avant-garde and Culture Industry: Essays on European and American Art from 1955 to 1975* (Cambridge, MA: MIT Press, 2000). Two anthologies of representative writings are *October: The First Decade, 1976–1986*, ed. R. Krauss et al. (Cambridge, MA: MIT Press, 1987); and *October: The*

Second Decade, 1986–1996 (Cambridge, MA: MIT Press, 1997). On art of the late '80s and '90s, see H. Foster, *Return of the Real* (Cambridge, MA: MIT Press, 1997).

Two anthologies, conceived as a pair, that were influential in disseminating postmodernist theory and criticism are *Art after Modernism: Rethinking Representation*, ed. B. Wallis (New York: New Museum, 1984) and *Blasted Allegories: An Anthology of Writings by Contemporary Artists*, ed. B. Wallis (New York: New Museum, 1986).

Lucid introductions to the development of modern linguistic theory and its applications are: T. Hawkes, *Structuralism and Semiotics* (Berkeley, CA: University of California Press, 1977); R. Harland, *Superstructuralism* (New York: Routledge, 1987); and A. Berman, *From the New Criticism to Deconstruction: The Reception of Structuralism and Poststructuralism* (Urbana, IL: University of Illinois Press, 1988). See also the studies of J. Culler: *Structuralist Poetics: Structuralism, Linguistics, and the Study of Literature* (Ithaca, NY: Cornell University Press, 1975); *The Pursuit of Signs: Semiotics, Literature, Deconstruction* (Ithaca, NY: Cornell University Press, 1981); and *On Deconstruction: Theory and Criticism after Structuralism* (Ithaca, NY: Cornell University Press, 1982). For the philosophical background: G. Gutting, *French Philosophy in the Twentieth Century* (Cambridge: Cambridge University Press, 2001). See also *The Cambridge History of Literary Criticism*, vol. 8: *From Formalism to Poststructuralism*, ed. R. Selden (New York: Cambridge University Press, 1995). There are a great many introductions to the work of individual theorists and the themes that relate them to one another; among those not cited elsewhere are: D. Carroll, *Paraesthetics: Foucault, Lyotard, Derrida* (New York: Methuen, 1987); M. Payne, *Reading Theory: An Introduction to Lacan, Derrida, and Kristeva* (Cambridge, MA: Blackwell, 1993); and, by the same author, *Reading Knowledge: An Introduction to Barthes, Foucault, and Althusser* (Malden, MA: Blackwell, 1997).

F. de Saussure, *Course in General Linguistics*, ed. C. Bally et al., trans. W. Baskin (London: Fontana, 1974); F. Jameson, *The Prison-house of Language: A Critical Account of Structuralism and Russian Formalism* (Princeton, NJ: Princeton University Press, 1972); P. Steiner, *Russian Formalism: A Metapoetics* (Ithaca, NY: Cornell University Press, 1984). C. Lévi-Strauss, *The Savage Mind*, trans. J. and D. Weightman (Chicago: University of Chicago Press, 1966; orig. edn 1962) and *Structural Anthropology*, trans. C. Jacobson and B. Schoepf (London: Penguin, 1968; orig. edn 1958).

R. Barthes, *Mythologies*, trans. A. Lavers (New York: Hill and Wang, 1972; orig. edn 1957); *Elements of Semiology*, trans. C. Smith (New York: Hill and Wang, 1967; orig. edn 1964); *S/Z*, trans. R. Miller (New York: Hill and Wang, 1974; orig. edn 1970); *Image/Music/Text*, trans. S. Heath (New York: Hill and Wang, 1977); *The Responsibility of Forms*, trans. R. Howard (New York: Hill and Wang, 1985); and *Camera Lucida: Reflections on Photography*, trans. R. Howard (New York: Hill and Wang, 1981).

The best point of entry into Derrida's work is the essay "Structure, Sign, and Play in the Discourse of the Human Sciences" and the other essays in *Writing and Difference*, trans. A. Bass (Chicago: University of Chicago Press, 1978; principal quotation here from p. 292). Also helpful are the interview with J.

Kristeva in his *Positions*, trans. A. Bass (Chicago: University of Chicago Press, 1981) and the essay on *différance* in his *Margins of Philosophy*, trans. A. Bass (Chicago: University of Chicago Press, 1982). His more extensive critique of Saussure and of Western metaphysics is laid out in *Speech and Phenomena*, trans. D. Allison (Evanston, IL: Nothwestern University Press, 1973) and *Of Grammatology*, trans. G. C. Spivak (Baltimore, MD: The Johns Hopkins University Press, 1976). For an overview of his career that stresses his more recent work, see C. Howells, *Derrida: Deconstruction from Phenomenology to Ethics* (Cambridge: Polity Press, 1999). His writings on art include *The Truth in Painting*, trans. G. Bennington and I. McLeod (Chicago: University of Chicago Press, 1987) and *Memoirs of the Blind*, trans. P-A. Brault and M. Naas (Chicago: University of Chicago Press, 1993); his writings on architecture are included in the citations regarding Eisenman below. An interview with Derrida on the implications of his ideas for the visual arts is found in *Deconstruction and the Visual Arts*, ed. P. Brunette and D. Wills (New York: Cambridge University Press, 1994). For an introduction to deconstruction: C. Norris, *Deconstruction: Theory and Practice* (New York: Routledge, 1982); see also *Deconstruction: A Reader*, ed. M. McQuillan (New York: Routledge, 2000). Outstanding critical studies include: S. Melville, *Philosophy Beside Itself: On Deconstruction and Modernism* (Minneapolis, MN: University of Minnesota Press, 1986); R. Gasché, *The Tain of the Mirror: Derrida and the Philosophy of Reflection* (Cambridge, MA: Harvard University Press, 1986); and F. B. Farrell, *Subjectivity, Realism, and Postmodernism: The Recovery of the World* (New York: Cambridge University Press, 1994).

J-F. Lyotard, *The Postmodern Condition: A Report on Knowledge*, trans. G. Bennington and B. Massumi (Minneapolis, MN: University of Minnesota Press, 1984). His *Discours, figure* (Paris: Klincksieck, 1971) has not been translated into English. See also *The Lyotard Reader*, ed. A. Benjamin (Oxford: Blackwell, 1989); G. Bennington, *Lyotard: Writing the Event* (New York: Columbia University Press, 1988); and *Judging Lyotard*, ed. A. Benjamin (New York; Routledge, 1992).

G. Deleuze, *Difference and Repetition*, trans. P. Patton (New York: Columbia University Press, 1994; orig. edn 1968); *The Logic of Sense*, ed. C. Boundas, trans. M. Lester (New York: Columbia University Press, 1990; orig. edn 1969); *Cinema I: The Movement-Image*, trans. H. Tomlinson and B. Habberjam (Minneapolis, MN: University of Minnesota Press, 1986; orig. edn 1983); and *Cinema II: The Time-Image*, trans. H. Tomlinson and R. Galeta (Minneapolis, MN: University of Minnesota Press, 1989; orig. edn 1985). Two good introductions to this difficult thinker are J. Marks, *Gilles Deleuze: Vitalism and Multiplicity* (London: Pluto, 1998) and C. Colebrook, *Deleuze* (New York: Routledge, 2002); other studies include M. Hardt, *Gilles Deleuze: An Apprenticeship in Philosophy* (Minneapolis, MN: University of Minnesota Press, 1993); P. Goodchild, *Gilles Deleuze and the Question of Philosophy* (Madison: Associated University Presses, 1996); and D. Olkowski, *Gilles Deleuze and the Ruin of Representation* (Berkeley, CA: University of California Press, 1999). Two useful anthologies of essays about his work and its influence are *Gilles Deleuze and the Theater of Philosophy*, ed. C. Boundas and D. Olkowski (New York: Routledge, 1994) and *A Deleuzian Century?*, ed. I. Buchanan (Durham, NC: Duke University

Press, 1999). More speculative interpretations, yet somehow in keeping with the creatively transgressive nature of his thought, are J. Rajchman, *The Deleuze Connections* (Cambridge, MA: MIT Press, 2000) and I. Buchanan, *Deleuzism: A Metacommentary* (Durham, NC: Duke University Press, 2000).

J. Lacan, *Ecrits: A Selection*, trans. A. Sheridan (London: Tavistock, 1977); *The Four Fundamental Concepts of Psychoanalysis*, trans. A. Sheridan (New York: Norton, 1981; orig. edn 1973); *Television*, trans. D. Hollier et al. (New York: Norton, 1990; orig. edn 1974); see also *Feminine Sexuality: Jacques Lacan and the École Freudienne*, ed. J. Mitchell and J. Rose (New York: Norton, 1982). Two general introductions are E. Grosz, *Jacques Lacan: A Feminist Introduction* (New York: Routledge, 1990) and M. Bowie, *Lacan* (Cambridge, MA: Harvard University Press, 1991); exemplary interpretative applications of his thought include: K. Silverman, *The Subject of Semiotics* (New York: Oxford University Press, 1983); J. Rose, *Sexuality in the Field of Vision* (London: Verso, 1986); S. Žižek, *Looking Awry: An Introduction to Jacques Lacan through Popular Culture* (Cambridge, MA: MIT Press, 1991); and J. Copjec, *Read My Desire: Lacan against the Historicists* (Cambridge, MA: MIT Press, 1994).

For Kristeva, see *The Kristeva Reader*, ed. T. Moi (New York: Columbia University Press, 1986) and A-M. Smith, *Julia Kristeva: Speaking the Unspeakable* (London: Pluto, 1998). See also *French Feminist Thought: A Reader*, ed. T. Moi (Oxford: Blackwell, 1987). An ambitious attempt at a comprehensive survey of feminist perspectives on art is *Feminism–Art–Theory: An Anthology, 1968–2000*, ed. H. Robinson (Oxford: Blackwell, 2001); an overview of feminist artistic production is *Feminist Visual Culture*, ed. F. Carson and C. Pajaczkowska (New York: Routledge, 2001). M. Kelly, *Post-partum Document* (London: Routledge, 1983) and *Imaging Desire* (Cambridge, MA: MIT Press, 1996). On Cindy Sherman, see R. Krauss, *Cindy Sherman, 1975–1993* (New York: Rizzoli, 1993). J. Holzer, *Truisms and Essays* (Halifax: Nova Scotia College of Art and Design, 1983); see also D. Joselit et al., *Jenny Holzer* (London: Phaidon, 1998).

A leading figure in the adaptation of post-structuralist theory to film criticism was Christian Metz, *Film Language: A Semiotics of the Cinema*, trans. M. Taylor (New York: Oxford University Press, 1974; orig. edn 1971–2); and *The Imaginary Signifier: Psychoanalysis and the Cinema*, trans. C. Britton et al. (Bloomington, IN: University of Indiana Press, 1982; orig. edn 1977); another was Raymond Bellour, *The Analysis of Film*, ed. C. Penley (Bloomington, IN: University of Indiana Press, 2000). On feminist approaches to film theory, see C. Penley, *Feminism and Film Theory* (New York: Routledge, 1988). Mulvey's essay is reprinted, along with some of her subsequent reconsiderations, in her *The Visual and Other Pleasures* (Bloomington, IN: University of Indiana Press, 1989).

On architectural theory: *Rethinking Architecture: A Reader in Cultural Theory*, ed. N. Leach (New York: Routledge, 1997) and *Architecture Theory Since 1968*, ed. K. M. Hays (Cambridge, MA: MIT Press, 1998). On Eisenman, P. Eisenman et al., *House of Cards* (New York: Oxford University Press, 1987); *Re: Working Eisenman* (London: Academy, 1993); and A. Vidler, *The Architectural Uncanny: Essays in the Modern Unhomely* (Cambridge, MA: MIT Press, 1992).

Among the contemporary analytic philosophers engaged with aesthetics is Nelson Goodman: *Languages of Art: An Approach to the Theory of Symbols*

(Indianapolis, IN: Bobbs-Merrill, 1968) and *Ways of Worldmaking* (Indianapolis, IN: Hacker, 1978). Another, particularly sensitive to the historicity of art, is Arthur Danto: "The Artworld," *Journal of Philosophy* 61 (1964), pp. 571–84; *The Transfiguration of the Commonplace* (Cambridge, MA: Harvard University Press, 1981); *The Philosophical Disenfranchisement of Art* (New York: Columbia University Press, 1986); and *After the End of Art: Contemporary Art and the Pale of History* (Princeton, NJ: Princeton University Press, 1997). For responses to his work, largely from within the analytic tradition, see *Danto and his Critics*, ed. M. Rollins (Malden, MA: Blackwell, 1993).

On the "culture wars," see *Art Matters: How the Culture Wars Changed America*, ed. B. Wallis et al. (New York: New York University Press, 1999). For an excellent introduction to "cultural studies," see *The Cultural Studies Reader*, ed. S. During (New York: Routledge, 1999). An example of such work, an important model for subsequent studies of contemporary culture, is D. Hebdige, *Subculture: The Meaning of Style* (London: Methuen, 1979). For the critique of science from within cultural studies, see *Science Wars*, ed. A. Ross (Durham, NC: Duke University Press, 1996). On "visual culture": *The Visual Culture Reader*, ed. N. Mirzoeff (New York: Routledge, 1998) and *Practices of Looking: An Introduction to Visual Culture*, ed. M. Stuken and L. Cartwright (New York: Oxford University Press, 2001). On the transformation of academic art history under the influence of postmodernist theory: K. Moxey, *The Practice of Theory: Poststructuralism, Cultural Politics, and Art History* (Ithaca, NY: Cornell University Press, 1994) and *The New Art History: A Critical Introduction*, ed. J. Harris (New York: Routledge, 2002). Among the anthologies that offer samples of such work, two of the best are *Visual Culture: Images and Interpretations*, ed. N. Bryson et al. (Hanover: Wesleyan University Press, 1994) and *Vision and Textuality*, ed. S. Melville and B. Readings (Durham, NC: Duke University Press, 1995). A range of attitudes toward developments in the field is reflected in "Visual Culture Questionnaire," *October*, 77 (1996), pp. 25–70. For an interesting example of the way in which academic art history has influenced the practice of contemporary art, see T. Crow, "Profane Illuminations: The Social History of Jeff Wall," *Modern Art in the Common Culture* (New Haven, CT: Yale University Press, 1996), pp. 151–69.

Among Judith Butler's most important works are: *Gender Trouble: Feminism and the Subversion of Identity* (New York: Routledge, 1990; principal quotations here from pp. 6, 180); *Bodies that Matter: On the Discursive Limits of "Sex"* (New York: Routledge, 1993); *Excitable Speech: Contemporary Scenes of Politics* (New York: Routledge, 1996); *The Psychic Life of Power: Theories in Subjection* (Stanford: Stanford University Press, 1997); and (with E. Laclau and S. Žižek) *Contingency, Hegemony, Universality: Contemporary Dialogues on the Left* (New York: Verso, 2000).

C. West, "The New Cultural Politics of Difference," republished in *The Cultural Studies Reader* (cited above; quotation here from pp. 256–7). On multiculturalism: *Mapping Multiculturalism*, ed. A. Gordon and C. Newfield (Minneapolis, MN: University of Minnesota Press, 1996). On post-colonial theory: H. Bhabha, *The Location of Culture* (New York: Routledge, 1994; principal quotation here from p. 173). See also R. Young, *Postcolonialism: An Historical*

Introduction (Malden, MA: Blackwell, 2001); *The Cultures of Globalization*, ed. F. Jameson and M. Miyoshi (Durham, NC: Duke University Press, 1998); and *Reading the Contemporary: African Art from Theory to the Marketplace*, ed. O. Oguibe and O. Enwezor (Cambridge, MA: MIT Press, 1999). Trinh Min-ha, *Woman, Native, Other* (Bloomington, IN: University of Indiana Press, 1989); *Framer Framed* (New York: Routledge, 1992); and *Cinema Interval* (New York: Routledge, 1999).

On postmodern ethnography: C. Geertz, *The Interpretation of Cultures* (New York: Basic Books, 1973); *Local Knowledge: Further Essays in Interpretive Anthropology* (New York: Basic Books, 1983); J. Clifford, *The Predicament of Culture: Twentieth-century Ethnography, Literature, and Art* (Cambridge, MA: Harvard University Press, 1988); *Visualizing Theory: Selected Essays from V.A.R., 1990–1994*, ed. L. Taylor (New York: Routledge, 1994); and *The Fate of "Culture": Geertz and Beyond*, ed. S. Ortner (Berkeley, CA: University of California Press, 1999). Among contemporary sociological theorists, Pierre Bourdieu deserves special mention in this context, both for his attention to symbolic values in culture generally, and for his interest in the social structure of the modern art world: see his *Outline of a Theory of Practice*, trans. R. Nice (Cambridge: Cambridge University Press, 1977; orig. edn 1972); *Language and Symbolic Power*, ed. J. B. Thompson, trans. G. Raymond and M. Adamson (Cambridge, MA: Harvard University Press, 1991); *Distinction: A Social Critique of the Judgement of Taste*, trans. R. Nice (Cambridge, MA: Harvard University Press, 1984; orig. edn 1979); and *The Field of Cultural Production: Essays on Art and Literature*, ed. R. Johnson (New York: Columbia University Press, 1993).

On theoretical approaches to the body: *Fragments for a History of the Human Body*, ed. M. Feher et al. (3 vols, New York: Zone, 1989). On contemporary body art: *The Artist's Body*, ed. T. Warr and A. Jones (London: Phaidon, 2000). On fetishism: *Fetishism as Cultural Discourse*, ed. E. Apter and W. Pietz (Ithaca, NY: Cornell University Press, 1993); and H. Krips, *Fetish: An Erotics of Culture* (Ithaca, NY: Cornell University Press, 1999). J. Welchman et al., *Mike Kelley* (London: Phaidon, 1999); M. Kelley, *Foul Perfection: Essays and Criticism*, ed. J. Welchman (Cambridge, MA: MIT Press, 2002). For the Lacanian aspects of Hatoum's *Corps d'étranger*, see E. Lajer-Burcharth, "Real Bodies: Video in the 1990s," *Art History*, 20 (1997), pp. 185–213.

Haraway's "Manifesto for Cyborgs" can be found in her *Simians, Cyborgs, and Women: The Reinvention of Nature* (New York: Routledge, 1991); evidence of the following it has won are anthologies such as: *Technoculture*, ed. A. Ross and C. Penley (Minneapolis, MN: University of Minnesota Press, 1991); *The Cyborg Handbook*, ed. C. H. Gray et al. (New York: Routledge, 1995); and *The Gendered Cyborg: A Reader*, ed. G. Kirkup et al. (New York: Routledge, 2000).

The literature on technology and its implications for art and culture is already vast and growing exponentially, it seems, every day. An excellent introduction to the issues surrounding art and digital technology is P. Lunenfeld, *Snap to Grid: A User's Guide to Digital Arts, Media, and Cultures* (Cambridge, MA: MIT Press, 2000); see also O. Grau, *Virtual Art: From Illusion to Immersion* (Cambridge, MA: MIT Press, 2002). Other important sources, representing a variety of philosophical positions, are: *Culture, Technology and Creativity in the Late Twentieth*

Century, ed. P. Hayward (London: Libbey, 1990); *Culture on the Brink: Ideologies of Technology*, ed. G. Bender and T. Druckrey (Seattle: Bay, 1994); *Resisting the Virtual Life: The Culture and Politics of Information*, ed. J. Brook and I. A. Boel (San Francisco: City Lights, 1995); M. Castells, *The Power of Identity*, vol. 2 of *The Information Age: Economics, Society, and Culture* (Malden, MA: Blackwell, 1997); R. L. Rutsky, *High Techne: Art and Technology from the Machine Aesthetic to the Posthuman* (Minneapolis, MN: University of Minnesota Press, 1999); N. K. Hayles, *How We Became Posthuman: Virtual Bodies in Cybernetics, Literature, and Informatics* (Chicago: University of Chicago Press, 1999); and C. H. Gray, *Cyborg Citizen: Politics in the Posthuman Age* (New York: Routledge, 2001). On genetics: G. Stock, *Redesigning Humans: Our Inevitable Genetic Future* (Boston: Houghton Mifflin, 2002).

A sampling of current concern with subjectivity is: C. Taylor, *Sources of the Self: The Making of Modern Identity* (Cambridge, MA: Harvard University Press, 1989); *Who Comes after the Subject?*, ed. E. Cadava et al. (New York: Routledge, 1991); *Deconstructive Subjectivities*, ed. S. Critchley and P. Dews (Albany, NY: State University of New York Press, 1996); S. Žižek, *The Ticklish Subject: The Absent Centre of Political Ontology* (London: Verso, 1999); and *Subjectivity: Theories of the Self from Freud to Haraway*, ed. N. Mansfield (New York: New York University Press, 2000).

A case for the continuing importance of theory is simply but eloquently made in T. Eagleton, *The Significance of Theory* (Malden, MA: Blackwell, 1990). On the practice of theory in current political and cultural conditions: *Theory Rules: Art as Theory/Theory as Art*, ed. J. Berland et al. (Toronto: University of Toronto Press, 1996).

index